"Education is not the filling of a pail, but the lighting of a fire."

—William Butler Yeats

AMERICAN TEACHER
HEROES IN THE CLASSROOM
KATRINA FRIED

Foreword by
PARKER J. PALMER

WELCOME BOOKS NEW YORK

Foreword *by Parker J. Palmer*

I've worked with American teachers for nearly three decades, and they truly are "heroes in the classroom," but too often they are unseen and unsung. That's why I'm delighted to introduce you to this beautiful book, a visual and verbal celebration of people who are doing some of the most important work on the planet: helping to educate and raise up the next generation.

My high regard for our classroom heroes explains why I wrote a book called *The Courage to Teach* (1997) and created a teacher renewal program by the same name. That program, now in its twentieth year, has served tens of thousands of courageous American educators.[1] As I reflected on what I wanted to say in this foreword, I recalled a story from the early days of the program that will take us to the heart of the matter, once I take a moment to set the stage.

The Courage to Teach program takes a cohort of twenty-five K–12 educators through eight quarterly retreats of three days each—retreats led by a well-trained facilitator and held at centers with access to nature, good facilities, healthy food, and private rooms for all. The program is more costly than most teachers can afford. So when we launch a new cohort, we must raise money from the local community to cover costs. Our teachers deserve this kind of gift, and giving it to them pays off handsomely in teacher renewal and retention and deeper service to students.

At one of our first fundraisers, we gathered fifteen local wealth-holders around the conference table at a community bank. Our aim was simple: to remind these folks that their teachers did vital and demanding work day in and day out, and needed the kind of support our program offers to keep doing it—support we could provide only if people of means made it possible for them to attend.

But things are never simple when it comes to public education in America! We'd been warned that the people around that table were deeply divided over such hot-button issues as vouchers, charter schools, teacher unions, and high-stakes testing. We were told that unless we quickly "took control" of the meeting, it would likely degenerate into an education-policy food fight.

As the meeting got underway I said, "Let's start by getting to know a bit about each other. Please tell us your name and say a word or two about your work. Then tell us a story about a teacher who made a difference in your young life—a teacher who comforted and encouraged you, or gave you inspiration and guidance, or somehow touched and even changed your life."

We took some time in silence while people strolled down memory lane. Then they began to tell their stories. By the time the fourth or fifth teacher story had been told, tears had been shed. By the time everyone's story had been told—and *everyone* had such a story—all those divisive questions about vouchers, unions, and high-stakes testing had disappeared. Now we were all focused on one vital question: "How can we help today's teachers touch and transform their students the way we were touched by the teachers who changed our lives?"

That's the question America needs to focus on today. Sadly, American teachers are too often treated by politicians, the press, and the public as scapegoats for problems that the rest of us lack the wit or the will to solve. It's all too easy to point to "educational failures" such as chronic underachievement among certain student populations, to pin the blame on "bad teachers," and to propose yet another policy that involves achievement tests and punishments for teachers whose students fall below the norm.

But every thoughtful observer of America's "educational failures" understands that the root cause is not "incompetent" or "lazy" teachers. The root cause is poverty and all that flows from it, depriving children of the resources they need—from adequate nutrition to strong adult support—to succeed at school.[2] The American public needs help cutting through the disinformation that keeps us from understanding that teachers are heroes,

not goats. These heroes keep returning to their posts *for the love of children*, despite the fact that their work is too often maligned, too many are underpaid, and our schools are underfinanced.

The book you hold in your hands helps with that "cutting through" by taking us inside the lives of fifty courageous teachers on the front lines of American education. The stories told in this book are so vivid and compelling that they reach into our hearts as well as our heads. Here, for example, are a few words from Keil Hileman of Shawnee, Kansas, a teacher whose story you'll find within: *I had a little eighth grader the first year I was teaching who was on his way to getting kicked out or dropping out of school—Jason. He was tiny and had a terrible temper. He got into fights all the time. But Jason had been abused by his parents. Dad sold drugs. Mom sold herself. So Jason had been sent to live with Grandma.*

Read about Jason and feel your heart break. Then, in the next paragraph, read about what Mr. Hileman did for Jason and many other students, and give Hileman, Jason's grandmother, and everyone else involved a full-hearted standing ovation! The more we know about stories like this one—and there are many in American education—the more "We the People" will understand and appreciate our teachers, and the better able we will be to press for meaningful education reform.

I have only one hesitation about this book's title, and that has to do with how we Americans tend to treat our heroes. We ask them to take risks for us. We cheer for them when they emerge victorious. We give them a plaque and maybe a parade. Then we promptly forget about them.

We owe our heroes a lot more than that, and in the case of teachers, that means several things. First, we owe teachers our partnership. Parents and grandparents have many ways of collaborating with teachers, at home and at school, in the education of their children and grandchildren. If you don't have young children in your life, volunteer at a neighborhood school to tutor kids who are having a hard time in some basic subject. You'll be rendering a great service, and it will bring you new life.

Second, we owe our teachers the kind of understanding that leads to meaningful support. I know a city where high-tech executives went to the superintendent of schools with an offer they felt sure he couldn't refuse. "We want to donate computers for every classroom. That will cure much if not all that ails our schools." "Thank you," said the superintendent. "But before we proceed, I'd like to ask each of you to shadow a teacher for a few days. Then we'll talk."

A week later, when the executives met with the superintendent again, they had changed their tune. "We thought *our* jobs were hard! We don't know how these teachers do it. We still think computers would help in the long run. But first tell us what we can do to make teachers' work more viable and their lives more sustainable." All of us can contribute to achieving these goals.

Which takes me to the third thing we owe our classroom heroes. We must "speak truth to power," truth that's rooted in a deep understanding of what teachers need to succeed on behalf of kids. We need to remind our political leaders that poverty is the real driver of many "educational failures"; that punitive testing programs are not the answer; and that we want our politicians to give teachers the support they deserve while *they* seek to solve America's growing poverty problem.

As you read the many moving stories in this book and get to know fifty remarkable teachers and some of their students, I'd like to ask you to do the same thing I asked of the folks I met at that "Courage to Teach" fundraiser twenty years ago.

Think back to a teacher who made a difference in your young life, a teacher who saw more in you than you saw in yourself. Spend some time contemplating how much richer your life has been because of that teacher's life-giving and perhaps life-changing support. Feel the gratitude that comes from realizing that a teacher went above and beyond the call of duty to help you become who you are today.

Then do whatever you can to support this generation of American classroom heroes as they, in turn, nurture our precious children.

[1] http://www.CourageRenewal.org
[2] http://www.salon.com/2013/06/03/instead_of_a_war_on_teachers_how_about_one_on_poverty/

Introduction *by Katrina Fried*

I was crazy about school. Raised in a liberal, intellectually stimulating enclave of New York City, I attended the same small, progressive school from kindergarten through twelfth grade. As much life preparatory as it was college preparatory, mine was a very specialized education in its way, one defined by the omission of rigid structures, strict rules, and the urgency created by competition. It was an environment that encouraged independent thinking and in-depth exploration, both self-directed and teacher-guided.

With just thirty-five kids in my high-school graduating class, our diverse student population was so small, there weren't enough of us to segregate into the typical cliques. Jocks, science nerds, artists, dancers, math geeks, music prodigies, slackers, potheads—we all worked, played, and bonded together. Our teachers were equally eclectic—a collection of passionate characters that varied in age, background, and pedagogical style, and were as much surrogate parents as they were academic sages. School was a second home, my classmates and teachers a second family. And as it is in all families, we fought, we loved, we screwed up; we fell in and out of like with one another; we had epic moments of dysfunction and equally epic moments of triumph; we floundered and sometimes failed; we carried each other through—we grew up together. And also as it is in any family, each child was utterly unique, requiring a different type of adult guidance and attention. Our individual needs for achieving success, both academically and holistically, were widely varied and largely well met. Our teachers taught all the traditional subjects, but more than that: they taught us how to teach ourselves.

You will find that these same qualities—such as teaching the whole child, differentiating instruction, supporting student-driven learning, and creating a unified classroom culture—are deeply embedded in the philosophy and practice of every one of the fifty outstanding teachers in this book. They are, I have learned, both from my years as a student and from the stories shared by the educators I interviewed, inarguably the backbone of great teaching.

It wouldn't be until much later in life that I came to truly understand how special and uncommon my educational experience was in comparison to the vast majority of young people in this country, for whom the inequities are indisputable and the consequences are heartbreaking. I was so very lucky, and with that luck came the opportunities and confidence to do and become whatever I dreamed of. I owe that to those who nurtured my mind and spirit along the way—my family and friends, of course, but above all, my teachers.

There are more than 3 million teachers in this country, and surely, an untold number of them deserve our praise, support and recognition. I view the fifty teachers featured in these pages as exemplary delegates of their profession. They were chosen based on a well-considered set of criteria. All teach at either public or public charter schools in the United States. Most have been widely recognized and highly decorated for their excellence in teaching; some came to my attention through the recommendation of educational organizations; a few were suggested by fellow teachers. As a group, they represent a broad variety of ethnicities, backgrounds, subjects, grade levels (kindergarten through twelfth), and demographics. They range in experience from two to fifty-two years, and in age from twenty-five to seventy-plus. Some have come to teaching as a second career, others have always been in the classroom. All are beloved, remembered, and venerated by the students they have taught.

The final bit of criteria simply came down to whether I was left with the following thought at the end of each lengthy interview: *God, I would kill to have had this person as my teacher.*

Individually, each of the teachers in this book is making a lasting impact on the kids who are fortunate enough to sit in their classrooms. Through innovative curricula and hands-on projects, they are lighting the pathway to lifelong learning. I'd wager that Keil Hileman's eighth graders will never forget the chill they felt digging up real World War II bullet casings in archeology class; Brigitte Tennis' seventh graders will remember the difference between circumference and diameter every time they blow a bubble; and Alex Kajitani's middle schoolers will rap the times tables they learned in math class to their children someday.

Collectively, their narratives also provide a broader view into the story of America's public-education system. Embedded in each of their classroom experiences are the realities of a crippled structure. One look at the statistics leaves little argument that as a whole, we are failing. American students rank twenty-fifth and twenty-first out of thirty-four countries in the subjects of math and science respectively. Resources are scarce, compensation is low, evaluation and reward are often solely based on students' standardized test scores—a system that can stifle creativity and force teachers to follow predetermined curricula; and professional support is lacking—leaving new teachers to essentially sink or swim. It's little wonder, therefore, that half of all teachers quit within their first five years to pursue more lucrative and less frustrating careers. The wall of obstacles that stands between a public-school educator and their students often seems insurmountable.

Yet, despite this taxing environment, many teachers are still rising to, and meeting, the challenges they face day in and day out. Even within failing schools, there are teachers whose classrooms have become islands of achievement—where students are thriving, growing, and learning hand over fist. In Rafe Esquith's inner-city school in Los Angeles, for instance, only 32 percent of all students make it to graduation, yet Esquith's fifth graders are known to go on to the top colleges in the world. Why are these teachers succeeding where others fail?

In the hundreds of hours I spent talking with teachers whose students are flourishing by any yardstick—including test scores, grades, graduation rates, and beyond, there emerged a number of commonalties to their pedagogy. Though their styles of teaching and individual rubrics are as diverse as their students, threads of a shared methodology can be found woven throughout their narratives. I have come to think of these as "The Rules for Being a True Classroom Hero."

Rule 1: *Rules are made to be broken.* Agricultural science teacher Pat Earle always tells his student teachers, "There are only three things you've got to remember every day. The first is, you've got to be prepared. The second is, you've got to be prepared. And the third is, you've got to be prepared." Not a teacher among these chosen fifty would disagree with the critical importance of Earle's advice—you must never step into the classroom without a plan. But perhaps of equal necessity is having the flexibility to modify or even scrap that plan and start from scratch. Great teachers are human barometers—attuned to the shifting moods of their students and amorphous qualities of their surroundings. "Each day is different," says Betty Brandenberg, who has been teaching middle school for more than twenty-five years. "You never know what's going to happen." Being responsive to one's environment goes hand in hand with a willingness to throw out the rule book sometimes and follow your instincts. When Michael Goodwin launched Rivers and Revolutions—an alternative interdisciplinary educational program, he did much more than retool a lesson plan: he reinvented the model for high-school curricula. Says Goodwin, "Really good education is all about risk-taking and about making a mess; learning is chaotic, right?"

Rule 2: *All for one, and one for all.* Great teachers have learned that taking the time to foster a classroom culture that's built on mutual respect and tolerance sets the stage for authentic learning. Donna Porter, who teaches oral communication to grades nine through twelve in Picayune, Mississippi, believes this to her core. She doesn't even ask her students to step up to the podium until halfway through the first semester. "I want to create this synergy in the room first, a familial atmosphere where my students start falling in love with one another, so they will be less fearful," she explains. Similarly, Suney Park, who teaches sixth grade in East Palo Alto, California, uses the metaphor of a pyramid to explain to her students the purpose of doing team-building exercises. "I tell them that at the very base, are the essential human needs like water, food, and shelter. Then we talk about emotional needs, like safety and acceptance. Without the first, you can't live. Without the second, you can't learn."

Rule 3: *Bring your passions into the classroom.* To keep "the fires burning" as Rafe Esquith describes it, many ambitious teachers have integrated their own interests and passions into their curricula. "I have three great loves in the world," says Esquith. "Baseball, rock 'n' roll, and Shakespeare. None of these are in the California curriculum, but they are all part of my classroom." In English teacher Clint Smith's case, he uses his gifts as an award-winning spoken-word artist to introduce his high-school students to the power of poetry. Sometimes bringing what you love into your teaching can spread beyond one classroom and influence the culture of an entire school, as is the case with Daryl Bilandzija. His commitment to environmental stewardship moved him to turn a half acre

of his school's campus into an Edible Learning Garden, which has transformed the identity of Odyssey Charter School in Altadena, California, and "put it on the map."

Rule 4: *Never teach to the test.* Despite the fact that both student and teacher assessments are directly tied to performance on the plethora of state-issued exams, there is not an educator among these fifty who approaches his or her curriculum with the primary end goal of achieving high scores—though make no mistake, their students do dominate. Why? Because these teachers are finding inventive ways to knit the standards into the fabric of their curricula. As Josh Anderson, who teaches English and coaches the debate team at Olathe Northwest High School in Kansas puts it, "Exceptional test scores, brilliant job applicants, and competitive colleges should simply be by-products of a great education, not the sole purpose of it."

Rule 5: *Keep it real.* Introducing real-world, hands-on applications of academic ideas—or as one classroom hero calls it, "learning to do and doing to learn"—is a mainstay of effective teaching. The notion that kids assimilate knowledge—rather than just memorize it—when they have an authentic purpose and context for learning is foundational to Janey Layman's lessons in computer systems. Her eighth graders, for instance, learn Excel by tracking and predicting the sales of their own lunchroom lemonade stand. In Ron Poplau's community service class at Shawnee Mission Northwest High School in Kansas, seniors discover firsthand the satisfaction that comes with giving back by committing their time to local nonprofits and individuals in need.

Rule 6: *There is no such thing as an un-teachable child.* "My students are kids just like any other kids. Of course they can learn. Of course they can love school. Of course they have a voice. They just need to learn how to use it." So says Julia King, who teaches math to seventh graders in Washington, DC. Believing that all children have the capacity to learn, regardless of their histories and circumstances, goes to the heart of what it means to be a successful educator in our public-school system, where classrooms are often comprised of students with a wide spectrum of abilities and proficiencies. As one classroom hero explains, "It is easy to find reasons why students don't learn; it is much harder, and much more rewarding, to find ways that they can." The key is meeting each child where they are. "Every kid wants to succeed," maintains band teacher Alvin Davis of Florida's Miramar High School. "No one in this world ever initially raises

their hand and says, 'Hey, I want to be a failure.' You just have to find out what they're good at and then show them how to achieve."

Rule 7: *Necessity is the mother of all invention.* Perhaps no teacher better exemplifies this steadfast rule than itinerant music teacher Jason Chuong. Tasked with teaching percussion at seven different public schools in Philadelphia on an annual budget of $100, Chuong bought a slew of plastic paint buckets from the Home Depot for $2.80 a pop, and introduced his students to the urban art of bucket drumming. Being strapped for resources and funding is part and parcel for all of these teachers (most of whom have undoubtedly reached into their own pockets many times over), but none view this as an excuse to do less. Whether it's making the best of what they have, as Chuong has, or tapping outside sources for support, as Mississippi teacher Peggy Carlisle has done by receiving more than $180,000 in grants over the course of her career—outstanding teachers will always search for and find ways to give their students what they need to thrive.

Rule 8: *Produce good people, not just good students.* As the boundaries between school and home grow increasingly blurred, particularly in at-risk urban communities, many teachers feel called to assume a more parental role in their students' lives. And like any good parent, their aim is to raise confident, compassionate, civic-minded, and independent children. When Michelle Evans transforms her classroom into a virtual economy-based community each year, her sixth graders learn far more than how to balance their checkbooks—they also discover the true meaning of good citizenship. Dave Crumbine, of the KIPP Academy in Houston, actually teaches a class called Life to his fifth graders, which aims to help kids develop their own moral compass and a skill set for becoming well-rounded human beings. In Helena Moss-Jack's music room, in an area of East Oakland she refers to as "the 'hood," Moss-Jack often finds herself acting as much a mentor as a teacher: "Many of them don't have an adult to go to; I leave my door open so that the children understand I am a listener for them, and if I'm not the right person to help, I'm going to find the right person."

Rule 9: *The future is now.* As technology advances at a fever-ish pace, it seems a foregone conclusion that new media will play a significant role in the future of the American classroom. Already, many teachers have found the integration of technology and education to be a game

changer. The "instant access to information is making our students' learning more efficient, and it's making the impossible possible," says physics teacher and self-professed technology geek Greg Schwanbeck. An early proponent of technology as an educational tool, Esther Wojcicki—who leads an award-winning journalism program in northern California—began using computers in the classroom as far back as 1987. So passionate is she about the use of new media as a teaching tool, she frequently provides technology training to fellow educators—"There are a lot of people who still need to be enlightened; so, that's what I do." In Escondido, California, Jo-Ann Fox not only uses iPods in her fourth-grade classroom—she has also created video lessons and embraced the "flipped learning" model to teach her math curriculum. "It's not that I consciously try to plan a lesson that has technology in it," Fox explains. "It's just that it's woven in. It's almost invisible."

Rule 10: *Be the person you want your students to become.* Or as Gandhi once said, "Be the change you want to see in the world." Our best teachers believe that being a model for their students is one of the pillars of providing a successful education. Says Jane Klir Viau, who teaches AP Statistics to inner-city students in New York: "In order to expect commitment from my students, I must first demonstrate my own commitment to each of them." Rafe Esquith puts an even sharper point on it: "Our main mission in my class is to be nice and to work hard. That means I have to be the nicest and hardest-working person the students have ever met."

Rule 11: *You can't do it alone.* The vast majority of these classroom heroes have learned firsthand that mentorship and collaboration are requisites to becoming the best teachers they can be. As Jeff Charbonneau, 2013 National Teacher of the Year, explains, "Success does not occur in isolation." Many experienced teachers, like Jason Fulmer of South Carolina, have even made it their mission to provide continued training to classroom educators: "We do a lot of great things around this country, recruiting top-notch people to the profession, but we have to meet them when they arrive and make greater efforts to retain and support them once they get there." For new teachers just starting out, seeking support is an absolute must. "I have learned that building strong, real, collaborative relationships is the single best thing I can do in the service of my students," says seven-year urban-ed veteran Celeste Hoffpauir. "Honestly, without that, I don't know if I would have found the strength and courage to stay an educator."

Rule 12: *Be a student of your students.* Sarah Brown Wessling, 2010 National Teacher of the Year, refers to herself not as the teacher of her students, but simply as the "lead learner." "Because of my own willingness to put myself in the same positions I put my students in, I recognize that the path to autonomous learning is not through the accumulation of facts, but through the messy and edifying pursuit of ideas." The essence of this student-centered teaching philosophy is the fervent belief that empowerment is the key to true learning. Encouraging students to take ownership of their ideas and voices, and joining them in their process of discovery, opens the doorway to higher learning for teacher and student alike. When Stephen Ritz, who had no experience in the art or science of gardening, chose to try and grow a box of donated flower bulbs with his inner-city special-ed students, he had no clue it would evolve into a community-wide environmental program that would uplift the lives of thousands. Had he been unwilling to learn alongside and from his students, history would have written itself quite differently. Perhaps Vermont's Teacher of the Year Jay Hoffman, who has been teaching media arts for eighteen years, sums it up best: "You think you are going to teach, but boy, do you learn."

Every moment of every day, each of these heroic teachers gives 100 percent of themselves to their students. Neal Singh—who teaches AP Environmental Science at LaGuardia High School in New York—describes the intensity of teaching this way: "When I'm on fire, I'm on fire. When I go home, I collapse. But while I'm in the classroom, I give my ninth period the same energy as I give my first." This constant exertion—or what Dave Crumbine calls the "brute force of teacher power"—requires tremendous stamina, passion, and commitment. Which makes it all the more urgent that we figure out how to right the wrongs of the American public education system. Because as strong, gifted, and willful as many of our best teachers are, the level of intensity required of them, coupled with the lack of support, seems simply unsustainable.

So how do we fix a broken system? I do not have the answer, but I can tell you that if we want to know what our schools need, there are no better experts than the teachers who sacrifice their earnings, their time, and personal lives to provide our kids with the tools, love, and guidance they need to become whole and happy adults. All we have to do is ask.

"I am a reflection for many of the kids I teach. I didn't have that as a child, but now, as an adult, I can be that for my students. They are a constant reminder that I am where I need to be; that I am in the right place."

Liliana X. Aguas

2nd Grade
General Studies, Dual Language Immersion

Ms. Aguas in her classroom's Observation Center, which is filled with cool specimens of all varieties.

Liliana Aguas knows what it means to be an outsider. From a very young age, she faced the cultural stigmas and language barriers that so often come with being an immigrant in this country. Guided by strong familial values, Aguas' hardships only strengthened her determination to succeed and, ultimately, to dedicate her life to helping children who encounter similar challenges. Her gifts in the classroom have been validated many times over by both the accomplishments of her students and the prestigious honors and awards she has received (including the Outstanding Young Educator Award in 2012 and Teacher of the Year in the Berkeley Unified School District in 2013). As a dual-language teacher for second graders, all the lessons of Aguas' own history are now bearing fruit for her young students and providing them with the foundation to live their dreams, regardless of what language they dream in.

I spent the early years of my childhood in Mexico City. But when I was nine years old, my parents decided to move our family to the States—to a predominantly immigrant and African-American community in Southern California. I was the only monolingual Spanish speaker in my entire third-grade classroom. My teacher sat me apart from the other children. I had to figure things out on my own, and *quickly*. By the time I entered high school, I had proven myself as an English speaker. That experience definitely had an effect on me; it stayed with me. My father would say to me: "Lily, because of who you are you are going to have to work twice as hard, but never let that stop you. You keep going. Just keep moving forward. And I'll tell you something else. The secret to success is to do more than you have to. Always. And have pride in whatever you do. You will stand out if you do that."

My family couldn't afford to send me to a four-year college even though I had been admitted to several, so I chose Long Beach City College. The first counselor I met, an older man, looked at me for five seconds and said: "You're at the wrong campus, dear. The vocational campus is on the other side of town." Imagine my shock. Here I had walked in thinking I was too good for the place and before I could even say my name, this counselor had decided that I wasn't suited for community college. Just at that moment, a female counselor walked by and I think she must have noticed how upset I looked. She asked me if I was okay, and I remember I couldn't even articulate what I had just been told—and by a man who was in charge of advising thousands of students about their futures.

She asked me many questions about myself and

about my academic aspirations. "You are so Berkeley!" she concluded. I had no idea what she meant. But she handed me this really fat book—it was UC Berkeley's course catalogue. I spent that night reading it from cover to cover. I had only been at college one day and I had already found my major. I went back to the counselor the next morning and told her I'd decided to major in conservation and resource studies, and that I needed to do everything I could to transfer to UC Berkeley in two years. I was a first-generation college student and an English-language learner speaking with an audible accent and I now knew where I was heading.

The community you formed inside our electric classroom was truly unique. You created an atmosphere in which we could comfortably ask questions, make mistakes, perform, try new things, and learn. We spent time outside acting out Sacagawea's journey, figuring out math problems, starting the school garden, and playing games. We went on more field trips than any other fifth grade class that year. We saw dance productions, visited the ocean, and observed urban creeks. All of these adventures brought the class together in a way I had never seen. You created a safe space. The confidence I gained from my year with you inspired me to run for Student Body President of Harding Elementary in sixth grade. I was so proud when I won! My time with you has influenced many decisions to join clubs, pursue leadership roles, and seek out similar learning environments to the one you created.

Maddie, age 18,
former student

Looking back, I can honestly say that becoming a teacher was completely unintentional. I had always thought that I was going to be a scientist, a lab rat. My plan was to graduate and start working with microscopes and pipettes as I had done in the Aquatic Entomology Lab on campus. But then I spent my junior year studying abroad in England, India, the Philippines, New Zealand, and Mexico. I conducted research that explored the connection between environmental degradation and women's health. My findings revealed that women regularly suffered from preventable diseases due to lack of education. Throughout my travels, I continued to witness the impact that education had on children, their fami-

lies, and entire communities. Across continents, I saw people being empowered through education—the heart of villages and neighborhoods being the schools, where children and adults not only learn to read and became informed, self-determined individuals, but also where communities celebrate their culture and resolve problems. The power of education swept me off my feet. Upon my return to UC Berkeley, I immediately signed up for education classes and my life's path changed forever.

As an educator, it has always been very important to me to be part of a program that values a student's first language. I am now teaching second grade and our school is transitioning into a two-way immersion program, so all of our students will learn to be bilingual. Second grade, for example, is taught in 80 percent Spanish and 20 percent English. Each year more of the instruction is in English. The idea is that in the end, when they graduate from fifth grade, they're bilingual, bicultural, "biliterate" individuals. It's so valuable and important to be proud of who you are and also to celebrate differences at the same time. I watch my students experience a paradigm shift when it comes to accepting diversity. It begins in the classroom, but then it starts affecting the way they interact with others and the choices that they make, which hopefully translates to their contributions to society, to the country, and to the world. It is my job not only to be aware of their diversity, but also to take steps to ensure equity. Some of the students in my classroom have parents who are UC Berkeley professors or physicians or top-of-the-line in their particular profession. I also have students whose parents don't know how to read and write. No matter a student's background, no matter what he or she goes home to, they are going to have a learning experience that will give them the opportunity to discover, to exercise their critical-thinking skills, to problem solve, to be creative, and to be able to work with others. I think my kids really feel like they belong, even though we are all very different.

English-language learners are often viewed as having a deficit. They are told that if they don't speak English, they don't have the academic vocabulary that they need to succeed. But English-language learners *do* have a language, it's just not English; so let's build on that. Instead of subtracting, we must add. You're going to have better outcomes than if you put up barriers, like saying, "We only speak English here," which is what I was told as a student. What I learned in my own research in grad

school is that if students have a positive perception of their first language, they are more successful academically and certainly will outperform those students who have a negative perception of their first language. I believe that even if you don't share a student's first language, as long as you recognize and respect his/her language, that child will retain a positive view of it. That simple shift has really beautiful results.

My first year in the classroom, one of my students asked me, with such a shocked look on her face, "You are a teacher and you speak Spanish?" I think that was really powerful for her. I am a reflection for many of the kids I teach. I didn't have that as a child, but now, as an adult, I can be that for my students. They are a constant reminder that I am where I need to be; that I am in the right place.

My approach to instruction is very hands on; very minds on. I feel strongly about teaching children in a holistic way. I am committed to educating the whole child by promoting a genuine sense of community, where students learn cooperatively, are intellectually challenged, and where their learning needs are met through differentiated instruction. My students learn to value themselves through self-discovery via creative writing, readers' theater, and multicultural literature, and by exploring issues surrounding culture, bilingualism, and social justice. Together we learn about responsibility while maintaining our school farm and native-plant garden and caring for our tadpoles and caterpillars, which are ideal platforms for discussing insect anatomy, the life cycle, and environmental justice in an engaging and exciting way.

I believe that in many cases, teachers give way too much information to their students. I want them to have the opportunity to discover things on their own. As soon as you walk through my classroom door, you are in an Observation Center, where we collect specimens and objects to examine and learn about. Students use all their senses to observe, and they each keep a journal to record their observations. Right now we have Darkling beetle larvae that are just about to pupate. I don't tell the kids what they are, just that they're living organisms. The students will ask each other, "But they don't look like worms anymore! What happened to the worms? Did they disappear? Did somebody take the worms? They look different now. What do you think happened?" I love the sciences and my students share my enthusiasm. I think it's contagious.

I'm passionate about the power of observation. Every day as an elementary teacher you have the opportunity to see a little mind just glow and say, "Teacher! *Maestra!* Look!" I had two of my previous students run up to me one morning and say, "Can you help us identify this insect? What do you think it is?" I told them to look at the body parts and they realized it wasn't an insect at all—it was the larva of a ladybug. And now we have that larva in our Observation Center for other kids to see. They really start to learn how to play a powerful role in their own education.

Another of my students brought in a snakeskin recently, from home. One of the kids then asked me, "Did you know that snakes' eyes can change color?" And then another student, Cyrus, chimed in: "My snake does that! Yes it's true, it's true." I had no idea at the time, but they were right—just before snakes shed their skin (molt) their eyes change color! *I* learn things from *them* all the time. I love that about teaching.

> *"I believe that even if you don't share a student's first language, as long as you recognize and respect his/ her language, that child will retain a positive view of it. That simple shift has really beautiful results."*

I truly believe that the individuals who are going to change this world for the better are in elementary school right now. They're making their way up. My first class of fifth graders is actually about to graduate from high school, and the students still stay in touch and send me notes. "Remember to add my graduation day to your calendar, Ms. Aguas," and, "I am pursuing science, just like you, *Maestra.*" They love to say, "Remember when we did this?" and, "Remember when we did that?" It's interesting to hear what stands out in their memories the most. I've been asked so many times: "Why elementary education? You have advanced degrees from Berkeley!" I think it's because of those notes and many conversations with my former students and with the students I have now. I really feel the impact of what I'm doing, and I love that I had a little bit to do with their successes and what they will become.

> *"We must actively find new ways to reconnect our children with a culture that lies beyond computers and couches."*

Josh Anderson

9th–12th Grade
Debate, Forensics, Speech, and English

"In twenty or thirty years, I probably won't remember how to calculate the cosine of an angle, but I *will* remember what it means to live with great character and integrity—because I have seen it modeled firsthand by Mr. Anderson." So writes one of Josh Anderson's former students. Impassioned, opinionated, unconventional, and wildly intelligent, Anderson, who was named Kansas' Teacher of Year in 2007, is that singular teacher for so many: the one whose class they never forget, whose passion made them fall in love with learning, whose words they continue to live by long after they've passed through the halls of Olathe Northwest. This year, his debate and forensics program was ranked in the country's top .5 percent. The more he asks of his students, the more they want to give. "He's our coach, but he's also our teacher, our advocate, our strongest supporter, and our friend."

Mr. Anderson, the proud coach and teacher, stands in front of the Debate and Forensics Team banner.

They say that teachers can never find a good name for their own kids because every suggestion evokes the name of some devil child from one of their classes. Well, that was me—I was that child. For most kids, sixth grade is a period of discovery and imagination. For me, sixth grade was about the time I started honing my teaching skills. Using all the best practices of an eleven-year-old prepubescent punk, I pitted the boys against the girls (*small group learning*), stood around the hateful children on the playground (*proximity*

control), and frequently failed to turn in my work (*modified assignments*). Yes, it was the start of a promising career as a classroom teacher.

Then my life changed. In middle school, all those years of teasing and taunting others finally caught up with me. My weight ballooned, my ego deflated, and I became an easy target for any kid who needed a victim. I understood with perfect clarity exactly how cruel I had been to others as the long days rolled on, and I slowly pulled away from my dreams like driftwood in a tide.

> *"Like a sinner converted by the 'Hallelujah Chorus,' I would dedicate my life to teaching others to reach their full potential."*

Nothing is so sad as a child who believes he no longer deserves the right to dream and to wonder.

Then it happened. I met Mrs. Shipley when she and her students came to our middle school to recruit kids for the debate and forensics programs at the high school. Within just a few minutes, I was hooked. Debate club taught me that I had value and that I could contribute to the bigger picture. I think that was where I got my sense of community responsibility, and I learned that being in a community requires everyone to do their part. I went through a great transformation in high school. I developed a gift for public speaking and gained the self-confidence to express myself and formulate my beliefs through words and actions. Most important, I realized that I wanted to be a teacher.

This revelation came to me in senior-year English class, when we read *The Secret Sharer*, by Joseph Conrad. During a class discussion, my teacher pointed out that the shape of the cabin in the story was symbolic. That was the first time I recall understanding symbolism and that a writer had the power to put multiple layers of meaning into a single block of text. The world opened up for me. I really fell in love with literature from a teaching perspective. Here was something I could show other people. I'd always loved reading but it wasn't until that moment that I realized I wanted to share my love of reading with anyone else. I knew I wanted to give to others what Mrs. Shipley had given to me. Like a sinner converted by the "Hallelujah Chorus," I would dedicate my life to teaching others to reach their full potential.

My first teaching job was in Basehor, Kansas, and six years later, in 2003, when a position at Olathe Northwest opened up, I moved. The district was going to make a push toward technology in the classroom, and I knew that was my thing, so I came here and have stayed for the past ten years.

Now, of course, the technology is available to most of the kids at home. We did a survey last year that showed that 95 percent of our students have access to a computer and the Internet at home. I use the Internet to access debate performances and resources that my colleagues across the nation have developed and put online. I also post original content for other coaches to use.

My classroom is largely a "flipped" classroom, which means that a lot of the learning takes place during the homework phase. I send the kids home with assignments, and by completing those tasks the students do a great deal of learning. Our class time then becomes about asking and answering questions. This is a new way of teaching. It used to be that the teacher gave new content during class, you went home and practiced it, and you came back to school ready to be taught something new. Now the kids go home to learn and come to class with questions.

In the second semester of our English class, we do the "Anthology Project." This project begins in January, when each student picks a philosophical question. It could be something like, "Can our world ever achieve peace?" They start with the kind of universal question that would intrigue a sixteen-year-old, and they break it down into corollary questions. So, if my question is, "What is beauty?" maybe a corollary question is, "Who gets to define beauty?" And another is, "Can ugly things be beautiful?" Then they write fifteen process papers, which means there's a rough draft, a final draft, prewriting, and outlining. The papers are a mixture of creative writing, research, technical writing, and some writing that is meant to be persuasive. The students also have to find novels, magazine articles, and editorials that address their basic or corollary questions. So they are integrating research into their papers. I help them as they keep editing and refining their work.

I don't know any other teacher who does this, but I have what we call the "Ten Grammandments," which are the ten most important grammatical rules. Each violation results in a two-point deduction.

From the papers I grade, to the papers they submit and resubmit, the entire project is paperless. We only

generate physical paper when the project is complete. Then we print out their hundred or so pages, and the students put them into these beautiful artistic scrapbooks. They go to the hobby store and buy all kinds of decorative embellishments. And these books become prized possessions that they keep for many years.

At first, none of the kids want to do the project. Try telling a sixteen-year-old that they will be writing fifteen process papers and then rewriting them until the final is perfect, and the grade is based on grammar! You can imagine the reaction. So I make it a habit, any time I see a former student pass by our classroom in the hallway, to invite them in and to ask in front of our current students, "What did you think of this project?" And they all say the same thing: "I hated it at first. I hated it. But in the end it's the most important thing I've done in high school, and I will treasure my book forever."

From the time I started teaching, I was less interested in being a certain type of teacher and more interested in showing the students that they had worth and value. I believe that the true purpose of a teacher is to prepare kids to be good citizens of the world—to be satisfied, well-rounded human beings, which is not entirely about knowledge. A great measure of success is your ability to think critically and be intentional with your life.

I think we have far too many teachers now who are buying into the skill and drill assessments. The data-is-everything mentality is killing off that part of us that brought us into the teaching profession in the first place. Let's face it: Nobody becomes a teacher because they want to analyze state assessment scores. But unfortunately, the system sucks many of us in and our only goal becomes better test scores.

We are in danger of becoming a national institution devoted to producing empty children with outstanding test scores. The evidence for this is deeply woven into our daily instruction. When a child asks why she needs to know the four methods for factoring a quadratic equation, what is our answer? If a student asks when he will ever use *The Scarlet Letter* in the real world, how do we respond? Too often, our answers center on the need to use math and reading as tickets to get a good job or get into college. These answers ignore our human quest for a global understanding of a world that transcends money and careers. Galileo used quadratic equations to explain the orbits along which the planets travel around the sun. Nathaniel Hawthorne penned his novel as an indictment against an unjust society. For all the advancements our public schools have made in pedagogy and assessment, we often overlook the whole child. In our quest to leave no child behind academically, we may end up leaving them all behind culturally.

We must actively find new ways to reconnect our children with a culture that lies beyond computers and couches. Teaching the whole child does not require us to abandon our rigorous curricula, or standardized testing. It elevates learning to a new level by applying meaning and context to knowledge and information. Exceptional test scores, brilliant job applicants, and competitive colleges should simply be by-products of a great education, not the sole purpose of it.

"Nothing is so sad as a child who believes he no longer deserves the right to dream and to wonder."

Many years ago, I had a student named Danny in my speech and debate program. In the final round of the state speech championship, Danny shared the story about a first grader with a speech impediment so severe that few people could understand a word he said. The other children in this boy's class were such merciless bullies that it became part of their daily routine to tease, punch, hit, kick, and often ignore him. And the teacher was the biggest bully of them all, instigating the use of a wicked nickname for this child. "C'mon Pokey," he'd say, "you're behind again." "I can't understand you, Pokey." "You're embarrassing yourself, Pokey." As Danny continued, he shared all the statistics you'd expect to hear in a debate about bullying and teasing. Near the end though, he asked, "Whatever happened to Pokey?" Then he slowly raised his finger to his chest and pointed to himself. Danny was Pokey, and Pokey had grown up to be a three-time state speech champion, the National College Debate Champion, and later worked as an intern in the United States House of Representatives.

I believe it took more than years of speech therapy and a dedicated teacher for a kid like Danny to overcome as much as he did. It required the vision of a better future, the unwavering belief in his ability to achieve it, and the confidence to say "yes, I can" when everyone around him was saying "no, you can't." This is what I try and instill in my kids.

Daryl Bilandzija

7th–8th Grade
English, Ecology, Theater, and Gardening

Mr. Bilandzija in the Edible Learning Gardens, where students experience his "seed to table" curriculum.

Over the past four years, Daryl Bilandzija has turned the great outdoors into a living, breathing, open-air classroom for his students. With zero funding and having no more than the ground beneath his feet, Bilandzija converted a half-acre of his school's campus into a thriving garden and forty-tree fruit orchard, complete with chickens and a theater stage. The Edible Learning Gardens have become the foundation for a revolutionary, interdisciplinary approach to middle school education, one that celebrates and elevates the relationship between humans and nature. Under Bilandzija's guidance, students use the gardens to learn a myriad of life skills and intellectual lessons, such as how to cultivate and prepare their own food; practice observation; understand ecological concepts; and perform theater productions for the local community.

My style and approach to teaching is adaptive. It's about making connections and understanding the connections we have to each other and the spaces we live and learn in. I use the garden not just as a space to grow food or to relax and enjoy the outdoors, but also as a primary reference point for my curriculum. If you look at my course schedule, it says, "English," but if you walk into that class at any given moment, we could be studying a concept in ecology, we could be reading about something in history; or we could be talking about the current events that relate to a book we're reading. Rather than teach subjects in isolation, we

use the gardens as a means to integrate learning, to make connections among different subjects. Students don't just learn *about* a subject, they also learn *how to* apply their knowledge in a real-world context.

While working to create a classroom without walls, I also spend a good amount of time inside the walls of my classroom. In this context, my teaching style is fundamentally Socratic and inquiry-based. I create a space for students to practice the ancient art of dialogue and to ask and explore some of life's great questions. I try to teach

There is never a dull moment with Mr. Bilandzija. I don't really know what to call his class, so I just call it "Mr. Bilandzija's class," because while we do learn English, we also learn gardening, theater, ecology, and debate. One thing that I love about his class is that there is never a wrong answer so everyone always feels free to speak their mind. I love the conversations that we have because at the end of it all, they usually lead to a very important life lesson or a very important question. As far as gardening, it has been amazing watching little seeds grow into beautiful plants that I can just go out and eat from. There is no need for me to get a snack when I have fresh fruits and veggies right outside of my classroom. Mr. Bilandzija is the coolest teacher I've ever had and he's created the most amazing class I've ever taken.

Kush, age 13, current student

literature that is relevant to the problems my students are aware of but don't yet have a deeper understanding of. And then I help them find solutions to those problems. Because if all we do is barrage kids with, "This is the apocalypse, and the environment is dying, and the world's going to end," that's a really negative message and we can't blame them for getting apathetic and overwhelmed. We have to supplement the problem with a solution. That's the whole approach of my curriculum.

Last year, for instance, I decided to teach my students about the systemic problems associated with our industrial food system, and more important, give them opportunities to explore and apply local solutions to this otherwise global problem. We started the year by reading the book *The Omnivore's Dilemma: The Secrets Behind What You Eat* (Young Readers Edition) by Michael Pollan. This book helped my students understand the context of our

global food system and the effects it has on people on our planet. While reading and discussing this book, students experienced a full range of reactions, including anger, shock, and frustration. I kept reminding them that while the problems may seem overwhelming and too big to solve, the solutions are conversely simple, elegant, and, of course, local. When it came time for us to apply these solutions, I took my students to the school gardens. We designed, planted, and cultivated our own food forest at school, and learned how this could be replicated in our backyards at home.

To further incentivize students to embrace the localized food solution, I created a potluck project for each of my classes. The goal was simple: each student would research a recipe from their family or a good cookbook, and bring in a home-cooked meal to share with their classmates. There was a catch, however: the food had to be as "local and sustainable" as possible. This meant that students either had to grow their own food or support someone in the community who was growing food. Many students took the challenge to heart, and decided to plant their own gardens at home and teach their families about the benefits of local food production. I received many e-mails from parents telling me how impressed they were with their sons and daughters who took the initiative to start their own garden.

The potluck was such a success that I decided to incorporate a sustainable supper into our annual theater show. Last year's show was a production of *Alice in Wonderland*, which was staged in the school gardens. On the night of the final performance, we fed all of the audience members—more than 250 people—a zero-waste meal that featured ingredients from the school gardens. It was so great to see my students performing on stage in a garden they helped make, feeding our community not just a meal, but art of their own creation. As my students realized, the garden became much more than a place to grow food: it is now a metaphor for how we can think systemically, and collectively solve many of life's problems.

Working side by side, those two programs—Ecology/Sustainability and the Theater Arts, both of which take place in the orchard and the gardens—have cultivated a really different kind of community and put the middle school on the map. It's not just a place where you show up and rotate through your classes and go home. It's taken a lot of work, but it has terrific momentum now, so much that I have a number of parents who work with me in the

> *"The garden became much more than a place to grow food: it is now a metaphor for how we can think systemically, and collectively solve many of life's problems."*

garden and who help me with the shows. And the kids are deeply excited about it. Now it's more a matter of managing and expanding it rather than inventing it.

I think the program that I've created demonstrates at the local level what you can do at a public charter school that has limited resources and is understaffed. It shows other schools how it's possible to take stock of the resources that you do have and put them to work for you. And, if you're willing to take a little bit of a risk with some of your curriculum and experiment with more hands-on experiences with the kids, you can develop programs that are so much better adapted to the needs of the particular students you're teaching, offering them real ways to apply their learning instead of just passively receiving information.

I don't think it's any secret that our public-education system is failing on a lot of fronts. This is not to discount all of the amazing teachers and educators who are working despite enormous odds to deliver great experiences to kids—but if you look at it systemically, all the evidence indicates that overall, we are letting kids down socially, emotionally, and educationally. I think one reason for this is that the system itself has become so big, it's unable to address the individual needs of every school. And that's by design. We constructed a federal education system that is mandated by a top-down curriculum. Now there's a necessity to that, but I think it's become so over-reliant on that kind of teaching, that it's deprived schools of the autonomy and the creativity that is essential to transformative learning experiences.

There is no "one size fits all" approach, but if anything can be learned from my program, it's that if you go into any school, whether it's urban or rural, and you evaluate the existing resources and build on what is there, then you will find so many innovative ways to approach curriculum that you will liberate yourself from the state-dictated curriculum that is holding the system hostage right now.

The irony is that oftentimes, we're led to believe that the obstacles we face are too big to overcome without a top-down intervention or the passage of some legislative law. So we're always wringing our hands and waiting for the next great reform movement that's going to come through and give us the solution. And I think that's the problem. The problem is the way we think about the problem. If we started giving ourselves permission to be our own solution, then we would realize that, yes, we're still strapped for cash and resources, but we actually have a tremendous amount of resources right at our feet.

To be clear, I'm not advocating that we all just do what we want and end up with total anarchy. What I'm saying is that there has to be a way to have a system that holds people accountable, distributes resources equitably, and facilitates a sharing of ideas and information, while simultaneously providing enough freedom and flexibility for individualization. I think it's already happening. I know that there are many schools across the country and around the world that are taking this approach. It will take time, but I believe we're going to get there. Ironically, it's mainly about getting out of our own way.

"As students enter my classroom, they are unaware that they will leave not just as historians, but with an appreciation of the fact that American history resonates with their lives."

Josh Bill

11th Grade
American Studies and AP United States History

Plucked from more than one thousand nominees countrywide in 2012, Josh Bill was named National History Teacher of the Year by the Gilder Lehrman Institute. Ask Bill what meant most to him about winning this highly competitive award, and his answer charmingly betrays his true inner history geek. "I got to spend two hours at the New York Archive looking at George Washington's personal correspondence—in his own handwriting!" Bill exclaims with delight. "I liked that more than the ceremony that was held in my honor." And the only thing that turns him on more than studying history? Teaching history. "When you have a successful day or a successful moment with students, nothing beats it. It's like oxygen for a fire. It's rejuvenating forever."

Mr. Bill amid his students as they reenact a historical battle.

In my classroom, I'm just another historian in the room. What I say carries no more weight than a student's voice. In fact, my favorite days of the year are when my students have the floor for the entire forty-five minutes of class. During these "fishbowl" discussions, we tackle provocative questions such as "Was Jefferson a hypocrite?" or "Was the Great Depression an 'Era of Lost Dreams'?" I have made my students active constructors and reconstructors of American history.

I operate under the premise that everyone loves history. Some people have just had awful history teachers who have ruined the instinctive passion for the past that

exists within every human being. My classroom capitalizes on the common endeavor of humans to understand the person across the room or across the globe. My goal is to move Waukegan High School in the direction of tapping into the love of learning history that lies dormant within most of us. As students enter my classroom, they are unaware that they will leave not just as historians, but with an appreciation of the fact that American history resonates with their lives.

When I was a student, I was the unmotivated kid in the classroom. Not the troublemaker, not failing, just the kid who was doing just enough or, sometimes, not quite enough. No science club for me. No history club, no nothing. Just sports and socializing. I didn't see what school had to offer me. I think that's true of schools and students across the board—and often that's not a lesson learned until you're older. I often tell my students that when I was in high school my priorities were myself, sports, and my friends—in that order. I never worked to my potential, but I was fortunate to do well enough to get into Lake Forest College.

I am unbelievably excited for and jealous of the students you have in your classes. I especially value (and miss) your class when I remember all I learned and how I grew. Even if you don't wholly believe me, always remember you have the power to change your students' lives. I know because you've changed mine.

*Nancy, age 18,
former student*

College was the first of many defining moments uprooting everything familiar in my life. Friends and family were hundreds of miles away. It was gut-check time, and initially, I did not perform well. It was, however, then that a light went on—my family had sacrificed so much to get me into college and keep me there; I owed it to them to do better.

And so, my current work ethic (which many colleagues, friends, and family members think is unhealthy) developed. Years of slacking in school had made me a very slow and poor reader (I am still slow, but have taught myself the dedication to text that I needed). This resulted in too many all-nighters to count, as I tried to fulfill my dual major at Lake Forest in history and education. Late in my college career, I learned the invaluable lesson that diligence pays dividends: by my junior year I

was a mainstay on the Dean's List—not bad for the under-achiever who often flirted with failing semester grades in high-school math and science courses.

My junior year was also the year I was introduced to Waukegan High School. Lake Forest College places their undergraduate teacher candidates into Waukegan public schools for fieldwork—essentially a mini student-teaching experience. One fateful day, the social studies department chair, Mr. Frank Belmont, came in to observe a class of mine. At the end of the period, he slapped me on the shoulder and told me if I ever needed a job to let him know. I wouldn't realize the vital importance of that moment until years later.

By senior year at Lake Forest, I had my first real relationship with a girl whom I thought was the love of my life and I was spreading myself thin. My habits as a full-time college student—maintaining straight A's in night classes, student teaching during the day, spending afternoons with my girlfriend, and staying up as late as it took to finish planning for the next day—eventually caught up with me. I got very sick, missed several days of student teaching (a few without calling in), and I earned the reputation of being an unreliable college student. Any teacher knows his student teaching is crucial. Without paid teaching experience, you take on the job search with only your cooperating teachers as references. My references were less than glowing, and sent a clear message to potential employers: BEWARE: UNRELIABLE KID APPLYING FOR A JOB.

I had applications in multiple counties in three states and did not get a single interview. It was then that I called Frank Belmont to take him up on that offer he had made. I wasn't even certain he had been serious that day, but I was desperate. We set up an interview, and he hired me for a new social-studies position at Waukegan High School, which only existed due to a boost in enrollment of incoming freshmen. I had my first teaching job!

With a chip on my shoulder, knowing that I was better than my student-teaching performance suggested, I set out to do the best I could. I was assigned a classroom of "at-risk" students, freshmen at the lowest non-special-ed ability level offered at WHS, and who were unlikely to graduate. I loved every minute of this experience. During those years, I fell out of love with the girl I thought was "the one" and fell in love with Waukegan High School, and it is a love I don't ever see ending.

In my second year of teaching, I tried to do a commu-

nity history project. I didn't know the first thing about Waukegan except the school and the streets around it. I lived there but I wasn't really a part of its history at all. A lot of the students were first-generation American and didn't have a clue about their community's history either. We started by investigating a local factory that had exploded a number of times and killed a lot of people. The students were into it. It had blood, of course. More so, it revealed an injustice, because the factory had been taking advantage of an immigrant population. There was a certain way that my students—mostly children of Latino immigrants—were able to identify with that. Through that project and through others like it, more and more of my students were getting hooked into the idea of doing history.

My classic line is that all my students are historians. But, what that really means is that they take primary sources—documents that were produced by people who experienced these events—and they make the call. The kids take these documents and they interpret them. And, then they get to tell the story about what happened. And sometimes it's not the story they've been told or sometimes it's not the story that's in books. What they don't have is a textbook that tells them what to think. I only use a textbook in my AP class, and then only because I have to. I hate it.

History cannot be made without contextualization. This is my most important role as a teacher. How can you understand the unanimous Declaration of Independence without the Patriots' belief that they could win? Can you truly comprehend 1930s isolationism in America without ample knowledge of the Western Front? Virtual field trips are taken as often as possible, whether it is to the balcony of the auditorium, where my students reenact the Battle of Bunker Hill, or to the floor of a dark, hot, filthy classroom, where they sit as I narrate through letters home from the Western Front. Students approach their essays, projects, and primary-source analysis assignments with a keen eye, understanding the culture and era they are undertaking.

We are not simply limited to the virtual field trips either—an annual tour of Chicago's five statues of Abraham Lincoln calls upon students to ponder: What would Lincoln think of these? Does the public have a clear view of our sixteenth president? At the center of this endeavor are sources like the Lincoln-Douglas debates, as well as words from Lincoln's contemporaries, which eventually get students to realize that no one ever had Lincoln

figured out. I'll start a class on Lincoln by saying that he is our most celebrated historical figure, the president that everybody can name, the "Great Emancipator." Everything we recite about Abraham Lincoln is based on what he did in the last year of his life. And that is because he was assassinated at a time when he was most appreciated. When my students and I look at Lincoln's presidential campaign speeches, he's a man of his time. But a white man of his time was racist by our 2013 standards.

> *"My classic line is that all my students are historians. But, what that really means is that they take primary sources—documents that were produced by people who experienced these events—and they make the call."*

Students are really surprised by this, and by certain ideas Lincoln had, such as wanting to move all people of African descent back to Africa when slavery was over. With this knowledge, they debate things like "Does Lincoln *deserve* the title of Great Emancipator?" They'll talk about what his actual views on race and slavery were. Most of the time they initially come to the conclusion that this is not a man to celebrate. But then we take a closer look at him after he becomes president and we see what the Civil War did to him personally and we experience his encounters with Frederick Douglass. He changes, he evolves. He's a listener.

I was just talking to somebody who actually asked, "Isn't there a danger that kids will get the wrong impression about historical figures?" I said, "No. It's the truth." In some ways I think we might expect too much of our historical figures. A lot of teachers will hesitate in giving the full story of Abraham Lincoln because Lincoln *does* deserve to be celebrated. He probably *is* our best president. And by the time we finish examining Lincoln, my students have usually come to acknowledge that. That's important, too, because students have to understand that the more you uncover things in history the more refined and polished an interpretation of history gets. But I think you have to have the right to make those decisions yourself. You can't have some textbook or some teacher telling you what to believe. What's the fun in that?

> *"The one thing that hasn't changed in my teaching is that I've never been afraid to take chances."*

Betty Brandenburg

6th Grade
Social Studies and English Language Arts

For more than twenty-five years, Betty Brandenburg has been teaching the kids of American servicemen and women. She believes, as Mark Twain once said, that you should never let schooling interfere with your education. "I focus on helping students learn in an entertaining way that, hopefully, makes them want to know more," says Brandenburg, who rarely teaches from a textbook. Consequently, her students will dress in sheets to put Socrates on trial or mummify a chicken when learning about ancient Egypt. Her unique teaching style is the reason why she's been honored as Teacher of the Year (Fort Knox district) and was named to *USA Today*'s All-Star Teacher Team. Brandenburg claims that she wants the epitaph on her tombstone to quote one of her early ESL first graders, who, when asked how he learned English so quickly, answered, "She teached me!"

Ms. Brandenburg and her class discuss "superheroes" and what types of powers they'd each like to possess.

During American Teacher Week, the kids at my school are given the opportunity to write and then read aloud something about their teacher. I am always described as "crazy"—but in a nice way. At least I hope it's in a nice way. Some of the kids use the word *unique*, which I like a bit better than *crazy*.

I am probably a frustrated stand-up comic, because I bring that into my classroom. Most of the kids respond to it and I tell them that they can't be class clown because I've got that position sewn up. At the same time, ironically, I am one of the strictest, by-the-book teachers in

the building. I'm always the one that can quote page 16 of the student handbook, which says, "Gum is prohibited at Walker School." I'm a bear on things like that, but I explain to the kids that if you follow the guidelines and the rules, we can have a lot of freedom and fun. My kids are quiet in the hallways. I let them know what their parameters are.

In my classroom, we have one rule, and it's about respect—which is why I always belt out Aretha Franklin's song at the start of the year. Respect is the only rule you need in my class and, I think, in life. I believe that if you respect yourself, others, your environment, your spiritual being, and your country, well, that pretty much takes care of everything. Some of the kids get it and get it quickly, and for others, it takes a little bit of convincing.

"My belief is that we need to take the children from where they are to as far as they can go."

Sixth graders can handle just about anything. Young children are like sponges: They're interested in everything. I drive my kids insane with the word *why*. I won't accept the answer, "Because it's in the book." I want my kids to question things and to learn. My belief is that we need to take the children from where they are to as far as they can go. Give them wings and let them fly; but if they need a soft mattress to land on, we supply that, too.

I was raised on a farm, as an only child, so I was very sheltered. My best friend and confidant was a mule named Jack. I always thought I'd grow up and be a cowboy; I didn't want to be a cowgirl! I was this little stubborn, rebellious kid. I was the proverbial comic-book kid who goes to school the first day and doesn't understand why she has to go back. The food was awful!

I've spent my adult life trying to make the first (and every) day of class better for my kids because, as a child, I truly disliked school. I played hooky forty-some days in the fourth grade, so today I can tell when any of my students are faking it in class. I was bright, but school was not a good fit for me. I liked learning but I'd never been taught how to really think or dig through to answer something. I had never trained my brain.

In eighth grade I was the first girl in the history of the school who refused to take home economics. I told the counselor I wasn't at all interested in learning how to cook or sew; I wanted to take agriculture. He laughed at me. "You can't take agriculture," he said, "that's for boys." He was adamant, so I said I'd take art. They had me make a drawing as a test. I drew a horse and he let me take art, which I did for four years. My art teacher really helped me come to the realization that it was okay to be unique and to speak your mind, as long as you do it respectfully. He showed me that if you could laugh at yourself in a positive way, you could win over most people. Later in life I told him how much I appreciated what he'd done for me. I wanted him to know that I admired the fact that he was willing to be different.

We took an aptitude test in school and they said I could be a lawyer or a judge. I went home and told my parents. They laughed, not in a mean way, but the idea of college was totally foreign in my family.

I wanted to quit school at the end of freshman year in high school. My very wise mother told me I could, but only if I went back to school with a smile on my face and gave it my best try for two weeks. Sometime during those two weeks, I fell in love with learning and being myself, which, I believe, every child has the need and right to have instilled in him or her from the earliest age.

I graduated at the top of my class and went to visit a couple of colleges. My mother said they would pay for the first semester so that I could see if I liked it. I did. College was more fun than high school because I got to choose my classes.

I didn't know what I wanted to do. I was interested in learning, so I took an introduction-to-teaching class, and I liked it. I discovered I had a natural affinity for getting up in front of people and making things entertaining. I got interested in rural education, and decided I was going to be a psychologist or a social worker and fix the kids that the school system screwed up. One day, one of my favorite professors asked why he hadn't seen me in the education-department wing of the school. I told him what I planned to do, and he looked at me for a moment. He said, "Well, the best way to fix a broken system is from within," and he walked off. I knew he was a man of few words, and when he said something it was important. So, I actually stopped and analyzed what he told me. That— coupled with the fact that I had to take another statistical analysis class, which I hated—made me decide to go into education.

I take exception to people who say they want to teach just because they love kids. Who doesn't? To me, you've got to love learning, because, some days, the kids

are going to frustrate you. Some days they are not going to be lovable.

I married in college and went to Germany with my husband, who was in the military. There, I came into my own as a woman and learned who I was. I also discovered that the world was much bigger than I had ever imagined. *Magical* is a pretty good word for it.

We have a lot of multicultural families in the military and it was a very different environment from my childhood. I've got kids in my classroom who've lived in two or three different countries, and they're much more urbane and sophisticated than I am, for sure.

I am constantly evolving as a teacher. I don't teach today what I taught yesterday. I remember a teacher once said to me, "Oh, honey. The first year's the hardest, and then after that you just teach the same thing." Well, I've never done that. I think that each day is different, so you can't script anything. You never know what's going to happen. The kids are in different moods from day to day. The one thing that hasn't changed in my teaching is that I've never been afraid to take chances.

In fact, the risks I take are grounded in educational theory. For example, we just did the trial of Socrates to determine: Did he really incite the youth of Greece to rebel against the government? The kids couldn't use their textbooks; they had to do research and focus on the charge. We had a prosecution and a defense and they got to decide whether or not Socrates had to drink the hemlock. The kids dressed up in bedsheets and they actually held a whiz-bang trial. I may not be able to fly my class to Greece, but, by golly, for that one day they weren't in a concrete-block classroom in Fort Knox, they were in the Grecian Assembly outside the Parthenon deciding whether Socrates was going to live or die.

I love to do simulations like that. When I was teaching fifth grade, we changed history because our Christopher Columbus never discovered America. The kids came in dressed as Columbus, Leif Erikson, Erik the Red, Native Americans, Prince Madoc or anyone else who claimed to have discovered America.

When we were studying ancient Egypt, we mummified a chicken! In the age of the Internet, where the kids think everything they read online is the truth, it's good to see them analyze and dissect information. I think it is an important skill they are acquiring. Kids tend to absorb so much more when they lose themselves in the joy of learning. I could sum up my method of teaching by saying that I try and give my students an experience they may not have had in their life.

I had an assistant superintendent who was one of my greatest supporters, but she always told me I needed to verbalize what I did. I told her, "Well, I could BS anything." She said, "I know that, but for young people learning the craft, you have to be able to explain it." Then we got into a big discussion about whether teaching is an art or a science.

There are a lot of teachers who are excellent at giving information and teaching facts but they don't understand the art to it. Then there are teachers who are creative and the kids love them, but they couldn't follow a standards-based curriculum if their life depended on it. I think good teachers have a smattering of both talents.

> *"I could sum up my method of teaching by saying that I try and give my students an experience they may not have had in their life."*

It's kind of a joke in my building that I don't get student teachers anymore because I scare them off. I think I frustrate them, because they will ask, "Oh, how did you know to do that?" A lot of it is intrinsic, which makes it hard, if not impossible, for me to explain how I knew what to do to calm a kid down, for instance. I mean, it's not on page 38 of the textbook; it was just something I thought of trying.

I did have one young student teacher once, though, who I could see right away had "it," whatever that indefinable "it" is. She would run her lessons past me and I'd just get out of her way, because all she needed was some practice. Today she is an excellent educator and she knows how to capture her students' attention. She gives me confidence that there are still good new teachers out there.

Teachers are sometimes their own worst enemies. Too many of my peers say, "I'm just a teacher." I almost have to be restrained. *Just a teacher?!* My goodness, what a wonderful chance we have to shape future generations. I'm very proud to say I am a teacher, and I mean that sincerely. We should all proudly proclaim our profession and be cheerleaders not only for our profession, but also for our kids, because they certainly deserve the very best that we can give them.

"My students learn to be scientists, to ask probing questions, to design investigations, to seek answers."

Peggy Carlisle

2nd–5th Grade
Science and Social Studies, Gifted Program

Mrs. Carlisle and her fifth graders study the evidence animals leave behind by dissecting fake animal "scat."

A quick review of the awards Peggy Carlisle has been honored with in her thirty-year career as a teacher leaves one to wonder what could be left on Carlisle's professional wish list. From winning the Presidential Award for Excellence in Mathematics and Science Teaching, to being inducted into the National Teachers Hall of Fame, Carlisle has been recognized for her educational achievements many times over. Her life in the classroom personifies the words of Maya Angelou: "Do the best you can until you know better. Then when you know better, do better." Struggling to motivate her inner-city third-grade students in the late 1990s, Carlisle agreed to pilot a life-science kit being offered in her school district. The positive results were immediate, and she realized she had stumbled upon a way to authentically reach her students. The kits were eventually discontinued, but Carlisle persisted with her interactive approach to teaching and has never looked back.

I was born in rural Mississippi, in farm country outside of Jackson, in a house my great-great-grandfather built and in which I still live. I began teaching in 1973 and worked fairly close by for eleven years. When my husband and I started our family, I stayed home for nine years while I was raising our daughters. I reentered the classroom as a third-grade teacher and got a job in an inner-city district in Jackson with one of the highest drop-out rates in the state. All of my students were of African-American heritage and 97 percent qualified for the federal

free lunch program. I had much to learn about my students, their families, and their lives. The children seemed so discouraged when they came to school. Performances on standardized tests were well below state averages. Little interest was shown in academic subjects or in reading for pleasure. I struggled to find a way to reach them.

Often, as I asked my third graders to take out their English or science textbooks, I would hear a collective groan throughout the room. It was very clear that textbook-based instruction was not effective or inspiring for my students. My goal became to find a strategy, a technique that would empower my students with the necessary motivation to become successful, independent learners.

Dear Mrs. Carlisle,
You were the best teacher that any student could ever ask for. Till this very day I still have a treasure box full of projects from your class. You made me look at the world and people with a completely new perspective. You taught me to never take life for granted and to appreciate every little thing. You're still considered my favorite teacher—because you taught me more than a lesson, you taught me better ways to improve my life.

Written by a
former student

I found the answer to my dilemma in 1997, when my district received a grant from the National Science Foundation. I was selected to pilot a hands-on life-science kit called Structures of Life. The students engaged instantly. Through these kits, they learned to be scientists, to ask probing questions, to design investigations, to seek answers. I discarded all textbooks, integrating all subjects and curriculum objectives into our science themes—for example, incorporating writing through the documentation of experiments. Driven by their own curiosity, students found new meaning and purpose in reading. Children collaborated with one another. Math skills such as measurement and computation were necessary to investigations. My students found that learning is not only fun, but also that it is relevant. Their desire to learn extended beyond the classroom. During a study of dinosaurs and paleontology, one student's grandmother told me, "Every time I look out of the kitchen window, LeArron is digging holes in the yard."

After a while, I was teaching second through fifth grades, using science as my vehicle. I was getting grants to buy books and computers, even books for them to take home and keep. Students searched in our school library for material related to our themes. They were not satisfied with just the information gained from our class. They wanted to learn more. For example, following a discussion of carnivorous plants, my student Darius found that our library had no books on the topic. The next day he told me that he had walked two miles to the city library to satisfy his curiosity.

One rainy day, a visitor to our class mentioned that he had forgotten his umbrella. We had recently completed a study of the properties of water in which students explored water's reaction to different substances. One of my students, Sherman, remembered this and volunteered, "If Mrs. Carlisle will give us wax paper and some sticks, we can make you an umbrella."

The students planted seeds. They germinated. They peeled the seed coat off the bean and discovered the little cotyledon growing out. They learned about owl pellets. When an owl eats a mouse or a rabbit, it swallows the animal and its stomach processes and digests the meat. Then it coughs up the bones, which is the owl pellet. The children had charts that showed owl food chains. They took the pellets apart themselves with tweezers and magnifying glasses and matched the bones to the chart, analyzing exactly what the owl ate. This was exciting. They were learning.

Over time, we filled the classroom with kits and little pets. We had a hydroponic garden so that they could watch the roots growing. We had many organisms in the class—Madagascar hissing roaches and such. We came in one morning to discover that the classroom crawfish had fought during the night. We could see the evidence. One of the children wrote about it. She noted that two out of four of them were still alive. She concluded that you do not keep four crawfish in the same bin. We separated them from then on and took better care of them. We watched the survivors molt their new shells and followed the way their new skin, the exoskeleton, went from being soft to hardening up. That experience was so wonderful. Many of the children had never had a pet, so I thought, *Well, I'll get them each a crawfish*. I remember the next day, Sherman— he was so excited—said, "Mrs. Carlisle, I have to tell you we were watching television last night, and my crawfish got out of his bin because he was looking for me." Now I'm

sure that it wasn't really looking for him, but he felt he had a real relationship with his pet. So, one of the purposes of bringing creatures into the classroom is to teach children appreciation for life and a respect for life.

I guess I don't understand why more people don't teach in this way. I know it takes a lot of time and resources to develop units full of the skills that students must have. I think you have to be—not just brave—but I think you have to have confidence in your abilities to be able to plan units that can encompass so many different subject areas.

If what I do does not impact student learning positively, then it is worthless. Even simple things like displays out in the hall. They're not supposed to be cute. They're supposed to really demonstrate things that students have learned.

Since I've changed my teaching, I've mentored a lot of candidates for National Board certification. I've written articles for *Science and Children*, the national science teachers' journal for elementary educators. I'm the preschool elementary director for the National Science Teachers Association. I never, ever would have thought any of this would happen. You do not know where your path will take you. You absolutely do not know. It's just a surprise.

Over the past twelve years, I have received over $180,000 in grants for my classroom in order to provide the quality books, organisms, technology, and hands-on materials that will best benefit my students. Our projects center around topics of interest to the students, using themes from science, art, and social studies. Students are varied in their abilities but all have persistence as they create original artwork—from Matisse-like sketches to delightful clay models. Social studies takes the guise of foreign studies—favorites are Japan and Kenya. As we delve into a country, we learn the culture through art, dance, and music. We create artwork using techniques commonly found in the particular country. We cook and enjoy the country's cuisine, study the language, read books about the children, and view videos in order to understand life in a faraway land. This gives my students many occasions to look at another culture carefully and to realize that even though we have differences, we also have many similarities.

A teacher from Kenya had a connection with one of the churches in our neighborhood. When she visited the church, she asked to visit an American school. So, they brought her to Pecan Park and the principal took her to my room. She spoke fluent English and shared stories with my students about the life of Kenyan children. The children that she worked with live in mud-brick houses and get their water from a stream or a spring. They have one-room schools and many of the children learn outside because there is not enough room for everyone inside. They write on the ground with sticks because that's all they have.

My children were just enthralled. This was really their first taste of learning about students their age who live a very different life from their own. When she left they asked me, "What can we do to help?" We decided to raise money for them to buy more supplies. We started by gluing eyes to rocks and selling them. Then we started making little houses for the pet rocks. Then city scenes and country scenes. We also sold all kinds of school supplies. Everything had to be cheap. I think the most expensive item we sold was fifty cents. Over the course of about four years we sent the teacher about $3,500. My kids also wrote and illustrated a book for her kids and we sent them fifty copies of it. It was called *Living in America*. They sent us back videos.

> *"I discarded all textbooks, integrating all subjects and curriculum objectives into our science themes."*

Several years ago, Roneisha, a former student of mine, dropped by my room to invite me to her high-school graduation. Roneisha had been in in my third-grade class nine years earlier. That year, a local paper ran a story focusing on our class's hands-on science activities. The photo that accompanied the article featured four students engaged in a chemistry investigation. Roneisha was one of those students. During her visit with me, she explained that her high-school years had not been easy. In fact, Roneisha had given birth during Christmas of her junior year. I told her that I was pleased that she had not dropped out of school despite her obstacles. And what she said then amazed me. When Roneisha was in the third grade, her mother had framed the newspaper photo and hung it in Roneisha's room. She said that over the years, when she thought that times had become too difficult to bear, she would look at that picture and know that she could accomplish her goal—to graduate. She now attends college, and is majoring in biology.

"When you set up a culture in your classroom where your students know that they're going to achieve something great if they work at it, if they're willing to step over their failures and rise back up when they falter, then you've created a paradise."

Jeffrey Charbonneau

9th–12th Grade
Chemistry, Physics, Engineering, and Architecture

Jeff Charbonneau was supposed to be a well-to-do doctor. At least that was always the plan. Before moving to Zillah, Washington, in middle school, Charbonneau grew up on an Indian reservation in a remote area in Northern Washington State, where his mother was an EMT and his father drove an ambulance. Inspired by watching his parents help save lives, Charbonneau (the first in his family to go to college) enrolled at Central Washington University as a premed student. But an opportunity to tutor local high-school students in biology during his sophomore year forever changed his path. Charbonneau fell in love with teaching, and found his calling. As 2013's National Teacher of the Year, there seems little doubt he made the right career choice. And though he may not pull in a doctor's salary, he dramatically impacts lives every day in the classroom.

Mr. Charbonneau plans a lesson in his science lab.

I start out every class period the same way, by saying "Welcome back to another day in paradise." It has become my mantra, and to my students it has become legendary. Even students who have never taken my classes will ask me, when I walk down the halls, if today is another day in paradise. I know it's a pretty dorky cliché, but what do you expect? I am, after all, a high-school science teacher. And I truly do believe that where I teach is paradise. But the reality is, paradise exists only where

people care enough to create it and work hard enough to maintain it. You have to put in sweat equity. You have to have triumphs over adversity. You have to want it badly enough. A lot of people will talk about the negatives of education. I consciously choose to see the positive in things. And, when you do that, when you set up a culture in your classroom where your students know that they're going to achieve something great if they work at it, if they're willing to step over their failures and rise back up when they falter, then you've created a paradise.

When I first began teaching at Zillah High School in 2001 (the same school I'd graduated from just five years earlier), I was a very stereotypical science teacher: "You will do this assignment on this day, and you may not turn it in late. You will take this quiz, and you may not redo it." I would go to the file drawer, pull out worksheets, and just pass them out. I'd tell the kids to do the worksheet because that's what I thought I was supposed to do. The problem with that was that I never even read the questions. I wasn't even checking to see if the questions I was asking meshed with what I expected them to learn. One day I just realized, "This is wrong. Why am I doing it this way?" And I switched and said to myself, "Okay. No more of this."

> "If a student were to complete all of my courses while in high school, they would graduate with twenty-four college credits without stepping foot on a university campus."

Then I recognized that my students were bored with their textbooks. Why were they bored? Because we were talking about atoms and electrons in high-school chemistry. They had already learned about that in seventh grade, and now we were doing it all over again. We weren't raising the bar. So I tried to respond to that by doing more labs. They had more fun, but I don't think student learning increased. Then I grabbed one of my old college textbooks. I threw a chapter of college-based chemistry at them and they soaked it up. It was an unbelievable experience, just how much a kid can actually do if you give him that chance to do it. With that, I went to my principal and said, "I want to buy all college books."

Two things happened: one, the rigor of my classroom went way up. I demanded much more out of my students.

And two, enrollment jumped. More kids wanted to take the class because they saw that kids were being challenged. Students wanted to learn more and dig deeper. My courses became so advanced that colleges started to take note. Now 60 percent of Zillah High School juniors take college chemistry. And 25 percent of my seniors take college physics. In sum, if a student were to complete all of my courses while in high school, they would graduate with twenty-four college credits without stepping foot on a university campus.

About five years ago I had another important revelation that changed my teaching approach. I realized that if I'm going to give a student an assignment, it's because I want them to learn something from it; it shouldn't really matter what the timetable is, as long as they eventually absorb the lesson—that's the ultimate goal. So suddenly, I started letting students turn in assignments late. And then I started allowing them to retake tests. Student understanding went way up. Grades stayed virtually the same. And the kids accomplish so much more.

I've been in the classroom for twelve years now, and my best advice to new teachers is twofold: one, spend as much time as you possibly can learning about the kids. There are some students who I know I can push really hard. And, there are some who, if I see a certain look in their eye, I literally have to say, "Okay. Take a break. Go get a drink of water, because I know you're on the verge of getting frustrated and breaking down." Students can't learn when they're angry. They have to be in a positive environment. If one of my students gets upset, I know I have to stop teaching at that point. And then I have to break it back down, review, and build up their confidence again. You have to know your students. Relationships in education are far more important than content.

The second thing is, don't limit potential. And I mean that for both students *and* teachers. Don't limit what you think you are or can be as a teacher. For example, I'm a quantum mechanics/physics guy, but I'm also the yearbook advisor. I'm the assistant drama director and also a union president. Those things don't normally go hand in hand. So often I see kids and teachers put themselves into boxes, and then they have trouble escaping them. If I could change one thing in my classroom right now, it would be the confidence level of my students. Some of them come in having lived more of a life than I ever have, because of the adversities and challenges that they've had to overcome. I wish that they could see just how powerful they are.

All my hobbies tend to be school-related. I'm involved in a number of programs and extracurricular activities, but one of my favorites is something called the "Zillah Robot Challenge," which is a response to the fact that my school, and virtually all schools, have limited resources and limited funding. I was looking for a way to get my students involved in robotics, but we didn't have the money to buy robots. I talked with a group of teachers and parents, and together we formed the Zillah Science Boosters. We went out and asked area businesses and individuals to donate money so we could purchase one hundred robot kits to start the robotics program.

The program serves as an introduction to robotics; however, the goals are much wider in scope. I aim to provide free, hands-on experiences in math and science education to any willing student, regardless of what school he or she attends. I maintain an open invitation to all schools in Washington State to participate in the program at no cost. Public, private, alternative and home schools are eligible. Zillah High loans robot kits to schools. Teams then work as part of an in-class, club, or after-school program for approximately six weeks to learn how to assemble, program, test, and modify their robots before the competition. Competition day features keynote speakers from around the state.

More than a thousand students from more than seventy different middle and high schools throughout the state have participated in the twelve competitions from December 2008 through the fall 2012 season (competitions are held twice a year). The year 2012 saw the most growth in the program, with more than eighty-five teams from twenty-seven different high schools having participated in the December high-school competition.

When somebody says there aren't enough hours in the day, that's true. There aren't enough hours for the things that aren't important. But there will always be enough time for the things you care about. I have a six-year old and a three-year old and I make sure that I am home every night by 5:30 P.M. to be with them. They typically go to bed by 7:30 P.M. and my wife follows at around 9 P.M. And, then I'm up. I work on school from 9 P.M. until midnight or 1 A.M. Sometimes I'm on the computer at home, sometimes I go back down to the school. The kids like to joke that my truck never leaves the parking lot. In the mornings, I get to school at least an hour early each day. There are almost always students already waiting on campus. I welcome them into my room and help them study subjects from English to algebra to music appreciation.

The overarching theme behind all that I do is simply this: Kids get one chance to go to high school. And shouldn't that one chance be absolutely the best experience they can possibly have? And isn't my job as a teacher to give them that? So I find time to do all these things because it's the right thing to do. It's an addiction—in a good way. It's an addiction to making things better. And it's what I love doing.

> *"The magic formula in education is not hiring the right person. It's hiring the right group of people, who all want to achieve the same goals."*

I feel like I haven't gone to "work" a day in twelve years. I truly enjoy what I do. And that's what I want for my kids. Even though I teach science, I'm not necessarily concerned with making a great nation of scientists, per se. If my students want to go on to quantum mechanics, that's great. But I'm equally as proud of my students who go into nursing or acting, or become welders or beauticians. I just want them to love what they do and have the confidence to do what they love. That's the goal of education.

I've just been named National Teacher of the Year. I'll be taking a sabbatical from teaching in 2013–2014 to tour the fifty states, and I'll give 150 speeches over the course of the year. It's something that very much excites me. And it's an honor, of course, knowing that I've been chosen out of the 3.3 million teachers in this country. But I've been telling a lot of people, "Success does not occur in isolation. You can't succeed in education by yourself as a teacher." It's only because of the teacher next door, the teacher down the hall. It's because of the secretaries. It's because of the administration. It's because of a whole staff working together to try and make good things happen. The magic formula in education is not hiring the right person. It's hiring the right group of people, who all want to achieve the same goals.

It's funny, because when I graduated high school in 1996, I uttered those fateful words: "There's no way I'm ever coming back." Yet here I am. And when my term as National Teacher of the Year is up, I hope I'll be right back in my classroom. Right back in Zillah.

> *"Here I was, a first-year teacher, with 250 students and a $100 budget. My solution was bucket drumming."*

Jason Chuong

3rd–12th Grade
Instrumental Music

Mr. Chuong teaches drumming on his signature orange buckets to sixth graders at the Julia R. Masterman School.

Armed with not much more than a stack of Home Depot paint buckets and a slew of drumsticks, Philadelphia music instructor Jason Chuong is successfully cultivating a citywide ensemble of young drummers, one phat beat at a time. With an annual budget of a single C-note (that's less than the cost of one *used* drum set) Chuong's necessity-is-the-mother-of-all-invention approach to teaching even caught the attention of President Obama, who publicly praised his program, and earned him an audience with U.S. Secretary of Education Arne Duncan. Chuong's combination of classroom creativity, community commitment, and irrepressible optimism beautifully exemplifies the potential every teacher has—regardless of available resources—to influence the lives of his students.

My upbringing was quite unique, and I credit my family and my family's story for shaping who I am today. My parents and their siblings are all Chinese, but almost everyone was born in Vietnam. My father was drafted into the South Vietnamese army at eighteen, and he soon became a high-ranking officer.

During the war he was captured by the North Vietnamese and was placed in a prisoner-of-war camp for three grueling years. After he was released, my parents, my two uncles, and my aunt fled the country illegally (they were known at the time as "boat people"). During the escape they were forced to land on a remote island in Malaysia where they were stranded for one and a half months. They struggled to live off the land, and my mother was pregnant with my oldest brother. Eventually they were found and rescued by the Red Cross, and were taken to a refugee camp. Families lived in shelters made of sticks, tarps, plastic, and whatever else they could find. They received rations of food that they cooked over a fire. My family lived like this for nine months! At the time, different countries, like the United States, France, and Australia, were accepting Vietnamese refugees. My family was chosen to come to the States, and they were flown to Connecticut in 1980.

They had no money when they arrived here—only a bag of dirty laundry. My aunt and uncles were just seventeen or eighteen, they did not speak English, and they enrolled in high school as freshmen. They worked part-time after school, studied hard, and succeeded. By the time they graduated high school, they were in the top 5 percent of their class. Today they all have houses, jobs, nice cars, etc. They live a comfortable life that was achieved through hard work and education. They literally started from scratch in this country!

When I was young, my family made sure to remind me of their story. They've inspired me to work hard, stay disciplined, and believe it is possible to achieve whatever successes I decide to pursue. My brothers and I all followed in my family's footsteps to continue their legacy. We graduated from the same high school as my two uncles and aunt. All of us graduated in the top 5 percent of our class with straight A's for all four years.

I come from a long line of engineers and my brothers

both carried on the family tradition. I was a bit of the black sheep and chose to pursue a career as a jazz musician and a music educator instead. It was a little tricky at first—but my parents always supported my passion for music. They even bought me my first drum set, my freshman year in high school.

After receiving a degree in jazz performance and a master's in music education, my objective was to balance my life between performing and teaching. I wanted to share my love and excitement for music with under-privileged students and pass on the same hope, direction, and compassion that my family's teachers gave them.

As long as I have known him, Mr. Chuong has not let the music die in my life. A large part of my future is inspired by him in that I too wish to pass on my everlasting passion and love for music to my children and future generations. Perhaps one day I can be a hero to someone just as Mr. Chuong has been to me. I am who I am because of Mr. Chuong, and I'm nothing but proud to say so.

Travis, age 17, former student

I took the first job that I was offered, which was for the Philadelphia School District as an itinerant music teacher, teaching full-time, grades three through twelve—mostly percussion—at a number of different public schools all around the city.

I entered the school district just before they experienced a giant budget deficit. So my entire annual allowance, for all seven schools that I teach at, was and is one hundred dollars. Few of my schools have enough functioning instruments. In fact, during my first year of teaching, one of my schools had no musical equipment at all—no supplies, no instruments, no music stands. Not even a piano.

So here I was, a first-year teacher, with 250 students and a hundred-dollar budget. My solution was bucket drumming. I had the idea to go to Home Depot and buy a bunch of five-gallon paint buckets to use as drums. The kids loved it. I mean, picture twenty kids bucket drumming, straight across a giant stage. It's just amazing. This is my fourth year now, and it's really taken off. The program has created almost a mini-culture of young drummers roaming around Philadelphia's public schools.

Each bucket costs about $2.38 and I buy as many as I can afford. At most schools I have a small storage area where I can keep a pile of buckets; otherwise I have to carry them from school to school in the back of my car. I love what I do. And as long as they continue to offer me this position, I'll keep doing it. As one of sixty-six itinerant music teachers in the district, sometimes we are the only music service provided in a school—so we're literally all these kids have got. I have so many amazing drummers in my classrooms. And it's frustrating to think about how much more they could do if they had even slightly better resources.

Music teachers have so much potential to impact a child's life. If I can show students that they can develop confidence, ingenuity, discipline, and self-respect through music, they can apply those skills to all parts of their life. For the typical inner-city student, music is an outlet and an escape from the difficult aspects of their lives. It's such an easy way to bridge the gap between what happens in the community and what happens in the classroom. For this reason, I try and make the material I use as relevant and relatable as possible. For example, if I am giving a lesson on improvisation, song form, or rhythmic ostinatos, I may use a hip-hop or a pop song to teach the concept.

One of my most memorable "proud moments" as a teacher was about four years ago in a very difficult neighborhood in North Philadelphia. When I started teaching at this particular school, I met a very talented eighth grader, who was known among his classmates and teachers as the best drummer in the school. He was very respectful and hardworking, and he loved music. I worked with him for about six months and he rarely ever missed a lesson—I always saw him in the hallway with sticks in his hands. Suddenly he stopped showing up for class. I spoke with his friends, and they told me that his father had committed suicide in his home, and that he had been in the house when this occurred.

When he came back to school, it was during the week of our spring concert. I decided to feature him in the performance, even though he had missed about a month's worth of classes. Although he was in a terrible place and had barely rehearsed with my ensemble, I convinced him to participate. He ended up performing a long improvised drum solo while the rest of my percussionists accompanied him on bucket drums. He received effusive compliments from his friends, teachers, and administrators for weeks after the concert. I was so proud of him for being able to find the courage to play his music and do something positive. I will never forget seeing the smile on his face after his performance.

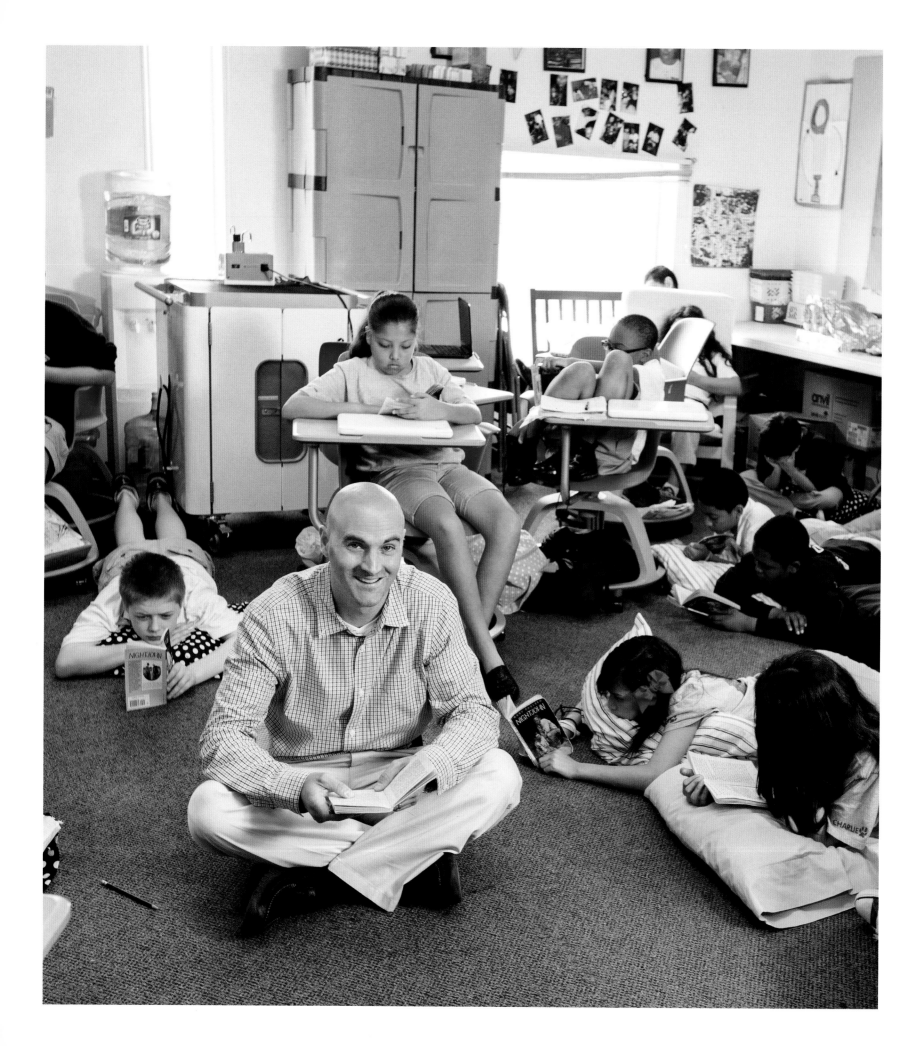

"I have a firm belief that if anyone wants to be a good or great teacher, they have to infuse whatever passion they have as a person into their classroom."

Dave Crumbine

5th Grade
English and Life Class

Senior year of college, Dave Crumbine picked up a Teach For America brochure, turned it over, and saw a smiling African-American girl looking up at the camera with a tilt to her face. He thought instantly, "I could do that every day. Teach and hang out with kids." And that's just what he's done for the past thirteen years, eleven of which have been spent at the KIPP Academy Middle School in Houston. KIPP was founded in 1994 by Mike Feinberg and Dave Levin, two Teach For America alums whose fiery determination to revamp the model for public education inspired a national network of free, open-enrollment, college-preparatory charter schools (more than 80 percent of KIPP alumni have gone on to college). There are currently 125 KIPP schools across the country, serving 41,000 students, 86 percent of whom are from low-income families. KIPP Academy Middle School's revolutionary curricula focuses as much on building character as it does on improving academic performance—a philosophy that Crumbine practices, preaches, and believes to his core.

Mr. Crumbine and his English class get comfortable while they read Nightjohn, *by Gary Paulsen.*

The irony of me teaching in inner-city Houston, Texas, is clear: a rich kid growing up on the East Coast, falling in love with Richard Wright and lyrical social-justice rap and now teaching kids who can't afford to replace their ripped shoes. And I love every day of it. As if that's not enough, I had few friends growing up and was shy—I was an introvert in front of an IBM XT personal computer who hated to read and couldn't stand talking in small groups, let alone having people stare at me. Oh, and speaking about childhood—my parents? They're two beautiful people in soul and intention who expected me to figure out right from

wrong, how to correct my errors, how to handle difficult discussions, and more, by watching what they did and learning by their example. Modeling, modeling, modeling. There were very few "let's talk about that decision you just made" conversations.

Every Friday for the past fourteen years, I have taught Life class. Five days a week, I teach reading to ninety-six sets of eyes. If only my kid self could see me now.

My first year with Teach For America, I was placed in a fourth-grade class at Rusk Elementary, which was the feeder school for Houston's main homeless shelter. I had something like ninety-seven kids come in and out of my

classroom throughout the year. The insanity of that fluctuation didn't really dawn on me because I'd never taught before. I didn't know any different. One of the boys, Joe, liked to stick around—he was basically always there, just being really helpful. I knew he loved basketball at recess. So we would play together and hang out. One day I offered to drive him home and I started doing that on a consistent basis. No big deal.

> *"I'm not scared to have them fail. It doesn't bother me if they fail once or ten times, and I don't want it to bother them."*

Joe lived with his mother and older brother in half of a house that was tilted to the side. He never wanted me to come inside. And I understood; I got it. Eventually, he did let me in one time. First he said, "Hold on, let me clean up a little bit." When I walked in, there were just layers and layers of clothes piled all over the place and there was an incredibly strong odor of uncleanliness. There was no air-conditioning. There was no heat. There were only drapes in the window, fluttering in the wind. That's when I understood the real reason he hadn't wanted me to come in before. His mother had Alzheimer's disease. His dad wasn't around anymore—he was an alcoholic and had been abusive. Joe was raising himself—he made all his own meals and somehow managed to do laundry. He was a small kid and super fast. So, the gangs would have him break in through the windows of people's houses and take things. The next day, he'd come to school asleep on his brother's back because he'd been out all night, not even really understanding what he had done.

After months of spending time with Joe because he was such an amazing kid, I was like, "Oh, screw it." And I asked him if he ever wanted to stay the night at my house. I mean, I was just so naïve at the time. I told him to ask his mom and she just smiled and nodded her head—I'm not even sure she understood the question. So he stayed over. And, then he kept staying over. He had his own pillow and blanket on the couch, and a stash of clothes. I had to put his clothes through the washing machine twice just to get the smell out.

After my second year at Rusk, a KIPP teacher who had helped me out when I first came to Houston invited me to come interview. I was honored. I had visited KIPP before, and I'd thought, "Holy cow, I didn't realize kids could pay attention for that long!" That's how clueless I was as a teacher. I was voted the Teacher of the Year at Rusk my first year and I have absolutely no idea why. I was awful.

I got the job at KIPP but there was no way I was going to leave Joe behind. So I asked him if he wanted to come with me. He'd go to sixth grade at KIPP, and I'd be teaching fifth. So he did. After three years at KIPP, he went to boarding school in Connecticut. Now he's back in Houston going to college part-time to finish up his associate's degree and working full-time as a manager at one of the top welding companies.

Every day, when I get off the phone with him, he says, "I love you, Pops." I've always referred to Joe as my son. And I'll always be his dad. So, it's simply that concept of how one person can make such a huge difference. I had no intention of doing it—that was just the reality: Joe made me become a better person. He absolutely did more for me than I did for him. Even though he would never admit that—because he's just so humble and so giving.

A favorite maxim of mine comes from John Wooden: "Big things are accomplished only through the perfection of minor details." In these past eleven years at KIPP, I have noticed this is one constant that continues to show its face no matter the situation. In all of our mistakes and in each sweet victory that so often never sees the spotlight, this has been a rock guiding the way we think, the way we plan, the way we decide, and the voice that tells each successful teacher where his or her focus should reside.

One aspect of KIPP that seems to take visitors by surprise is our lack of programs. Oh sure, we plan. I'm not sure I spend more time doing anything else. But what's not present is a preset system of self-running programs. I remember being surprised by this myself when I first joined the staff. It didn't take long to realize that what gets done here every day comes from the brute force of horsepower, or rather teacher power, that gets extracted from us every day. All of the accomplishments, tasks, lessons, conversations, high fives, parent conferences, student conferences, and even hugs are the minor details that comprise the sum of what it means, not to teach at KIPP, but to *live* KIPP.

In the quantity of hours I give to my job, from my first phone call at 6:45 A.M. to the last at 9:45 P.M., the

sheer number of small steps that are walked each day far surpasses any one large step. I look at this very much like good parenting. Or rather, great parenting. I remember being overwhelmed when I looked at my sister's daily to-do lists when she had two young children in the house. She was busier as a full-time mom on any given day than she had been as a private-school teacher for six years. This analogy rings true for what we do at KIPP. Many days I'm exhausted, but not because of some traumatic intervention in awful student behavior—not because of a screaming parent or a sudden culture shift in the attitude of the students as a whole, which can be common in other schools.

Back home, my neighbor to the left and my neighbor to the right both teach in public schools. I hear them giddy the days before a long vacation, excited to get away from their kids and classrooms because, "The kids just don't concentrate before a vacation. They're a nightmare." I don't tell them that, although the rest will be nice, I'm counting the days I will lose in the classroom instead of the days of vacation. I've even been known not to be aware of when a vacation is coming, and I forget to let the kids know. When I put the homework on the board and it says, "No school Monday," I put a sad face next to the words with tears coming out of its eyes. I don't share these tidbits with my neighbors. I never know when I might need to borrow eggs.

Teaching in the Houston public-school district, I have seen plenty of teachers tired at day's end. Yet their fatigue seems to stem from a very different source. Where they are exhausted from what school has thrown at them, I'm exhausted from what I have given. Yet, it is the giving and performing of so many small tasks from each KIPP teacher that creates the sheer quantity of polite, patient, and loving students within our walls at KIPP Academy Middle School.

We try our best to make every detail count, to listen to that voice that tells us what to do. Every single issue that seems to arise, every side comment made by a student, every overt or hidden piece of news that comes to light gets our attention. Our time is grounded in one mission: Teach every single student—and I do mean *every single student*—how to solve their own problems, or we solve the problems for them as any great parent would try to do. Our big accomplishments arise from our focus on the smallest details.

I have a firm belief that if anyone wants to be a good or great teacher, they have to infuse whatever passion they have as a person into their classroom. And, if they don't have a passion, then they sure as hell shouldn't be a classroom teacher. My passion is computers. I'm a huge computer geek. I'm not a programmer, but everything else—I love it and I eat it up. Especially Macs. So I've turned my classroom into an English lab.

About two years ago, I started creating digital online lessons—everything from grammar to reading and writing. I'm up to seventeen now. The kids watch each lesson at their own pace, they take notes, and then they take a quiz that tells them their score, but not the answers. They have to get a 90 or higher to get one point and move on to the next lesson. They can retake the quiz as many times as they want, but I have to reset it for them. That way I don't have a kid taking the same quiz ten times within twenty minutes and just doing trial and error until he/she gets it right. So, it does force them to go back, rewatch the lesson, retake the notes, get tutoring, or ask for help. For this past academic year, 97 kids have collectively mastered 1,043 lessons. In traditional teaching, if a kid fails, maybe they get one more chance, but the teacher's going to keep moving forward with the curriculum. And kids get left behind. I've never taught a single major grammar lesson at the board the whole year and my students have learned all the skills on their own.

"Our big accomplishments arise from our focus on the smallest details."

At the beginning of my English class, the kids walk in and immediately start assigning themselves, which is KIPP-speak for choosing something productive to do in the first few minutes of class. It can be anything—it's their call—it doesn't even have to be for English. This habit drills in the concept that all of your time is valuable. Once everyone has assigned themselves, the computer managers—who are students—pass out the thirty-two computers. The kids turn them on and they instantly go to the English-class web page, which I update daily. They read the announcement section and look at what homework I've posted, and they write it down in their agenda. Then they check the "Do Now" page, which has instructions for what they should work on first. Once they've completed the "Do Now" tasks, then they just go right

back to assigning themselves, while waiting for me to start on the lesson.

If they have a question, they don't come to my desk or raise their hands. Just like at the deli counter where you take a number, I created a digital version of that in a Google form. So if they need something, whether it's to go to the restroom or to retake a quiz, they go to the Google form and fill it out. It populates a Google spreadsheet on my computer. All the communications are sequenced in the order they were received, and I can see exactly what they need and why they need it. And then, remotely, I can control their computer from my desk. Or, if it's something that I can have one of my assistants do, I'll pass it to them.

> *"At the end of the day, if we're going to have to choose between the academics and the culture at KIPP, we're going to pick the culture."*

So, if you were to walk into my class for the first time, you would see all of those things happening. Nothing is unruly. Nothing is loud. But all the kids are moving around, performing different tasks, interacting, while it basically looks like I'm doing nothing—and that's my goal. Kids can do so much: If you empower them, it's amazing what they're capable of. I try my darnedest to make them incredibly independent. I'm not scared to have them fail. It doesn't bother me if they fail once or ten times, and I don't want it to bother them. But I want it to incredibly bother them if they don't work their tails off to find a solution.

One day a week, I teach Life class. The content is eclectic, but one big part of the course has to do with decision-making. There was a Harvard professor named Lawrence Kohlberg who studied thousands and thousands of decisions that people make every day—from whether we're going to brush our teeth to how we're going to react to that person who cuts us off in traffic. He looked at how or why we make those decisions. He boiled it down to six reasons. It starts with the most basic pre-K, level-one reasoning, which is: I don't want to get in trouble. So I'll do whatever I need to and it doesn't matter what it is, I just don't want to get in trouble. I would assume, for example, that a huge percentage of prisoners function on level one. Level two is: I want the reward. That's a drug

dealer. Drug dealers live and die by level-two decision-making. No, they don't want to get in trouble, but they know they might. They're willing to risk it because they want the reward so badly. Level-three thinking is: I want to be liked. This is especially true in middle and high school. Everything's about what your friends think of you. Nothing matters more than friends. Whatever my friends need, I'll do it. I don't want to get in trouble, but I'm willing to risk it. And, maybe I want the reward, maybe I don't; but I absolutely have to make sure my friend likes me. Level four, which gets a little deeper, is: It's the law. So you actually understand the thinking behind the rule of law and you respect it.

Levels five and six are the rare ones. Level five is: I don't want to hurt anyone. I'm willing to get in trouble. I'm willing to sacrifice the reward. I'm willing not to be liked. And I'm willing to break the law. Anything to avoid hurting someone. So, believe it or not, that's actually not Martin Luther King, Gandhi, or Malcolm X. They're actually above that. That's level six, which is: I'm following my code—whatever that may be. What do you believe in? Who are you? And that's the only thing that's going to drive you. You're willing to get in trouble. You're willing to skip or sacrifice a reward. You're willing not to be liked. You're willing to break the rule or law. And you're actually willing to have someone get hurt if need be. And people did get very hurt in the Civil Rights movement, for instance, or when they lay down in front of the tanks in Tiananmen Square. Being a soldier—that is the ultimate example of level six. It's one percent or less of our population that are level-six decision makers. I want our kids to understand that.

My goal, by the end of the year, is to have evolved as many kids as possible to level-six thinking without ever using the word *level* or mentioning numbers one through six. I want them to really understand what the six levels are by going through the Life-class lessons that epitomize each of them. By this point, we've already been doing this for months in the background. They just haven't been aware of it.

At the end of the day, if we're going to have to choose between the academics and the culture at KIPP, we're going to try to get as much of the academics in, but we're going to pick the culture.

There's always time to do the academics or to get your work done. But I'd never prioritize that over being a good person. That's the code I follow.

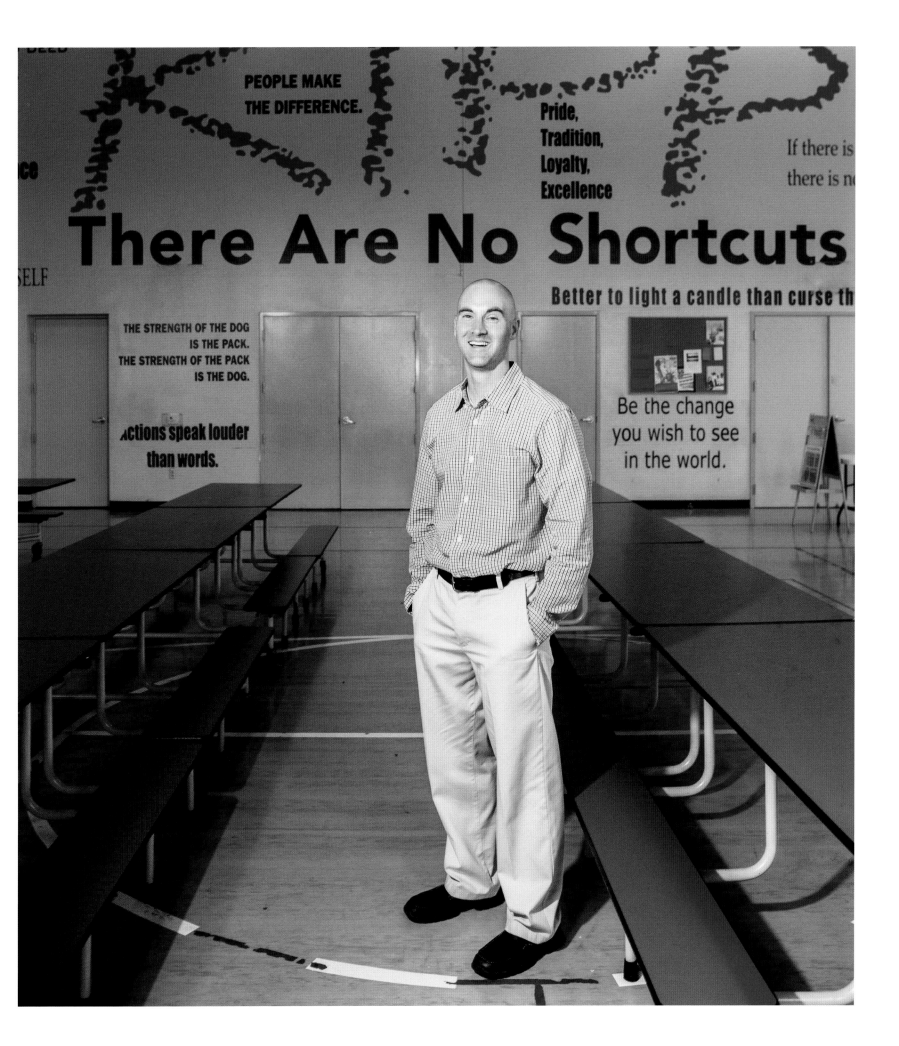

> *"It might take thirty or forty years, but you can change the success of an entire community just by focusing on education."*

Alvin A. Davis

9th–12th Grade
Music and Band

Mr. Davis prepares to inspire his class of musicians to bring their instruments to life.

Alvin Davis has been teaching music and band in South Florida for the past thirteen years. He was named State Teacher of the Year in 2011 and was a finalist for National Teacher of the Year in 2012. Close to home, he is considered an educational hero—the city of Miramar even proclaimed September 7, 2011, to be Alvin A. Davis Day. Davis believes his life is proof that, as Joseph Campbell once said, "Opportunities to find deeper powers within ourselves come when life seems most challenging." Growing up on the tough streets of Chicago's South Side, where neighborhood violence was commonplace, Davis knew from an early age that he wanted to be a high-school band teacher and combine his love of music with his dedication to helping others. Using rap songs to teach the fundamentals of classical music, Davis's classes are everything but ordinary. "Success is a disease that can sometimes spread," he says, "and I try to infect my kids with that disease of success."

My parents were from two very different worlds. My mother came here from Mexico when she was six and didn't speak English. My dad was from Tupelo, Mississippi, and moved to Chicago in the 1940s without having had more than a high-school education. Still, I was blessed with parents who sacrificed everything, and I mean everything, to ensure that I had the best possible education. In fact, at one point, unbeknownst to me, they took out a second mortgage to pay for my tuition. I got my degree but they lost their house.

I may not have had many of the luxuries in life but I was wealthy in the love, kindness, respect, and fortitude of caring parents. Growing up on the drug- and gang-infested streets of the South Side of Chicago left lifelong impressions. I had a friend who lived two houses down from me and he was shot dead on his porch. That was an everyday occurrence. But no memories of my childhood are greater or more profound than the ones made by my parents.

One summer afternoon my father took me to Oak Woods Cemetery, and although of course I didn't realize it at the time, I would live my life by the words he told me that day. He said, "Son, there are only three important things carved on our tombstone when we die. One, the year we were born; two, the year when we died and three, the most important one—the dash in the middle. What will you do during your life—during your dash—to make a difference in this world and in someone's life?" As I looked down at the name on the stone, I realized we were standing over my grandfather's grave. Not too many years later, I would stand over my father's grave and finally understand that most important lesson.

My parents got me into Poe Classical on the South Side of Chicago, which is in the top 95 percent of all elementary schools in the country. I was taking high-

school courses in the seventh and eighth grade. We had many programs that were geared for college prep. My friends in the neighborhood who were part of the program are all successful today. Most of the kids who went to local schools are either dead or in jail, or still struggling.

I came to my passion in life quite young and I remember the moment with clarity. It was the summer of 1987; I was eleven years old and sitting in the basement at 220 South Michigan Avenue in the heart of downtown Chicago. Our instructor said, "It's time; stand up." We walked down a narrow hallway and found ourselves backstage at the historic Orchestra Hall, home of the Chicago Symphony Orchestra. Suddenly, a voice onstage announced, "Next to perform is the Chicago All-City Elementary Youth Chorus." As the crowd roared, we scattered onto the stage and waited until the applause died. My heart was racing. An awkward silence fell upon the hall as the conductor raised his hands, looked directly at me, and gave the chorus the cue to prepare. It was at that singular moment, even before the first piano key was struck that I knew music was my passion!

"Everything we do in music and in the band is meant to be transferred to real life."

I also knew that I wanted to be a teacher. In fact, in tenth grade I wrote a paper about what I'd be doing in ten years, and I said that I was going to be a high-school band director. In college, I majored in music education, and planned on returning to Chicago to teach, but I was offered a job in Broward County and I've been here ever since. I started at a middle school but after three years I knew I wanted to make a bigger impact on a larger and older group of kids, so I moved to Miramar High in 2003.

We're an inner-city school in what some would consider a high-poverty area. We have a 98 percent minority population with 70 percent on the free or reduced-cost lunch program. But even with those demographics, we have an overall 90 percent graduation rate. We have a 94 percent graduation rate for African-American males. In the State of Florida, we grade our districts, and this is the second year we were considered an A school for the state.

It was very different here ten years ago. I think that education reform starts with the cosmetic part of school. Our campus looks like a suburban, well-to-do community because we keep up the premises. If any graffiti appears, it's painted over within a couple hours. This is so important because if the school looks run-down, it will have that demeanor and that feel. But when you walk into a school every day and the floors shine and the walls are clean, the kids are going to be proud of where they go to school. Success like this comes slowly: it's taken us about a decade to change the culture here.

Being a musician, I look at education as if it were a symphony orchestra. When conducting Beethoven's fifth symphony, it is not important to focus on the intricacies of an individual violin. The importance lies in ensuring that all violins, trumpets, and other instruments are doing their part in contributing to the entire welfare of the music. What is right for the flute is not what is right for the clarinet, cello, or bassoon; they all have their individual roles, but they come together in one unified sound to create a masterpiece. I don't want my students playing Beethoven's fifth symphony as good as the Chicago Symphony, or the New York Philharmonic; I want them to play it better! Being in the top 10 percent of their class is not good enough. I want them to compete for the title of valedictorian, and that competition starts on day one in my class.

It's hard to fail my class because I'm going to let you take a test as many times as you need. If you take a test once in my class and you fail it, no problem. If you take it twice and you fail, no problem. If you take that test twenty times and you fail, that's okay because the kids know that on that twenty-first time, when they finally understand the content and they pass, I'm not going to count those previous F's. Everybody learns at a different pace. So, let's find out why you're not understanding this material. The goal is to have you learn it, no matter how long it takes.

I never look at a student's limitations. I teach a diverse group of students and am charged with the task of giving them all a quality education, despite any challenges they have. In order to do so, I must constantly think outside of the box. I have three students now who are homeless and don't have anywhere to sleep at night. I've had kids who were living out of their cars, literally. Still, I believe that every kid wants to succeed. No one in this world ever initially raises their hand and says, "Hey, I want to be a failure." You just have to find out what they're good at and then show them how to achieve.

I make my curriculum come alive by choosing songs with historical accounts. When learning "Elegy for a

Young American," a song dedicated to the life and death of John F. Kennedy, it isn't enough just to play the music. The students are charged with learning about JFK's presidency and the tumultuous events of his time, like the Bay of Pigs, the Cuban Missile Crisis, and finally, his assassination. I want them to understand where the song came from and what it was about. When teaching students how to properly tune their instruments, I incorporate science and technology by explaining the properties of sound waves and how acoustics play a part in the overall sound of the ensemble.

Most inner-city schoolkids love hip-hop and don't want to study classical music. Not too long ago, I taught a lesson on Pachelbel's "Canon in D," and how there are so many songs that are all written with the exact same melody. I pulled out all of these popular songs—hip-hop, reggae, and such—and I played them over and over and over again. Then I played "Canon in D" and the kids said, "Wait, that's the same thing these rock bands are playing." I said, "Yes, it is the same, only this was written four hundred years ago."

We also have an electronic music class where we teach music business, and the kids get to write music and make music videos. One of the first lessons on how to write a song starts with reading the morning newspaper and pulling the titles from the headlines. In this way, the kids relate the music to something they know. I always try to keep it fun and exciting.

We have a motto for our band that spells the word PATRIOT: perseverance, ambition, tenacity, respect, integrity, order, and togetherness. We teach the kids that these are the keys to success in life. And they are the values that every student and every member of my organization must follow.

Everything we do in music and in the band is meant to be transferred to real life. I know that after the kids graduate from high school, 99 percent of them are never going to touch an instrument again. Maybe for some it will be a hobby, but for most it's probably going to be a faint memory of high school. However, what they will remember in college is how to persevere, with ambition, tenacity, and respect. And later on, those traits that they learned playing their instrument will help make them successful in life, and in their marriages, in their jobs, and in their communities. That's what's important.

There is no secret to success. There are great examples of urban, suburban, rich, poor, and underfunded schools that are exceeding standards regardless of the cards they are dealt. We know what works. We know what is needed from master teachers to acquire positive results. We have examples of effective schools, like Tech-Boston Academy in Dorchester, Massachusetts, or the KIPP (Knowledge is Power Program) schools in twenty states across the country, or even my school, which was one of two schools chosen to represent Broward County as finalists for the Broad Foundation prize—an award given to urban school districts that demonstrate the best overall performance and improvement in student achievement while reducing achievement gaps among poor and minority students. Miramar High is also in the top 2 percent of schools in the State of Florida for students who received career-ready industry certifications in 2012.

"No one in this world ever initially raises their hand and says, 'Hey, I want to be a failure.' You just have to find what it is they're good at and then show them how to succeed."

Education is the cornerstone of the American dream, and there is nothing more honorable and rewarding than educating the leaders of tomorrow. I believe that if every teacher meets the educational needs of their students in a safe learning environment, we will achieve academic success within all elements of instruction. By focusing on academics and discipline, ensuring a yearly 100 percent graduation rate, and counseling my students not only through high school, but also through college graduation, I have mentored everyone from MIT graduates (Massachusetts Institute of Technology) to FBI interns.

The beautiful thing is, if these kids who grew up at a 70 percent free-and-reduced-cost-lunch school go to college, become successful, and return to their community, they can begin to make a significant change. Because soon their children and grandchildren will become college graduates as well. And then a community of high-school graduates becomes a community of generations of college graduates. It might take thirty or forty years, but you can change the success of an entire community just by focusing on education. It's like that old saying, "There's nothing to it but to do it."

"It's not that I wanted to be wealthy, but I wanted to have a life worth living."

Marlo E. Diosomito

9th–12th Grade
Physics and Chemistry

Mr. Diosomito at the Cypress ISD Instructional Support Center, where he develops physics and chemistry curricula for his school district.

Marlo Diosomito's life is a lesson in humility and a testament to the power of a great education. Raised in poverty in the southern Philippines, Diosomito claimed authorship of his destiny from a very young age, eventually graduating from his country's most rigorous university and becoming an award-winning teacher of the sciences. Today, in the Title-1 classrooms of Houston's Cypress-Fairbanks Independent School District, Diosomito does for others what so many of his teachers did for him: He instills them with a love of learning and the conviction that their dreams are theirs for the taking. Says Diosomito: "I inspire my students to persevere even in the face of overwhelming adversity."

My upbringing helped me to develop the philosophy I have about education, which is that if you work hard, nothing is impossible. You can do anything in your life if you have a good education. I was born in Manila, but was sent to live with my grandparents in a small agricultural community in the southern Philippines when I was five. We lived in a grass hut without electricity or any of the conveniences of modern living. Farming was our main livelihood. Every day, my siblings and I would wake up very early to tend the farm, and were expected to come home immediately after school to feed the numerous animals we raised or water the crops we grew. Despite our daily duties, we were never late to school. We finished our morning responsibilities just in time to catch one of the few *jeepneys* (public transportation in my town). In the afternoon, we walked the several miles home.

Despite financial hardship, my family emphasized the value of education, responsibility, and character. My siblings and I completed our schoolwork by the dim light of kerosene lamps, perusing our math, science, and writing homework at night before going to bed. My mother and grandparents read to us from a collection of used books and magazines; they showed us the world outside our small town—the countries that we might visit and the things that we could only imagine owning. Though they did not go to college, they immersed us in history, music, arts, and philosophy.

After high school, I got a full scholarship to the University of the Philippines, which is the top university in the country. I was only nineteen when I graduated college which is why my students would say to me, "Mister, you are very smart." But I'd say, "No. Not really." The reason why I worked so hard to finish my education early is because of our economic situation, and I wanted so much to get out of poverty.

It is not that I wanted to be wealthy, but I wanted to have a life worth living.

While I was in college, I volunteered to teach chemistry at an inner-city public school where the students were very economically disadvantaged. The majority of my students worked either very early in the morning or after school to help support their families. Many came to school without breakfast, and only a few could afford to buy the supplies needed in class. Some came to class in worn-out slippers, clenching their tattered notebooks, which were wrapped in plastic grocery bags to protect them from the rain.

My "classroom" was an open shed with a makeshift blackboard (a two-by-three-foot piece of plywood painted green) nailed on a log post. Students brought in their own chairs or they sat on makeshift wooden benches. I bought my own chalk and eraser, improvised learning activities from available resources, and developed lessons that incorporated the value of hope in learning and education. Every day I was looking into the eyes of kids who were just like me. Realizing this, I inspired my students to work hard and persevere even in the face of adversity.

In all honesty, your class has actually inspired me to change my character in order to physically help others who are truly in need. Everyone has always told us how much education matters to become knowledgeable in the future, but you showed us ways that knowledge will help expand our life experience. No one really teaches us about the problems families confront in other countries, about the problem we have with obesity in this nation, and about all the diseases we may face in the future. Thanks to you I have started to think twice before making certain choices in my life. I have even informed my brothers, my parents, and other family members about the topics we discuss in class.

Stephanie, age 19, former student

Despite the challenging circumstances, I developed personal relationships with my students. Eventually, my semester-long assignment ended. Although I was pleased with my students' progress, I was worried about their future. When I sadly bid them good-bye, they surprised me with handmade cards and bought me a farewell gift—even though I knew for a fact they had almost nothing. That really touched me. I learned later that several of those students graduated with honors and completed college; one of them even became a community doctor.

That experience made me realize there is something about education that you cannot get in other careers. You can really make a difference if you are a teacher. You can touch hearts and change lives.

My first teaching job after graduate school was with the Houston Independent School District (Houston ISD) in 2000. I moved to Texas and was thrilled when I found out I would be teaching general science to grades six through eight at Fonville Middle School, an inner-city school that was about 95 percent Hispanic. My excitement turned to shock when I met my preadolescent students on the first day of school. I was horrified by the students' disrespect, apathy, and recklessness; the students made it very clear that they did not want to be in school. My first week was a disaster; a sense of impending failure started to overwhelm me, and I didn't know if I would be able to rise to the challenge of teaching in an educational system so drastically different from the Philippines. I remember driving home every day after school, and feeling both angry and sad. I thought, *What are these kids thinking? Why are they acting this way?*

And then I made a commitment to make a difference: I had to find new strategies and ways to interest them. I researched my students' backgrounds, made an inventory of their personal interests, and regularly incorporated current and significant events in my lessons. I also created classroom structures and routines based on mutual trust and respect. I started by getting to school very early and leaving my classroom door open. I allowed them to come in and talk if they felt like it. They would tell me about their home lives or they'd ask for advice about a crush, or sometimes we'd just talk about the movies. But in between those conversations, I would ask them questions like, "So what's your plan in life? What do you intend to do?" I was also very open with them about my life—and the reason why I do things. My students saw that I'm not just a teacher, I'm also a human being. I think that kind of honesty is one thing that's missing in a lot of classrooms.

Slowly, the students' attitudes changed; they showed more interest and they began to ask thought-provoking questions as I provided them with more exploratory and problem-based learning activities. I found that my students couldn't focus for more than fifteen minutes. So I became much more interactive in my classroom. I would go to Houston's Chinatown and buy a pig's heart or a whole fish and dissect it with the kids. When we started studying ecosystems, we went out in to the open fields surrounding the school and examined the relationships of organisms, and built a living pond for various ecology experiments.

By the end of that first year, those kids loved me and I loved those kids. I would say that they really taught me to be a good teacher. I learned so much, and they did too. I'd found a way to bring excitement to the study of science and helped my students realize the value of their education. More than 90 percent of my eighth-grade students passed the Texas Assessment of Knowledge and Skills (TAKS) science exams. Several applied and got accepted

to various Houston ISD magnet-school programs. Three of my middle-school students followed me to Booker T. Washington High School when they recruited me two years later.

I can mention numerous "proud moments" in the span of my career—from helping my students win academic and scholarship competitions to producing successful graduates, many of whom are now giving back to the community. Perhaps I am proudest of what I was able to accomplish as a chemistry teacher and science-department chair at KIPP Houston High School (KHHS). I articulated a mission and vision for the department to achieve a common goal of educating the next generation of socially responsible science-literate graduates.

I joined KHHS almost seven years ago to be part of the founding science faculty of the newly established school. Immediately, I noticed the students' disinterest in science and the teachers' lack of passion in the classroom. The previous physics, chemistry, and biology teachers taught by rote memorization and overlooked laboratory activities due to a lack of resources. The relevance of the curriculum was not clear to the faculty, students, or the administration.

I made several changes immediately in the way I taught science in my classroom. I integrated inquiry-based lab assignments into the curriculum. Through Socratic discussions based on topics that interested the students, relevant current events and scientific breakthroughs were incorporated into the lessons. The students developed their critical thinking skills rapidly. Science investigatory projects became a requirement for all chemistry students and some presented their projects at the Science and Engineering Fair in Houston. At the end of that first year, 100 percent of the junior class passed the exit-level TAKS exam, up from 81 percent.

In my second year, I introduced AP Chemistry to twelve students (18 percent of the graduating class). As AP enrollment grew rapidly, the department added an AP biology class. Both AP classes influenced the students to take more rigorous science classes. New courses such as Independent Science Research and honors science classes became available. I co-taught an amazing class called Bioengineering and World Health, which explored the intersection of government, sciences, and sociology. Students learned about the cycle of poverty and health. They did research on the relationships between the zip code they lived in and the health issues in that area. It

was very powerful. We talked about breast cancer, for example, and what populations are most affected by it, and we looked at statistics that relate to age and demographics. For my students, it was really eye-opening.

The students' expanded interest in science was evident by the number of KHHS students deciding to pursue engineering or the sciences in college. Many of these students received academic scholarships. I had one KIPP student whom I will never forget. When she was in her junior year, she would talk about how she was living with a guy. Think about that: how young she was. So she would come to me to talk. I'd listen and then I would give her my two cents. She had a lot of difficulty with AP chemistry. She almost failed. She would get so upset, she would cry, but I always encouraged her not to give up, that she could do it. And, guess what? She's now graduated from college with a degree in chemistry. I have always been a strong advocate for the importance of hard work and perseverance in the face of difficult obstacles—it's the same principle that helped me push the boundaries of what I've personally achieved.

> "I didn't know if I would be able to rise to the challenge of teaching in an educational system so drastically different from the Philippines."

I consider this pedagogical shift that took place at KHHS to be my proudest moment. Although the work is ongoing, I am hopeful that our graduates will not only make a positive change in their lives but also in the communities that they will serve.

This summer, I'm hoping to go back to the Philippines so I can offer teacher training and share some strategies on how to teach the sciences in the high school where I used to study. I'd like to do that and help them.

At the end of every school year, I know that I won't see some of the students that I have in the classroom again. So I always conclude with a conversation about making a difference and giving back to your community. I tell them how important it is to live your life to the fullest and be kind every single day to the people around you. Because it's kindness, I feel, that's missing in our society.

I might be teaching the sciences, but in the same manner, I'm also teaching values.

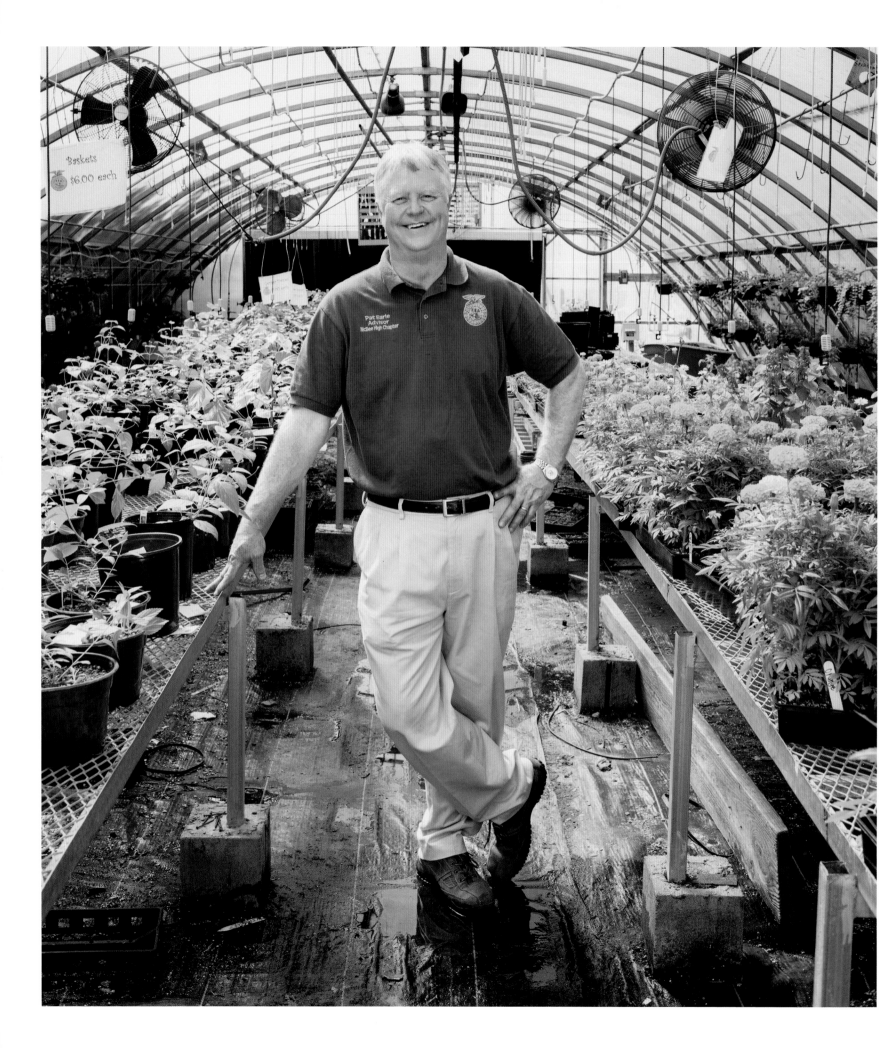

"It's not my job to make a student do anything. My job is to open a window and let them see what's out there in the world."

Walter Patrick Earle

9th–12th Grade
Agricultural Science & Education

Walter Patrick Earle has been teaching agriculture in a tiny rural farming town ("Have you ever heard of Mayberry?" he replies when asked to describe it) for more than thirty years, having taken over after his father retired from the same position. "I was the son of a career teacher, probably the one person who influenced my decision to teach more than anyone," Earle says. In fact, Earle took agriculture for four years under his father, and has carried the tradition forward by teaching both his own son and daughter when they were in high school. A 2011 National Teachers Hall of Fame inductee, Earle may teach at a small school, but his gifts in the classroom are widely recognized. With far fewer kids growing up on the family farm, Earle's mission is to make sure his students still understand what it takes to produce food and fiber. In every subject he addresses—from building irrigation systems to working with livestock—Earle's approach to teaching reflects his basic philosophy of learning and doing as a stepping-stone to service for the greater good.

Mr. Earle in his classroom greenhouse, where he teaches his students to plant seeds for the future.

I was born and raised in this little one-stoplight town of McBee, in South Carolina, population six hundred. We are a rural community and I grew up working on farms, where I developed a deep love for the field of agriculture. Today very few of the kids in my school are involved in any kind of agriculture, so my goal is to get the next generation involved in understanding where our food comes from.

Today there are about 250 students in the high school where I have been teaching agriculture for thirty-three years. I come from a long line of educators. In addition to my dad, who taught ag here for forty-one years, my son, my brother, and about eight of my aunts and uncles are teachers. Most of us lean toward teaching agriculture. Farming is part of our heritage.

My dad was the star of the family. He was always recognized in town as doing such a great job and it was kind of intimidating to try to fill his shoes when I first started teaching. I always tell the story of how this one student came to see me and asked, "How is Mr. Earle doing?" I told him I was doing fine. "No," he said, "I'm not talking about you. I am talking about the *real* Mr. Earle." Well, that kind of put me in my place.

I've had seventy-seven-year-old men tell me what an impact my dad had on them. They still remember somebody who taught them in high school! That just showed me how much influence one person can have as a teacher in a little school like ours. Here's another thing: The building where I teach is named in my dad's honor and I see his name on the door every day.

In April 2011, I was very proud and humbled to be inducted into the National Teachers Hall of Fame. I was only the second teacher from South Carolina to be so honored. I treasure that moment because my dad was able to attend the ceremony. He died four months later.

My wife teaches biology at the school and we have lunch together every day. When they were young, my kids would have their mama first period and me second period, so it was a double dose of parent teachers. It wasn't at all unusual to be the child of a teacher because 30 or 40 percent of the students were teachers' kids. At one point, sixteen faculty members (out of twenty-five) were alumni of the high school, so we were all teaching one another's children. School is a big part of our little community. Everybody knows everybody and that's what feels comfortable to me. When my wife and I go to Walmart or one of those places, it usually takes us about forty-five extra minutes just to stop and talk to everybody that we know.

"I'm almost back to the old days when we had one-room schoolhouses and the teacher was everything to the kids."

I've been very lucky as a teacher from the standpoint of getting good students. It's kind of like the story about the football coach who was such a success because he had good players. Good players make pretty good coaches. Ag is an elective at our school, but over the last twenty-five years we have seen a little more than eighty of our kids go on to graduate from Clemson University's College of Agriculture, Forestry and Life Science. That's about three or four a year. From a little school that has only forty or fifty seniors, that's a pretty good percentage. And I'm proud to say half of them are females.

I work with student teachers from Clemson and I tell them, "You can teach a long time. You can teach one year thirty times or you can teach for thirty years." To understand what I do as a teacher, you need to understand that sentence. I think every class is different, which is why I never get bored. I teach four different levels—from ninth through twelfth grades—so there's a lot of variation in my students.

As a teacher, one thing I pride myself on is that I can handle diversity. In my class I could have a student who got a 1500 on his SATs sitting next to a special-needs kid. Sometimes, my ag class allows students to be successes for the first time. I will be having lunch with the other teachers and they'll start talking about how a certain student causes so much trouble. And I'm thinking it can't be the same kid that's in my class because he is a star for me. I have one kid who is a C student in his other classes but he's one of the best in my class. He is going to take what he is learning with me and one day he will make a very good living, more money than the schoolteachers. I like to think that ag education is a pathway to career success and personal growth.

At the end of their first year in ninth-grade ag science, I ask the kids to write a paper on the value of ag education from their own point of view. One boy wrote, "It taught me to live." This helped me formulate my philosophy of teaching. It's not enough to just impart knowledge. We must recognize the concept of total student development as being necessary for young people to assume successful roles in society and enter the labor market.

Students today are different from the way they were thirty years ago. Not better or worse, just different. And we teachers have to adapt and understand the difference. We're the ones who also have to change. We have to evolve, learn new techniques, and stay abreast of technology. I'm almost sixty years old and I still take new classes to keep up.

Today in the classroom, everything is going to notebook computers, Kindles, and iPads; we are within an eyelash of not even having textbooks anymore. But I still want to impress on my students that you have to think, even with Google. I give projects. I'll give the kids a bunch of objects and tell them to build the tallest structure possible. It's always exciting to have a competition because you never know what they will make. The point is to get them to think and figure it out for themselves.

My students get to know me, not only in class, but we also do a lot of things with our FFA chapter. Each summer I take about thirty kids to leadership camp at the beach in June. That's a whole week of being with them twenty-four hours a day. That's a lot of time on buses and sitting around talking. I get to know them really well. I probably taught their parents. I know their families and how they were brought up, so that gives me insight as a teacher. I never raise my voice in class. I've probably only ever sent

> *"I tell them there's two things that you're going to get paid for: what you know or what you do, and in some cases a little bit of both."*

one person to the office for discipline. Instead, I just say, "I'll go talk to your mama." That's a lot scarier than facing the principal.

I do try and keep a small degree of separation, but I think any good teacher ends up being more than just a teacher. A few years back a young lady, who I had helped gain a scholarship, asked me to give her away at her wedding. What higher honor could there be?

Our FFA motto is "Learning to do, doing to learn. Earning to live, living to serve." That's twelve words that describe my style of teaching. We do a lot of things in class to get the students involved and out of their seats. For example, when we were studying irrigation systems, we went out into the football and baseball field and designed, installed, and implemented the whole system. We dug the trenches, wired the system, put in the pipes and determined where to put the sprinkler heads. That's what I call learning to do and doing to learn. I guarantee those students remember that project a whole lot more than they will remember anything else they heard in class.

Teaching is an art and a science but it's not just about imparting knowledge. I don't like to use the term "role model," but teaching is about showing them the correct way to do things in terms of character. I'm almost back to the old days when we had one-room schoolhouses and the teacher was everything to the kids. I have about fifty kids in my senior class and at least half of them have been together for twelve years. One morning the principal came to class to tell me that one of the students, a senior, had been killed in a car wreck on his way to school. I had to break the news to the class. So of course the lesson plan went out the window and we spent the ninety minutes talking. That's when you stop being a teacher and become just a friend.

I think some teachers take the stance that their job is to stand in front of a class and recite stuff that kids are supposed to learn. My goal is to make them want to learn and to help them figure it out themselves. I am more of a guide. It's not my job to make a student do anything. My job is to open a window and let them see what's out there in the world. My philosophy is that the purpose of education is to inspire them to achieve and get to the point where they can make a living. I tell them there's two things that you're going to get paid for: what you know or what you do, and in some cases a little bit of both.

We must develop our kids' work habits, ethics, leadership skills, and interpersonal skills. I have responded to hundreds of questions from potential employers concerning student employment, and most often, the inquiries are not about grades. Ninety percent of our education system focuses on academics; eighty-five percent of keeping a job has to do with attitude.

To be honest, teaching requires a tremendous amount of energy every minute that you are in the classroom. You've got to keep the kids connected and focused. That is a lot of work. I tell my student teachers that there are only three things you've got to remember every day. The first is, you've got to be prepared. The second is, you've got to be prepared. And the third is, you've got to be prepared. I've been doing this for thirty years and, even today, I have to have everything ready and in order, so that the kids can be focused. But it's still fun. I still walk into class smiling every day.

Rafe Esquith

5th Grade
General Studies

"I am a professional explainer, that's my job," says Rafe Esquith, who has been teaching fifth grade at Hobart Elementary in Los Angeles for twenty-eight years. The acclaimed author of *There Are No Shortcuts*, *Teach Like Your Hair's on Fire*, *Lighting Their Fires*, and *Real Talk for Real Teachers*, Esquith was honored as Disney's National Teacher of the Year, and has received Oprah Winfrey's Use Your Life Award, been made a Member of the British Empire by Queen Elizabeth, been awarded the Sondheim Award by the Kennedy Center, and is the only teacher ever to receive the National Medal of Arts. His Hobart Shakespeareans were the subject of a PBS documentary and were featured at a TED conference. Esquith has been offered incredible amounts of money, a Hollywood movie, and other enticements to leave teaching, but claims that will never happen. "I already have the best job in the world," he says.

Mr. Esquith brings Shakespeare to life in Room 56.

I was six years into my teaching career when I won the Disney Teacher of the Year Award. It was the worst year of my life. I kept reading in the papers that I was a genius and a saint and I knew it wasn't true. I was failing as a teacher. Then one day I realized, "Okay, if they're saying all these things about me, then I should make them true." Still, it wasn't until my tenth year that I began to understand what I wanted from my students and what it

should look like. Year after year, I got a little bit better at what I was doing.

In 2012, I spoke at the TED convention and I drove the publicists crazy. The session was called The Classroom, and they had nine teachers come down; they all talked about how wonderful they were. My speech lasted thirty seconds. I said, "A classroom shouldn't be about a teacher talking. It should be about the students doing." I left the stage. My kids came out and performed. They got a standing ovation.

I knew I wanted to be a teacher when I was thirteen years old. I took a job in a summer camp because I had a crush on a girl and wanted to make a few dollars to take her out. I discovered that, for some mysterious reason, kids listened to me and I had so much fun working with them. To this day I still do not understand why this happens. Up until then, the defining moment of my childhood had been the death of my father when I was nine. He was a great man who'd been called by the House Un-American Activities Committee and refused to name names. My mother raised me to serve the community, as my dad had done as a social worker. By teaching, I felt I was giving back and making the world a better place.

Room 56, my fifth grade classroom, was where at the age of nine I read Shakespeare, where I learned how to play the Stratocaster, where I could appreciate *Citizen Kane*, and where I was introduced to Crosby, Stills, Nash and Young. In Room 56, Mr. Rafe Esquith taught me to be different, to challenge the mainstream, and shaped me to be who I am today.

Joanna, 23,
former student

I was a public-school kid, which is why I'm a very devoted public-school teacher. I have a thousand visitors a year to my classroom. I recently went to China and spoke to 100,000 teachers. I'm pretty famous in America, but in China I'm called the "Confucius of the West." One of my messages to young teachers is: This is a really hard job! Teaching is not like a Hollywood movie and it can be very discouraging when you start out. I always tell them, "I fail all the time and I am good at this!"

My brilliant, amazing wife, Barbara, is the real secret to my classroom. When I was young, I could have become one of those test-scores-are-everything teachers, and it was Barbara who slapped me around and said, "Rafe, you've got to create good people. You have to help these

kids become good human beings." And when I said, "Oh man, that's much harder," she said, "Well, then your job is harder." Barbara is a very smart woman.

The greatest challenge I face is to teach my students to be honorable in a dishonorable world. I want them to be decent even though they are growing up in an environment surrounded by indecency and a media that celebrates awful behavior. I've had kids who steal and when I talk to their mom, she says, "Oh Rafe, stop it! Everybody steals!" I have to say, "Well, no, everybody doesn't steal. I don't steal."

My job is to show children that there is an alternative way to live one's life. So my approach to teaching is to be the person I want my students to be. Teaching is all about being a role model and I model my own life after Atticus Finch in *To Kill a Mockingbird*. There's a seminal scene in that book, and in the movie, when Atticus comes home and Scout is crying. He asks why and she says it's because the kids at school are harassing her and using racial epithets because her dad is defending an African American. "All the kids say you shouldn't be doing it," Scout says. "So why are you?" And Atticus answers: "For a number of reasons, but the most important one is that, if I didn't, I wouldn't be able to tell you what to do anymore."

I really take that to heart. I think the reason my students listen to me is absolute trust. It's not that I am a perfect guy, but the kids know who I am and they know that I am not leaving them.

Our main mission in my class is to be nice and to work hard. That means I have to be the nicest and hardest-working person the students have ever met. We work incredibly hard at what we do, make no mistake: We take our work very seriously. And we are really nice to one another while we work. That said, I give almost no homework. I'm an anti-homework teacher. I don't want my children sleep-deprived. You have to understand that most of my students show up here around 6:30 in the morning. They don't have to. They want to be here—and they often stay until 4 or 5 P.M. That's a long day. And, they're ten years old. But my students are really fresh because they go to bed at 8 P.M., like they should.

I mentally divide my class into three kinds of kids. Number one is the kid who wants to be in school, who likes school, and is supported at home. This kid is a gift from God. Kid number three is at the other end of the spectrum. I've had kids who say, "My uncle is a gang member and he's going to kill you and piss on your grave."

This is the nightmare kid. And then there is kid number two: the kid who thinks he is average—not the fastest runner, not the best writer. And what happens in most classrooms is that the teacher spends 95 percent of his or her time with kid number one or kid number three. Kid number one is fun and you are so thrilled that they get it. You spend time with kid number three because they are destroying your life and you are either going to get killed or kill them.

And nobody pays any attention to kid number two, but that's my favorite kid in the world. If you open a door for the kid who nobody noticed before, they will run through walls to make it happen. They are so grateful that someone noticed! These are the forgotten kids who I work really hard to help.

What sometimes shocks people about my teaching is, if I have a student who doesn't want to participate, or doesn't want to do the work, that's absolutely fine with me. It is not my job to save your soul. My job is to provide you an opportunity to save your soul.

I had a really incorrigible kid last year. He was violent. Cussed all day long. On the first day of my class, within five seconds he punched out the girl next to him. Before I even said good morning. I walked over and said, "You must be ..." and I said his name. He said, "Let me tell you something, man. You're not my f___ing teacher." And, I said, "Well, actually I am your f___ing teacher," and his eyes got really wide. And, he said, "Well, just get me the f___ out of here. I know where the principal's office is." And, I said, "You're not going to the principal's office. In my class, you're my student. But, in my class, like in society, if you're incapable of coexisting with people, I separate you. If you don't want to do the work, that's fine with me. But this young lady wants to do her work and you're preventing her from doing that."

So I sat him in the back of the room at a separate table. When it was time for recess, he started to get up, and I said, "Where are you going?" He replied, "Recess." "No. You're not going to recess because that's for people who know how to play together. You don't know how to do that." "When can I go?" he asked. "I don't know. You'll be the one who decides that." "I want to talk to you." "No, we're not going to talk. I have teaching to do."

He sat in that room for a month scowling at me while I ignored his comments and threats. After about a month he finally said, "The kids are having a lot of fun. I want to go outside." And, I said, "Well, I'll tell you what. I'm not

the one who goes out with you. So the kids will have to decide that." We called a meeting and the class really let him have it. But after that, he went on to have his best year ever of school. Having missed over fifty days of school the year before, he never missed a day in Room 56. Best of all, he is doing well in middle school. When he comes back to see me, he always stops by to say hi to our principal. He laughs at himself and says, "These days I visit because I want to and not because I have to!"

The challenge to a teacher is to make your activities so much fun and so relevant that missing the activity is a punishment. So if we're playing baseball and you tell somebody they suck, you're out of the game that day. You can play tomorrow. If we're doing a spectacular art project with hammers and you misuse your hammer, you're out.

What usually happens with the incorrigible kids in my class is that I do not change them forever. But what does happen is, they have the best year of their life, and they function. I do have incredible children, but I want to make this really clear: I do not reach them all.

"I always tell young teachers, 'I fail all the time and I am good at this!'"

Now, I'm a math guy, always have been. I knew nothing about music when I started teaching. Then in 1998 I met a student who changed my life. Her name was Joann and she was an astonishing music prodigy. At ten years old, she was a world-class pianist, but she was so humble that no one knew about her extraordinary talent. She never told anyone; she just went quietly about her business. Joann became the vision of what I wanted for all my students—to be really good at what they do and never brag about it.

She was also the one who showed me that I needed to teach music. "Rafe, right now you are thinking of the kids as guitarists or pianists," she told me. "Start thinking about them as musicians." That is when I put together a band. It took another seventeen years and I got lots of help. That's another thing that makes a good teacher—collaborating with very good people.

Every day in my class we play an hour of music. When a child plays a musical instrument they are learning much more than how to blow a horn or strum a guitar. They are learning about the responsibility of practice and about making mistakes and correcting those mistakes. They are

learning how to listen and how to focus. In a world where kids can't pay attention anymore, music is a great focuser.

I have three great loves in the world: baseball, rock 'n' roll, and Shakespeare. None of these are in the California curriculum, but they are all part of my classroom. I do everything the school requires of me but I supplement that with my passions. Listen, I don't expect anyone to duplicate what I do because I am a lunatic, but I think teachers get so busy with the system—teaching that chapter or this book—that they lose themselves. I tell them to share their passions with their kids. If you love to garden, then take the kids with you to plant flowers. This is what keeps the fires burning. I think that what young teachers learn from me is to be yourself. Don't forget who you are. All successful teachers bring themselves into the classroom.

> *"I have three great loves in the world: baseball, rock 'n' roll, and Shakespeare. None of these are in the California curriculum, but they are all part of my classroom."*

I'm a tough guy but the system can crush you, if you let it. I have a patron, the son of Katharine Graham of the *Washington Post,* and he once spent sixty hours with me—going to every meeting and watching every encounter I had in school. At the end of the week he said, "Rafe, I now know your greatest accomplishment. It's not that you're the world's best teacher, although you probably are. It's that in thirty years of teaching, you haven't killed anyone yet." He asked, "How do you walk around this nuthouse with these ridiculous rules, in a classroom that leaks, in a school that's falling apart, and deal with these very unpleasant people? How do you do it?" I told him, "Well, my students are watching me and this is how I would want them to act." It's really that simple.

I teach life skills in my classroom. Most of our time is spent talking about who you are as a human being, what you stand for. For example, in my classroom, we don't read any of the Basal State Readers. I made a list of all the books that have been banned, and those are the ones we read. All of our reading deals with moral dilemmas and young people—Huckleberry Finn, Malcolm X, or Holden Caulfield—who have to make decisions about who they are.

Standardized tests will ask how many chambers there are in the human heart. And that's good because it's important to know there are four chambers. But the students in Room 56 also know how to take care of the heart, how to eat to keep your heart healthy, and how to run several miles every day so that you live a long, fruitful life. The reason why my students are successful is because I'm thinking long-term.

At the end of the year, I am not concerned with the standardized test. Tests don't measure what's really important. I always tell people I'm sure Bernie Madoff did very well on his tests. The real assessment is to see where the students are ten years from now. Only 32 percent of the kids at Hobart Elementary School finish high school. My Hobart Shakespeareans finish college.

I don't have a desk in my classroom. My students are very independent of me and we are best known for our productions of Shakespeare. Although I teach all subjects all day long, after school about fifty to seventy students get together and spend a year—no exaggeration—about 50,000 hours of collected work, to put on an unabridged production of Shakespeare. (This year it is *The Tempest*.) This is not about acting; here the kids are learning how to speak in front of other people, how to work as a team, take chances, sometimes fail and then correct their mistakes. The focus of the class is not about the show; we care about the thousands of rehearsals leading up to the show. The Royal Shakespeare Company has flown in from England to see us.

The kids are never nervous when they perform because they are so well-rehearsed. We do our shows in T-shirts and jeans and we perform in our classroom even though we've been offered places like Carnegie Hall and Broadway. Why would that help the kids learn the language any better? Sir Ian McKellen, who is a big supporter of this class and a huge influence on me, said, "Don't worry about building a set. That doesn't help your children. If you keep things in your classroom, on a bare stage, then the language becomes the star."

These are lessons that stay with my kids. I can't tell you how many high-school teachers have called me and said, "Rafe, we can spot one of your kids before they even open their mouth." They say they can tell my kids by the way they carry and conduct themselves. They're super-focused and organized. This is more important to me than their test scores. These are life skills that carry through to adulthood.

For example, Rudy was a young man in my class

who came from a very difficult home situation. (About 92 percent of my kids are from families living below the poverty level.) Rudy's family problems blocked practically all roads to success before he started his journey. He was living in three different places a week, being passed around among various relatives. He was disorganized and messy, but given his domestic situation it would've been a biblical miracle if he came to school prepared each day. Our classroom, and not his home, was the only place where Rudy would have a fighting chance to change the course of his life.

Consequently, in fifth grade, Rudy was asked every day about what books said to *him*. Rather than simply go home and complete reading tasks centered on skimming the surface of language, Rudy spent every day of fifth grade reading with a teacher who constantly reminded him why he was doing this. When we read *Lord of the Flies* together, Rudy was not asked on an exam to name the boys on the island, or describe the relationship between Jack and Ralph. These are of course important points. But Rudy spent most of our discussions putting himself on the island, and eventually seeing his own school as the island. He was encouraged to recognize the parallels of William Golding's masterpiece with his own life.

George Orwell's *Animal Farm* was more than a brilliant satire of Russian history and of corruption in power. Rudy discovered his own Snowballs and Napoleons, and took delight at comparing the school system itself with Orwell's commentary on our times. Students in the class laughed hysterically when they cleverly created a parallel chart not comparing the animals to Russian leaders but to everyone they knew at school.

Many years later, Rudy attended New York University, and although he had a scholarship, I heard from several of his peers that he was working odd jobs to make ends meet. As so many teachers do, I dipped into my pocket and wrote my former student a check. I mailed it with a letter saying I hoped to have dinner with him soon as I was invited to give a speech to teachers in New York City.

Rudy returned the money and wrote:

I cannot ask you to give of yourself like that. As I said, I CAN do it on my own. I just need to work a little harder and cut down on my expenses. I would feel terrible knowing that energy that could be devoted to getting a kid started on the path YOU got me on would be wasted on me, when I can manage just fine. I appreciate your willingness to help me. It reminds me (as if I could ever forget) that you are one of the greatest people I have ever had the honor to meet. But I'd much rather the money you are offering me go to the class so that one day maybe some other kid will be in a position like mine.

And while I'm on that subject I just have to tell you, I tell our story to anyone who will listen. Rafe, I honestly believe I would be dead right now if it wasn't for you. I was headed down a dark path, where drug dealing didn't seem so bad and the acceptance of a gang was looking like the only way to be accepted. You SAVED me from that and now I am at a top university, studying an art that I would never have tried had you not cast me in a play. You showed me a better life, a better way to live. When I tell people about the class and you, I have found myself comparing what you did for me to Plato's Allegory of the Cave. I knew only pain and disappointment and thought that was the way of the world until I met you. I thank God that I did and had you in my life. I don't tell you this enough. I don't think I ever can. And please don't say I give you too much credit. Yes, I have worked hard and sacrificed and gone through a lot, but I loved every second of it, and you gave it all to me. You are the BEST! I can't wait to see you in New York City.

First of all, I had to look up Plato's Allegory of the Cave to make sure I understood what this boy was expressing. But after laughing at my own ignorance, I realized that this young man was a reader for all the right reasons. He did not read to complete an assignment or take an exam, but to take the wisdom off the page and apply it to his own life.

"I made a list of all the books that have been banned, and those are the ones we read."

"During the 5th grade, when I walked into Room 56, everything changed," wrote another former student, who now attends the University of Notre Dame. "The world outside stopped existing and disappeared. No matter what was happening anywhere in the world, all my problems could be fixed in this safe haven, and I constantly retreated to it when I had family troubles. And even today, when I am looking for a place where there is only love and joy, where anger and hatred do not exist, I still retreat to Room 56."

All I can add is that this can be the result when we teachers make sure our kids see the relevance of what they are doing.

"I saw that when a child senses how truly valuable his or her input is, then they can really shine."

Michelle Evans

6th Grade
General Studies

When the local economy took a turn for the worse in Michelle Evans' small town in Utah, Evans witnessed the heartbreak of her students' families as they lost their homes, their jobs, and their sense of pride. Determined to help her sixth graders learn basic financial-planning skills so that they would never face the same fate as their parents, Evans invented and implemented a virtual economy in her classroom that mimics that of the real world. As members of this simulated community, students have bank accounts and jobs, receive salaries, pay rent, and are responsible for their money management. The lessons being taught go far beyond an understanding of fiscal accountability; within the safety of Evans' classroom, these young adults of tomorrow are learning to become civic-minded, conscientious, and empathetic citizens.

Mrs. Evans demonstrates the equation "distance = rate x time" with the help of a student volunteer.

I can cook zucchini into everything from casseroles to cakes, used to sew everything from my husband's suits to my son's underwear, still sing opera, and love to hike, write, read, talk on the phone, multitask, and exercise. I've always been good at a lot of things, but it wasn't until my husband's health took a frightening turn, requiring I go to work outside the home, that I chose a career for myself.

At the time, I had been volunteering at my children's school, helping out in the classrooms. Every time, a sticky hand would reach towards me, and imploring eyes would lock onto mine: "Are you gonna be my teacher today?" Affirmative. "Yay! I love you!" Pretty soon I was hooked! I went back to school to get my certification, and was

given an internship to teach fifth grade before I even had my license. The following year I was hired to teach sixth grade. Twenty-six years later, their "hormonal minds" are still my favorite!

My first big "Aha!" moment as a teacher came when my students and I built a ninety-foot blue whale on the playground out of Visqueen and PVC pipe. First of all, it was a blast—we all had so much fun working together. But it wasn't just about doing something creative and hands-on, it was also a way of integrating a great deal of learning. The whale satisfied every state core objective with regard to measurement, including radius, diameter, and circumference of circles. It also satisfied many core objectives in language arts because of all of the writing we did. A unit in our basal reader was devoted to whales and undersea creatures. This made the subject come to life for our landlocked Utahns. The students researched everything, prepared everything, helped build everything to scale, and loved every minute of it. Moreover, they learned how to learn, to present as an authority on their subject matter; finally, they wrote about it all in their journals. Eventually we tore down the whale and used what we could the next year to build an undersea world. Black lights made the "whalebones" look as if they were resting on the bottom of the florescent depths of the ocean. Terrifyingly cool. The third year we built a replica of the *Mayflower* so that we could see just what our Pilgrim forefathers endured during the voyage here.

"The econoME community is an opportunity for the kids to experience all kinds of financial situations."

What all these projects gave the kids was a real purpose. They felt that what they learned was important, and that they could disseminate that information to others. I think that was the eye-opener for me. I saw that when a child senses how truly valuable his or her input is, then they can really shine. That notion is really what's at the heart of the classroom-management program I've developed called econoME, which is essentially a virtual economic community that all my students belong to.

In my econoME classroom, every student has a specific job. I offer them myriad employment opportunities that assist in running our classroom and the school in general, including mayor or council members for leadership, veterinarians for my class pets, cyber news journalists for publications, display managers for decorating the room, information techs for any electronics assistance, custodians, messengers, tutors, file clerks, librarians, store managers, hall monitors, and bankers. Each student becomes an integral, functioning member set on a journey throughout the year to discover how an education applies to their own interests and abilities.

We have a class currency called *ebucks*, and each student is responsible for managing their finances. They can keep their ebucks in the bank, which is overseen by our bankers. In order to earn ebucks and keep their jobs, students must maintain their grades, complete their homework assignments, and demonstrate good classroom behavior. The econoME community is an opportunity for the kids to experience all kinds of financial situations. One of the rules of our society is that no one can be homeless. All students must pay weekly rent with their ebucks. Anyone who does not or cannot needs to work during recess to pay their debt.

On the first day of school we bring the kids all together and say, "Okay guys, this is how it works. Here's the econoME store. It will be open in about a week and a half after we have hired our store managers and bankers—they will run the store, stock it, mark the prices, sell goods to you, and keep track of the money." The store will have anything from a used waffle iron to somebody's old necklaces. Families, students and teachers all contribute items. My husband donated his fishing gear so he could upgrade. Another popular item is beef jerky. We want the kids to explore the differences between needs and wants, and to be tempted by things. The store is a great way to do that.

Then we hold elections. Each sixth-grade classroom elects a mayor and two council members, a marshal, and a clerk. They will be in charge of our weekly meetings. If you have a beef, if you're upset about something, that's the forum to discuss it. The elected officials also work with the teacher to help fill all the job positions. So they do all the hiring. They also plan the All Done Have Fun parties. Once a month we'll check all the student progress reports, and if everyone's up to date on homework, then they can have a forty-five-minute party. They take the planning very seriously. They're so meticulous and excited about having the power to control their futures.

Only the kids with the best grades and citizenship are eligible to run for election. And they can lose their

positions if they don't maintain their work. Once I had this darling kid. Just one of those children whose mother must've kissed him every day, and deservedly so—the sweetest face, cute hair, really outgoing. He hadn't done one lick of homework since he was in the third grade. He was so charismatic that he'd just charmed the pants off his teachers all the way through. He was elected as the first council person—just one vote away from being mayor. He was thrilled with his position and got up in class to lead, being the outgoing dynamic child that he was. But he didn't turn any work in that first week. So, I called him over to my desk and I said, "You know you can't be a council person unless you're getting your homework done and being a good student." He said, "Oh, I never do any homework. I just take the tests." I said, "Well, that doesn't fly here." "Oh, Mrs. Evans"—he smiled—"it will all work out." "No," I replied, "let me tell you how it will work out. I'm going to put you on probation today. And in one week, if you haven't caught up and stay caught up, then you will lose your position." He flashed those pearly whites at me and didn't change a thing. The following week I called him to my desk again, and I said, "I need to let you know that you're fired." It about blew him away. "You're firing me?" "Yes, I'm firing you." "Is there no hope for me?" "Well, not this term, no. But if you get your work in you can run again next semester."

Well, he was a success story, because that kid, from that day on, did every bit of his homework. He ran again second term and this time he carried his weight as a student and he won a leadership position. But he also started a little club for kids who weren't getting their homework done. He told them, "I want you guys to learn from my mistakes and do your assignments. If you don't know how to do it, then you come and see me and I will help you." He's in high school now, but he came back last year when he was still in junior high and gave me a big hug and said, "Thanks for what you did for me." And I thought, "I didn't do a thing except fire you."

Every year econoME students face a mock catastrophe—which I call Disaster Day. It teaches the kids to bond as a community under horrendous circumstances and figure out what they can do to help each other. Disaster Day is always a surprise; it happens out of the blue. The students come back from an assembly or short break to find emergency lights flashing in the classroom, sirens blaring, and a dozen of our thirty-five chairs and desks taped off with yellow caution tape. The room is a mess.

Paper is strewn everywhere. Some desks are overturned. (I have done all of this while they were out.) The students are stunned. They react with confusion and outcry. Then I take the microphone and say, "Everyone, there has been a disaster! Those students whose desks are taped off have lost their homes! If you have any ebucks on your person, at home, in your desk, or anywhere except the econoME bank, then you have lost it all! It will cost fifteen hundred ebucks per desk and chair to get you back into your home! If you have econoME insurance (a weekly payment as well) you will only need to pay the two-hundred-ebucks deductible. Those who are homeless must be back in their homes within ten minutes or cholera will set in! If this happens, all of you may perish! Mayor and council members, organize yourselves and take care of this! The clock starts ticking now!"

> *"We want the kids to explore the differences between needs and wants, and to be tempted by things."*

It is always an interesting exercise, resulting in many lessons for the kids. I remember one time when a particular group of students responded to the "emergency" with such sincerity and compassion that everyone in the room was choking with emotion when it was over. After I'd made my announcement, the mayor took charge immediately. He called the class to order. He and the council quickly assessed how much money was needed, and whether or not people had enough to restore their homes. They called upon class members to contribute. One by one, each homeless student was able to sit down. Tearfully, students gave of their savings and earnings. When it came down to the last few, a popular kid who had already been saved gave his money to rescue a classmate who had few friends and needed help. The class rallied behind the final homeless students, giving their last ebucks with seconds to spare.

Then we sat together and talked. "How did you feel when you realized that there had been a disaster? How did you feel when you realized that you were spared? How did it feel to help every single person?" With a gush of emotion, the students proclaimed that they had never felt so good in all their lives. We shared our thoughts for half an hour. One proud teacher went home that day knowing that the world is in good hands.

> *"Of all the books and professional journals I've read, of all the conversations I've had and workshops I've attended, it is still behind the closed doors of my classroom where I have learned the most about being a teacher."*

Jo-Ann Fox

4th Grade
General Studies

Ms. Fox in her "flipped learning" classroom.

While the rest of us spend our Sunday nights relaxing in front of the television or curling up with a good novel, Jo-Ann Fox is probably tweeting. Sunday evenings are when she and fellow teachers from all over the state gather on Twitter for their weekly chat group—#CAedchat—to share their thoughts, innovations, and ideas on a variety of educational issues. Which is to say, Fox is doing exactly what she loves most about teaching: learning. One of only fifty applicants worldwide to be accepted into the Google Teacher Academy, Fox actively seeks out opportunities for continued professional development, particularly when it comes to the integration of technology in education. From video math lessons to one-to-one digital devices, Fox's fourth-grade classroom has become a model for the positive impact of hi-tech tools on student comprehension. But Fox's sights are set far beyond her own four walls. Whether it takes joining California's Education Technology Task Force or offering new-media training to other teachers, Fox won't rest until every public school in the state has the same resources she has.

I come from a long line of teachers and administrators—going back generations—so I truly can't complain; I knew what I was getting myself into! Perhaps it was the influence of my mother or grandfather, but I have always known that teaching was the career path of my future. For me it was just a question of, "A teacher of what?" It wasn't until college, when I volunteered at an elementary school for a class requirement, that I fell in love with the primary grades. I embraced the curiosity and innocence of the younger students and I immediately felt right at home in their company.

I believe great teachers are born to teach. I can already pick out the students in my class who would be phenomenal teachers. And it's not always the smartest kid in the room; in fact it's usually the kid who has to work a little harder.

When I was growing up, school didn't come easily to me. I spent my whole childhood comparing myself to classmates, especially the ones who would learn things the very first time they were taught. It seemed so simple for them. It always baffled me, because I'd hear something once and I'd think, *Yeah...I don't understand it yet. I need to go over that again.* My experiences as the kid who repeatedly had to be coached through problems actually made me into a teacher who knows how to effectively reach her students.

I taught second grade for a decade. Then, last year, I asked my principal to surprise me with a new grade level. I wanted to keep myself fresh and challenged, and felt a different age group would add a welcome spark to my teaching career. It sure did! Little did I know I would fall in love with my fourth graders.

The biggest surprise was how difficult a time both my students and I had with the math curriculum. My students were failing the math quizzes, and I was running out of time to fully teach a skill before I had to move on to the next. I was beginning to feel like I was leaving students behind. I was not at all okay with this.

After a month of frustration, I decided it was time to make a change. That weekend I got busy creating videos of the coming week's lessons. I used my iPad to screencast what I would normally teach in class. And this is what I said to my class the next day: "So how does everyone feel about math so far in fourth grade?" This was followed by one loud moan and one or two cheers. Well, the few cheers were nice, but this is not what I wanted to hear from a group of bright-eyed nine-year-olds. So then I asked, "Why are there so many moans?" They answered with: It is too hard; math moves too fast; my mom can't help me with homework, etc.

> ## *"It's not that I consciously try to plan a lesson that has technology in it. It's just that it's woven in. It's almost invisible."*

Next I asked, "How would you feel if I came home with you and helped with your math homework? Do you think you might do better if I started doing this?" At this the class broke out it cheers. They all offered to have me over for dinner. Until one savvy student raised her hand and said, "You can't possibly come home to all of our houses." To which I replied, "Yes, I can!" I explained that no longer would I be sending them home with worksheets and lecturing during class. Instead, they would be watching my instructional videos at home and coming to school ready to ask questions, practice the new skill, and make real-world applications.

This style of teaching is called "flipped learning," and my students absolutely love it. I knew I had something that worked when my students started passing the math quizzes.

Since my first job as a teacher, I've watched my students' needs change, and my goals have changed alongside them. My current objective is to better meet the needs of my twenty-first-century learners. Technology has changed my teaching and directly affected my students' learning. It's not that I consciously try to plan a lesson that has technology in it. It's just that it's woven in. It's almost invisible.

The skills my students need for their future require them to be effective communicators, have organization and management skills, use inquiry and research to answer questions, and be able to collaborate with others, as well as self-assess and reflect about their own learning. Project-based learning provides the setting for these skills to be utilized while teaching content standards at the same time. Technology has provided the platform for my students to access these much-needed relevant skills. It's almost like it is as important as our pencil and our eraser, and our books.

My classroom has been transformed ever since I began using one-to-one iPods—which just means that every student in my class has been provided with their own iPod touch. My students literally have an infinite amount of information right at their fingertips and access to apps that allow them to communicate their learning in ways I never thought possible. However, many people think technology is just a distraction in the classroom and that students should not be "playing" with these devices. Well, if anyone walked into my classroom and said that my students were just playing, you would hear a chorus of my students saying, "We aren't playing, we are learning!" And they would be the first ones to prove it.

Kids come knowing how to use these devices. I don't have to teach them how to use the iPod; I just have to teach them how to use it as a learning and creating tool. Now, when they're reading a book and come across something that they have never heard of—they have that iPod at their desk. So they can quickly Google it and learn about it. For example, right now we're reading *Patty Reed's Doll*, which is the story of the Donner Party. We're reading about all these places that they traveled when they left their homes. "What is Chimney Rock? Let's look up 'Chimney Rock.'" So right away they find this visual reference of what's actually being described in the text. That's something that we never had as kids, and it's definitely a game changer.

Our school system today has really changed very little since the nineteenth century, while the world around us changes at an increasing rate. However, many of our classrooms today do not reflect the pace of technology or the shifting student population we have entering our classrooms. Our students were born into a world where

communication is rapid, access to information is unlimited, and devices fit into the palms of their hands. Technology for them is natural. In fact, it has been said, that technology is only called technology if it was invented after you were born. Students today don't even consider something like an iPad to be anything extraordinary; to them it is just exists. Technology is just a normal part of their lives.

Beyond being a phenomenal teacher for my students, I really want to help other teachers in the area of improving their use of technology in the classroom. And I want to be able to provide that professional development in a way that's done respectfully—that's basically modeled after how we teach our students. We approach our students knowing that every child comes with a different skill set, from a different background, with different fears, possessing different talents. When we approach professional development for teachers, we have to take into account that there are some people who are honestly fearful of technology. We have to figure out ways to help teachers to become comfortable and understand that it's okay to take baby steps—to start at the very basic level of technology integration.

We've all experienced that person who knows how to use a computer better than we do, leaning over us and saying, "Just hit that button!" And you feel like the smallest, most insignificant being at that moment. I don't want to approach other teachers like that. I want to approach them in a way that I would a student. I would never belittle a student, or an adult who wants to learn something new. So we have to find ways to effectively help these teachers, because it is going to be the future.

Believe it or not, Twitter has made me a better teacher. I know that sounds crazy, but it is true. Many people have no idea how many educators are on Twitter every moment of the day. It's a global network. I'm collaborating with teachers in Australia, New Zealand, Canada, and England—across the world. And we aren't there to share the weather or what we ate for dinner. We all have one goal in mind, to collaborate and share our thoughts about the best teaching practices. Twitter is where I first learned about flipped learning, for instance. I currently follow more than two thousand educators and I proudly call all of them my PLN (professional learning network). My PLN inspires me on a daily basis, and I have this amazing web of peers I can go to if I need advice or an answer to almost any question.

I believe in surrounding myself with those kinds of people who will stay up till all hours of the night talking with other educators, just to be inspired and motivated. And I truly believe, from my experiences in the school and the district where I work, and with the people I collaborate with in my community and around the world on Twitter, that there's more hope in education than the media wants to portray. There are more quality, innovative educators out there than people realize.

Of all the books and professional journals I've read, of all the conversations I've had and workshops I've attended, it is still behind the closed doors of my classroom where I have learned the most about being a teacher. It is the thirty-one sets of eyes, each different and unique, each a puzzle of cultural capacities, which have taught me to be the kind of teacher I am today. I have worked in school settings where students come to school hungry and their only two meals of the day are

"Believe it or not, Twitter has made me a better teacher. I know that sounds crazy, but it is true."

those that are given to them in the school cafeteria. And I have worked in a school where children have every door of opportunity open to them. I have worked with a plethora of students who have immigrated to the United States and found themselves not only trying to learn to read, but trying to learn to read in an entirely new language. Each setting has provided me a set of circumstances that led me to strongly believe that all children need to be taught at their level and it is my job to meet each child's needs in a way that best fits their learning style through differentiation.

As an educator in the public school system, I am responsible for inspiring kids to develop a love for learning, above all obstacles in their lives. I can't tell you how many times I have gone home and cried my eyes out over some of the things that my students have to go through. They come to school every single day, despite what has happened in the morning to them, despite where they slept last night, and they come into class with a smile, excited to learn. I love these kids. And they need caring adults who are wholly dedicated to their well-being. And my classroom is quite often their only safe place.

"I teach in the hopes of making the world a better place."

Jason Fulmer

Kindergarten–12th Grade
Teacher Leader and Program Director

At the tender age of twenty-five, after only three years in the classroom, Jason Fulmer was named Redcliffe Elementary's Teacher of the Year; the following year, he was the youngest teacher in South Carolina history to be honored as the state's Teacher of the Year (and went on to become one of the four finalists for National Teacher of the Year). From a childhood spent playing teacher to joining a Teacher Cadet program in high school, Fulmer doggedly followed his calling to become an educator. "Aristotle once said that where the needs of the world and your talents cross, there lies your vocation," Fulmer says, and then adds, "Teaching is my passion, my challenge, and my joy." Like a proud father, Fulmer has remained connected to all his former students, even attending every one of their high-school graduations. "I want them to know that once they were in my classroom, they will always be my students."

Mr. Fulmer with alumni of his third-grade class at Redcliffe Elementary.

F ew things in the world are more powerful than a positive push, whether it be in the form of a smile, an optimistic word, or a helpful "You can do it!" when situations are tough. Thinking positively and enthusiastically about people and their potential comes naturally for me because my parents, my first teachers, believed in me. One of my favorite stories as a young boy was *The Little Engine That Could*. My mom read the book to me so often that "I think I can" became a part of my daily vocabulary, fueling my desire and commitment to reach for my dreams.

My first "students" were Mickey and Snoopy. I taught

them the alphabet with my child-size chalkboard. Eventually, my sister and the neighborhood kids picked me to be the teacher in our imaginary school in the living room. Being a teacher was always my dream role to play. I was fortunate because throughout my schooling, teachers made my education interesting and fostered in me a love of learning and the value of community.

I can name every single one of my teachers. Many of them taught me not only mere facts, but also life lessons that stick with me today. My third-grade teacher, Mrs. Watson, believed in me and pushed me to never settle for second best.

One day in class, Mrs. Watson said that she wanted to introduce us to a special teacher from New Hampshire: Christa McAuliffe. I was intrigued by the idea that a teacher was going to space. We watched the launch of *Challenger* on January 28, 1986, with eager anticipation, clapping and cheering at liftoff. As third graders, we didn't understand at first what happened, until our teacher, with tears rolling down her face, explained it to us. Mrs. Watson said that teachers are heroes, and that day Mrs. McAuliffe became my hero. I'll never forget that moment.

"Teachers, I believe, are in the dream-developing business."

My seventh-grade teacher, Ms. Toepke, helped me overcome my fear of math. She also taught my sister and, every year, has lunch with my family during the Christmas holidays. My high-school English teacher, Mrs. Armstrong, was a role model, showing me what it takes to become a quality educator. My high-school math teacher, Mrs. Suggs, made each student feel important, operating from the notion that we must "reach them before we can ever teach them." As I grew up, I realized I wanted to be able to help kids the way that each of these teachers reached out to me. Teachers, I believe, are in the dream-developing business.

In college, I was certainly in the minority as a male elementary-school major at the University of South Carolina Aiken. Some people couldn't understand why I chose education and cautioned against my career path. "It will be hard to support a family," many advised. "There are not many men in elementary schools; you can make more money with another career and then you can volunteer to teach." I wondered how many other guys before me were discouraged from becoming teachers. Determined, I continued to pursue what felt like my calling in life. My family supported me and when I faced obstacles, gently reminded me of the little engine that continued to strive.

In the weeks before my first day of teaching third grade, my principal, Dr. Pope, told me I would be assigned one of the mobile trailers that the school was using because they were in the process of expanding. My unit was #15, the farthest from the school. When I looked at it, I knew I had to create an environment that would make the students excited about coming to school every day. My favorite place to be, other than my home, is the beach community where my family vacations every summer, so I decided to transform the mobile unit into a beach house. Friends helped me paint it a calming blue color. I got some beach chairs and hung fishnets from the windows. It was like an "extreme trailer makeover" but well worth it, because the kids were thrilled when they arrived. One of them said, "Mr. Fulmer, this place looks just like Red Lobster, I'm going to love it!" Like everything else in life, small things make a difference. Highly inviting and cozy classrooms encourage kids to learn and keep them coming back every day for more.

I strive to make connections with my students and their parents or guardians from the moment I get my class roster, as this sets the stage for the entire year. For example, I would send postcards to the families over the summer to introduce myself and tell a bit about third-grade life. At pre-open house, I'd have a science fair board with a picture of me in third grade on it so the kids could see that I was just like them.

When I went into teaching, I set up a pen-pal program between the kids in my class and students from USC Aiken. I had a pen pal in grade school and we communicated for many years, until he was tragically killed in a car accident. I know what a powerful tool letter writing can be and I wanted my kids to have that experience. Also, I wanted them to see that they, too, could go to college one day.

No child, no group of students, and no day is ever exactly the same. I must tap considerable resources of energy and creativity to bring information to students at their level and really engage them. I function as a tour guide of sorts, encouraging my students to further their knowledge. I believe we must customize learning experiences and differentiate instruction to meet the diverse

needs of children. If you visited my third-grade classroom you might wonder, "What do TV commercials, beach balls, and dancing the shag have to do with my educational philosophy?" Well, it's been my experience that creative lessons and strategies help students increase their mastery of skills. I will try whatever it takes to engage my students. Tossing a beach ball with literature questions printed on it engages my students to participate in the discussion of a story we are studying. History comes to life when I teach my students about the rich culture of South Carolina and teach them our state dance, the shag.

As for TV's influence, let me explain how instrumental a jingle or sitcom theme song can be. In my first year of teaching third grade, I was working with my kids on rounding numbers to the nearest ten. They were pretty good at it, but one of our standards asked them to round on the number line and they just weren't getting it. One night I was up late working on a lesson plan and *The Jeffersons* came on TV. I was singing the theme song when it hit me. If the Jeffersons could "move on up" to the East Side, then my class was going to "move on up" the number line. So I went back in the next day and tried that jingle on the kids. They really got into it and started moving on up the number line. They began to understand it because we were taking the concept and applying it while moving our bodies. I'm a big fan of body mapping. What you learn with your body you never forget, because you take it with you everywhere you go. Pretty soon I had kids asking if we could use their favorite songs. Once we were learning about geometry and Kayla said her mom's favorite song was "Stop! In the Name of Love," by the Supremes. So that became "Stop! I'm an Octagon—I have eight sides and eight angles, think it over."

Teamwork, student ownership, and collaborative efforts at work are the foundations of my teaching philosophy. Some days we make giant leaps, while other days we make small footsteps toward our goal. I must help students take their first step, and then inspire them as they continue on their own pathways to success. Sidney Hook once said, "Everyone who remembers his own education remembers teachers, not methods and techniques." Raising a score on a standardized test does not mean we have created a learner, a collaborator, a difference maker, or a volunteer. Tiny victories are often overlooked, but not in my eyes. I always choose to celebrate successes. Seeing the joy on students' faces when they are learning and watching them grow and make wise choices is very rewarding.

I tell my students that once they are my kids, they are *always* my kids. I'm proud of all that they've accomplished. What's so amazing is to know those footprints we established long ago are the foundation for where they're headed as they make their mark in the world.

In my current role I'm serving as Program Director for Mentoring and Teacher Leadership at CERRA, which is South Carolina's Center for Educator Recruitment, Retention, and Advancement. I'm passionate about mentoring. We lose so many outstanding teachers during the first five years of teaching—the data is alarming, across the nation. We know that impact has huge ramifications, not only for the system, but also ultimately for kids, because all that turnover in the profession has huge costs for our students. We do a lot of great things around this country, recruiting top-notch people to the profession, but we have to meet them when they arrive and make greater efforts to retain and support them once they get there. I think that is the missing link. We must embrace research-based, structured support systems that provide mentors with the tools, strategies, and resources they need to deliver quality support. For many years the focus of much educational discussion has been on recruitment with too little being focused on keeping, training, and supporting the teachers we have. CERRA's goal is to assist in building accomplished teachers who can help students succeed and to accelerate new-teacher development. Providing time for educators to engage in professional dialogue about their craft and building learning communities for students and teachers will improve the quality of every school.

> ## "I tell my students that once they are my kids, they are **always** my kids."

My experiences as a student and as a teacher have brought new opportunities for me to grow, reach, and stretch. I teach in the hopes of making the world a better place. There are still worlds to change, lives to touch, and powerful work to be done. There will always be those out there who can provide all the reasons why we shouldn't, won't, or can't. That's why we cherish those rare individuals who remind us why we should, why we will, why we can! That's our job as educators and I am proud to serve among those who reach out and make a difference every day.

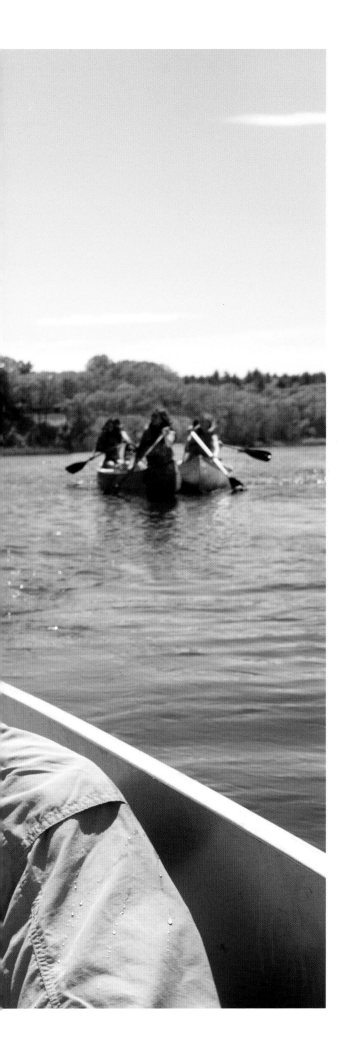

"It is critical to break down barriers among disciplines and between the classroom and the world that exists outside."

Michael Goodwin

11th–12th Grade
English

Michael Goodwin grew up surrounded by books and ideas. Considering that his parents were both writers—his mother is the Pulitzer Prize–winning historian Doris Kearns Goodwin and his father, Richard N. Goodwin, is a former presidential speechwriter and a successful journalist, author, and playwright—it seems natural that he gravitated toward a life that embraces the import of critical thinking, the value of public service, and the power of literacy. "I recognized that providing equal educational opportunity is perhaps the most important task of our time," explains Goodwin about his decision to become a teacher. Goodwin first launched his experimental interdisciplinary program, Rivers and Revolutions, in 2010, as a two-week tuition-free summer intensive for secondary-school students. It has since grown into a semester-long accredited "school within a school" that offers blind admission to interested juniors and seniors at Concord-Carlisle, where Goodwin himself went to high school, and where he has taught since 2008. The pioneering program's main mission is to provide students with a meaningful context that unifies the various strands of study in a traditional curriculum.

Mr. Goodwin and his students canoe along the Sudbury River to Fairhaven Bay—a favorite spot of Thoreau's.

Ever since I was a teenager I have wanted to be involved with education. When I went home after my first day of high school, I envisioned coming back years later, clutching a grade ledger and an attendance book. Ironically, I did just that.

I wanted to teach high-school students because they are at a very hinge-like moment of transition. You're capturing them at such a critical time. And there's a piece of me that's very academic so I really love reading complicated texts and talking about big, meaty ideas. The capacity of older students to engage in that work is great, but it is still hard to reach everyone no matter how enthusiastic I can be. If I get up and teach about the events that led up to the American Revolution, and I reenact the ride of Revere, Dawes, and Prescott to warn that the British are coming, no matter how exciting I make it—and I can really ham it up—not every kid is going to connect to the historical narrative. However, if I bring in *The Midnight Ride of Paul Revere* by Grant Wood—this really odd and bizarre painting made during the Great Depression—all of a sudden I've captured, perhaps, those two or three kids who needed that visual. I've found that the more I bring art, music, and science into what I am teaching, the higher the level of engagement. It's all about creating a greater number of access points.

"Really good education is all about risk-taking and about making a mess; learning is chaotic, right?"

There are very few schools that purposefully try to create lines and connections between different fields. The way most high schools are set up, you're in history class, and then the bell rings; then you go to science class, and then the bell rings.... You go through a whole day and a whole semester constantly being pulled from one thing to the next. I think that prevents students from having the time and space to really develop a relationship with the material. I find it is critical to break down barriers among disciplines and between the classroom and the world that exists outside.

I am currently running an interdisciplinary, experiential "school-within-a-school" program of my own design: Rivers and Revolutions. Through the lenses of literature, social studies, mathematics, science, and the arts, teachers and students investigate the following units of study: rivers, revolutions, air, fire, love, migration, seasons, and equilibrium. Time in the classroom is matched by time in the field as the cohort explores sites of cultural, historical, and ecological significance.

I wanted to make sure that these units were broad and would provide us with the capacity to actually reflect on the human condition. So, all these phenomena sort of tie the world together and are bigger than just the human experience and bigger than just a specific place or specific time or specific culture. For example, we're studying love right now and we are considering the question, "How can you define love?" How have poets and novelists tried to do that? We're acting out scenes from Shakespearean sonnets about love but we're also studying what attracts people to each other through biology and even chemistry. We are studying the symmetry in a person's face and evaluating the mathematics of attraction through population growth and magnetism. We are creating life-size body maps in order to better understand ourselves in relation to those we love. What is the conversation surrounding love and social movements, or the Endangered Species Act, or social justice? What are the different ways of thinking about love, and is love ultimately definable?

Really good education is all about risk-taking and about making a mess; learning is chaotic, right? And if you don't have an environment in which there is a sense of trust, then teachers and students are going to be a lot less likely to engage in those kinds of risky activities. I'm constantly encouraging students to step into zones in which they're not totally sure they can succeed, where they maybe feel slightly unprepared, because that's where growth really occurs. So, when you create a space that is not specific to one field of study, that's not particular to one notion of intelligence, it really allows a much greater number of students to come to the table, to share what they learn, and to gain a greater sense that they can achieve and that they have something to offer.

The inspiration for Rivers and Revolutions derived from the fact that I spend a lot of time by the river and it just struck me: How cool would it be to study the river through science, mathematics, literature, history, and the arts? It was my wife who thought of the companion idea of revolutions. We played with that idea and then the course thematically unfolded. One way to think about the span of a river is that it starts up as a little mountain-born stream and then rages downhill, joins up with other brooks and streams and becomes the river that meanders and then, in old age, enters the ocean as its final destination. You start here, you end there. But of course, the whole time water is evaporating, feeding the atmosphere and coming back down as rain and feeding the brooks. So, there's also something very circular about that

relationship. And with revolutions, that same phenomenon is going on where, in a linear sense—historically—you're moving along, there's major upheaval, you keep moving along and there's another upheaval.

Students who enter the program leave the mainstream curriculum for an entire semester, making a choice to enter a very different educational environment in which much of the work is hands-on, and where all of the work is connected to the lived experience of the students—it is akin to going abroad for a semester, but it doesn't cost anything extra and it's on campus. Our program is open to juniors and seniors and in our pilot year we were successful in attracting a true diversity of students; in fact, we are currently the most heterogeneous class in the high school—in terms of race, ethnicity, and socioeconomic status, as well as academic ability.

It's only 10 to 15 percent of the day that there's a teacher in front of the room directing. It's very much students working with one another. Further, all students in the program take on a formal stewardship role in which they leverage their learning in the program in the service of an ongoing project in the community. Instead of exams, students submit synthesis projects that allow them to make connections across disciplines by creating an artifact that represents their interests and passions. At the conclusion of the semester, students—in groups of five—offer a full day of instruction to the entire cohort, exploring a topic that connects to the thematic arc of the program as a whole. Teachers take on the role of students. But students also take on the role of teachers.

Also unique to the program is the embedded professional development for the teachers. The five core teachers in the program are in the room all the time; when the math teacher is teaching, I—the English teacher—am also there, helping to support the instruction but also playing the role of student. There's also a history teacher, math teacher, science teacher, and arts teacher. So, even though we all take turns planning the lead instruction, we are also always there to help make sure the conversation stays coherent and stays interdisciplinary.

Team-teaching is a big change for teachers in the program. Teachers are used to having control over the classroom. You shut the door and basically it's your zone. Typically most educators are observed a handful of times a year and that's formal evaluation—a static snapshot to assess a teacher. I think that's a huge barrier to instructional improvement, because if you're not being observed and observing others regularly, it's really hard to continue to grow as an instructor. In our classroom we're making collective decisions about everything—from deadlines to content to what projects should look like. And we're all watching and learning from each other.

Perhaps the greatest frustration I have faced was the resistance I met when bringing Rivers and Revolutions to the high school. Thankfully, I had a strong network of support that helped to keep me focused on providing an alternative for students for whom the mainstream curriculum was not working. The larger challenge, of course, is that the fragmentation and alienation that define most curricula also mark the entire educational landscape. How to help the public-school system re-envision its very purpose, how to bring holistic and innovative practice into all schools for all students, are the central questions I now grapple with as I consider the next phase of the work.

You're one of my heroes. I want you to know that. Your passion for teaching is inspiring, and if I become a teacher, I want to be like you. I hope all your dreams for administrating and education reform come true, because I know you could have a huge impact. You've already had a huge impact on me.

Adam, age 16, former student

I am currently in the process of designing the Concord River Institute, which will offer a tuition-free experiential program much like Rivers and Revolutions to one hundred students between Fitchburg and Boston. At its core, however, the Institute will be a school for schools; teachers and administrators from around the country will be invited to observe, participate, and experiment with alternative instructional methods and models.

Our closing celebration for the fall semester of Rivers and Revolutions was held at deCordova Sculpture Park and Museum in Lincoln, Massachusetts. A huge crowd of family and friends gathered, and a number of our students spoke. One student, Nick, offered: "I have never liked school before...I hated it. I was made to feel stupid. I just couldn't see how what I was learning would impact me later in life.... After joining Rivers, I've never loved school more. It has changed me as a person." The next day, he was featured on the front page of our local newspaper. When I gave him a copy, he began to cry and said, "This is the first time in my life I have been in the paper for something other than football or the police log. My dad will be so proud."

> *"We engage Bach and we play all sorts of great material, but sometimes we have to let our hair down and just rock out."*

Erik Herndon

6th–8th Grade
Orchestra, Guitar, and Music Technology

Mr. Herndon and his seventh-grade students rock out in guitar class.

When Erik Herndon was hired to teach orchestra at Jean Childs Young Middle School, an inner-city school in the heart of Atlanta, he had seventeen students and his "classroom" was a little trailer parked outside next to the football field. Eight years later, his award-winning program has grown to serve close to 130 kids a year and is housed in the school's new fine-arts wing. Herndon's success can be attributed to his relentless commitment to expose his students to the transformative power of music. He teaches from experience—he spent many years living the life of a rocker (and still performs with his band in Atlanta), before swapping the tour bus for the classroom. His partnership with the national nonprofit Little Kids Rock, which provides free instruments to more than 100,000 children from low-income families in dozens of cities, is one potent example of how Herndon goes above and beyond the norm to guarantee his young players have the means to succeed.

I grew up by the Elizabeth River off the Chesapeake Bay in Virginia in a modest middle-class home during the eighties. My parents were both very passionate about their work. My mother, Rosemary, was very involved in yoga (and still is) and was one of the first people in our community to engage Eastern contemplative practices. Likewise, my father, James, was dedicated to two great loves: education and karate. My dad was always going to school. It wasn't enough that he was the first in his family to go to college; he pursued higher education with a fervor resulting in two doctorates. It was common

in my household to meet gurus, swamis, karate masters, psychics—you name it.

My relationship with music started young. My uncle gave me my first guitar when I was ten and by the time I was twelve I had started to teach myself how to play. Music was my big outlet. R.E.M. and the Smiths were popular. It was the time of MTV and alternative music. I would learn songs, and then I began writing my own. All I wanted to do was be in a rock band. I didn't even really know what that meant.

> *"The ultimate goal is for my students to find meaning in the process and make music for themselves."*

I moved to Richmond, Virginia, where they had these incredible bands—bands that went on to influence many, many other great bands. I stepped into the middle of a music scene where people were going places. They were touring the States. They were touring Europe. They were touring the world. It was a great time intellectually and artistically, creatively and socially, and I was lucky to be there. The scene embraced me and I embraced it. I self-identified as a hardcore kid, a punk rocker. I joined one band and then another, put out records, and went on tour, doing odd jobs to make ends meet between shows and gigs.

I eventually moved to Atlanta, and continued playing with a band, but I wanted to do something with more meaning and purpose, so I joined AmeriCorps. That work placed me in the communities and classrooms of metro Atlanta, and it was during this experience that I first considered becoming a teacher. I was twenty-seven when I finally decided to go back to college. I thought I'd study science, because that was the other area that had always interested me, but of course, I ended up in a music class, which led to taking another music class…. Five years later, in 2005, I graduated *magna cum laude* from Georgia State with a degree in music.

I knew I wanted to teach orchestra to middle schoolers, because that had been such a tough age for me. I wanted to get kids at the beginning of their journey, when they're just starting to play and explore their creativity, to help them get some fundamentals and solid direction. It ended up boiling down to either taking a job at a school outside the city, or working for Atlanta Public Schools, and that was a big decision. The truth is, I didn't want to work in an inner-city school—I thought it would be too challenging. And yet, when I went on the interview, there were so many things that clicked. I asked my band members for advice, and I'll never forget what my drummer, Buffy, said, "Well, what would be the most punk-rock thing to do?" And I thought, "Of course, it's way more punk rock to teach in the city than in the 'burbs." These are the kids who really need me.

I was hired at Jean Childs Young Middle School to be a full-time orchestra director for the sixth through eighth grades. When my principal realized I played guitar, he asked me teach that as well. I didn't have instruments to start with, so I went through a training program with Little Kids Rock, an incredible nonprofit, in 2006, and they gave me thirty guitars. I started a class after school, but after our first concert, my principal was so blown away he wanted to offer guitar as part of the regular curriculum. The timing was perfect. It became a Little Kids Rock class, where you could play guitar, sing, drum, or play the electric bass and keyboard. We started with the guitar, but we just kept adding to it.

The kids are amazing—curious about all the same things I was at their age. They want to know about rock. They want to know about metal. I can talk to them about it very authentically because I lived it. I bring that to the classroom. I "get" kids. Not all ears are the same. While it is important to teach fundamentals and notation, and ground ourselves in tradition—I advocate for self-expression, creativity, spontaneity, improvisation, and composition.

I'm not a counselor, and I'm not their parent, but I want kids to be aware of what's going on inside themselves. I want them to understand how it feels to be present, to be focused, and how to be in the moment. When they come in the room, they can sometimes be scattered. So I ask them to take a moment and get centered. I want them to be awake and alert when they learn.

In my orchestra class, things are generally more traditional. We get our instruments out, we read music, and we make music. We engage Bach and we play all sorts of great material, but sometimes we have to let our hair down and just rock out, figure out a hip-hop song or play a jazz riff.

In my guitar/Little Kids Rock class, often we're co-creating and learning contemporary music. I'll ask them to listen to a song—for example, "Too Close" by Alex Clare. We do a couple activities around guided listening, and I ask them questions like, "What do you hear? What's

"There are many wonderful things happening in my classes every day, but make no mistake—this is a tough environment."

going on musically?" And, then, "Okay. Well, what do you think? Can we do this? Is this something you want to learn?"—and, if they're game, "How do we figure it out?" There is no curriculum for a song that just came out on the radio. So, we cocreate. We go from the simplest thing that everyone can do, and raise it up and up, until we've reached a point where most of the students are playing at a professional level, where all the instruments are working in tandem—the bass, the drums, the keyboards, the vocals. We do that together. It's a lot of fun and it's empowering for the kids because they get to have a say in what and how they're learning, and how much of a challenge they can take on. I'm not interested in perfection so much as in effort. If you're having a problem with that passage, or if you can't play that note, you might need to practice it more another time. But what can we do in the here and now? What can we do in the moment to make music? I'm not going to yell at them for missing notes, but don't get me wrong: We get results. The ultimate goal is for my students to find meaning in the process and make music for themselves.

I'm always looking for funding. I don't like asking people for money, but literally, we don't have enough resources through the school to maintain our instruments. I do a lot of the repairs myself, but there are things I can't or don't have time to do. There's no budget to take the guitar amp into the shop. So we fund-raise. For instance, we received an amazing grant from the Atlanta Families' Awards for Excellence in Education, which gave us the means to allow my kids to record music. I built a recording studio in the classroom and got some iPads and recording gear, which created great new possibilities. Now if the kids want to write their own music, document it, keep it, or leverage it—if they want to enter a songwriting contest or post a video up on YouTube—they can.

I'm stubbornly idealistic. I'm looking for excellence. The hardest thing about being a public-school teacher is how quantified it has become, how boxed in you feel. The

conversation about education in this country is all wrong. We need more passion. We need to engage our creative selves more than ever. Not the opposite. It can't be just about passing these damn tests. I'm not opposed to measurement, but that is not what makes me rise in the morning. What keeps me going is that I provide a place in school where it's going to be safe, where it's going to be positive, and where it's going to be creative.

I go to work early every day and I come home late. And it's not because I'm a workaholic, and it's not because I want to take time away from my family. I get to school at 8 A.M. every day, even though we don't start until 8:45 A.M., because literally more than half of my kids cannot take their instrument home or practice there, for a variety of reasons. I stay after school frequently to give kids the opportunity to rehearse or have some studio time, because otherwise, it wouldn't happen. The process of creating music is not necessarily linear—you can be

> If I could describe Mr. Herndon with one word it would be passionate. He can do more than dictate you into playing right, he can make you love the sound that you produce from your instrument. This ability is so rare that it cannot be undone once taught. Gifted, passionate, understanding, wonderful, Mr. Herndon has changed the way I look at music. It's supposed to move an audience so much that they are inspired. And in essence, that's what Mr. Herndon is, a teacher who inspires his students to reach new heights of creativity. I cannot think of a better definition of a great teacher.
>
> *Makeda, age 15, former student*

working on a song for weeks without getting anywhere, and then suddenly you're there. Part of my success as a teacher has been providing enough extra time and space for that to happen.

There are many wonderful things happening in my classes every day, but make no mistake—this is a tough environment. We need systemic change for these kids. And we have to answer serious questions about the way we educate them. Where is the role in this country for long-term education that speaks to critical thinking, to information discernment, to technological skills, and to a base level of knowledge that will keep you competent in a complex world? That's the conversation we need to be having.

"Word spread that I was the crazy instructor who collected historical objects to teach with. Twenty years later our Classroom Museum has acquired over 20,000 artifacts."

Keil E. Hileman

6th–8th Grade and 11th–12th Grade
Museum Connections and Honors Archaeology & Artifacts

Mr. Hileman stands among thousands of teaching artifacts housed in his Classroom Museum.

No one can argue that Keil Hileman hasn't had far more than his fair share of life-threatening curveballs and professional challenges. The survivor of a brain tumor and two shattered legs, Hileman was told he would never stand at the front of his classroom again or have children of his own. He fervently believes that his deep passion for teaching is the reason he is now the founder of two of the most innovative and creative history curricula for middle- and high-school students in the country, and is very happily married, with three young daughters ("a redhead, a blonde, and a brunette—a trio of beautiful little rowdies; yep, they're Charlie's Angels gone wrong!" Hileman jokes). His Classroom Museum courses and Archaeology Lab program are extraordinary models for hands-on learning and proof that the only limits to a teacher's success are the boundaries of his own imagination.

I had a little eighth grader the first year I was teaching who was on his way to getting kicked out or dropping out of school: Jason. He was tiny and had a terrible temper. He got into fights all the time. But Jason had been abused by his parents. Dad sold drugs. Mom sold herself. So Jason had been sent to live with Grandma.

We were talking about the Civil War in class and I shared a few historical objects that my parents had—a couple pictures and an old book. Jason said that he also had some Civil War stuff. And he brought in a huge box of artifacts and told the class stories about them. The other

students were just amazed. He was a star. So, I bought a little two-shelf bookcase and we displayed his objects. The rest of the class started bringing things in too. They'd ask their mom, dad, friends, relatives, or people at church, community centers, and synagogues. Pretty soon the little bookcase filled up.

The unit ended. Everybody took their objects home. But Jason's grandma sent me a letter saying that I'd inspired her grandson to go to school—that seeing me and what we were going to do each day kept him in his other classes. So, she said, if I promised never to sell the artifacts and always to teach with them, I could keep them. There was a family Civil War Bible, an old candlestick, a candle maker, some antique bottles and tools—neat, neat stuff. If I knew then what I know now, that letter would be framed in gold and hanging on my wall.

The moment I walked into Mr. Hileman's classroom and inhaled the scent of history, I knew this would be not just a class, but also an experience. There was not one surface in his room, not one inch that did not have historical value. We're not in a classroom, we were told; we were in a MUSEUM! Not a day went by when he did not take something off the shelves and explain what it was, how it was used, and why it was important. His artifacts enthralled us. We connected with them, we felt in our hands the Civil War—the weight of lead bullets, the size of a slave ball and chain worn by a grown man, forced into slavery in the south. He presents the past in such a manner that his students live it. They gain not just facts, but experiences. More than I ever knew I could, I realized how important history truly is. We have to learn from our past; our successes and our shortcomings.

Jamie, age 17,
former student

Word spread that I was the crazy teacher who collected artifacts to teach with. Kids started asking to have my section. The further I took it, the more connections to history I was able to make. My students were really learning and they wanted to be there. The collection grew and grew.

Over the past twenty years, our Classroom Museum has acquired more than twenty thousand teaching artifacts. I've never turned down a donation—if I can't use it, I find a teacher in the district or a museum that can. The Museum does get things that honestly should have stayed in families, but not everybody appreciates history. For instance, we received a Nazi flag. The elderly man that brought it wished to remain anonymous because he didn't want us to know who his grandkids were.

I teach lessons every day surrounded by such pieces of history as a 1790s slave collar, a 1796 flintlock musket, an 1898 brass cash register, a 1920s porcelain barber's chair, a 1907 nickel-and-cast-iron stove, a three-thousand-year-old Chinese coin, and countless other artifacts, because of my partnerships with students and parents.

I'm only interested in using an artifact if it connects directly to history, if it has a story. I have a piece of the World Trade Center. A little girl in one of my classes, Carly—her grandfather had been a firefighter in New York. He had volunteered weeks of his time to help after 9/11. At the end, he was allowed to keep a chunk of concrete to remember all of his work there. He chipped it in half and sent us a piece—it's about the size of a third grader's head. I think it was part of the courtyard or the open area between the buildings. When you pass it around the classroom and tell them it's a part of the World Trade Center, even kids that weren't alive during 9/11 or haven't heard about it or seen the videos say, "Ooh, I want to touch it." It's so exciting to watch the expressions on their faces. History can be so stimulating. It's just a piece of concrete, but the next day there will be kids who raise their hands and ask, "Why did people do this?" "Why would anybody hurt anybody?" "Are these Americans doing this?" "Foreigners?" It'll lead to some great and important conversations.

I always wanted to expand the Museum to a lab environment. In 2010, I got the chance, when the school board asked me to broaden the program so that any high-school student in the district could have the opportunity to experience the Museum. We looked at a number of ideas, and the one I kept coming back to was an archaeology class. But I couldn't figure out how to create realistic simulated digs inside the classroom. So I started Googling *sandbox, sand table, dirt table, dirt storage* and I found this plastics company that had made a sandbox for an executive's office so his baby could sit and play in the sand. So I took that idea and turned it into a science table. You know those big, heavy blacktop tables you see in science classrooms? They're pretty standard and indestructible. I found a company that manufactures those down in Missouri. I got in touch with their engineer. He was a brilliant man. I went down to work with him. We sat at his desk and drew pictures and computer-assisted designs,

played with models, did measurements. And we came up with this modified dig table.

It had to be completely self-contained, with a lid on it. With all my experience in the classroom, I wanted it to be bulletproof, atomic-bombproof, something that would last for twenty years. We created a prototype, and in the end they built sixteen tables for me. There are two dig stations per table, and each one can hold about 80 to 120 artifacts. In between each pair of dig stations is an empty space that's really deep, where the sifted sand goes as you work your way down through the site.

For the sand, I wanted something as close to soil as possible. But soil is living dirt, which is full of microbes and bacteria. If I left it over the summer, I'd have entire generations of creatures growing come September. So I tested about eighty bags of different types of sand. Eventually, I found this toy sand called Moon Sand—great squishy stuff that never dries out. (I actually called the manufacturer to make sure about that and they sent me a big sample. I made little sand people and put them on the shelf for three months and sure enough, they stayed moist!)

To get the right brownish dirt color I had to combine purple and yellow Moon Sand and then add it to some regular sand. It was awesome. But it still wasn't the right texture. So I went outside and played with real dirt and realized that it usually has some rocks in it. I bought different types of sharp, pointy rocks and smooth, round rocks—the size of your pinky fingernail, not terribly big—and mixed it all in. And the next thing I knew, I had this cool substance that feels and looks like real living dirt but is always clean and dry, and yet compressible. You can grab a handful and squeeze it and it's moist, like soil. I can bury artifacts in it—put them at different layers. I can even compress the "dirt" so the kids have to literally excavate the items—carve around them and dig them out.

Finally, I had to find tools. I couldn't give them real archaeology instruments—they're sharp and would have been dangerous. So, I found plastic copies or tools that function the same way—like paint stirrers, which work like awls, for scraping and digging.

The whole archaeology program was designed for high school only, but I received three grants from Walmart so that the sixth, seventh, and eighth grades could also each do a dig. Sixth grade does World Cultures. Seventh grade does a Native American dig every nine weeks. Eighth grade does a Civil War battlefield—that's my favorite because I found the coolest diggers to buy

artifacts from—cantankerous old men and women around the country that go to national battlefields and search adjacent farms for relics. (The farmers hate Civil War artifacts—the cannonballs and bullets get pulled into their combines and cause thousands of dollars' worth of damage—so they're happy to have their fields cleaned.) So when my eighth graders are digging up a bent bayonet or Civil War bullet that hit something or someone—they're real! And man, you should see their shaking hands and wide eyes when they're holding these objects and realizing, "Oh my gosh, that could have really hurt somebody." Yes, it could have.

"Fires are awesome, but you still need something to get them going. I think sometimes the right teacher in the right place at the right time can do that."

High school does an ancient China dig and a dinosaur dig. We have a couple guys from the East Coast who created their own self-contained scuba gear systems with bright lights and they go swimming in rivers and find prehistoric ocean fossils—megalodon sharks' teeth, whales' bones, all kinds of cool stuff. A tooth in mint condition can go for $500 to $4000, but we don't need perfect. They sell me buckets of the cracked teeth and bones for just $3 apiece.

The neatest part of the Classroom Museum and Archaeology programs is how much support it's gotten and excitement it's generated. People have sent us things from around the country. Businesses have donated money. Community members have volunteered time. It's been an awesome journey. A lot of people think emotion makes you weak, but I have found that the more you care about something, the more you tend to fight for it. I'm very, very blessed. Getting recognition or awards for how I teach—it's kind of like giving a medal to a fish for swimming. I'm doing what I'm supposed to be doing. I feel called to do it—almost like a minister. Name it what you want. But so many good things have happened, and so many people have come together. It's almost like it was waiting there all along. It just needed the right spark. Fires are awesome, but you still need something to get them going. I think sometimes the right teacher in the right place at the right time can do that.

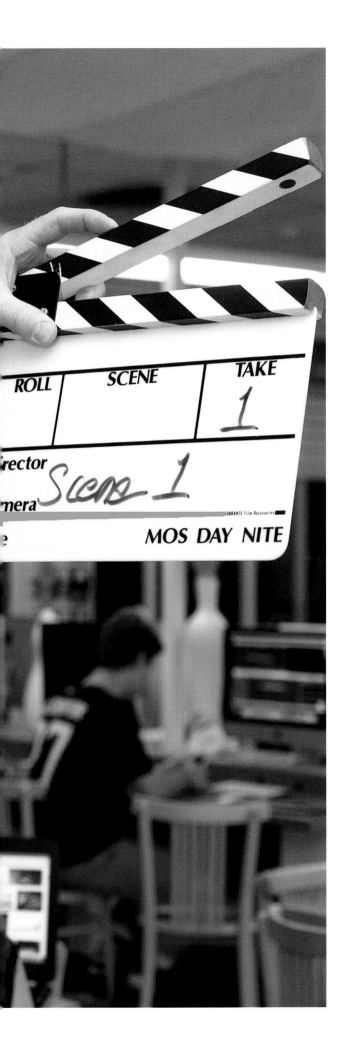

Jay Hoffman

6th–8th Grade
Multimedia, Broadcasting, and Social Media

Jay Hoffman has spent his whole life building things. First as a student in his high-school shop class, then as the owner of a construction business, and finally, as a teacher in his Vermont middle-school classroom, where he transformed an archaic industrial arts lab into one of the most successful technical-education programs in the country. A visionary both inside and outside the classroom, Hoffman has a long list of achievements, among them being the first teacher in his state to design and send an experiment into space, being 2013's Vermont Teacher of the Year, and receiving the National Cable and Telecommunications Association's "Leaders in Learning" Award for innovative contribution to education in 2009.

Mr. Hoffman shows his students how a slate is used in video production, during his social media class.

I have a mantra—*let kids be kids*. I see it as my job to protect and nurture my students so that they are free to explore the world. I know what can happen when a child's spirit gets crushed or broken. Long before I became a teacher, I learned this all too well from my own experiences.

I grew up in upstate New York. Dad was a cop and mom was a teacher at our local Catholic school. I had two brothers and three sisters. Everyone called us the Brady Bunch. That's what the world saw. But behind closed doors, I was beaten and abused by my father, almost every day. It never stopped. He would kick me up and then back down the stairs as my sisters looked on in horror. For some reason, he singled me out. I remember being chased around the dining room table by my dad wielding

a cattle prod. I was his stress reliever and his punching bag. I look back and I think I was a good kid, but every little thing I did made him fly off the handle. I learned to take care of myself and be on my own. I was extremely shy. I did not smile much as a middle-school boy.

High school was a defining time for me. I loved to use my hands and create things. I was a natural at it and my shop teacher was patient and kind. Those were my greatest "feel good" moments in school. I finally applied and was accepted at a state teaching college because of their industrial arts program. I married a week after I graduated and started my own construction business. I would be thirty-one and a father before my life's journey took a turn back to teaching.

"You think you are going to teach, but boy, do you learn."

It began in Wappingers Falls, New York. I taught industrial arts to seventh and eighth graders. It was a highly diversified school. I called it the boot camp of teaching. It was tough, but that was where I belonged. The teacher I replaced had left thirty years' worth of curriculum stacked up on the desk so high I could not get around it to reach the chair. Everything was so old, there wasn't much I could even use. So I flew by the seat of my pants. At the same time, I went back to college to complete my master's. I soared through the course with A's and I met a professor who talked me into staying for my administrative degree. I was an outside-the-box teacher from day one. I innovated and loved it. When I came up with ideas I didn't know if I could do, I just went ahead and did them anyway.

For example, I was pondering why kids shouldn't be able to access their homework online. Computers were just coming into vogue then. This was 1992. We had an IT department and there were some old circa-1982 Mac computers in the school. Words like "networking" and "hubs" were just starting to become part of the vernacular. It was a new language and I did not know much about it. But, my dream was for kids to check in from home on the computer and get their assignments. So I approached an innovative professor at Marist College and asked if he would allow me to pitch my idea to his students as a class project. The kids thought it was crazy, but they took it on. There was a lot to figure out. How much would this cost and what kinds of computers would we need?

Could they find existing software or did we have to write it? We developed a plan and it actually worked. When we went online we received big coverage from the local newspaper. I had been granted $21,000 for this project at a time when the district really didn't have any money. It gave me some notoriety and I became the chair of the district technology committee underneath the assistant superintendent. She was a great mentor.

I learned something very important during those years: Teaching reflects you. If you can look at that reflection, you will really learn about yourself. That humbles me and brings me to tears when I talk about it. Because in the beginning, I was scared of what I saw. Kids find the cracks in your armor. It is not that they set out to, they just do. But if you are willing to step back and reflect, you can grow so much. It is a wonderful, unexpected caveat. You think you are going to teach, but boy, do you learn. I have come to understand that, truly, *I am my students' student*.

My wife worked for IBM and had an opportunity to take a position in Vermont. We found a better life for our boys, and I wound up in the best school system in the state, where I have remained for eighteen years. I remember when I went to interview in South Burlington, they showed me their industrial arts lab and it looked every bit of fifty years old. I sighed and thought, *I do not know if I can do this*. I knew I'd have to throw everything out and start from scratch. I accepted the job, but I said to the principal, "Here is what I am going to do and if you don't like it, don't hire me." He said—and I'll never forget his words, "I will give you all the rope you want to hang yourself." So, I began to build this state-of-the-art lab. I knew from the beginning that the ability to create media, and manage and distribute it, would be at the forefront of our culture. I knew my kids would have to become media savvy. So I kept retooling my skills, my curriculum, and the lab, until I had evolved the program from industrial arts to tech education, where students learn design and engineering principles, and physics. We built rockets, race cars, and bridges. These were terrific hands-on projects. And, as we became more digital, we also created media.

Learning needs to be relevant and connected to the outside world. In fact, the outside world should no longer be outside. The world is our classroom. I began to teach my kids how to become civically and socially responsible, sending them out of the school to shoot videos down in Burlington and learn about the local businesses and the people. These were middle schoolers, so they couldn't drive

yet, but the police department would take them wherever they needed to go. One day I called Senator Patrick Leahy and asked if he would grant my students an interview. He said, "I'll tell you what. I will be in downtown Burlington to speak at Ben and Jerry's anniversary. I will give your kids ten minutes if you get them here." Sure enough, a local squad car rolled down with the kids in it. They went without me. They were taught to be independent.

I had a dream of creating a student-run news team. I wanted a TV in every classroom. I wanted my kids to broadcast to the entire school. We would use music and collaborate with the music department; we would integrate skills. And the dream would not go away. So I wrote a grant and got $40,000 from my community education fund organization. But we had no idea how to air a newscast. I called up the local public television station and said, "You know, I have got this crew of twelve kids—could you help?" They sent someone over and, long story short, our first show was broadcast in February 2003. I was thrilled and proud. In 2012, we started streaming our programs online, so that any school that wants to log in and watch us can be part of our broadcast.

In 2004, I wanted to see if I, as a teacher, was cutting it. *Am I giving my students all the skills they need in media?* So we began to compete nationally. We entered our first contest, sponsored by C-SPAN. Obesity in America was a hot-button issue at that time, so my kids created a documentary video about it. They went out to local gyms and they went to the senators' chambers in Montpelier, the capital. Of course, they also scripted it, which is another wonderful thing about video—it reinforces students' writing skills. The video took an honorable fourth place out of about a thousand entries.

Our interaction with the community is well-known and important. For example, Teen Lures Prevention, a sexual crime prevention organization that is international in scope but based in Shelburne, Vermont, walked into my classroom one day and asked if I would be interested in trying something new. They said, "What do you think of kids teaching kids about sexual crime prevention?" I thought that was a good idea. Then they said, "What do you think about your kids doing a broadcast? We have written some scripts." I took a look and they fit us to a T. So, I brought it to the kids and asked them to make the decision. They took it on. We became the first class in the United States to do this. CBS's *The Early Show* came up and filmed us. An education crew came from Korea to film a documentary on us, which aired to 4.6 million people in Korea.

Concurrently, about nine years ago I was approached by Vermont's teachers union and interviewed for and accepted a position to become a new teacher trainer. I travel throughout the state, working with teachers through the National Education Association on classroom management skills, bullying and harassment issues, and most recently, best teaching practices based on Charlotte Danielson's work. I love doing it. I have developed a passion for training teachers. I know that our current evaluation process is not helping us become better teachers. I know because, for example, in my own last evaluation I was tops in nearly every category and that is not right. I know that I still have a lot of work to do and I wanted to hear my weaknesses so that I could work on improving them.

> *"You can be a good teacher, but you can always be a better teacher. It is a journey. We never arrive."*

I always use this golf analogy: Tiger Woods was on a green with Bubba Watson not too long ago and Watson is a natural. He's self-taught and he is a fabulous golfer. Tiger looked at him and said, "Bubba, when are you going to get a training coach?" Bubba said, "What are you talking about?" And Tiger said, "You will never get to the next level if you do not have a coach." Bubba went out and got a coach and the next season he put the green jacket on for the first time, having won the Masters. That is what teachers need: a coach. We can only get so far on our own. You can be a good teacher, but you can always be a better teacher. It is a journey. We never arrive. We never get to a point where we can say, "I am the best I can be." We need somebody to help us through. Somebody who evaluates us regularly, points out our flaws gently, supports us, and nurtures us. We do not need a punitive evaluation tied to salaries and student outcomes the way so many states are doing. That is detrimental.

So that is my current passion. For another fifteen years, I am going to work at training teachers, and at changing and getting policy that supports teachers to become the best that they can be. I know, through data, this is the best way to increase student achievement. Oh, there are a lot of layers. We all know that. But I have taken on one layer. This is my layer. This is my epitaph. This is what they will write on my headstone.

"I see my classes as the intersection of literacy and leadership. I want my students to understand that reading and writing has a vital role in their ability to make an impact."

Celeste Hoffpauir

9th and 12th Grades
Academic Leadership and Ethnic Studies

Ms. Hoffpauir's ninth graders hold up books of their own choosing for their independent reading time.

Celeste Hoffpauir grew up with all the advantages of privilege: financial stability, a stellar education, plenty of intellectual stimulation, loving parents, and a network of adults who nurtured her. Add to that her California-surfer-girl good looks, and from the outside, it's not far-fetched to assume she could have had her pick of potential futures. Yet the one she chose is perhaps most reflective of her true character, which has nothing, and everything, to do with how the world might see her. Her upbringing taught her to trust her internal compass, which ultimately led her to follow her passions. As a high-school classroom teacher in urban education, Hoffpauir is not just contradicting her own stereotype, she is teaching her inner-city students to do precisely the same. While providing her students with a rigorous academic education, Hoffpauir strives to nurture their identities, validate their personal narratives, and help them discover their innate power to take ownership of their futures.

I had a very full and caring family life growing up, but I was a very sensitive child who felt extremely responsible for others around me. I worried a good deal. This was my inner life. In my outer life, I was gregarious, even outgoing. I always made friends easily and loved learning and experiencing the world. The piecing together

LEADERSHIP PUBLIC HIGH SCHOOL HAYWARD, HAYWARD, CA

of new information and skills in school excited me. I am a very relationship-centered person, so my teachers had a big impact on me. I enjoyed the accolades that came with achievement, but I also took comfort in the safety of routine and ritual. I treasured being a part of a class and having a place within that community. I adored reading and writing. My parents are huge readers and reading was constantly modeled and highly valued in my family. My mom read to me every evening until I was seven or eight. I grew my own avid literary life from there, reading each night before bed, developing favorite authors and genres, cherishing that I could escape into these different worlds. Even at a young age, I valued the creative-writing process—the expressive, descriptive powers of words.

"A lot of being a successful teacher in urban ed is about hustling—working with what you have and problem solving as you go."

I had a public-school education until middle school, when I moved to a private school that I refer to today as the utopia of education. It was heaven on earth to me, and I often say seventh through ninth grades were the best years of my life. I am well aware that this is a total anomaly in our society—maybe in the world as a whole? My middle school spent four weeks out of the school year engaged in outdoor education through rigorous biking, camping, and backpacking trips. The belief was that young adolescents are more embodied and live and learn through metaphor rather than through "mere" classroom academics. So though we had regular academic classes (which were good), the heart of the school's culture was borne through our biking and backpacking trips. There is nothing more powerful than seventh graders spending two weeks away from home with peers and teachers, biking from ten to sixty miles a day, backpacking in the rain, sleeping in tents, and always, *always*, gathering together around a campfire to have the challenge and triumph of their days encapsulated by and punctuated with Native-American and Greek myths. We became larger than ourselves. Every student had the opportunity to speak whatever he or she wanted into the fire—to honor or acknowledge another person, tell a story, or share a personal fear or grief. What we learned was that we had a voice, what we had to say

mattered, that we could take risks, were responsible, and were to be trusted. We were vital members of the community, and that connection was strong and integral in developing our sense of self and resiliency.

I had the privilege of many opportunities, extracurricular classes, and new experiences as a child: dance class, Girls Club, fast-pitch softball. I discovered theater and acting when I was in the sixth grade and there was no turning back for me. I felt the magic of becoming another person and in turn, helping to create another world. I was in every school play through my senior year; I was in a summer theater program every season from age eleven through twenty-one. In high school I wrote two one-act plays that were produced by local theater companies. I believed in theater; it was my first love. In the community innate to any theater experience, I found my voice and learned to trust myself and others.

Teaching for me is in many ways like theater. There is a unique synergy that occurs in the classroom, just as it does on the stage. In a play, the live performance can never be replicated quite the same way ever again. Each performance stands alone; the actor is right there onstage, in the moment, and the audience with that exact combination of people will never be identical. And so it is with teaching. In the classroom, there is a fusion and dynamic that creates the same spark that makes live theater magical for me. What happens in my block-three academic leadership class may be totally different from what happens in my block-five class, even if it is the same lesson with the same materials, because the students are bringing their unique lenses and life experiences and energy to the lesson and I, as the teacher, am sensitive and responsive to the needs and energy in the classroom. The magic of that moment, or class period, cannot be replicated. Teaching is the perfect synthesis of my love for the theater and for learning. The act of bringing together ideas and people, of creating an arc filled with the urgency and drama of learning, has always been my calling. My greatest goal is for my students to find, and begin to trust, their voices in the process of learning.

As a high-school educator, I strive for my students to comprehend and empathize with other "actors" in our human history and experience, and to believe that the problems of the world are theirs to help mend—that their ingenuity, insight, and hard work can and will lead to solutions. I see my classes as the intersection of literacy and

> *"The act of bringing together ideas and people, of creating an arc filled with the urgency and drama of learning, has always been my calling."*

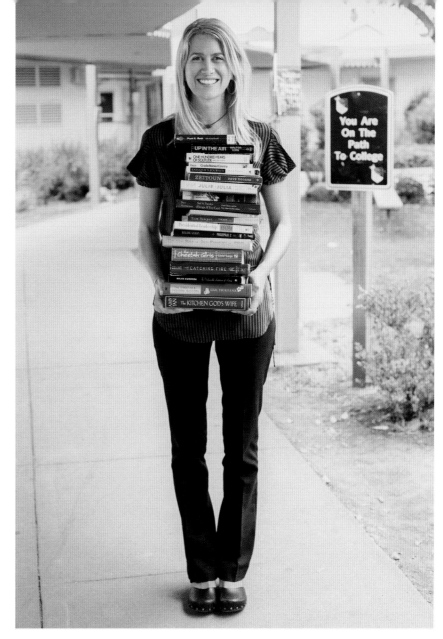

leadership. I want my students to conceive of themselves as change makers and leaders, and to understand that reading and writing has a vital role in their ability to make an impact.

I began my teaching career at a public middle school in a working-class area in the East Bay. I arrived, résumé in hand, at the district HR department, where the principal interviewed me for ten minutes and hired me on the spot. I didn't know it at the time, but it was the lowest-income middle school in the district, had the lowest test scores, served the highest number of English Language Learners, and had some of the highest teacher and administrative turnover. I didn't know any of those things. I was just thrilled that I got a job.

I struggled a lot the first two years. The only thing that saved me is the support and guidance I received from a few of my colleagues, some truly valuable professional-development trainings from the district, and the fact that I had a really good curriculum. I'd been trained with strong methodology, and, thank God, my master teacher from student teaching gave me all of her ancient-world-history curriculum, which was brilliant. It was interactive and primary source-based, and included simulations, critical-thinking skills, writing, reading—it was terrific. I had all of the lesson plans and the sources, everything I needed, which I supplemented with new lessons that I wrote. And I brought in tons of artifacts—statues, religious symbols, art—all kinds of great props to bring the curriculum to life.

A lot of being a successful teacher in urban ed is about hustling—working with what you have and problem solving as you go. You get really used to not having enough and it can feel like you have to do everything by yourself. In time, I learned that this feeling of scarcity was not a reality and that I just needed to ask for help and use the resources available. And it became clear that there were some tools that I lacked and desperately needed. In particular, I did not yet have the cultural competency necessary for that educational environment—a Title 1 school with a student body that was about 70 percent Latino, 15 percent African American, 10 percent Asian-Pacific Islander, and 5 percent white. Many of my students' backgrounds and needs were new to me, having had little exposure to people of color where I grew up and very little experience with African-American culture or the Latino immigrant experience.

I learned very quickly that I had to invite my students' identities and life histories into the classroom as much as possible so that I could get to know them. And I had to show up authentically, and in turn, share my own identity with my students. When I learned to do that, a community began to form in the classroom. I started to seek out curriculum that was about acknowledging our stories. I would open every year with these lessons, and then I'd integrate them as often as I could so that my students' voices were part of the dialogue.

I also brought in culturally relevant material; like texts by Latino and African-American authors that would provide access points for student engagement. I was undergoing a process of self-discovery. I was learning who I was as a teacher and a white woman teaching an ethnically diverse student population.

I was also fortunate to have some wonderful formal and informal coaching and mentorship. One of my best friends—who is an administrator now—had emigrated from Nicaragua when she was young, and had grown up in the East Bay. She'd attended the school where we were teaching, and understood what it meant to live in that community, to be Latina, and to be an English-language learner. It was vital for me to have a peer who was willing to take me on the inside and show me what I didn't know. And because we had No Child Left Behind money at the time, there was a significant amount of funding pouring into the school for a short period. One of the stipulations for the money was that every teacher had to have a one-on-one teaching coach, which was brilliant. I believe to this day that if every teacher had that, it would fix so many problems in the classroom.

Hey Ms. Hoffpauir,
To tell you the truth, I've never liked English in any way, but you have helped me change my perspective. I am very grateful that you are one of my teachers. You have made learning so fun for me. Now I have an aching devotion to learn thanks to you.

Paloma, age 14,
current student

I had some great moments those first couple of years, but my weak classroom management skills resulted in a sometimes chaotic classroom with student outbursts, throwing of desks—mayhem. I did not yet understand the implications of "severe emotional disturbance" as indicated in an Individualized Educational Plan (IEP). A number of students were not getting the services they needed—both emotionally and academically. I had not yet learned the critical importance of clearly communicating expectations to students and having strong procedures, rituals, and routines. I was young.

Even though I eventually learned how to create a safe learning environment in my classroom, with a real sense of community and a rigorous curriculum, I felt like there had to be a way to do this better as a school. Ultimately,

I felt complicit in the fact that my students' needs were not being met. My experience in that community helped me to comprehend the reality of the achievement gap we have in our public education system, and though I felt called to stay in urban ed, I was burnt out.

I chose to move to Leadership Public School (LPS) Hayward, a charter high school with the exact same demographic. Although I do not believe charter schools are the answer to our systemic problems in public education, choosing to teach at one was the next best step for me. Their four hundred students are accepted through a lottery system. The school has strong adult leadership and a defined school culture. I wanted to apply my previous classroom experiences and learn how to be a leader in urban ed. LPS Hayward is a successful charter school as measured by test scores, graduation rates, and college entrance rates—so we're doing a lot of things right. The staff collaboration and culture, commitment to best practices and inquiry, and ability to innovate in order to better meet students' needs is extraordinary.

LPS Hayward has been the answer for me to stay in the classroom and continue to build my identity as an educator. My teaching philosophy today is built upon both what I learned in my first six years of teaching and what I have been able to implement in my current position. I strive for my students to see themselves as powerful change agents and I give them opportunities as part of my classes to practice by identifying problems they care about, analyzing the causes, researching possible solutions, and then taking concrete steps to help address the issues.

One of the classes I teach is a ninth-grade academic leadership class, which is a supplementary English course. The course was well-developed by my teaching partner before I arrived at the school and together we have been able to enhance and refine it. There are several components. One is an independent reading program in which the kids read silently for twenty minutes every day (the only rule is that it has to be a book they love), and the ultimate goal is for them to develop their reading identity so that they feel empowered in libraries and bookstores. The rest of the class is devoted to breaking down the reading process, and we teach informational text and research skills with the thematic focus on leadership.

The first unit is called Literacy Leadership and Power, where we read a number of literacy autobiographies,

like those of Nelson Mandela, Malcolm X, and Sherman Alexie. So, the students develop this idea that we each have a reading/writing identity, and then they really reflect on what their personal identities are as readers and writers. Each asks: What are my experiences? Where have I struggled? Where do I hold trauma? Where have I been empowered? The whole class is about growing those identities. Then we study these leaders and the role that literacy played in their ability to lead social change.

The second unit is all about health. We study the fundamentals of nutrition and exercise—like what's a calorie, and the exact benefits of physical activity. But the essential questions for that unit are broader and deeper: What does it mean for me to be a healthy individual? What does it mean to have a healthy community? What is my role in helping to make my community healthy? And ultimately, what is the connection between health and leadership? We watch documentary films that complement all the research that we've been doing—like *Food, Inc*. It's a lot about pulling the veil back and exposing what's wrong in the world.

The end of the unit culminates in a health fair that's led by the students—it's essentially a daylong graduate-style research conference. They come up with a research question in small groups. Then they go through a scaled-down version of the collegiate research process—identifying credible sources on their own, reading and extracting pertinent evidence and information; working on paraphrasing direct quotes and using MLA citations, and of course, improving reading comprehension. We develop our reading skills all year, so the health fair is really a cumulative assessment of all the skills they've learned throughout the course.

The kids prepare their research and practice their presentations. They plan every aspect of the actual event; my teaching partner and I facilitate from the background, guiding them. It's awesome what they put together. And the reason there's a lot of tension and urgency for the students is that we invite the mayor, all the city council members, the kids' parents, and the rest of the student body and faculty. Having a real audience raises the stakes and creates this incredible buzz and energy every year. More than ever, I believe it is critical to find authentic ways for our students to apply academic skills in front of an audience. I can't emphasize enough the impact this has on student learning and outcome in English and humanities classes.

The students make really cool brochures. They have to wear professional business attire. This is where the theater comes in, because the students feel like they're performing. They present to all these important guests, and then I invite the guests to present to the students. For example, the farmers' market comes and we have incredible presentations on whole foods and the disappearance of farmable land. It is a day that I would say absolutely embodies empowerment. The students are the directors of their own education and use academic language to talk about things that they care about.

> *"The better you know yourself and make time, space, and room to reconnect with what feeds your heart, the more you will be able to show up authentically in the classroom."*

My best advice to a new teacher is to spend time getting to truly "know" yourself. Teaching mirrors back who you are—your fears, gifts, and flaws—like *no other profession*. Invest in your own personal identity and realize that you have an inner life as a teacher that inevitably impacts your instruction and the quality of the learning, and the community that exists within your classroom. The better you know yourself (this includes strengths and weaknesses, light and shadow), and make time, space, and room to reconnect with what feeds your heart, the more you will be able to show up authentically in the classroom.

And never go it alone. Many times, our schools are conducive to isolation, but I have learned that building strong, real collaborative relationships is the single best thing I can do in the service of my students. It has taken me years and many missteps to learn that partnership, and working in a team, is *always* better. I need to be vulnerable, patient, and flexible to do this, but inevitably my lessons, practice, delivery, and response in the classroom, and in turn, student learning, are strengthened when I work collaboratively.

The wisest thing I did as a new teacher was to ask for help, and seek out instructional coaching and social and emotional support. Honestly, without that, I don't know if I would have found the strength and courage to stay an educator.

"I help my students to recognize mathematics in the world around them. I want them to get excited by the mathematics of doing laundry and making coffee."

Elisabeth Jaffe

11th–12th Grade
Algebra, Trigonometry, and Rhetoric

The third oldest of seven kids, Elisabeth Jaffe played the role of mediator and conflict resolver in her family from a young age. That gift for problem solving would become a vital asset to Jaffe as both a mathematician and a mentor to her urban students. Though Jaffe had always gravitated toward the profession of teaching, she was a late bloomer when it came to being a passionate student. A product of the New York City public-school system, Jaffe struggled to find satisfaction in her early education. It wasn't until her college years that she tapped into an intense love for learning. Once she found it, Jaffe threw herself headfirst into academia and spent seven years pursuing her master's and doctorate in math education while concurrently teaching high-school math. In 2012, she was invited to Washington, DC, to receive the Presidential Award for Excellence in Mathematics and Science Teaching.

Ms. Jaffe stands ready to give guidance as students finish up their math assignments.

Every element in this world is laced with mathematics, including the fractals of shorelines, the golden ratio in our bodies, the Fibonacci sequence in the petals of a flower, the exponential function of economic growth, the trigonometry of sound waves, and an infinite number of other places and things. It's not simply about right and wrong answers; it is about seeing all aspects of the world around us. As a teacher, that's what I want most to share with my students. I want them to open their eyes to a new world. In every unit I try to communicate the beauty of mathematics.

Part of me has always been a teacher. I grew up in a large family in New York City and I was one of the older children, so I was always helping with homework. In elementary school, I volunteered in kindergarten and first-grade classrooms. In college, I taught Hebrew school. But I truly realized I wanted to get in front of a classroom every day when I was twenty-one and took a class in the

It's Dr. Jaffe's unique teaching methods that really make her stand out as a math teacher. All too often, my classmates have asked how math would ever help them in the real world. Dr. Jaffe promised us an answer to that age-old question at the beginning of the year, and all throughout the course she demonstrated it to us. Her creative projects blended math with real issues of business, philosophy, and English, always going beyond the classroom. The most valuable thing I learned from Dr. Jaffe was that I was wrong to believe math is black and white, right or wrong. Math is more than numbers and variables—it's a way of approaching the world, of making sense of abstract notions, and of organizing any type of chaos in our lives. Dr. Jaffe taught me this not through worksheets, but through projects, demonstrations, and an unbridled love for her subject.

Andreea, age 17, former student

sociology of education. I learned how flawed the system was and I wanted to close the learning gap and make sure no student fell through the cracks. I also wanted men and women to feel like equals in mathematics classrooms, and for every student to feel intelligent, appreciated, and eager to learn. Fortunately, this was during a time when schools were allowed to hire directly out of college. My first year after graduating, I had my own classroom at Baruch College Campus High School. I've been here twelve years now.

When I started, I was an idealist but also a realist. I knew I wasn't changing the world but I thought that, even if for just one classroom I could be aware of all the inequities that happen, I could make a difference. Always, I have students who introduce themselves by saying, "I'm terrible at math. I don't have the math gene." That was what I really wanted to change. My philosophy is very much: You're not going to use everything that you learn here in your job someday, but you will walk out into the world and recognize it. You will see a dog on a leash and you will see

a locus. You will go to a water fountain and you will see a parabola. You will eat an apple and realize the relationship between surface area and volume. I give them glimpses into higher-level mathematics to help pique their interest. I help students understand why formulas work and where they come from. I emphasize both conceptual and procedural understanding in my classroom.

My greatest challenge is reaching the children who do not want to be reached. I have some students who see no purpose in even coming to school. They have no familial support, feel they are incapable of success, have trouble picturing their future, and do not see anything good in themselves. These students come to school in spurts. Sometimes they are absent for weeks or sometimes just a few days. How do we reach those students? Most unfortunate, really, is that they are not the ones who don't care—*those* students are easier to reach. These students *do* care, but have never experienced success in any part of their lives. They feel no one else cares, so in their eyes, their life is hopeless. I work on this every day. The challenge is that every one of these students needs to be treated differently and carefully. It is hard to know what to say, and it is hard to contact them when, many times, they refuse to go to school.

I believe every student is capable of succeeding and should feel empowered when they walk into a classroom. I help my students to recognize mathematics in the world around them. I want them to get excited by the mathematics of doing laundry and making coffee. Right now, for example, we're studying banking, and they're going crazy because they're doing a project where they have to create monthly budgets for their first few years out of college. As a result, they all want to live with their parents because they've realized how expensive it is to live in New York City. In my advisory class, I want my students to realize that books transport us through time and allow us to learn about countries we may never see, time periods we will never experience, people we may never meet, and cultures we may never come into contact with. In my writing class, I want students to be able to see their own ability to create, to defend their opinions, and to express their thoughts. In every class, I want my students to come into school every day and see its purpose.

Mathematics is not simply a series of concepts; it is also a frame of thought. It is logical and analytical. We interpret mathematics just as we interpret literature. The circles in Dante's *Inferno* are analogous to the ideas

of chaos theory. The way in which we find evidence to support our theories is the same as the way in which we support our arguments when writing essays about works of fiction. There may only be one answer to a problem as there is perhaps an intended way of reading a piece of literature, but there are multiple ways to find that answer and an infinite number of problems.

My students like me because I pay attention to them. I listen to what they have to say and I try to be flexible. If they're feeling overwhelmed, I will move tests around. I help them determine where they are going wrong. I give oral exams. I give assignments that allow choice. I definitely give them a voice in my classroom and I think that's really important. One of the simple things I do, which has a big impact, is just learning their names the first or second day of the semester. I acknowledge them as individuals. I feel a big part of my job is having high expectations and I feel like I'm successful when they develop those high expectations of themselves.

I also give them the opportunity to write as opposed to just doing problems. So I make sure they understand the concepts. My most exciting moment is deriving the quadratic formula with them because it is one of the formulas I never knew how to derive until I started teaching. They also do an analysis of statistics that are presented in the *New York Times* and they write critiques for these articles. I have students read books (*The Housekeeper and the Professor* and *Einstein's Dreams*) to see mathematics from a different perspective. They go home and they write their own chapter. In Probability, we talk about *The Lottery*, by Shirley Jackson, and the likelihood of getting chosen in the lottery. I assign projects like this all throughout the year. When students work in groups, I don't group them by ability. I group them by their greatest strength in the way they communicate mathematical ideas (writing, speaking, diagramming, modeling, abstract thinking). I want every student to know they can do mathematics.

I also try to instill confidence by meeting with them individually to discuss their goals for the quarter. I focus on how they can improve their participation and test scores. We look for ways to break down complex material into simple steps and different methods for problem solving. Students come after school for help on a regular basis. They are active learners both during and after school hours. We have a Google group, where students can post discussions and get their questions answered by me and one another. This year 72 out of 107 students

applied to AP calculus for next year. The Algebra 2/Trigonometry Regents exam is optional for our students, but approximately 90 percent choose to take it. Our students are less afraid of mathematics.

As an advisor, I provide each of my students with someone they can trust. I try to be their guide. I want them to know I care about them both inside and outside the classroom. We develop strategies both for improving academically and for becoming comfortable in social situations. We work on building entrepreneurial spirits. When they graduate, they are not just ready to go to college; they are ready to face the world.

"I knew I wasn't changing the world but I thought that, even if for just one classroom I could be aware of all the inequities that happen, I could make a difference."

I don't have favorites. I will say there are some students who require more attention and some who are maybe more overbearing. But they are all capable and I work hard to make them believe that they're capable because that's half the battle. I mean, I have had a lot of students who never spoke in class and now they're active participants. Students come in and say, "I've never gotten an A in math before and now I'm getting all A's. This is amazing."

I've taught every level of math at this point for at least a semester. Once I got my doctorate I started teaching writing, too, which I love. I am the chairperson of our mathematics department, but the other math teachers and I work collaboratively as a team. There are often more than two teachers for one grade, so we plan curriculum together. I am a mentor for all new mathematics teachers at my school and I've also taken on many student teachers.

Our world is a mathematical one. We need to be taught of mathematics' existence in order for us to recognize its true permeability. It remains hidden, and sometimes forgotten, until we learn to think with a mathematical mind. The science of patterns is a silent language. It can be seen, but not heard. It is an eternal story that exists in every book, in every time period, and in every part of the world. It is one of the only ideas and visions to which millions of eyes can open.

> *"I realized that rap music was the greatest teaching strategy of all time. At that point my mission became crystal clear."*

Alex Kajitani

Kindergarten–6th Grade
Mathematics

Alex Kajitani, the original Rappin' Mathematician, uses music, games, and whatever else he can conjure to teach the fundamentals of math and create a classroom that is the envy of the iTunes generation. "I'm a teacher who raps," he claims, "not a rapper who teaches." His first song, "The Itty Bitty Dot" (about the decimal point), started a revolution, showing teachers how to engage students and spend less time managing the classroom and more time teaching and learning. Named California's Teacher of the Year for 2009, Kajitani has recorded CDs, starred in videos, been featured at TED conferences, and appeared on TV. "Be prepared to take risks, be willing to fail and to succeed," he tells teachers, "but most of all, be comfortable with who you are. Find what you love and share it with your students."

I am on a mission to make math cool. I am known to my students as the Rappin' Mathematician, but I must admit I didn't start that way. In fact, several years ago I was a brand-new teacher absolutely struggling to survive in my classroom. I couldn't get my students to pay attention or even sit in their seats. I certainly couldn't get them to remember any math rule I tried to teach.

I was extremely frustrated. Then I realized that the kids had no problem memorizing every single word of a rap song, which unfortunately was all about violence, drug use, and abusing women. One day in class we were studying adding and subtracting decimals and I just absolutely had enough. I decided to write my own rap song about the decimal point. I called it "The Itty Bitty Dot."

I went home and did an Internet search to find a free rap beat online. Then I practiced all night in front of a mirror. I thought I was going to be "da bomb." I came to school early the next morning to get ready. My students came into the class. They sat down. I hit play and I busted out "The Itty Bitty Dot."

They began laughing hysterically at me. It was a complete disaster and I was totally humiliated. One student, Jose, laughed so hard that he fell out of his chair and hit his head on the floor. I had to send him to the nurse for an ice pack.

I thought it might be the end of my teaching career.

Then a strange thing happened. In the lunchroom, all the kids were singing my rap song, even the ones who weren't in my class. And the next day, the students were excited to be in my class. They were saying things like, "Oh, Mr. Kajitani, yesterday was the best day ever in math class. Are you going to rap again?" Jose asked if I was

going to quit teaching and be on MTV full time. At the end of the week my students' test scores shot through the roof.

Intrigued, I started to research rap music and its role in society; what I found was both fascinating and disturbing. I discovered that teens who regularly watch Gangsta Rap videos were three times more likely to hit a teacher, two times more likely to have multiple sex partners, and two and a half times more likely to get arrested. That's when I realized that rap music was the greatest teaching strategy of all time. In two-minute increments, rap was teaching our kids how to talk, how to dress, and how they should perceive reality. Rap music can make anything cool. At that point my mission became crystal clear. Instead of taking two days to teach a math concept, I'd show it to the kids in the form of a two-minute rap video.

"I am considered the grandfather of the math rap movement, but I try to make it clear that I am a teacher who raps and not a rapper who teaches."

So I wrote another song, about parallel lines, and gave it to our after-school video club advisor, who, along with our students, created a video called "So Many Lines." Embedded in this short video are countless student hours, utilizing skills like learning how to operate a camera, edit video, tell a story, and work collaboratively, as well as solve math issues like distance, angles, and timing. This video went on to win the IVIE (Innovative Video in Education) Award for Best Student Film.

One day some of the teachers came to me and said, "Gosh, we've been hearing so much about these raps and the kids really like them. We don't want to rap in our own class, but could you record a CD that we could use?" So I recorded some of my songs and called the CD *The Rappin' Mathematician Volume 1*. I created a website and word got out. Teachers started using the CD and parents started buying it. I got so many e-mails and phone calls saying, "We love *Volume 1*, but do you have anything for the times tables?" So I made another album, *Volume 2*, called *Multiplication Nation*, which was all about the times tables, with really positive lyrics and strategies for counting and for multiplying. People said, "We love the music, but do you have anything the

students can do besides listen to the music? Do you have any worksheets?" So, we created a workbook with flash cards, games, certificates, pretests and post-tests, and it became much more of a program. Now it has taken on a life of its own. I believe it demonstrates that we need to give our students as many ways as possible to learn the material in whatever form works best for them.

After I was named Teacher of the Year in California, I got a lot of exposure. I did a whole bunch of interviews and I had teachers coming up to tell me they were doing the same thing, rapping about science or history or whatever their subject was. You can go on YouTube and see how many people are out there now, making rap videos to use in their classroom. I am considered the grandfather of the math rap movement, but I try to make it clear that I am a teacher who raps and not a rapper who teaches.

I enjoy using alternative methods in my classroom. I credit my mother with my ability to be organized and get things done. I grew up in Irvine, California, back when there were still orange trees in Orange County. I am half Japanese and half Jewish. My father is an inventor, so I credit him with my creativity and ability to think outside of the box.

My mom worked in the security business, but she was a teacher before we were born. I always knew from a very young age that I wanted to be a teacher. I also knew that I didn't want to go straight into teaching after college. So I worked for a few years managing a restaurant to get business experience and then I traveled around the world. I was thirty when I started teaching.

I did my student teaching in middle school and I fell in love with teaching seventh and eighth graders. I enjoyed them and empathized with their awkwardness and struggles, but I was astonished by how many of them lacked basic skills. One student, Eduardo, didn't know how to tell time. When I asked him why, he said it was because no one had taught him. That day I took the clock off the wall and changed my lesson plan.

I didn't train as a math teacher. I studied sociology and passed a test to teach history. But there was such a need at the time for math teachers that I moved in that direction. I think because of my training, my education, my business experience, and my travels, I knew how to see the bigger picture and how concepts and ideas are interrelated, which is something I use in my classroom.

For example, I created a game called The Math Professor to show my kids the relevance of mathematics

in their lives. It's very simple. I pretend to be the Math Professor and I declare that there is nothing that does not have something to do with math. I challenge my students to try to think of *something* that I cannot relate to mathematics. The students come up with all sorts of crazy things to stump me.

For some reason they always bring up ketchup, and so we talk about ratios, proportions, calories, and cost production. Or they bring up soccer, and we talk about distance, angles, and keeping score. Now, I will admit that once they almost got me. A student raised his hand and said, "Oh, Mr. Kajitani, I know something that has nothing to do with math. Love!" And I said, "Huh."

I was about to admit defeat, when another student raised his hand and said, "Well, when you're in love, it can get very expensive." Another student raised his hand and said, "Oh, I know. Normally in math, one plus one equals two. But, if you're in love and you're not careful, one plus one can equal three." I cut it off right there, but this is what happens when the students are engaged and excited about participating. They start to say things like, "Oh, hey, Mr. Kajitani. I thought of something that has nothing to do with math. Oh, wait, no, never mind. I figured it out." After a while they don't want to play this game anymore. That's when I've got them; when I know I've instilled in my students the real relevance of mathematics and why it is part of their curriculum.

A few years ago, I started getting invitations to speak to and coach teachers—not just in math, but also on different aspects of education. I began putting together training courses and writing speeches and I absolutely loved it. When I speak to teachers, my classroom becomes much, much bigger. I love teaching thirty students at a time, but when I teach thirty teachers who each have a classroom of thirty students, I suddenly have a classroom of nine hundred. I really feel like the next phase of what I have to contribute to education is advocating for teachers and helping them be the best that they can possibly be.

What I didn't realize when I started teaching is that I didn't have to pay for everything myself. Many times, I went out and bought supplies or food for the kids; accepting it as part of the job—an unintended expense of being a teacher. But after I'd been in the classroom a few years, I started to form partnerships with local stores and businesses and asked them to donate the supplies that I needed. Once I learned to reach out for support from the community, I discovered that people love to help

teachers. Though it is hard sometimes, teachers have to be willing to ask for help.

I have a poster hanging in my classroom that says "Kajitani Style" and it shows kids how to format their papers—where to put their name, how to number their pages, and basic style things like that. When I'm walking around checking off homework I don't have to say to a kid, "Hey, how come you didn't circle your final answer?" I just say, "Hey, is that Kajitani Style?" and they fix it. But, what also happens is that over the course of the year, "Kajitani Style" becomes something much greater. It becomes a part of the culture of our classroom. So, when I walk into class with a new haircut, the kids say, "Hey, nice haircut; that's Kajitani Style right there." One day I spilled mustard on my tie at lunch, which left a stain. I walked into my next class and said, "Check it out, folks. It's the mustard-on-the-tie look. That's Kajitani Style, yeah."

"Once I learned to reach out for support from the community, I discovered that people love to help teachers."

After a while the students begin to form their own "styles." A loud and rambunctious student like Myra starts to develop Myra Style. A quiet and shy kid like Victor develops Victor Style. Suddenly, all the weird and awkward things that bother my middle-school students about themselves become their "style." By my example I am trying to show the kids how to be comfortable with who they are. When you're comfortable with who you are, suddenly you're cool. For myself, I've learned to be comfortable being that weird math teacher who gets up and raps.

Even though I am known as the Rappin' Mathematician, I've tried to be very clear with teachers that what I do is really not about rapping. It's about finding and creating ways to engage students in the lessons. I tell teachers, if you love hiking, take your students for a hike, just make sure you get some math or science in there. If you love knitting, teach the kids how to knit and get some engineering concepts in there. Find something you love and incorporate it into your teaching; let that become your "style."

The true key to education is to stop forcing the lessons we need to learn into our lives, and to start putting our lives into the lessons we need to learn.

"I believe there are two inseparable parts to a successful and meaningful education: academic excellence and character development. This twin focus is at the core of DC Prep's mission to bridge the educational divide."

Julia King

5th and 7th Grades
Math and Reading

When Julia King told her parents she wanted to attend a particular magnet public high school, they bought a house in that school district and moved the family. That's how prioritized education was in King's upbringing. Today, as a classroom teacher at DC Prep, a high-performing network of urban public charter schools in the nation's capital, she works relentlessly to ensure that every child in her care has the same academic opportunities she had, regardless of economic status or geography. In 2013, she was named DC Teacher of the Year and will soon take on the added leadership role of assistant principal in a brand-new DC Prep middle school. King's mission, simply put, is to see the achievement gap in this country significantly reduced in her lifetime. And she fiercely believes it is possible. "What motivates and excites me isn't the problem but the solution," says King.

Ms. King with a group of her students in the halls of DC Prep.

It's actually pretty ironic that I became a teacher. I liked school, but I was always getting into trouble: for talking while the teacher was making some erudite point, for leading a boycott against funky school lunches, and for getting all the other sixth graders to fake smile at Ms. Wilson until she self-consciously burst into tears and ran out of the room. So, the last place I thought I'd be hanging out was the teacher's lounge.

But when I was in college I took a class on social justice and learned about the institutionalized disparities in our educational system—what Jonathan Kozol called "savage inequalities"—based on wealth. I learned that the "fix" to poverty must be multifaceted, but ensuring that every child has access to excellent teachers is a critical component to leveling the field. When I graduated, I decided to join Teach For America (TFA).

My first year was tough. I was teaching third grade in Gary, Indiana, at one of the lowest-performing public charter schools in the state. Only three of my kids were performing at grade level. All of them were poor and the neighborhood was dangerous. For the first month I cried in the car every day on the way home, panicking that my inexperience was going to further contribute to the opportunity divide. Slowly though, I realized that just as my students had agency over their efforts, I did, too. I learned to use frequent student assessments and state standards as teaching mirrors that allowed me to see where I needed to put more attention. I wasn't teaching to the test, but testing my teaching for each individual child.

I also assembled a small army of teachers in my school who were invested in helping me move toward proficiency. I never wanted to be an island as a teacher—closing my door in September and not being seen until spring. I'm never afraid to receive constructive criticism or scrap what I'm doing in favor of someone else's better idea.

Despite my rocky start, at the end of the year, my students were recognized for making the greatest gains in reading across a network of eleven charter schools. I looped with them to fourth grade, and over the course of two years, raised the passing rate for the standardized test from 23 percent to 84 percent in English language arts and from 23 percent to 88 percent in math. At the end of my TFA commitment, I was awarded the Sue Lehmann Excellence in Teaching Award—TFA's prestigious national teacher of the year award given to just one elementary school teacher from a corps of over six thousand. Many of

my practices have been adopted by Teach For America on a national scale, and for the past two years, my classroom techniques for creating a culture of achievement have been studied by seventeen thousand incoming corps members.

My plan was to spend two years in the program and then pursue my intended field. So toward the end of my commitment I flew back to Washington, DC, to interview for positions in international relations. It was during that week that I realized that what I thought was a temporary commitment with TFA was actually the beginning of my career. I have now been teaching math and reading to fifth graders and math to seventh graders at DC Prep for the past three years.

You're always there to remind me to do the right thing and help my classmates achieve by setting a great example. You never give up on a student no matter what. You talk honestly about why it's important for us to get an education. You've told me that so many DC students don't graduate from high school or college. You've told me that people in this city expect us to just give up when things get hard. You've told me we shouldn't do that; we should succeed. You've told me that trying hard is what we all have to do to succeed in life, and that having an education is key. Thanks for being such a great teacher.

Orie, age 13, former student

I believe there are two inseparable parts to a successful and meaningful education: academic excellence and character development. This twin focus is at the core of DC Prep's mission to bridge the educational divide. In my classroom I explicitly teach both every day.

I weave fun and creativity into my lessons, but at the heart of each is a methodical approach to teaching specifically defined skills and assessing student understanding. For example, I recently taught my students to identify the mean of a set of data. I started by handing out twenty-five army figurines to five students in the class. One student got ten, another got only two, etc., and complaints ensued. I said, "Well I don't *mean* to be *mean*, let's even it out." They redistributed the figurines amongst themselves, so that each of them had five apiece. We did this again with the whole class in groups of four, each group getting twenty-eight items. The students took turns handing them out "unfairly" and then saying, "Well I don't mean to be mean, let's even it out." They eventually saw that the mean was seven no matter how the data was distributed.

Character development cannot be taught after recess and before social studies. It must be embedded into lessons throughout the day. Things like following directions, working well with others, caring for your belongings, staying on task, expressing your feelings appropriately. The idea is that those qualities and skills aren't practiced in isolation. They are habits that need to be reinforced and practiced every moment in order to reach your goals and your potential. We talk a lot about how we all need to succeed and be the best as a class. Everyone at DC Prep is expected to help upon request or to accept help. I leverage competition to invest them in helping one another—so that we can all be better.

Since my first year as a teacher, I've used a Stanford University study about self-discipline. It revealed children who would wait to eat a marshmallow are more likely to go to college and be successful. During the first week of school I put a marshmallow in front of my students and say, "If you can wait, I'll give you another marshmallow." For fifteen minutes I continue to teach a lesson. Of course, many students eat the marshmallow and are disappointed not to receive another. I explain the study to them and the importance of showing self-discipline and taking baby steps toward a big goal—even if it's difficult. We now use the saying, "Don't eat the marshmallow," as a reminder to show self-discipline and stay focused. By being able to exercise self-control, a child can learn to overcome distractions, cooperate with others, and work toward goals.

I think the biggest thing that sustains me as a teacher is my determination to ensure I'm doing everything I can to make my students successful. I truly believe that they can thrive, and that belief has always reassured me. I ask myself, "What else do I need to do?" And, "Who do I need to learn from so that I can be effective at this job?" But I never think, "This is not a solvable problem." Teach For America really instilled that conviction in me, in addition to my upbringing and my view of the world. I know I can do it because my students are kids just like any other kids. Of course they can learn. Of course they can love school. Of course they can build good relationships. Of course they have a voice. They just need to learn how to use it.

DC Prep really values parent and family involvement. And so we will do whatever it takes to keep families involved in the process and really see them as part of the solution, which I don't think all schools do. Before each

> *"The real goal is not for charter schools to take over. It's for them to prove what is possible, to set a strong example and then to create a tipping point."*

school year starts I call every parent. I ask questions like: What do you hope for Jerome this year? Throughout the year, I try to call every parent twice a month just to check in. I share all data with my students and their families. I have frank conversations with parents about the achievement gap and what their child needs to be ready for the next grade and beyond.

I recognize that my key influencers have different preferred methods of motivation. For example, Devon is late to school 60 percent of the time. He was regularly late last year, too, and the normal systems to encourage punctuality failed to motivate his mom. Recently, my whole class began to leave her a quick, boisterous "thank you" voicemail if she gets her son to school on time three days in a row. It's unorthodox, but it works.

If not the parents, then there's someone in a kid's life who loves him or her and wants the best for them. As a teacher, you have to find who that person is and then ask them for help. I also had to learn how to make sure that I was being perceived correctly. I'm not a mom. I'm young. I'm not black. I'm not from their neighborhood. I don't know a lot of things that they know.

So I often set it up like this when I talk to a parent: "Here is something that I'm struggling with. Kai shuts down when she doesn't understand something. She misses what she's supposed to learn and then when she checks back in, she's too far behind and confused to participate." I ask, "Do you ever see this at home?" If the answer is yes then I continue with, "You're her mom and I'm sure that you've got tricks that I don't know. How do you respond to that?" And, "I know that you're important to her and that if she sees that we're on the same page, I will probably have a better chance at changing her behavior. How do you feel about me using the same term or language you use?" That brings the parent in. I'm valuing their way of coping with the problem and probably leveraging my impact, too.

I had an excellent education growing up and was raised to believe that I could do whatever I wanted to if I just put my mind to it. And that's the same thing I want for my students. I tell them all the time: "Based on the statistics, half of you shouldn't graduate from high school. Can you pick out half the class who you want to have that destiny in this room?" Of course, they're like, "No." And the fact is, it doesn't have to be that way. In their school it isn't. So there's no acceptable reason why half the kids at the public school down the street should be on a track not to graduate and lose the opportunity to choose what they want to do with their lives. There's so much that we're doing that's working at DC Prep, that could be replicated and used in low-performing schools nationwide that I am confident would result in happier, more successful students.

The real goal is not for charter schools to take over. It's for them to prove what is possible, to set a strong example and then to create a tipping point. DC Prep is 98 percent African American and 80 percent low income. In DC, on average, only 45 percent of students are on grade level. In my classroom it's 100 percent for math and 92 percent for reading. Once you see what is possible it becomes unacceptable to have anything else.

Ms. Law and a group of her students let their hair down in the classroom.

"I like to get them up and moving a lot. We dance together every day."

Kristi Law

3rd–5th Grade
Magnet Program for the Gifted

Kristi Law never sits down. Standing only a few inches taller than many of her students, she has as much energy as all seventy-five of them put together. In Law's world, every day is different—you might walk into her classroom just in time for a Senate simulation, or catch her students making a volcano to end their geology unit with a boom. But no matter what day it is, there will always—always—be dancing. Earning both her bachelor's and master's degrees in elementary education, Law went on to attend the renowned Galileo Institute for Teacher Leadership. Law empowers her students to move through their comfort zones and become risk takers, and slowly but surely, she helps them find and nurture the incredible potential she sees inside each of them. She builds trust and confidence the way engineers build bridges.

Ms. Law and a group of her students let their hair down in the classroom.

I can tell you the two teachers who made the difference for me. I remember their names, I remember what they did, and now I do some of those things with my students. In fourth grade I had Mrs. Goshorn. Up until then I was known as Derek and David's little sister. She was the first teacher to get to know me for me. My fifth-

grade teacher was Ms. Michaelis. She would go around and work with us one on one. She brought everything to life and made it all relevant. She had us create our own businesses. She called this activity "mini-society." My business was mix tapes. Fifth grade to now—twenty-six years, and I still remember.

My grandfather left his family when my dad was about fourteen years old. To earn a living, my grandmother worked as a switchboard operator for Hudson's in downtown Detroit. She thrives on people—my mom and my grandmother are very much alike in this way—they both love talking and really connecting. My mom taught me to stand in the grocery line and make friends. She and my dad will be celebrating their fiftieth anniversary in February. My dad is really into commitment. He's had the same job as an mechanical engineer with Ford Motor Company since I was little. He's always been the "pusher." He was at every one of my dance practices, watching through the windows. Both of my older brothers played hockey. My dad never missed a game. He always told us we could do just about anything.

"I come to life in front of others, but an audience of children makes me strive to be a better person."

My plan was to go to college and become an engineer like my dad. So when it came time for orientation at Michigan State, I was ready. I took a look at my classes. Not one of them sounded fun. I ended up switching my major to "no preference." Throughout my freshman year I kept asking myself the same questions over and over again: What do I want to do every day? What will make me happy? I spoke with advisors, my friends, and of course my family, and then sat down to list what my ideal work environment would include: no cubicles or office doors, the use of music to inspire thinking, constant problem solving, ongoing excitement, and most important, me being me. It took all year, but I finally realized: teaching was my ideal profession. I come to life in front of others, but an audience of children would make me strive to be a better person.

My first job out of college was teaching second grade. At the end of every school year I told my principal, "I don't care where you put me next year, as long as you think I'll be serving students in the best way." Then, after my third year, all but one member of the teaching team that was running the district-wide Magnet program for talented and gifted students retired. The moment I heard this I ran to my principal, "That's my job! That's the job you hired me to do, you just didn't know it at the time!"

It's my fourteenth year teaching now, and for eleven of those years I've been with Magnet.

The first day of my first year in the program, I said to the students, "All right, guys. I want to see what you can do. Take a few minutes and write for me." One of the boys came up and said, "Well, Mrs. Law, I would like to write about a guy who travels to another planet, so I'll need to know how many earth days it would take to get to Jupiter and back." A few minutes later we were in the media center. We got some books, we looked it up, and he finished his story. That was day one and I've never looked back—I knew I had found my calling.

In college they teach you how to write a curriculum but they don't teach you how to manage a class of thirty-two kids. One of my goals that I work on every day is becoming a good listener. I did a teacher leadership program and they took us through Dr. Stephen Covey's *The 7 Habits of Highly Effective People*. The one that stuck was, "Seek first to understand and then to be understood," and it is something that I will work on until the day I die. When I have amazing days it is mostly because I have learned to be quiet. Truly being someone who listens and not just hears is about as innovative as it gets.

I am huge on empowering the students. We wrote a classroom constitution together with the kids that's got a bill of rights at the beginning. It's very clear. It covers our homework policy and exactly what's expected. We have a monetary system. We are teaching life skills and organizational skills, which is a must in our room of seventy-five third, fourth, and fifth graders. We even have sheriffs. What I love about our sheriffs is they handle all the "court cases." "So-and-so took my pencil out of my desk"—those small things that just take away from my energy and everything else that I'm doing, but are still important and need to be addressed. We've trained them, we've sat with them, we've talked to them. And then my teaching partners and I deal with the bigger issues that arise.

I have to know my students to the core. I have to know that their parents just got divorced or even that they're thinking about getting divorced. The parents don't tell you that, but the kids will, if you are listening. So, I greet them at the door every morning. "How are you?

Hey, what's up with the face?" I have a little private box, too, where they can put their personal questions, suggestions, thoughts. That's my way of making sure that a kid who does not want to share something in front of the class can still be heard.

There are many kids in our class who have told us year after year that they never made a friend until they came to Magnet. In many cases, these kids are so far beyond their other classmates both mentally and academically that they just can't relate—like, they don't care about Pokémon. I don't know how a general-ed classroom can truly meet the needs of kids who are reading two grade levels below. Whom do you give attention to? The fourth grader who is reading at a second-grade level or the one who's reading at a high-school level? One of the moms of a student who used to be in general ed said to me the other day, "I just wanted to see my son's teacher give him a book about dogs and tell him to write a report. He'd have been in seventh heaven. But instead he was sitting in the corner learning what the letter T sounds like. The kid's been reading since he was three."

The project that I'm doing right now with my fifth graders is probably my favorite. It's our poetry unit. I have them analyzing songs. All the kids bring in lyrics of their choice. Any song they want as long as their parent signs off. The writing that I am getting from them is out of this world. I took something that meant a lot to them—their music, what they listen to on a daily basis—and said, "Apply what I taught you." To me, my job is to give them the content that I need to and then let them do what they want with it. I'm not saying that I don't support them or talk them through the assignments, but it is their work and I facilitate.

I have a book that says, "Never say what a kid can say." I learned early on that when I say something the kids take it as fact. But if one of their peers says it, then all of sudden they're not so sure, now they have to at least pause for a second to analyze whether she's right or wrong. That creates a different kind of thinking. I'm not afraid to give them that little bit of freedom. I always tell them "I trust you. We're a team."

Every morning meeting I tell them about my day, and I'm honest: "Guys, I'm in a bad mood today. I got off to a late start. I'm going to need ten minutes to perk up because I'm crabby." The more I let them into my world—appropriately, of course—the more they let me into their world. If you can build a connection with your students,

they will do just about anything for you.

I always tell my kids, "If I'm bored, you must be bored!" We don't do "busy work" in our classroom. Every lesson involves doing projects, conversing, and problem solving. We work with an amazing engineering program called A World in Motion, brought to us by SAE International. The program partners us with real engineers and allows our students problem-solving experiences that help teach them the investigative process, communication skills, the laws of physics, and other scientific principles.

I may be teeny tiny in stature—I'm four feet eleven—but I have a very big personality. I'm told I offer an energy that is unmatched. When you walk into my room there is a vibe that's different from any other classroom. There's a Tom-Cruise-jumping-on-couches kind of excitement. I like to get them up and moving a lot. We dance together every day. I feel like I make the kids see a piece of themselves that they may not otherwise have seen until later in life. One of the things that I love the most is getting the quiet kids out of their shells. When I have a student

> "I always tell my kids, 'If I'm bored, you must be bored!' We don't do 'busy work' in our classroom."

who says, "Mrs. Law, I'm kind of shy," I always say, "Okay, we're going to find your inner Mrs. Law by the time we're done." And that's become the standing joke. By the end of the year their parents always say, "They found their Mrs. Law." That's what I love the most.

One particular student of mine, Jordyn, was very introverted. This was a girl who would never speak. Who would never raise her hand. Who wouldn't take risks. Other people told me: "Kristi, she's quiet. Let her be." But no one should want to feel that isolated as an eight-year-old. So, every day: "Hi Jordyn. How are you Jordyn?" I just took the time. Jordyn's mom knew she had confided in me over the years. The last day of school she came to me and said, "Jordyn locked herself in her room last night and came out with this envelope in her hand and tears streaming down her face. Here it is. Whatever you did for my daughter, I'll never be able to repay you." Jordyn's an eighth grader now. I just saw her in a musical. In the letter she wrote, she said I helped her become the person she's proud to be.

I teach because I'm me and I'm me because I teach.

> *"Every project has to result in something the kids can use or put up on the wall."*

Janey Layman

6th–8th Grade
Computer Systems and Business Education

Mrs. Layman in the computer lab with her students.

Janey Layman has teaching in her blood. Just as the plumber's son often becomes a plumber or the lawyer's daughter joins the family practice, so Layman followed the footsteps of her parents, right into the classroom. But once there, Layman blew tradition out of the water, making innovation and collaboration the mainstay of her teaching style. She takes what many would consider boring bread-and-butter computer skills and turns them into exciting tools used to achieve real-life goals. Whether it's teaching her students how to use Excel through forecasting the statistical likelihood of who will win the Super Bowl, or guiding them through the fundamentals of Photoshop in the design and production of a homemade board game, every assignment she doles out is project-based, has tangible value, and most important, is every kid's definition of cool.

As soon as I graduated college, I became a professor of business ed at the university level and stayed for ten years. And then there came a point when I just felt like, "I can't do this anymore; I can't teach what I've never actually done for a living myself." So, I went into the corporate world and worked as a trainer, a systems programmer, and an analyst. I learned database management and networking skills. A decade later, I missed teaching. I've been at Southmoreland ever since.

Experience has taught me there should never be a teacher who goes into the classroom without having had some other job first. What exactly are you teaching kids if you've never applied what you know in the real world? You have to get out there and put your skills to good use, and then bring back those experiences to your students. My advice

to aspiring teachers: *do* something first. Even as a professional teacher, I continue to work outside the classroom as well, just to keep my skills fresh. It's important.

I teach computer systems and business, rolled into one. Depending on the grade level, my students learn how to use Word, PowerPoint, Excel, and Photoshop. They also learn digital photography, a little bit of video making, and programming. Every single thing I teach is very purposeful and project-based. I don't ever teach out of a book. I create assignments that have real-life applications. Every project has to result in something the kids can use or put up on the wall; and every project incorporates tons of computer-systems skills. My number-one priority is for the students not to memorize facts and skills, but to *live* and *learn* them through real-world experiences.

THANK YOU Mrs. Layman for being an AWESOME, amazing, creative, and techie teacher! Computer time is not boring, NO! From making a music video with a 4 ft. Heinz ketchup bottle to actually running a HUGE school-wide deck tennis tournament, every day is simply magical. We do things other kids just dream about.

Samantha, age 14, former student

When I first returned to the classroom, I was teaching high school. I had an entrepreneurship class that was just phenomenal. They learned by creating and running actual businesses—not just simulations. For instance, we created a new burger for our local Wendy's. The class was divided into three teams, and each group worked with the school's foods department and came up with an original burger. Then I had the Wendy's executives come in and rate the burgers. The winning one was called the Fire Burger—and the execs loved it.

Our biggest success is the Frosty Open Golf Tournament. We raise about $4,000 for charity every year with this event. It has all these crazy twists to it. On one hole you have to putt with a hose. On another hole you have to use a driver that is, like, two feet long. Little did we know, when we started a decade ago, that this "small" event would go on and be sponsored by Wendy's and Walmart, and that it would have a sell-out crowd each time. It became so big that we had to change venues, and more than seventy-five students became involved in the planning and execution of the tournament. Not only did the students learn project management, but they also had to learn how to present themselves in front of

adults and executives, how to fund-raise for charity, and how to control costs and maximize profits in a real-world scenario. Students each had positions from project manager to department manager to financial manager. It was a lot of work but it was unbelievable what they could do when they worked together and saw something real come to life.

Now, I've been at the middle school for three years and it's fun, too, but the skills I teach the younger kids are a bit more basic. For instance, typing on the computer is important for sixth graders to master. Since cupcakes are a hot product right now, I have them learn Microsoft Word and practice their typing by assigning them the writing of a business plan for a cupcake store. They have to pick a location for their shop, calculate how much they're going to charge, decide what kinds of cupcakes they're going to sell, and what makes their cupcakes unique. I explain what demographics are and they have to figure out who their customer is. They write about how they would advertise. I ask them to come up with as many creative ways to get the message out to the public as they can with a budget of $1,000. They have to do a little bit of online research for that. And then we create a mock-up menu. The business plan ends up being a six- or seven-page document. They've probably never typed more than three paragraphs before, honest to God. But because we do it together and we do it one piece at a time, and each piece has a reason and is part of a real-world project, they aren't overwhelmed in the slightest.

Then they go home and they bake some cupcakes and bring them in, and we have a little party. They put out the signs they made for their businesses with a price list and we invite one of the other classes to come over to test all the cupcakes and vote for their favorite. The winner gets the Best Cupcake Award. In the end, they've practiced their typing skills and learned how to write an entire business plan, think critically, do Internet research, and use all the different tools and functions in Microsoft Word. All the while, they're having a blast and they don't even realize how much they've learned.

The seventh-grade curriculum is more artsy. We create scrapbooking pages. We make very large digital prints. I've gotten a lot of grants and we have a little photo studio. I teach the students about what makes a good picture. We spend a great deal of time looking at photographs, critiquing them. And then I let them take some pictures with their friends and we learn how to use Photo-

shop to modify them. The kids take their pictures home as gifts for their parents. They also learn and practice Power-Point by creating an "All About Me" presentation, where they have to make ten different slides—of their family, their friends, some of the places they'd like to visit, things that they want to do in their lifetime. And then they have to get up in front of the class and make a presentation.

In eighth grade I try to squeeze in as much business ed and programming skills as I can so that they're prepared for high school. We do Excel to begin with. As our service project, we always run a lemonade stand for Alex's Lemonade Stand at lunchtime. So we chart our sales every week using an Excel spreadsheet, and then we talk about how we can boost sales. And we look at what's causing ebb and flow and why we sell so much at this time and what percentage each grade buys. We run it like a real business and they get to see how they're doing.

And then, if it's Super Bowl time, we make predictions. Luckily for us, we're in the Pittsburgh area, so we're fortunate to have been in several Super Bowls. It's been a lot of fun looking at stats over the years to see what matters the most in the outcome of all the Super Bowls. For instance, did the passing yards consistently matter? How about the receiving yards? And we target back about fifteen years and do some analysis and trending to see if we can figure out who will prevail. And then, of course, the day after the big game, we see if we were right or wrong. Did we make a correct assumption or not? And then we talk about the role of statistics and how neat it could be to do this for a living.

Since one of their favorite things to do in phys ed is play deck tennis (like tennis with a Frisbee) we decided to do a tournament for charity—similar to the idea of the Frosty Open, but with fewer elements. Out of 400 students, I think we had 320 participate. It was huge. My students planned out every component for the tournament. First, they had to do profit forecasts to make sure it would make money. They had to figure out how many party supplies we'd need, like napkins and plates, and call Sam's Club to get the cost. How many pizzas would we have to buy? What would it cost from this vendor compared to that vendor? If we assumed that there were 250 students coming, then how much would we make? What if there were 400? They had to do a whole cost analysis on what it would take to run this tournament.

The first year we had a ton of students, but we didn't make as much money as we forecast because we lost a lot on the pizza. When we had done our research, all the kids said, of course they wanted pizza, but when it came to the evening of the event, they either didn't have money for pizza or they were occupied doing too many other cool things. So, the next year we ran it as an all-inclusive. We decided to charge one price—$12—and that included pizza, drinks, a T-shirt, music—everything. So, if a kid didn't eat a piece of pizza, no big deal, we knew we'd already made money because we'd charged up front. My students came back into class the next morning and they were exhausted. But they felt so great about what they had accomplished.

> *"My number-one priority is for the students not to memorize facts and skills, but to **live** and **learn** them through real-world experiences."*

My mother and father both taught high school. My cousins are all teachers. My sister is a teacher. She teaches high-school calculus and I have to admit I get on her case every day. I ask her, "Why don't you make this relevant to your students? Where are they ever going to use calculus? Show them!" As much as I love math, it drives me bonkers, because math teachers never explain why you need to know this stuff. "Why do you think they hate math? Because they don't get that they need it in everyday life!"

The greatest challenge I face, without a doubt, is how little importance is placed on teaching technology and business skills in comparison with reading, writing, math, and science. The skills I teach incorporate all of the "core" subjects and actually show students how those subjects are applied in a real-life situation, yet those of us who teach "electives" (including art, music, and phys ed in my school) are deemed unimportant in state assessments and, in some cases, in our own school districts, making funding for our programs a big challenge.

In my opinion, we have it all backwards. We should teach the core subjects by vocation first, not the other way around. Kids should explore careers and goals, and then learn how math, science, reading, and writing are needed for lifelong success. Without that application, how do students know that being able to write a sentence, let alone read a book, is necessary for your entire life?

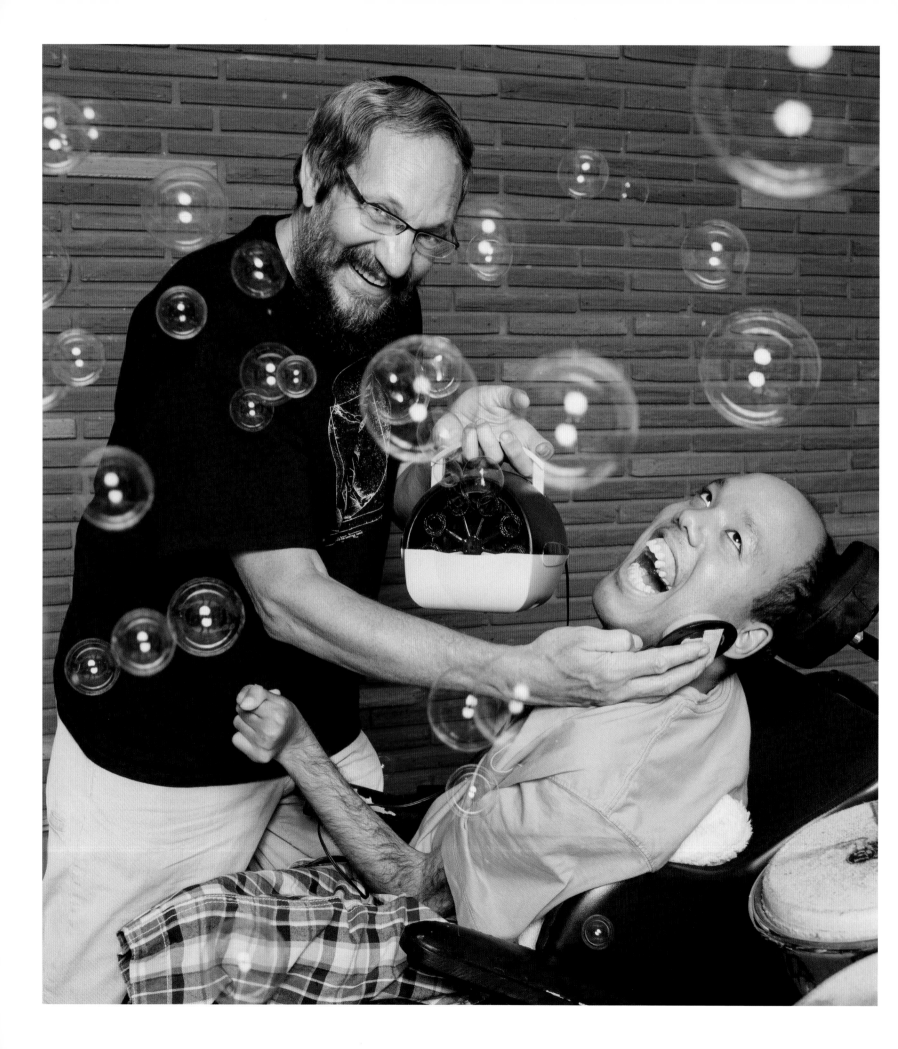

"I use an experiential approach to reach my special-ed kids. I have seen magical results when the expressive arts are combined with assistive technology."

Dr. David B. Lazerson

Kindergarten–12th Grade
Special Education Music & Drama Therapy

For the past thirty-five years, Dr. David Lazerson—affectionately known as "Dr. Laz"—has worked with special-needs kids of all ages and abilities. He believes, quoting the great poet Robert Frost, "I'm not an educator but an awakener." Lazerson uses music to awaken his students, bring them out of their shells, and help them interact more meaningfully with the outside world. In 2008, he was inducted into the National Teachers Hall of Fame and in 2007, he was named Broward County's Teacher of the Year. "Part of my teaching approach is the notion that music, especially experiential music, is magic," he says.

Dr. Laz teaches his student Tony ("T-man") with the help of bubbles and drums.

Like many teachers, I was inspired by the teachers I had throughout my schooling, from primary to high school and beyond. These were true educators who knew how to involve and motivate students. They taught material with a fun and more experiential approach. We did individual and student group projects. We went on field trips. I remember a physics teacher who brought in a Slinky to demonstrate what waves were and how to measure frequencies. I learned that even traditional teacher-centered classrooms could be taught in a more inspirational way.

The clincher for me was actually a graduate-level course in educational/psych statistics—a mandatory course requirement that most students, including myself, simply dreaded. But here, too, I was fortunate because the course was taught by a master teacher, and in a matter of weeks I was wearing one of those big, nerdy calculators in a pouch on my belt. I even found a mistake in one of our stat textbooks. But the lessons went much deeper than simply learning how to calculate a standard deviation or an analysis of variance. I learned about teaching by watching. It was clear proof to me that in the hands of a great teacher, anything could be taught in a way that challenges and excites students.

I wanted to become a teacher to help the underdog, believing that the fault never lays with the student but always with the instructor. Growing up I probably would have been in some sort of ADD/ADHD-type classroom, but they simply didn't have such remedial programs back then. In fact, I don't even recall hearing that label used when I was a student. I knew what it was like to struggle in class so, as an adult, I felt that I could make a meaningful impact with my students no matter where they came from or their level of daily challenges. They simply needed good education, not the usual heavy-handed dose of memorizing and testing.

After my undergrad degree I found myself in rabbinical school, studying the Talmud, which was taught in a paired-student fashion. I attribute much of my newly acquired enthusiasm for learning to this amazing approach. I went from hitting the books maybe eight hours a week in college to more than eight hours a day in this unique program, where students did the vast majority of their studying together, and engaged in a

process of questioning, analysis, and digging deeper into the texts.

I got hired at a Hebrew school and I was also a big brother at a counseling agency. There I worked with a guy who was a paraplegic, and right from the get-go I realized I wanted to teach kids who had special needs. I guess that coming from Buffalo, New York, and being a fan of the Buffalo Bills, I knew about rooting for the underdog. It seems like for all the Buffalo teams, we are always saying, "Oh, next year! Next year!" and, as crazy gluttons for punishment, we believe it! So when I decided to get my master's degree in education, there was no doubt that it would be in special ed.

Dr. Laz,

It is a privilege and a blessing to have you involved in Tony's life. Though Tony is a quadriplegic and is totally dependent on others for most of his daily needs, music has always played a big part in his life, and you have helped him tremendously to explore and enjoy it even more! Every time we mention your name and tell Tony we are going to see you for choir/band practice, his eyes light up and he gets very excited. It is people like you that help restore one's faith in mankind.

Hamilton & Katie,
Tony's Mom & Dad

While working for my master's degree, I was profoundly influenced by one particular teacher, a clinical psychologist. In our first class he told us to look out the window and tell him what we saw. Well, right across from Buffalo State College was Buffalo State Hospital, a scary place with barbed-wire fences and window bars. You could see men in white coats escorting patients around. The place was infamous for using shock therapy and having padded cells. Then the teacher asked, "Okay, what's the difference between the people behind that barbed-wire fence and the focused, success-oriented people in this classroom?" No one dared answer.

The teacher went to the blackboard and wrote these words: FID and GOK. Then he turned to us and said, "You will do great things for your students if you remember these two things. First of all, the people who are over there and the people in here all do the same kind of stuff. We all have our idiosyncrasies, our hang-ups, and our ups and downs. We all have negative things inside of us that we are able to keep under control. The difference is they're behind the bars because of FID. They do it more

frequently, with greater *intensity*, and for a longer *duration* of time. Other than that we're basically in the same boat." I just thought that was brilliant.

Then he added that when all of the significant others in a kid's life have had their say—all the therapists, psychologists, parents, siblings, teachers, administrators—when they're all done trying to figure out the kid, just remember that the answer is GOK: God Only Knows. And that was that. It was the most relevant thing anyone ever told me about teaching special ed.

I think my style of teaching could be described as student-centered rather than teacher-focused. It's one that involves the students as active participants rather than passive observers. I try to incorporate the things I've seen work wonders for myself as a student and for the students I've taught during the past thirty-five years. I see myself more as a facilitator; my job is to inspire. If I can kindle this inner light within them, there is no limit to what they will try and what they can accomplish. I use a variety of techniques to encourage this process, including the expressive arts, such as music, dance, movement, drama, visual arts, and journal writing. My teaching arsenal also includes peer tutoring. I'm a big believer in class outings and trips, as these reinforce all sorts of skills and help bridge the gap between the classroom and the "real" world. On our guided nature walks and outdoor adventures, whether it's kayaking or biking along birding sites, we leave our cell phones and digital gadgets behind.

For much of my career, I've taught students with profound autism, Down syndrome, cerebral palsy, and multiple disabilities. Each year and every class presents its own set of unique challenges. This is particularly true since I've had students from all across the academic spectrum—from the student who's a few years back in his or her reading grade level to the student who is classified as "medically fragile." My work has been both challenging and frustrating at times, since growth is often measured in very small steps. But at the same time, it's been incredibly rewarding.

Today I run the hands-on music program for the Quest Center, a special-education public school in Broward County.

Music has always been a major part of my work and my life. Growing up in Buffalo, great music was always playing at home. We listened to Count Basie, Joe Williams, Ella Fitzgerald, Billie Holiday, Benny Goodman, and many others. My older sister and I introduced my

parents to the Beatles and the Stones. As the years went by, we took music lessons in piano, drums, and guitar.

My passion for the drums was a noisy enterprise, so my parents came up with this rather wise plan: For every month I stuck with the lessons, they'd purchase another piece of the drum set. It took me close to a year but I did indeed earn a complete kit. Drums became my "ticket to ride," providing the boost I needed to find my strengths, self-esteem, and confidence, particularly when I joined a band and started performing. Thinking back, it does boggle my mind how much all of those lessons truly paid off for me to this very day.

My students now range in age from preschool through twenty-one years, and my greatest challenge is to help them grow and reach their fullest potential. It's not always easy, especially when some of them are basically nonverbal and confined to wheelchairs. I work with a very diverse group of kids, and during my first few years as the director of this music program, I realized that traditional remedial methods weren't going to cut it. So I use an experiential approach to reach them. I have seen magical results when the expressive arts are combined with assistive technology.

My students use a microphone for singing. The microphone is an awesome tool for anyone, but especially for kids with special needs. Some of them are the biggest hams in the world. Once they get their hands on a mic, forget about ever getting it back from them! When I say that music is magic, I have to add that the microphone equals super-magic.

My nonverbal students are taught American Sign Language (ASL). Students who use wheelchairs for mobility are trained in the use of assistive technology and adaptive switches. We can hook up a puffer switch and attach it to the student's mouth. Using special knee and head switches, my wheelchair students operate the lighting effects and special drumming and percussion instruments. With these switches you can hook up anything that has a battery and can be plugged in—a radio, computer, DVD, CD player, TV—anything you can imagine. One student runs a bubble machine from his wheelchair.

While I play live music on guitar and sing, students sing along while others use ASL to "sing" along and express themselves. We also perform several songs using the special medium of black light.

This unique group has performed at many different outlets in the South Florida area, including retirement homes and schools. The highlight came when we had the awesome opportunity to perform for more than a thousand people at the prestigious Broward Center for the Performing Arts. Needless to say, there wasn't a dry eye in the audience. People saw that my students, once given the opportunity, can indeed give to others in so many wonderful ways, and that they can accomplish so much more than what's often expected.

You see a kid in a wheelchair and you think, okay, they really can't do anything and you feel sorry for them. But then you give them switches that they can operate and pretty soon they're playing drums and communicating beautifully. School becomes a creative atmosphere. If you came into my classroom, you'd see these kids using the microphones to sing or make sounds. You'd see kids on a drum set, conga drums, and bongos. You'd see kids with bells on their wrists and on their ankles or wearing them as necklaces. Somebody once described my class by saying, "You either have a man cave going here or a total hippy den." Music and drama therapy allows me to be kind of wild and creative.

"I wanted to become a teacher to help the underdog, believing that the fault never lays with the student but always with the instructor."

As a teacher I believe that most people go into the profession because they want to make a positive impact on their students and they want to enjoy what they are doing. My dream is to make an educational program that incorporates motivational strategies. It would be an expressive arts academy and would be offered to regular students who thrive in the arts as well as individuals with special needs. The main focus would be on utilizing the healing and creative powers of making music (not just listening to music), performing in stage productions, and making art, together with assistive technology so students with physical and mental challenges can participate to the fullest measure possible. The school would involve students in computer research projects, paired interactive learning, outdoor and nature studies, community involvement, such as helping out and performing for senior centers and shelters for the homeless, and more. I believe we are only limited by our own imaginations.

*"My motto is, 'My students will leave my class knowing how to read books **and** read music!'"*

Genein Letford

Kindergarten–5th Grade
Music Education and Instrumental Music

Genein Letford's lively interdisciplinary approach to teaching music has earned her numerous awards, including the Great American Teacher of the Year award, and the adoration of hundreds of young students. Despite having 450 low-income children under her tutelage, Letford strives to give each and every one of them an equally joyful and enriching educational experience that extends far beyond her music room. Letford has spearheaded programs to connect students to their community and provide continued support for alumni, and she champions physical fitness and the visual arts through her Run Club and Photography Club. "I am here," she says, "not for selfish reasons, but to plant and cultivate the seeds of greatness within each child who is placed in front of me. This is my calling and why I do what I do. This is who I am."

I remember, when I was young, my mother's four-year-old godchild, Devonea, coming up to my mother while she was opening shelled nuts. The little girl looked bewildered that my mom could eat this hard oval object and asked her what she was doing. My mother, an educator at all times, showed her the shell of the nut and then proceeded to slowly open it with increased anticipation to reveal the edible treasure inside. "You can eat it?" she asked my mom, who then broke off a piece for her. The look of astonishment and discovery on that child's face continues to be a part of my motivation to this very day. To unshell new knowledge, wisdom, and self-discovery for my students, and be a part of their "Aha!" moments, is a lasting goal.

I am the second oldest of four children, and born a twin. Genae and I are six years older than our sister Genette, and twelve years older than our youngest brother, Joseph. We certainly weren't born with silver spoons in our mouths, but our mother found ways to make our plastic ones work out just fine. Being raised in a single-parent home in one of the worst school districts in Southern California, we were set up to be part of a failing statistic. But my mother and her tenacity never disappointed us. She fought hard to get us enrolled in the better schools in a nearby district and for my siblings to get tested for the gifted program. She made sure we were on task, and though we didn't have much materially, she made us aware we had all that we needed because we had

the power to learn and self-teach. There was no victim-mentality around our home. And I thank her for that.

Ours was also a very musical house. My mom didn't know how to play an instrument and she couldn't hang on to a note to save her life, but she knew the power and importance of the arts. Her mother, my grandmother, played piano, as did my father, and his father played guitar, so I think it was just innate for us kids. I played the trumpet throughout high school, Genae played the bassoon, Genette played the flute, and Joseph played the clarinet. The impact of music on our lives has been unparalleled because it taught us discipline, perseverance over difficulties and frustrations, and how to work coopera-tively within a group yet still be individually responsible for our own advancement. Priceless lessons wrapped up in a small cylindrical instrument.

"To unshell new knowledge, wisdom, and self-discovery for my students, and be a part of their 'Aha!' moments, is a lasting goal."

As a child, I was very shy and didn't speak much due to my speech impediment. I received special education services for speech throughout elementary school but opted out in middle school and beyond because I was too embarrassed to attend. Only recently have I fully embraced that experience and dealt with the damaging effects on my self-esteem and identity. It was difficult for me, being so creative and having valuable ideas, not to be able to contribute to discussions because of my mild stutter. Conversely, my twin was a powerful orator and actually won at speech and debate events during high school. Talk about trying not to compare yourselves! It was tough! It has only been in the last few years that, although I still stutter a little, I don't let it hold me back from sharing best practices and contributing to the educational arena. I have led many sessions on arts integration, lesson development, and grant writing for teachers in the past decade. Oddly, I've come to find that, while teaching, I rarely stutter at all. I'm in my element and in the perfect flow.

As I started my career as a third-grade classroom teacher, I made sure to include music lessons and art classes and take meaningful field trips. My motto was, "My students will leave my class knowing how to read

books *and* read music!" Now that I am a music specialist for kindergarten through fifth grade, I'm essentially doing just the opposite. Instead of teaching math and vocabu-lary and bringing in music, I'm teaching music but I'm sneaking in math and vocabulary. The fact that I'm a credentialed teacher with a general education background means that I'm aware of all the state standards, aware of what the kids are learning in their other classes. So, I developed a program that supported them not only musi-cally but also made connections to their core curriculum. And that's been really successful.

My classroom instruction is unique because it is always evolving as I become more creative and educated. For example, to inspire my students to practice playing their recorders more, I have instituted "tae kwon do music levels," which are connected to my Korean music unit. As in tae kwon do, the students have to pass certain tasks or songs to receive a new color belt. So as I teach them about Korean music and culture, they are also learning the skills of focusing, practicing, and goal reaching.

I love thinking of new ways to introduce concepts and I also employ theater, games, and positive confirma-tion tactics throughout my teaching. While using Boom-whackers (colored tubes that produce different pitches based on their length) to play and compose musical pieces, the students correlate the length of instruments with the pitch range they produce. Sound waves are a second-grade science standard, so it's a perfect fit for that group. Since my students are mostly English-language learners, I understand the importance of vocabulary development in the elementary years. Therefore I utilize exciting "read-alouds" that introduce various musical concepts, genres, or composers. I create "book tracks," which are musical accompaniments played at certain times throughout the story to make the plot come alive. We discuss the normal ELA (English language arts) focal points, such as author, illustrator, genre, protagonist/antagonist, climax/resolu-tion, mood, and various alternative endings to a story or a composer's life.

I love this approach for my students because they get to interact with the material from different artistic viewpoints more than they would in their normal general-education class. For instance, I have a historical-fiction book called *The Heroic Symphony*, about Beethoven's third symphony, which he originally wrote for Napoleon while he was going deaf. Once Napoleon crowned himself emperor, Beethoven felt betrayed and renamed the

"I tell my students that I'm their teacher for life and if they ever need anything in the future, I am here for them."

symphony after the heroism and tenacity of the people. I only read one section each meeting period (about ten to fifteen minutes) in class and then we play our instruments, but during that short reading time the students not only learn about Beethoven and listen to and analyze his symphony, but they are also exposed to historical events and key figures, and the role music played during that era. This approach, among many other academic ideas in our classrooms, is a wonderful alternative to textbooks for teaching history.

During class, all of my senses are on. Concurrently, I'm watching finger combination over keys, listening to individual and grouped sounds, and sensing frustrations and confusion so I can attend to students who are struggling or "pretending" to play because they were lost on the previous part of the lesson. My old boss used to say, "Repetition is the key to retention," and in music, this is very true. When students have a difficult time playing an entire song, we "chunk it" (just like reading a text) and divide it into smaller sections and replay each section over and over, until their little fingers know where to go automatically. The fact that I use this method is due to my research on the brain and my personal experience with how I process and retain information. We learn by connecting new information to previously learned information. For example, when we want to know about an unknown person, we usually compare him or her to someone we are already familiar with (e.g., the new comedian on *Saturday Night Live* is a lot like Robin Williams).

My day doesn't stop at 2:30 P.M., when the bell rings. Since I only see each class for forty-five minutes a week, I make myself available before and after school for extra tutoring and one-on-one instruction. Even as a music teacher of 450 students, I make it a point to erase the line between school and home, and I have connected with numerous families outside of the classroom. Many parents have my cell number, and they know I am always their children's advocate, even if their children are no longer in my class. I tell my students that I'm their teacher

for life and if they ever need anything in the future, I am here for them.

I'm a big believer in encouraging students from a very young age to aspire to go to college. Higher education certainly feeds into my everyday classroom culture. We discuss their goals as students, musicians, and community members. I have a section on my wall just for college posters. I even use it for encouragement and sometimes discipline. I say, "My job is to assist you in getting to college, so let's use the behavior that is going to help you get there." If there are late assignments or distractions, I remind them of my goal for them and it becomes their own goal by the time they are done with my class.

Of course there are times when I get frustrated in the classroom, when I've worked so hard and poured everything I have into my kids and lessons, and it just isn't clicking. I have to remind myself of something my father once wrote to me, which I keep up on my wall: that I am planting seeds. They may stay latent for a year or two, but they are there. And maybe I won't see them all sprout immediately, but I know they will someday, even if it's not in my sight, in my presence. "Years from now," wrote my dad, "when your first crop has reached their adulthood, many will return to say 'Thank you, Ms. Letford, for teaching me to believe in myself.' Those words will mean more to you than any paycheck you will ever receive. Trust me. That day is coming."

"Students enter my room knowing they can succeed, that there is a teacher making a special effort for all of them, who really cares about their future."

Glenn D. Lid

9th–12th Grade
Biology and AP Chemistry

Glenn Lid has spent thirty-four years on the front lines of public education in America and despite many battle scars, has never wavered in his commitment to changing the lives and affecting the futures of his students. Inducted into the National Teachers Hall of Fame in 2012, Lid has been showered with awards of excellence and various honors throughout his storied career, including the prestigious Disney Secondary School Teacher of the Year Award in 2004. Part mad scientist, part parental figure, part life coach, Lid's outside-the-box teaching style has earned him the respect, adoration, and praise of the thousands of students (not to mention fellow teachers) who have been fortunate enough to pass through the doors of Proviso East's Room 207. Outspoken and passionate about both the profound rewards and sacrifices of being a teacher today in a low-scoring, low-income secondary school, Lid dreams of a future in which teaching is restored to the honorable and valued profession it once was and deserves to be again.

My father was a printer, then a custodian, but most of all he was an explorer. He grounded me in the best possible training experience I could ever have had for becoming a teacher. He demonstrated the interrelation of one subject to another, something I always convey to my students. I was never a fast learner or a top test scorer and my dad recognized this. He allowed me the freedom to fail but was always there to redirect me, encourage me, dust me off after failing, and send me back to try again. So many of my students are like I was in school. I try to model my lessons after the creative, simple, and transferable methods my dad used with me as a child—like learning Morse code, getting my amateur radio license, playing with a chemistry set, constructing a wooden scooter, building airplanes to fly off our roof, collecting butterflies, learning how to wrestle on the living-room floor, and looking through a telescope with Dad in the middle of the night.

I would classify my science classes as *exocharmic*, a catch phrase I garnered from one of my mentors. It is my mission to infuse as much positive energy, humor, creativity, technology, and inspiration into my lessons as I can. Although this outward flow of energy is not always the same every day and does not always get transferred to every single student, students come to expect the unexpected from me. My students might see me glide across the floor on a hovercraft; see the letters BO on the armpits of my lab coat; find me dressed in a chef's uniform; see me light a match with steam or boil water with ice; watch me do a chemistry rap with acids, bases, and precipitates; see me drink from a self-filling cup; cause a bottle of club soda to freeze just by opening it; wear a raincoat; or launch a gigantic water bottle across the room on a bicycle cable. Students might find themselves rolling marbles on the floor, looking through rainbow glasses, constructing a PowerPoint presentation, shaking a box of Skittles,

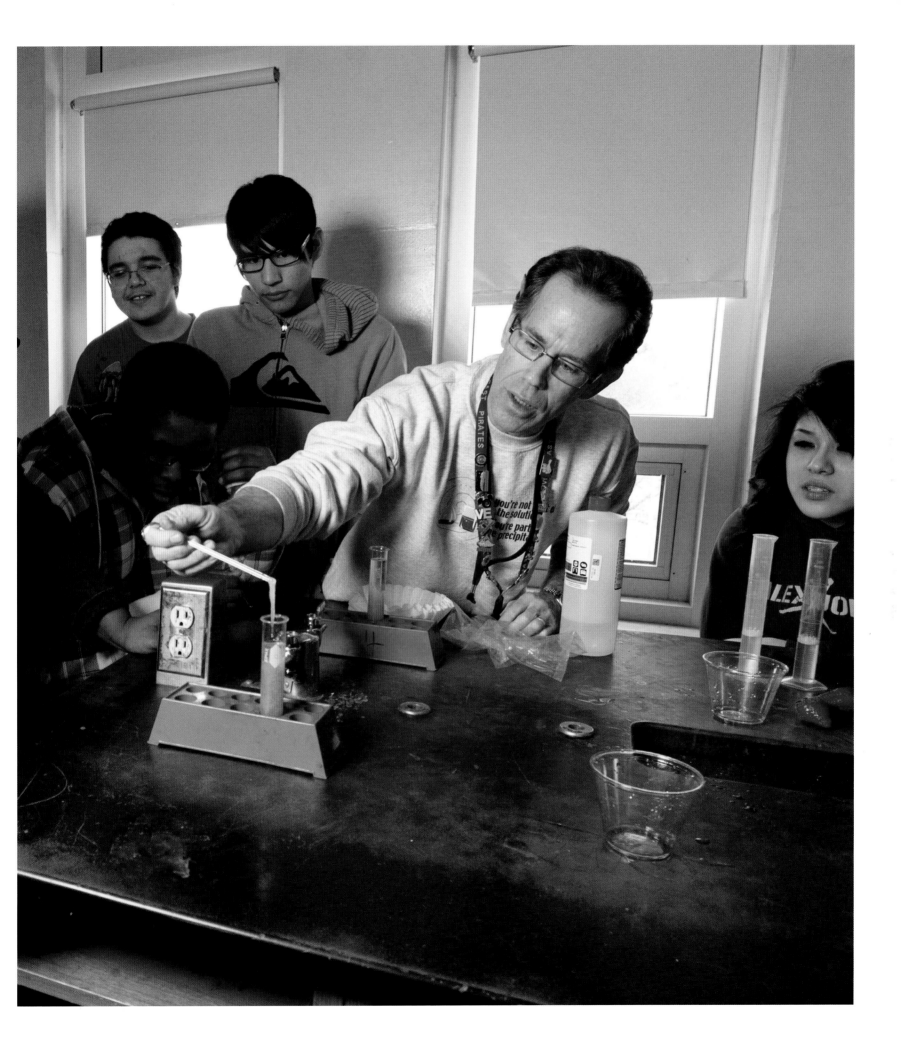

monitoring the pH of a titration with a LabQuest, making s'mores, making ice cream, determining the percent of sulfate in an unknown compound, using a spectrometer, using a centrifuge, or graphing data on Logger Pro.

In 2010 I had my honors chemistry class and AP chemistry classes meet in the auditorium and we were studying one of my passions. I asked the kids, "Do you know what WMD stands for? Do you know what Chernobyl was? Do you know what happened in Japan in 1945 to end World War II?" I would say more than 90 percent of them did not know.

So, after we studied the particulars of radioactivity I talked to them about a book of letters that was the first account of a survivor after the bomb was dropped in Hiroshima. The author wrote them to his wife about how he walked into Hiroshima looking for her and all of the carnage and radioactive sickness that he saw. After reading, we broke up into discussion groups and just talked about how the kids felt. And then when the Peace Memorial Museum in Hiroshima made it possible to interview survivors, my kids Skyped with a survivor and they asked him some phenomenal questions. The one that sticks out in my mind is, "Well, is there someone you would've said good-bye to if you knew the bomb was going to drop?" I almost started to cry.

> *"My expectations for my students must be as high as those of teachers in the highest-rated schools. In other words, if we want to be a great school, we need to act like a great school."*

When students come into my room, they know they are in for something different. My room even looks different. Over the door hang two big tablets, the "Ten Chemmandments" as well as a picture of one of my baseball players and chemistry students lost in a tragic car accident (we retired his number). There are pictures of former students, which I call the wall of fame. Motivational signs and student artworks are all over the room. Molecular models made from Mickey Mouse ears hang from the ceiling. Pictures of chemical compounds, their names, and formulas are pasted onto the window shades. There are student-generated posters hanging outside the

room of various workshops students have attended, the aftermath of the Hiroshima explosion, other chemical concepts, and two big posters saying "wrestling and baseball spoken here." I have pictures of famous minority chemists, stuffed moles of all shapes, and stickers with humorous chemistry sayings scattered all about my room. On my desk are a lava lamp and a digital photo frame showing students doing great things. I also have an electronic marquee that has a new riddle on it each week. (What do chemists breathe at night? Nitrogen. What do chemists take for bad breath? Elemints.) Humor is critical to infusing energy into the classroom, getting students to think, getting them to relax, and increasing student rapport. Students enter my room knowing they can succeed, that there is a teacher making a special effort for all of them, who really cares about their future. They leave Room 207 with a sense of accomplishment, excitement, good memories, and an increased level of confidence.

I've been teaching at Proviso East for thirty-four years now. I've taught physical science, all the different levels of chemistry, and all the different levels of biology. I've been the head baseball coach for twenty-one years and I've coached wrestling for thirty-four years. I also coach football and more recently I've started coaching golf. After all these years, I feel like I've been woven into the fabric of the community and the school.

I've seen superintendents and principals come and go. I've seen good teachers come and go—either because of the money, or they just became disenchanted with the way things turned out. It takes a special dedication to stick it out at a school of need, a special love and caring, because you are going to be tested and frustrated in lots of different ways. But you'll also be elevated to highs that you've never imagined because of some of the changes that you can make within kids. The highs and the lows—they're tremendous.

Teaching in America is really at a turning point. It's evolving very quickly into a specialized profession, with the teacher as "an educational physician" whose task it is to analyze instant data to make the correct academic diagnosis for every kid. But every patient has a different condition and not all get well at the same time. Everybody wants to push education toward a business model. But kids are not like cars coming off the assembly line; each one's different, with a unique set of variables that you have to deal with. I think the people that are pushing

testing are forgetting about the human being, the human side of it.

This creates a real dilemma in underperforming schools. Because of the emphasis on testing, if you, as a new teacher, have a high failure rate, the administration is going to call you in and say, "We don't want you anymore." So what are you going to do? You're going to do whatever you can to help those kids pass. And sometimes that means teaching the "gimmicks" to successful test taking instead of how to truly learn. So, I'll tell a young teacher, "You have two roads to choose from. You can do whatever you have to do to keep your job or you can stick to what you think is right and you might not have a job tomorrow." That's a tough choice for a young teacher to make.

Our society is speaking a bit out of both sides of its mouth: Let's put the best teachers into the worst schools but let's not pay them much. If you want teachers to be like doctors, if you want them to work 24-7, if you want them to be licensed, if you want them to be experts in their content area—which I think they should be—then you really have to pay them appropriately, because otherwise this is what will happen: when the economy gets better, teachers who are in specialized areas like chemistry or calculus will leave to go make more money elsewhere, where it is not so overwhelming.

Another major issue affecting schools like Proviso East is the cultural environment. It can have a very negative impact on students' dreams, goals, and the perception of the world in which they live. At Proviso East, 89.6 percent of the students do not meet state requirements in reading and 84.6 percent do not meet requirements in math; 44.8 percent are eligible to receive free or reduced-cost lunches. Gangs and drugs are an awful reality in our students' community. We have a truancy rate above 25 percent (26.3 percent). Many of our students are lacking male role models in the home, a fact that is especially significant for the boys. What do I do as an instructor to run interference with this cultural environment? I have to bring persistence and establish relationships with my students. My expectations for my students must be as high as those of teachers in the highest-rated schools. In other words, if we want a great school, we need to act like a great school.

I have all these inspiring quotes. One of my favorites is by Bob Ballard, the great underwater explorer—he was asked what his most important discovery had been

and his reply was, "My next one." I feel that teachers are like explorers, searching for the undiscovered treasures in our students. And the next discovery is what makes teaching so exciting. That's how I try to go into my class—thinking of myself as an explorer of human beings. And I have discovered some incredible kids that go on to do incredible things. That's what keeps the flame going. It's like what Maya Angelou says: "Let nothing dim

Mr. Lid's words, "Son, you have the potential to be great, you will change lives," still echo loudly as I continue to paint the story of my life, one brushstroke at a time. As my teacher, Mr. Lid fed my strong intellectual curiosity with humility and enthusiasm. As my baseball and wrestling coach, he taught me balance through patience and discipline. He urged me to be fearless and ambitious in regards to my own future and he assumed the role of a father figure, stressing the importance of ethics, scholarship, and personal integrity. He would say, "Quinnton, you have to stick your neck out and try something new, even when you are afraid." His powerful words provided encouragement amidst some deep personal issues I faced as an adolescent. I seemed to be fighting a battle that most people thought I could not win; but Mr. Lid was in my corner throughout, training me to be stronger. His use of humorous acronyms and songs to teach physical and mathematical principles continue to serve as an analogy to how I believe I should live my life: Always learn. Always Master. Always do it with a smile.

the light that shines from within." As a teacher, you can't ever let anyone dim that light for you. Clarence the Angel in *It's a Wonderful Life* said, "Each man touches so many others, and when he's not there he leaves a hole." If it's a teacher—I say—he leaves not just a hole, he leaves a canyon.

Another reason I love to teach—I was thinking about this for the first time just the other day—is that it gives me an opportunity to be close to my father, who died when I was just twenty-four. So many of my students have no fathers, but as their teacher I can give to them those same learning opportunities and experiences my dad provided me with. It only took me thirty-four years to figure that out.

Quinnton, age 23, former student

"A large sign on one wall of my classroom reads, 'You're the artist, so you decide!' It reflects my philosophy that the joyfulness in making art is in the freedom of creative expression."

Susan Menkes

Kindergarten–6th Grade
Visual Arts

Mrs. Menkes and her art students stand in front of an anti-bullying mural they painted themselves.

For Susan Menkes' 480 elementary-school students, each day brings a new fantastical journey into the history and making of art. Menkes' art studio is reputed to be an enchanted castle, where children sit on magic carpets and take turns playing the part of "Mrs. Magic Menkes'" wand-waving assistants. Lessons are prompted by the appearance of unusual props that spring from a mysterious bag, and a familiar chant always starts things off: *Abra-kadabra, kiddle kaboom, the children at Jackson School have a magic art room!* Her unrestrained imagination as a teacher can be glimpsed in every activity, every project, and every lesson plan she devises. Whether it's constructing a three-story prehistoric creature with her students or recreating a Florentine museum in her Long Island classroom, Menkes likes to think big, and is a passionate and vocal advocate for arts education. Her many honors for her larger-than-life methods include the Disney Award in 2004.

My husband got me a license plate that says "ARTNSOUL"—because I'm the type of person who, if I believe in something, gives it 110 percent. I'm passionate about teaching art and I bring enthusiasm to everything I do in the classroom (after twenty-four years that's a lot of positive energy!). I rarely do the same projects from year to year and often lie awake at night thinking up new ways to keep my

GEORGE A. JACKSON ELEMENTARY SCHOOL
AND JERICHO MIDDLE SCHOOL, JERICHO, NY

program exciting and engaging. Whenever I teach, I always feel like I'm a performer on a stage. I love to use props. I have a whole menagerie of stuffed animals and puppets, for instance, that help me introduce the work of famous artists like RembrANT, Pablo PIGasso, Georgia O'CALF, LeonAPEo da Vinci, Henri MOOSEtisse, Marc CHICKgall, and Andy WarHOG. I might start off a lesson on van Gogh by pulling out Vincent van GOAT—an engaging goat puppet with a silk sunflower in his teeth—to help spark discussion.

A large sign on one wall of my classroom reads, "You're the artist, so you decide!" It reflects my philosophy that the joyfulness in making art is in the freedom of creative expression. Decision making and a feeling of confidence are important roles in my students' development and maturity. My goal is to inspire all of my young magicians to *love* art and believe in themselves. My goal is to empower them. Whenever I hear adults proclaim that they "can't do art," I am sure that someone or something along life's road made them feel this way. If you come into my magic art room and ask, "Which of you are artists?" all my students will raise their hands!

"In my classroom, art has truly become the universal language."

The school in which I teach is unique, as it is genuinely an "inclusion school." In this environment, gifted children as well as those with IEPs (Individual Education Plans) and children with special needs, are taught in the same classrooms. Therefore, students arrive each week with a wide range of aptitudes and learning styles. I adapt every lesson and its goals to meet the needs of all my students, to allow each individual to grow and feel successful. I always aim to design a program that builds on each child's strengths, so that he or she also becomes a valuable member of the class "team." For example, in one learning experience, fifth-grade students reimagined the *Mona Lisa* in the style of various artists throughout history. In assigning each student a different artist, I used my strategies of modification. I encouraged the student in occupational therapy with some muscle coordination issues to utilize whole arm movements in order to create a stunning "Jackson Pollock Mona Lisa" while the artistically gifted student took on the challenge of a detailed "Vermeer Mona."

My teaching is also shaped by the diversity of ethnic backgrounds that my students bring with them. I infuse the art of world cultures into my lessons to teach about respect, tolerance, and understanding our differences. One of my favorite community resources is my first-generation American students' parents and grandparents. Inviting them into the classroom to discuss their heritage and the art of their cultures makes authentic connections and extends learning experiences beyond the confines of our school. In my classroom, art has truly become the universal language. My interest in other cultures has led me on many international adventures and I always embed my lessons with artifacts and art that I bring back from the places I have visited. As my students see the world through my eyes and experiences, their passport to learning is their intrigue and anticipation for what comes next.

As a Fulbright Memorial Fund Scholar, I visited Japan for three weeks with a select group of teachers. When I returned, my students became totally immersed in Japanese culture. Changing my name from Mrs. Menkes to "Mrs. Japankes," I greeted them for class in an authentic kimono and accessories. I dressed a stuffed-animal panda puppet I named Japanda in a kimono as well, to "help" me teach about Japan. Providing authentic experiences to engage my children in meaningful learning, I also absorb them in the topics I teach by having fun and allowing *them* to have fun! All my students delighted in trying on the traditional clothing I had brought to entice them with: children's kimono, *obi*, socks, *geta*, and even a geisha wig. They played with traditional Japanese toys and games, drank green tea from tea bowls, and discussed the Japanese art I shared. These discoveries inspired them to create magnificent original works of art that served as true measures of their understanding.

The Fulbright also allowed me to facilitate a cooperative learning experience through art between my group of fifth graders and a class of fifth graders in Japan. My project, "Peace by Piece; a Japan Connection," involved students from different sides of the world coming together to create two identical murals (one that is displayed in our school district and one in the school district in Japan), which illustrate their common desire for world peace. An additional source of pride: My students presented a canvas replica of the mural to the Japanese consulate at a special ceremony for our school and community. Soon after, a representative from the White House called and asked us to send another copy, for one of the Presidential

Libraries. Of course, with much excitement, the mural was sent!

Another example of student engagement, ownership, and understanding came after my summer-long painting seminar in Italy. I shared my landscape paintings as well as slides of the magnificent Sistine Chapel with my young artists. In a math-integrated lesson, students used a grid/ratio method to enlarge scenes from the Sistine Chapel. Others made paintings, Italian style. Then, all the students worked together to transform the art room into a museum. The huge Michelangelo renderings became the ceiling, and the students' paintings, with ornate metallic-gold frames hand made from dried pasta, lined the walls, just like at the Academia, in Florence!

Collaborating closely with other classroom teachers and their curricula, I continually design art projects that make book learning come alive. While learning about oceanography and sea life in science, we livened up cafeteria walls with murals of underwater scenes. During their section on ancient Egypt in history class, we covered each other in plastercraft to create life-size mummies in the art room. We crafted a thirty-foot-long by ten-foot-high papier-mâché dinosaur, complete with giant painted footprints along the school hallways that led to the collaboratively created creature.

"I am blind, but you have helped me to see in a new way!" Those were the words that forever shaped my role as a teacher. They were spoken to me by a student during my very first year teaching art, at the Guild for the Blind.

She had arrived at the Guild withdrawn, depressed, and despondent. I anguished every day over how I could help her in even some small way. We began with simple shapes, and with my guidance, the cool, forgiving clay began to take form, as did her feelings of self-worth. Soon, a connection developed between the artist and the medium, and a communication evolved between student and teacher. I read to her inspiring stories about Matisse, Monet, and Degas who had lost their sight as well. I encouraged my blind student to translate what she felt, and all she felt, to sculpture. I remember that her pride and joy was her sculpture of her Seeing Eye dog, and that its place in the art show had won her more than first prize—it had won her self-confidence, pleasure, and a way of seeing the world through an artist's eyes. Through this experience, I had a revelation about how powerful art can be. It would become my tool in making a difference for all who I would go on to teach. My goal continues to be to provide life-long learners with a confidence in their creativity and an understanding of the importance of their individuality and uniqueness. I encourage all my students to be the best that they can be and to make the most of who they are.

Dear Mrs. Menkes,
From middle to high school I had a very hard time going to school. Then I met you and your amazing teaching style. I woke each day happy to go to class. Through your instructions and advice I was able to express myself through my artwork. You never told us how to create our pieces but gave insight and wonderful ideas. You built up my self-esteem and gave me an outlet where I could shine. I learned so many techniques and was able to lose myself in the process of creating. You are a wonderful teacher and you have always made me feel that you loved being in the class as much as we did. When I look around my house at all my artwork, I think of you and I smile!

Elana, age 18, former student

Ironically, many of the sighted children I now teach *look* but don't really *see* the world around them. I continually strive to enrich my students with real-life experiences that open their eyes to art and nature. I sometimes "teach for the moment," grasping every opportunity to encourage my students to see in a whole new way. For example, one morning last winter, I drove to school in a winter wonderland. As my third graders arrived for class, I set aside the original lesson I had planned and invited them to look at the scene through the art-room windows. At first, when I asked them what they were looking at, they responded, "It's just white." I encouraged them to see through an artist's eye. They described and discussed how much there really was to see. Soon, I had elicited from them discoveries of the many gorgeous shades of white, spectacular black-and-white contrast, descriptive textures, positive and negative space, and compositions of linear design. Truly inspired, they were able to translate and transform this new insightful experience into meaningful and soul-searched paintings of winter scenes. This learning experience continued in collaboration with their third-grade classroom teacher, as the children wrote poetry about their artworks with a plethora of descriptive words about winter. And, as the snow melted, their paintings and writing melded!

Angie Miller

7th–8th Grade
English Language Arts and Publishing

Unafraid to take risks and expose her own weaknesses, Angie Miller strives to create a classroom culture that encourages her students to do the same. In the safety of Room 133, students learn to listen to and amplify their inner voices, discover the transformative power of literacy, and become architects of their own education. Miller's gifts and achievements as a teacher have been widely recognized—she was named New Hampshire Teacher of the Year in 2011 and writes regularly for the *Washington Post*'s "The Answer Sheet" blog. For Miller, affirmation of her impact is not found in test scores or awards, but in the small "Aha!" moments she glimpses in her students every day.

I grew up with cardboard on the walls. In our unfinished kitchen, an exquisitely old and beautiful cast-iron hand pump delivered our only source of water—and in the winters when the pipes froze, we retrieved our water from a local spring. A small wood stove heated the entire house, and on it, my mother cooked our food. It sounds like a quaint Midwestern prairie-like childhood, but really, we are talking about the 1980s in New Hampshire. My parents were circumstantial victims of poor education, poor decision making, and a poor economy. I watched their dreams and ambition blow out our drafty windows with their marijuana smoke; cries of outrage and fighting filled the air late at night as frequently as laughter.

We were poor. We were disadvantaged. But damn if my mother didn't insist that I was better than that. She sacrificed so that I could wear stylish clothes and she called my teachers if I didn't do my homework. She taught me to read and write at a young age and marched me into college interviews later on.

That was then. Today, my mother roams the town streets year-round, homeless and schizophrenic, making a bed down by the river. Every day I drive by her and I cannot help her. Three times we've tried to commit her but she won't consent, and they let her go. I have had a really hard time coming to terms with that. The woman I see now isn't my mother anymore. I've gone through that mourning process. All too often though, I still have to have difficult conversations about her with my children, the police, and sometimes even my students.

A couple of months ago, I was talking to my class and mentioned something about my mother. And one of the kids asked, "Well, does she live near you?" I replied, honestly, "Actually, my mother is homeless." "Where?" my student asked. And I told him she was in Plymouth. A whole bunch of questions followed. A boy raised his hand and said, "I know who you're talking about. Every Friday we get pizza and I give her our leftovers." It felt like a kick in the stomach. My students give food to my mother. I still haven't quite processed that.

I'm always very open in my classroom about my roots because I was very good at hiding it when I was my students' age. When I was a girl, everybody thought I was the goody-goody, the straight-A student. I was part of the popular crowd, played sports, and was the yearbook editor. In fact, I was living in squalor with no running water and a mother who would scream at us. I'm truthful about where I come from so that my students know that their lot in life has not been set for them.

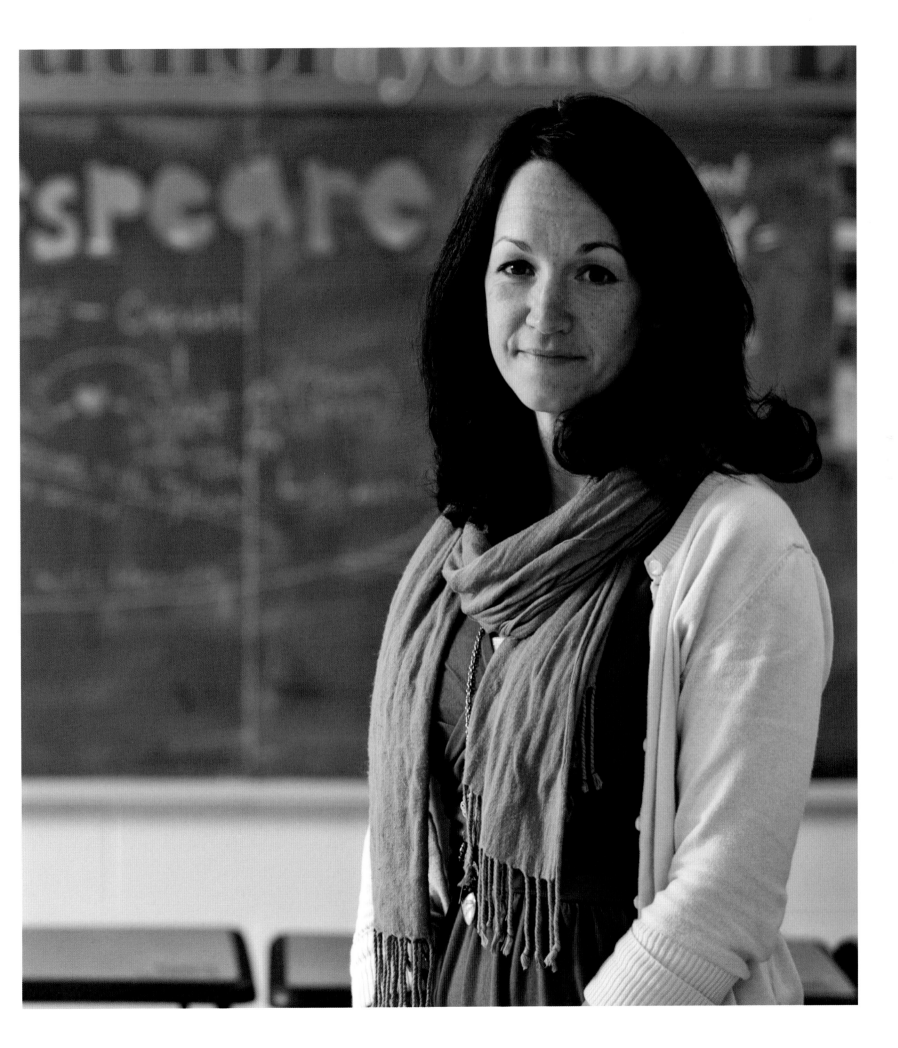

I'm the only person in my family who has gone to college. During my freshman year at Clark University in Massachusetts I found out I was pregnant. I was horrified. I mean, that was *not* me—I would have been voted *least* likely to get pregnant in high school. I moved home. Gossip traveled pretty quickly. I was the town scandal. But I have never seen my mom so strong and supportive of me as she was during that time. I went back to school eventually, at the university in our town. We lived in subsidized housing and I waited tables and paid my car off with my student loans, which I'm still paying back. We had food stamps and we were on every social program you can be on. Now I look back at photos of me with my daughter from that time and think, "Holy smokes, how did I do that?"

> *"I teach my students to apply my academic curriculum of reading, writing, speaking, and listening to a secret curriculum of the heart: doing, caring, thinking, and making change."*

For a short while, when my daughter was small, I attended nursing school, and I got in trouble for the amount of time I spent trying to educate my patients, and for the verbosity of my notes. When I expressed my frustration to a friend one night, she asked, "Why aren't you going to school for teaching, exactly? 'Cuz it sounds to me like that's what you're trying to do there—and they're running a hospital, not a school." At that point, I had long since abandoned my early teaching aspirations. Becoming an English teacher felt as far away from the realm of possibility as owning a house or having a husband or even paying my bills. But after a couple of glasses of wine, my friend had convinced me: I would be a teacher.

That makes it sound like a frivolous decision, and it's not a story I regularly share, but in retrospect, the very ease with which I made that decision is a testament to the teachers I had. Their dedicated practice pushed me to explore the world and question my beliefs, ultimately making such a clear impact on my life that I knew at some level, all along, I was meant to teach. They knew how to accept the imperfect and love the potential that rested quietly in a small soul like mine, and they spent a great deal of energy whispering quietly the one simple message of truth: Teaching is the most decisive and effective way

to make positive, long-lasting change in this world. I teach because of them. I teach because I know, firsthand, what the power of an education can deliver you from. I teach because no matter where I turned, that is what I did.

My first couple of years, I didn't know what the heck was going on. I was aghast that these kids did not know what was happening in their world. I was shocked that they did not see that writing was so powerful, that it was an extension of their voice, and that they had an obligation to use their voice for what they believed in. I think my teaching style evolved slowly based on what I was seeing students do, and then I began adding my own fierce fight-for-the-good-guy kind of passion.

That was a dozen years ago. Now I teach English language arts to seventh and eighth graders at Holderness Central School in New Hampshire, which, incidentally, is where they filmed the movie *On Golden Pond.* I teach my students to apply my academic curriculum of reading, writing, speaking, and listening to a secret curriculum of the heart: doing, caring, thinking, and making change.

My greatest challenge as a teacher is faced every single day: my students. How do I make what I am teaching relevant to a thirteen-year-old boy? To a girl who is cutting herself? To a kid who doesn't have food on the table? How do I stand before them every day when I question my own abilities and assure them that I have the authority to walk them through fifty minutes of their day, five days a week? How do I push an energized boy who devours every piece of literature I give him while meeting the needs of another boy who is sitting, unmotivated and confused, on the other side of the room?

My students are complicated beings. They have worlds greater than my classroom; they have worries greater than our school; they have hearts that hope and dream, and sometimes hearts that have been broken at a young age. They come to the table in all forms of inequity—some have been read to by a loving parent every day of their lives; others don't own a single book. We're in New Hampshire, so we're not really ethnically mixed. Our diversity comes from economics.

I try to get them out into the world to understand as much as possible about humanity so that they don't cast uninformed judgments. I want them to see they can make a difference and be respectful at the same time. Whatever we're doing, I look for some way to extend it beyond my classroom walls. Perhaps we are furnishing the home of a seventy-two-year-old woman who is moving out of the

homeless shelter into an apartment. We may be holding a Holocaust Informational Night at the town library or reading Karen Hesse's *Witness* at the local movie house for the community. We may have wandered down the hall to read to some younger students. You might find us hosting a Sonnet Showdown with another school or in an intense Skype session with an NPR editor about how to create dynamic radio stories. Our work can be found in a remote village in Sudan. And our donated books can be found in a Rockaway, New York, school that lost all of its books to Superstorm Sandy.

Whatever it is that we are doing in the classroom, my philosophy is to include three key components in everything we undertake: 1) It must be student driven, 2) Their work (and mine) must reflect and incorporate the realities of their world, and 3) I must respect their ideas, they must respect my decisions, and we must respect our journey.

I'm so privileged to teach reading and writing because I can make everything real and pertinent. And my students expect that from me at this point. They just assume that whatever they're writing will be read by somebody else and not just me. I'm interested in making sure that writing is not just kept within the classroom. Students need to be publishing their work online or sharing it elsewhere. In short, what is innovative about my classroom is that it's not a classroom at all, really. It is simply a portal into the greater world.

One of my proudest moments came just recently: We were doing poetry and one of my students turned to me during a revision session and asked, "Who's reading these?" This is a kid with a pretty severe learning disability, perhaps the most limited-ability student in my class. It was a majorly successful teaching moment because I realized that this boy, who does not independently initiate the use of writing for his own voice, knows that that's the power of it—that somebody *should* be reading it. And somebody did. His poem and the rest of my students' were spread throughout every store, restaurant, and public building in town—one poem per location—for the community to read.

Some days I am successful. Some days I am the best teacher for a specific child. But often, when the final bell rings, I sit and quietly reflect that no matter how much I juggled, I did not meet every need. Being a teacher leaves me with a constant sense of self-doubt. I want to do more—and I want to do it better and faster, and I usually have to do it with less. In reality, teachers are

heroes not because we are amazing, sacrificial creatures, but because we are people determined to overcome the flaws of ordinary humanity for the sake of a student. Every single teacher struggles every single day to effectively reach their students, to make their students' education relevant and powerful, and to inspire them and instill self-confidence.

"Thou shalt not be a victim, thou shalt not be a perpetrator, but above all, thou shalt not be a bystander."
—*Yehuda Bauer*

So read the words that hang above my bedroom door—words given to me by Angie Miller, my 8th-grade English teacher. Though her gift has certainly filled that role, it serves more as a reference and reminder to things already taught from my days in her class. While we, of course, learned grammar and sentence structure, all things academic, in retrospect, took a backseat to our other education, and we owe that to Mrs. Miller. She taught us to be genuinely involved with what we learned, and ready to explore further. Mrs. Miller took all of us under her wing, even at our most frustrating stages. It's not often that you can consider a teacher to be a friend, but that's how I see Mrs. Miller. Friends teach you how to be, well, friendly, and how to care for those around you, difficult as they may be. All these things Mrs. Miller impressed upon us, and all in a 45-minute, first-period block. It's pretty amazing. Those who came as victims went as heroes. Anyone who arrived a perpetrator became an ally. And, above all, no one left a bystander.

I wish more teachers would see that if their students feel alive, engaged, and immersed in their world, they would perform better in any arena—testing or the real world. I want to shout from the rooftops to all of these teachers: Take risks. Try new things. Encourage creativity. Learn from your students. Throw open your doors, roll up your windows. Push hard. Expect a lot. But always allow for the unexpected. Don't be afraid to give your students control of the classroom, because you will often be surprised at the direction their hearts, thoughts, and dreams will take them...and you.

Jacob, age 17, former student

"My students know that I am here to be their teacher, an adult in their life who they can trust and come to, and who cares about them. But I am not their peer. I teach with tough love, with an emphasis on love."

Helena Moss-Jack

6th–12th Grade
Instrumental Music

Helena Moss-Jack is a fighter, a one-woman army leading a charge against what she sees as the inequities of a public education system that often gives less to those who need more, and more to those who need less. She battles for the lives of her low-income students, not with fists or fury, but by listening to every child, by giving every bit she has, by showing up every day—no matter what. Moss-Jack has survived cancer, back surgery, and two knee replacements; she has lived through program funding gaps and a revolving door of school administrations; she has watched her students go on to Ivy League colleges and high-security prisons. And she's still in the classroom. Fighting for her kids. "I'm tired," admits Moss-Jack, "but I can't stop or give up."

I am biracial, with an African-American father from Birmingham, Alabama, and a mother from the Philippines. I was born and raised in Guam until age twelve. As crazy as this may sound, during those first twelve years of life I did not know anything about the "black" race. I just considered myself darker than the natives and the people I was growing up with. I asked my father later in life, why he didn't tell his children about the "black American experience" and his answer was, "I didn't want to teach my children hate." I didn't know or experience the racist attitudes and behavior skin color provoked until our family moved to the United States.

We moved to the Bay Area; it was not a very good part of town. It was a major culture shock to see that many black children in one place and to understand that there was a whole other way of communicating. The environment was oppressive and violent. I was the kid with the cat-eye glasses and the braids (and no one had braids in the early sixties!). I dressed differently. I didn't wear bell-bottoms. I was bullied.

It was my ability to play musical instruments that saved me. I went from being the most different and outcast child to the most popular student at the school. Suddenly the people who were bullying me were protecting me. This of course encouraged me to pursue music more intensely, eventually becoming a professional musician. Which was my primary job until, to make a long story short, it just wasn't fun anymore.

Wanting to become a teacher was a very slow realization for me. What usually takes kids four years to figure out in college took me twenty. I didn't get my teaching credentials until I was in my forties. The first teaching job I was offered was at Elmhurst Community Prep in 1996 and that's where I still am today.

I teach in a neighborhood labeled by the national media as "the killing zone." Some days it feels more like a third-world country—there's so much violence, ignorance, drugs, poverty, etc. There are classes where my students don't ever pick up their instruments—we just talk about something that's upsetting or worrying them. In this neighborhood, things happen all the time that deeply affect these kids. Many of them don't have an adult to go to. I leave my door open so that the children understand I am a listener for them, and if I'm not the right person to help, I'm going to find the right person. My students know what my expectations are in the classroom and why I try to create an environment where all the students feel safe to venture a response, make a comment, or ask a ques-

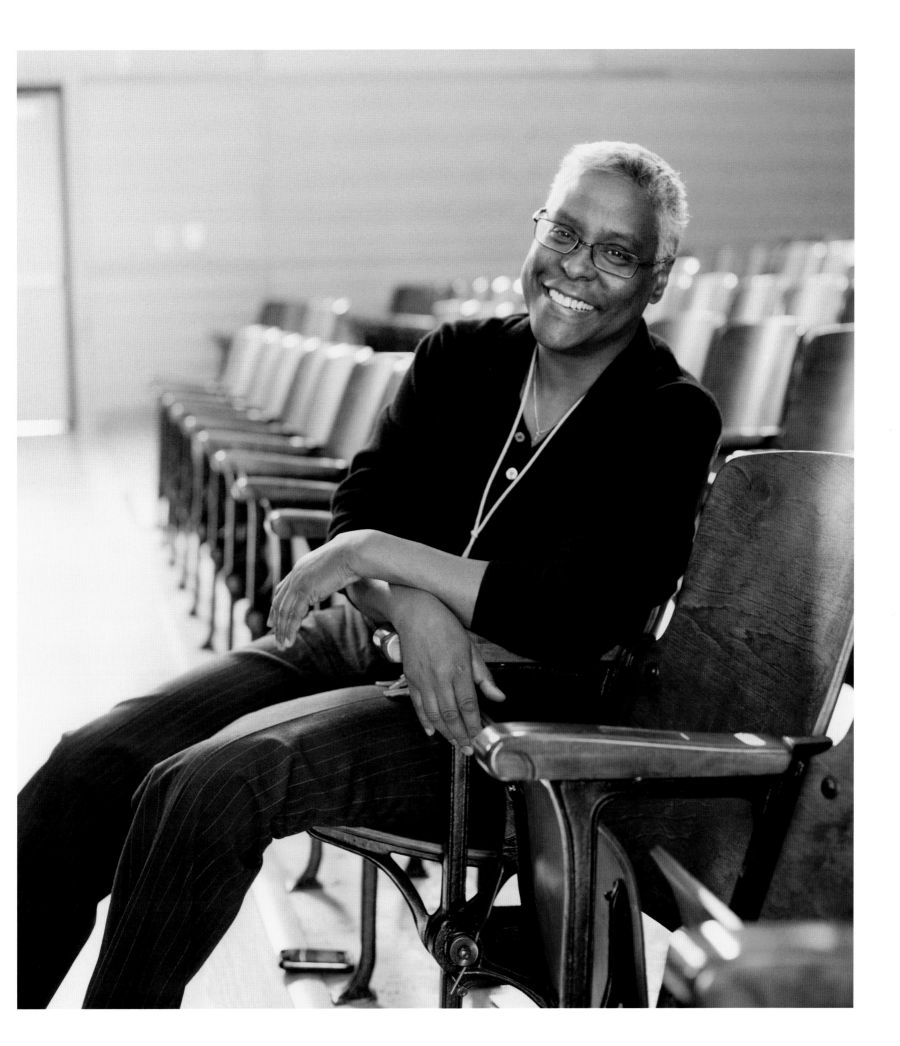

tion, no matter how stupid, trivial, or wrong they think it may sound. This is the place you know you can express your ideas and feelings and be respected. I insist on that. But I also maintain very strict boundaries with my kids. I make sure they know that I am here to be their teacher, an adult in their life who they can trust and come to, and who cares about them. But I am not their peer. I teach with tough love, with an emphasis on love.

> *"People forget that amidst all the negatives of these damaged urban communities are children with the same needs as those with privilege."*

We had an assembly for Black History Month recently—it was a collaboration between the drama department and the music department. We started out by giving the students a whole speech about respect and audience etiquette because they're not used to being in an auditorium all together. A child walked onto the stage, getting ready to do her speech. She had a skin issue, so she already had low self-esteem. She was well dressed, because that's what I insist on. She'd just got her hair done. There was a kid behind me slouching down in his chair, and he said, "Damn, she's ugly." I just rolled my eyes. And, I thought, "Lord, please. Let some other adult please come down here and deal with this young man—not me. Don't let it be me." Because I'm always the one. But I stood up and I asked the little girl on stage, "Please stop." She was shocked and I was just hoping she didn't hear what this boy had said. I turned around and bent over my chair so that I was right in this kid's face, and I was trying to reason with him, talking to him about respect, and how this was about honoring black history, *his* history. He was not having it. It's middle school, and he'd started this thing; now he had to keep going. I was about to give him that and let it go. But then he said to his friend, "Bro, could you get this woman out of my face before I bounce on her?" And, I thought "No! No, he did not say that!" My ears got hot. And I got loud—I got very loud. All these words came flying out of his mouth back at me; he had to hold his space. So I walked over to the microphone. And all the things that he thought he could say and call me, nobody heard it. Because I was louder. And I sent him out of the room with love. That's all I said

into the microphone—was that I loved him, "We love you. Your mama loves you, your grandmother, your ancestors love you, but you've got to go—and learn to understand that outside this room."

People forget that amidst all the negatives of these damaged urban communities are children with the same needs as those with privilege. Too many years I have watched well-intentioned policies miss the mark by not understanding the community they are meant to serve. In other words, funds are wasted. As a music teacher, the lack of funds to maintain an acceptable level of quality that wards off the inequities of teaching in the "hood" is a never-ending fight. And I am often frustrated.

Of course, it is worth the fight and there are certainly moments of glory. But those moments are too rare. I have had a lot of kids grow up and not make it in life. Not too long ago, a man knocked on my classroom door. I didn't recognize him. I've had so many kids, I can't remember them all, but this guy said he was in my class. I said, "Oh, really? Well, it's nice to see you and where have you been?" "In jail." "For what?" "Murder." We talked, and I realized he had come to see me to get in touch with his roots, to go back to someplace that felt good, where he had at one time felt supported. Before he left, I said, "You know where you're headed now, right? You're going to do the right thing?" I tried to pump him up a bit. He nodded and said, "Yes, Miss Jack."

Sometimes it works the other way around, and my students are the ones supporting me. Two years ago, I was teaching a high-school group. I stood up in front of my class and announced through my headset, "I have something to tell you that's very important that I want to share with you." They went dead silent. So I turned off my headset and stared at all these pairs of eyes. They were just waiting for me. I started stuttering. I sat down and then I stood up. I was very nervous because I was going to break my boundary with them that day. For some reason, I just thought it was time. Then I told them, "Well, I'm gay. I am a lesbian." They looked at me for a minute and then they started clapping. I was caught off guard and asked, "Do you have any questions?" They exclaimed, "We thought you were going to say you were going to die!" And that was the end of the conversation. And I said, "Oh. I thought this was going to be hard!" We all just ended up laughing. But it was a huge part of this whole journey for me, just to be myself in that moment. And then it was just back to class as usual, and back to being Miss Jack.

"'No': Music to my Ears"

Second-hand, plastic Selmer clarinet clutched between a reluctant palm, prepubescent sense of entitlement protruding from my tiny chest, overgrown ego in tow, I had made up my mind: a sixth grade education would suffice. I had the school thing pretty much figured out. I'd decoded the "real world" ruse and it was time I move on to a more autodidactic way of life—the girl's basketball team at my middle school, which happened to one, be a cooler social alternative to band geek and two, scheduled at the exact same hour as Ms. Jack's sixth grade after-school Jazz Band class. I really wanted to be a slacker, abandoning my passion for education in favor of getting by enough to pass.

An essay by Ebony Donnley, age 22, former student

After a year of toiling with a dizzying army of notes that could have been Rorschach tests for all I knew, and wrapping my mind around all the Miles Davis records she would play prior to teaching 12-year-olds a jazz legend's writhing precision and seamless seduction of every octave unimaginable, I found jazz too damn complicated. It all sounded so good coming from the speakers, but I knew I was incapable of emulating that strange marriage between melodic improvisation and classical technique.

My getaway had to be furtive. In other words, I had to get past *her*. Ms. Jack. The affable, albeit, no nonsense matriarch fabled by the likes of my 31-year-old brother who attended Elmhurst Middle School before I could even talk, much less hit an upper register B-flat on the bass clarinet. "Ms. Jack don't play," he warned when I told him my plan to quit the band. She didn't. And with a reputation beyond the music department as a teacher who *actually* challenged her students beyond the constraints of societal expectations of poor black kids in East Oakland, CA, I knew I had to cut out the middleman and go straight to her superiors.

"Mr. Arceneaux, can you let Ms. Jack know that I won't be returning to band? I'm going to join the basketball team." I smiled casually in the principal's office doorway, until I lifted my head from cleaning my nails, stunned. Ms. Jack was already there. She smiled that same big smile I saw gleaming from the podium 11 years later during my graduation speech for the University of California, Los Angeles' Commencement for the Class of 2012 (the slacker thing didn't work out).

Casually, almost breathlessly she quipped,

"No."

I didn't realize it then, but Ms. Jack's refusal to let me content myself with mediocrity, and her subsequent efforts to help me grow as a musician, student and human, thrust my musical ambitions from the clarinet to the bass clarinet, then alto and tenor saxophone by the end of my senior year of high school, all under the encouragement and tutelage of Ms. Jack. That "no" flung the Chicago Theater's doors open in 2009 when I performed in front of a crowd of 10,000.

> *"I don't think of teaching as a job. It's a purpose for living."*

Alma Suney Park

6th Grade
General Studies

Ms. Park sits down for some one-on-one work with a student.

The classroom is where Alma Suney Park feels truly in her element. It's also where she spends the vast majority of her time. Rarely seeing the inside of her apartment in daylight during the school week, Park keeps working hours that put the rest of us to shame. "I've gotten really close to the night crew because we're always there together," jokes Park about her workaholic habits. Even her students worry she has no personal life. "They send me links to Match.com—it's hilarious." But in all seriousness, Park couldn't be happier—or more ambitious. Her relentless aspiration to be the best teacher she can be has recently led her to embrace a previously untested technology-integrated math curriculum through a partnership with the Khan Academy. Khan is a virtual online educational resource that is stocked with a library of thousands of interactive video lessons. Its intent is to promote self-directed learning and empower students to become designers of their own education. From Park's perspective, it's been a stunning success.

Because my father was a pastor, my family moved every few years, whenever he was assigned to a new church. These moves were devastating for me. Each time, my insecurities multiplied as I tried to fit in and navigate new social structures. The most traumatic move was in sixth grade, when we moved from Nashville, Tennessee, to Seoul, South Korea. In Korea, I was an outcast. Although I looked like everyone else, I could not speak, read, or write in Korean. I went from a straight-A, popular, and outgoing student to a failing, lonely, and confused girl without a voice. I survived that

year only to return to the United States as a new seventh grader in Rochester, New York, and then to make yet another move, to Chicago in my junior year of high school.

All of these moves were defining events that shaped my personality. After returning to the States, I was able to carve out a place for myself at school by excelling in my studies. Socially, however, I never felt like I belonged, and that feeling still tints the lens with which I view the world. I am drawn to those who are on the outside, on the sidelines, and those who need an advocate and a voice. I'm purposeful about living a life that helps others, particularly those who have a greater need. This purpose has been the determining factor in my choice of profession, and who I want to teach, where I want to teach, and how I want to teach.

> ## *"I am drawn to those who are on the outside, on the sidelines, and those who need an advocate and a voice."*

I teach sixth grade now—the same age I found most challenging as a child. My students come to me fresh from elementary school. They are eager, enthusiastic, and wholesome—still childlike in many ways. However, during the middle-school years, with the onset of puberty and social pressures, I see the changes in countenance: Innocence is replaced by self-consciousness, self-confidence is replaced by the need to fit in. Often, students succumb to these social pressures and their education is no longer a priority. So, at a very young age and without being fully cognizant of what is happening, they begin closing doors to their futures. And many times, second chances aren't available. What makes me so frustrated is that I cannot always intervene at a level and intensity that is strong enough to keep these students on track.

The school where I teach in East Palo Alto is very unique. Our founders were Stanford grads who started Eastside College Prep with fewer than ten students in 1996. They wanted to serve a student population that came from underserved and at-risk communities. To qualify for admission, students would have to be the first members of their families to go on to a four-year college. Today, every student has his or her own sponsor—100 percent of each student's scholarship is paid for. One hundred percent of our high school grads go to college. Many even receive Fulbright scholarships.

I really love the intimacy of the family-like community that you can create in a self-contained classroom. Even before a new school year begins I have this mentality that these are my kids now and I come in ready to love them. Because I think that way, I start the year a little differently from some teachers. I've seen teachers spend just one day going over the classroom rules and then go right into their lessons. I devote almost two weeks to classroom culture and community.

On the first day of school I always tell my students that our classroom is their second home and that our class is an extension of their family. I believe this is just as important as creating an exceptional curriculum. We start by doing a lot of team-building exercises and "open talk," where everyone shares their feelings. The purpose is to let our hair down and really get to know one another. I tell them the class is a pyramid. At the very base, are the essential human needs like water, food, and shelter. Then we talk about emotional needs, like safety and acceptance. Without the first, you can't live. Without the second, you can't learn. So we talk about our classroom as a community that has to validate each person. When we realize the right kind of environment, only then can we be ready to grow and be scholars. In the safety of this atmosphere, we laugh, cry, fall, stand up, empathize, celebrate, encourage, and love one another. Sometimes the kids are, like, "Ew, why are we talking about feelings? This is school!" But as the year progresses, they make fun of my approach less and less.

For many years, I had been unsatisfied with my math instruction because I knew I wasn't always successfully teaching every student. With just one teacher, one classroom, and a limited amount of time, I felt it was nearly impossible to reach everyone. Two summers ago, the principal of my school, Chris Bischof, approached my colleague and me about piloting a new way of teaching math. At that point, I had only heard of Khan Academy in passing; I knew it was about students learning on their own with technology. I agreed even though I worried about what changes it would require; my desire to take risks for the possibility of a better method of teaching outweighed my fears.

Khan Academy's whole philosophy is based on individualized, self-paced, mastery-based learning. They wanted to see what would happen if a teacher just took a chance and tried using their library of instructional math videos in their curriculum, without providing any specific guidelines. So that's what we did. We just tried it!

During the first year of the pilot, I was still very much in control. I let kids move through the video lessons and explore them according to their needs, but within boundaries I had predetermined. This was my way of slowly integrating Khan Academy so both my students and I wouldn't be overwhelmed. However, I knew I was still holding on and not letting my students truly learn at their own pace.

The second year, I decided to dive completely into the technology-based individualized learning model that Khan Academy enables. During the first week of the year, I gave my students an overview of the sixth-grade math curriculum. Pointing to the different posters that hung from the ceiling, I explained that each poster represented one of the six units they'd be responsible for learning and passing during the year. There was Data/Statistics Land, Number Relationships Land, Fraction Land, Decimal Land, Percent Land, Ratios/Proportions Land, and Geometry Land. When everyone passes a "land," we all sign the poster.

For each "land," the students take a pretest, identify what they do or don't know, and then begin the unit. For each unit, I've created lists of all the videos and exercises on Khan Academy they must complete. In addition, students are also responsible for learning from their textbook and completing several assignments that capture the real-world application of what they are learning. In order to supplement Khan Academy material with more conceptually based material, I have students working throughout the unit on projects and problem solving. These they do together in groups. It is a great way for them to break from their individual journeys and come together as a collective class working toward a common goal. After students complete a unit, they review the Khan Academy lessons and then take the post-test. Once that's passed, they move on to a new "land." There's lots of peer tutoring going on during math class. And because everyone is working on his/her own, I am able to pull kids aside who need individual instruction and support. I can also form mini-groups of students who are struggling with similar math concepts.

I once read an educational article that challenged teachers with the question, "Is your classroom student-centered or teacher-centered?" We know what the answer should be: The students should be the focal point of our work. But honest, close reflection oftentimes reveals that I've compromised student-centered teaching in certain subjects for the sake of management, time constraints, and curricular requirements. It's extremely difficult to manage twenty-four students who come with different backgrounds, learning experiences, strengths, and areas of need. In a true student-centered classroom, teachers must individualize instruction, differentiate the curriculum, manage, and assess the learning outcomes of all the different levels, and help students set personal goals—all while simultaneously coordinating field trips, grading stacks of papers, making phone calls to parents, managing social interactions and adolescent drama, and the list goes on. Sometimes a one-size-fits-all approach to teaching seems like the only way to survive. It's so much easier, but it is so *not okay*.

> **Since the first day of school I knew you would be the best teacher I ever had—don't tell that to my old or future teachers. At first I wasn't use to the amount of homework you gave, but now I am. There are many things that make a teacher a great one (fun, interesting, answers questions, and is willing to help) and you went above and beyond those things. I feel bad for all the students that didn't get accepted because they missed the chance to be with the best teacher in the world. Now that the 2nd semester is about to end, I don't want it to. If 6th grade ends, that means you won't be my teacher anymore. You made the whole class feel like a family. Suney, you are the best.**

Christopher, age 11, current student

My decision to pilot Khan Academy in my math instruction was ultimately driven by my goal to remain uncompromisingly student-centered. Now, rather than me being the distributor of all knowledge, my students can learn on their own, at their own speed. Instead of seeing myself as the "sage on stage" in the math classroom, now I see my role more as a "guide on the side." Letting go of my control by giving control to the students through the use of technology has been the most innovative shift of my teaching in recent years.

Teachers have many precious opportunities to build a student's self-concept, help shape a dream, provide redirection, and impart knowledge and wisdom. Seeing these opportunities and acting on them is a choice we make every day. Having these opportunities and acting on them is what I value most about being a teacher. I don't think of it as a job. It's a purpose for living.

"I take my title literally—to me, physical implies 'to move' and education means 'to learn'—moving while you learn, learning while you move."

Sharon Patelsky

Kindergarten–5th Grade
Physical Education

Ms. Patelsky and her students prepare to exercise their bodies and their brains in PE class.

Sharon Patelsky is not your typical PE teacher. For Patelsky—whose inventive teaching methods have been featured in the *New York Times* and earned her the 2011 William T. Dwyer Award for excellence in elementary education—opportunities for multi-subject learning can be found in every basketball dribble, every push-up, and every lap around the track. Whether it's weaving a new vocabulary word like "trajectory" into batting practice or using soccer balls as metaphors for planets to sneak in a quick astronomy lesson, Patelsky's purpose is to condition young minds and bodies simultaneously. If you assume for a second this takes the excitement out of game time, think again. Patelsky's students don't even realize that they're picking up math and science skills on the playing field—they're too busy having a blast. And that's the beauty of it. Patelsky has figured out how to make learning synonymous with fun. If that isn't the holy grail of teaching, what is?

I came into the world as an underdog. In 1964, if you were born three months early and weighed in at one pound and fourteen ounces, your chances of survival were not very good. I grew up in a Christian home that believed in miracles, and as far as my parents were concerned, they got one. I spent my first five years traveling to and from the hospital for respiratory issues and then

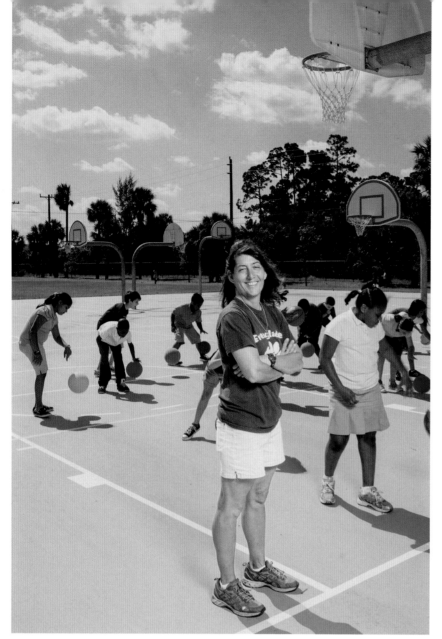

"We have elementary students developing type 2 diabetes, yet there are teachers that reward correct answers in class with M&M's. That makes me crazy."

are not dolphins at Sea World, jumping through hoops to earn fish, or mice running through a maze for a piece of cheese to show how smart they are. I am not against incentives but they really need to be appropriate, meaningful, and representative of the goal achieved. There are thousands of things that you can motivate students with, including your praise, which they really love. For instance, at Everglades, which is a green and healthy-choice school, we celebrate birthdays but the kids don't bring in cupcakes. We thought long and hard about how we could really embrace their special day and acknowledge the joy of it in a healthier way. So we announce each child's birthday in the morning and we give them goody bags that include things that can be used in school, like a new pencil that says "Happy Birthday," an eraser, and a little notepad.

Everglades takes a comprehensive view of teaching the whole child. We are saying from the get-go that we care about each child and how he or she fits into this world we live in, before we ever start worrying about test scores or the latest teaching methods. We absolutely do care about those things but we care about the children first. If they are healthy—mentally and physically—and feel like they are in an exciting and safe place to learn, it just makes sense that they are going to have a higher rate of success and productivity. Healthy students miss fewer school days and have better attitudes about themselves; they will be in school more and they will be happier to be here!

The entire school runs on a system of mutual respect and support. We try to make sure that every part of each child's day is connected to learning and living. Kinesthetic learning activities and movement breaks are incorporated into all classes, just as math, science, reading, and social studies are integrated into fine arts and PE, where applicable. This creates an environment where learning is purposeful and connected throughout the school day.

one day I just turned the corner. That feeling of getting healthy and strong changed me from a shy, withdrawn child into one who was full of energy and motivated to engage the world. It's like God flipped a switch and said, "Time to move," and that is pretty much what I've done ever since. When I feel good, I feel unstoppable.

I know from experience that when you don't have your health, everything else takes a backseat. I don't care what it is you want to be, you cannot effectively do it when you feel depressed, lethargic, or are in pain. As a physical education teacher, I'm very concerned about the decline of health I see in kids and their families. Despite our obesity crisis, in most schools every reward revolves around food—mainly junk food. We have elementary students developing type 2 diabetes, yet there are teachers that reward correct answers in class with M&M's. That makes me crazy. Our children

I think there is still a lot of stereotyping when it comes to the profession of physical education. The ex-jock sitting in a chair throwing out the ball has got to go. Students should be actively discovering how to control their bodies, practicing movement skills, developing healthy habits, and having educational concepts reinforced that naturally connect with other areas of their academic experience. To me, physical education is an incredible vehicle for facilitating *learning* through motion. Our lessons are designed to challenge students' bodies while challenging their minds. This integration is a wonderful opportunity to reinforce, complement, and sometimes even introduce concepts that flow during their instructional day. It absolutely lights me up when a teacher will share with me that they were going over something in class and the kids knew the answer because they'd already learned it in PE. I take my title literally—to me, *physical* implies "to move" and *education* means "to learn"—moving while you learn, learning while you move.

By far my biggest asset as a teacher is my ability to motivate. I have a lot of energy and passion for what I do and I think that reels people in from the start. I sometimes feel like the whole world has forgotten that learning is supposed to be fun. I strive to create a classroom where students are eager to discover new things and gain confidence, excitement, and pride with each accomplishment.

I offer my students a comprehensive program that encompasses movement skills, sports-specific skills, health and wellness, cross-curricular integration of concepts, and service and community outreach. While I cover all the traditional elements of physical education in my classes, I also integrate vocabulary, math, science, and even history into my lessons when I see an opportunity to do so. Instead of just being told to jog or walk around the track for the mile run, the students incorporate measuring the perimeter of the track; discovering the difference between perimeter and area; learning new vocabulary words, like *pace*; and using measuring skills and tools to assess achievement. Or, when I teach my students how to kick the soccer ball, I might compare the ball to the Earth. The ball's centerline becomes the equator, which divides the Northern Hemisphere from the Southern. And I tell them when they go to shoot, "I want your shoelaces to land right on the equator—not the North Pole, not the South Pole." Newton's Laws of Motion can be easily included in almost any movement lesson. Stacking Lego blocks into different columns while doing push-ups is a lot more fun than just doing push-ups alone to build upper-body strength. Why not count by multiples instead of by ones during warm-ups? Including math terms like *greater than* and *less than* are great ways to look at numbers. After all, what do we do in every sport or game? We keep score, or earn points. Points are just numbers. We know we won because we add them. We know by how much because we find the difference, or subtract them. Kids don't realize they are doing math, they just think they are playing a game or completing a movement challenge. The list goes on and on. Kids have awesome imaginations, so why not incorporate them into the learning process?

I am not taking anything away from traditional programs that only focus on sports and movement—I'm just adding and offering more. I'm not here to preach that my way of teaching is the right way and any other way is wrong. I just know how much I care. Like any good parent, I want to include every "teachable moment" I can, because education should be fun, exciting, and should occur naturally and fluidly. I feel every student is eager to participate in this type of program, whether a skilled mover or not. Skilled movers always love PE, but this approach offers a new dimension to those who want to be healthy and active but may not be drawn to sports or competitive activities. It's an approach that has worked for me for twenty years.

> *"Like any good parent, I want to include every 'teachable moment' I can, because education should be fun, exciting, and should occur naturally and fluidly."*

Faith and family are the driving forces in my life and like most teachers I think of my students as "my kids too." I was brought up with unconditional love and that inspires me to this day to not be afraid to love with all I have. Anything I can share with my students to help them be more successful—*anything*—I don't care what it is, I will do it. Whether it's morals or math or motion—I just want to give them every tool I possess. I want my students to see the beauty and the value in themselves, and find the strength and confidence to journey down the path they were created to walk and give it all they have.

> *"Our class motto is, 'The doer of good becomes good,' and I have seen it happen time and time again."*

Ronald W. Poplau

11th–12th Grade
Community Service

Upon completing his very first year as a teacher, Ron Poplau told himself, "This is what I want to do for the rest of my life." Fifty-two years later, he is as energized by and invested in his students as he's ever been. Poplau's award-winning community service program has activated generations of young people to recognize their capacity to better the world around them, and the world has taken notice. The recipient of countless awards, Poplau has been a guest of the White House and an inductee of the National Teachers Hall of Fame, and his program has been honored by the governor of Kansas and modeled by schools across the country. Every day, more than a hundred of his upperclassmen fan out into their community to help the poor, the elderly, and the disadvantaged. The impact is humbling.

I grew up in a small town of just two thousand people in South Dakota. We were very poor. That's where my interest in community service comes from. Every Christmas, neighbors would come to the house and put food on the table and unwrap gifts they'd brought us. I can remember my father sitting silently, staring at the wall, and I can still hear myself say, "At least you could say thank you." But what I learned from that is that you don't play hero in somebody else's house. That's what I teach my students. When we make food baskets for the poor, we take them to their homes and drop them off, and whatever presents we have, we give to the parents to give to their children.

My father was a German immigrant and unfortunately because of his nationality, he was not permitted to attend school. He died at age seventy-eight a *total* illiterate. He could write his name, but I'm sure he couldn't pick it out in a sentence. He couldn't even vote alone. He had to get permission for my mother to go with him into the voting booth so that he knew where to put the X. He

couldn't drive. He seldom walked on the main street; he almost always went through the alley. He would charge everything he purchased on a house account and say, "Write it in the book and we'll pay you at the end of the month." We would get a bill and my mother would pay it. My father was completely dependent upon my mother and me and my two brothers. A lack of education does that.

Yet Dad always insisted that we be good students, that we bring our books home, that we study, that we pay attention. All three of us were high achievers and on the honor roll—he demanded it. The only time my father ever stepped inside our school was when I graduated from grade school. I wanted so badly to be first in my class, but I ended up in second place. After I got my diploma, I found my father back in the kitchen. He was crying up a storm, so much so that I literally walked away. In retrospect, I think what he was saying was, "Now all three of my boys can read and write and now all three of my boys are free."

If I read the computer correctly, seven thousand

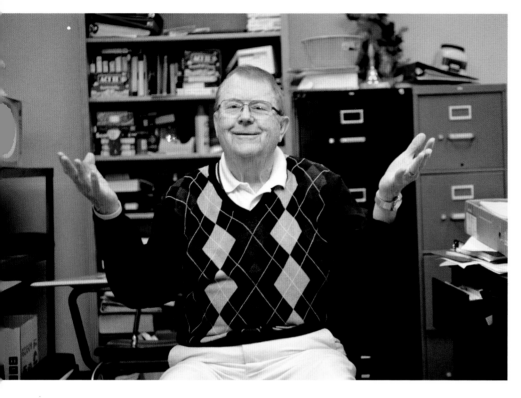

"If I were to do it all over again, my only regret is that I didn't teach community service right from the very start."

My first year in the classroom, a wonderful English teacher took me under her wing. She literally taught me how to teach, and she gave me some advice that I follow to this day. She said, "Always listen to the opinions of your students. Devise your lesson plans with their input." I learned very quickly and very well that students must be involved in their own education. I've had a student advisory board for every class I've taught ever since. They keep me current and effective. When students have a say in their learning, they *learn*!

Conversely, we must let teachers teach! Teaching is more than a textbook. Life is a living textbook. I am an avowed enemy of the "read and recite, tell and test" model. There is much more to teaching and learning than exams. All the teachers in my department are different yet we all have to give the same standardized tests. I hate that, and spend as much time as I can developing creative methods to draw the education *out* of the students. Given the opportunity, students will come through every time.

I've been at Shawnee Mission Northwest High School since 1969 and I've taught community service full-time since 1992. I had a contest to name the program in the beginning, and the winning entry was Cougars Community Commitment (CCC), which is what we've called it ever since. The class was very successful from the start and it grew quickly. At one point, I had nearly six hundred students a year doing community service.

The students absolutely love it. They want to come to class, and the effect it has on them is just unreal. Our class motto is, "The doer of good becomes good," and I have seen it happen time and time again. The kids have won every conceivable award. Even the governor of Kansas visited us to present the Spirit of Giving Award.

Once the kids experience community service, there is no holding them back. They tutor at elementary schools, they work with a nursing home, they gather mountains of food—we've got several local families that we feed.

students drop out of our schools every day in this country. That's my father times seven thousand *every day*. A life without education is no life at all, period. I have no letters from my father to remember him by, no birthday cards, no get-well cards, nothing. It's almost like he never existed.

Just before he died, my father begged me to return home and teach in the local high school. In the last conversation we ever had, he said: "Come home, Ron, come home." I replied that I had a home in Kansas City. He said, "You can make your home here with us." I stayed firm: "I am under a contract to teach in Kansas City. Why do you want me to teach there? " His final words to me were, "Because I love to see you teach, I love to see you teach." Now, when I begin each school year, I see him sitting at every desk in my classroom. He taught me the value of education by not having it. He gave me the very thing that pulled us apart: the best schooling he could provide. The defining moment of my life lasted seventeen years—the years I spent at home and saw what my future would be without an education. I received a scholarship to college— a full ride. There's no way we could have afforded it otherwise. I'm not ashamed to say this—in order to make it through grad school, I would buy a day-old white cake from the bakery and that's what I would eat for the whole day. I didn't have any money, so I really worked hard at my studies, and I appreciated every moment.

They've raised funds and awareness that have saved the lives of three children with a rare form of bone disease. Right now they are sponsoring an ex-convict who spent fifty-four years in prison. When he was released, the students befriended him. And what the prison couldn't do in fifty-four years the kids did in thirty days. They gave him friendship. They outfitted his apartment. They made sure he had food and clothing. And Henry promised them, "I will never, ever mess up." And he hasn't. He's been out since 1997.

The school I went to as a little boy, you opened up the front door, the back door would close. We didn't have overheads or a movie projector. And I still believe that we don't need all that electronic equipment and technology. We don't. We need the human touch, flesh and blood. And that's what my students experience when they volunteer.

At our school, community service is a regular part of the day, just like history, government, English, and the rest of the traditional subjects. What that teaches kids is that community service is of equal importance. A national study recently found that kids who are enrolled in community service score, on average, a whole grade point higher than those who are not. It appears that community service validates the curriculum. Since we began this program in 1992, Shawnee Mission Northwest has become a national Blue Ribbon School of Excellence, and a year ago it was chosen by *Newsweek* as one of the finest high schools in all of America. I think a lot of that has to do with CCC. The kids take their education more seriously. It means more to them. It's been said, "Youth is wasted on the young." Not for my students. These kids are learning the power that they have.

Students sometimes ask me, "How old are you?" And I always answer, "If you didn't know how old you are, how old would you be?" Working with this age group keeps me young. I just love it. All I can tell you is that it is one of the most rewarding experiences anybody could ever have. And it doesn't cost the school district a thing outside of my salary. The kids drive their own cars. They spend their own money on gasoline. They donate portions of their paychecks from after-school and summer jobs.

At Thanksgiving this past year, the kids fed more than two hundred families with $7,000 that they raised themselves. As families arrived to pick up their meals, one by one, the kids brought out their food. It was wonderful. I had to walk away and watch from inside the school. I was moved to tears by how mature the kids were, not only giving them the food, but also earnestly wishing them a happy holiday. And then they did the same thing for Christmas. They donated $35,000 to the local community center.

When the students achieve, it also affects the teacher—something lights up. It's like conducting an orchestra. Anybody who stands in front of the Philadelphia symphony is going to look good because they are leading one of the finest orchestras in the world. These kids make me look good, not the other way around.

Mr. Poplau taught me that the "doer of good becomes good." His words guided me to do the right thing. At first, I simply gave money or donated items to various causes. Then I began to donate my time and my abilities finding the true meaning of community service. Every day during class, I would go to my assigned site at Shawnee Gardens, which is a local nursing home. I found myself looking forward to my visits with Virginia, a woman in the Alzheimer's unit, who I talked to about anything and everything. The reason I tried to bring happiness to her every day was because of love. Community service is simply the spreading of love. By showing that you care about someone else enough to give without receiving is an unforgettable love that can change lives. To become a doer of good is truly to learn to give love relentlessly. Mr. Poplau not only has taught me that community service is a necessity for all people, but he made serving others a habit that I will always adhere to throughout my life.

Paige, age 18, former student

I would have hated like heck for this to be my last year, so I signed up for another one. And I know there's a good chance I'll feel the same way next year. When you've got kids who care this much, kids who want to learn and cooperate, who come in before school starts in the mornings and on the weekends, you can't help but want to continue.

All I can tell you is it's been a wonderful fifty-two years, and I pray every night for fifty-two more. If I were to do it all over again, my only regret is that I didn't teach community service right from the very start.

> *"I want to create this synergy in the room, a familial atmosphere where my students start falling in love with one another, so they will be less fearful to step up to the podium."*

Donna Porter

9th–12th Grade
Oral Communications and Oral Interpretation

Mrs. Porter in her classroom just before the bell rings.

Christa McAuliffe, one of the seven crew members killed in the space shuttle *Challenger* disaster, once described the meaning of being an educator this way: "I touch the future. I teach." That sentiment perfectly encapsulates what motivates Donna Porter to pursue what she calls the "priceless occupation" of teaching. There is no length to which Porter will not go to help a child in need if they are within her grasp. When Porter is not in her Mississippi classroom helping teenagers embrace both their inner voices and external powers of communication, she is traveling the country, sharing her unorthodox approach to classroom culture with other teachers. One of only ten recipients of the Stephen Sondheim Inspirational Teacher Award in 2012, Porter speaks about her methodology and personal experiences with the unmistakable poise and confidence of someone who knows in her soul she is making a positive difference; she is part of the solution.

The movie title *It's a Wonderful Life* describes my upbringing. My parents provided my sister and me with a house that was always a home—a home filled with magical Christmas mornings, prayer, poetry readings, books, and music. Throughout my childhood, I thrived at school. I was third in my class and was selected to the Hall of Fame by my teachers. Despite that, I really did not believe I had any important talents to offer this world. That is, until one day in 1974, in my public speaking classroom. It was my first speech and I stood in front of the class filled with anxiety, but when I started talking, it felt pretty good. Afterwards, my teacher, Ms. Derbonne, left me a note saying that I had just unwrapped a very special gift. Here was the defining moment in my young life: I was innately designed to speak. She invited me to be on her elite competitive-speech team. The countless hours of guidance she pro-

vided resulted in my placing as a finalist at the state championship in dramatic interpretation. I knew then that I wanted to become a speech teacher, just like her. I had to keep the ripple effect going.

I went to Mississippi State, majoring in speech education. During my junior year, I took a class titled Communication Disorders. Another new world had opened its doors to me. I decided to devote my life to helping people who could not speak because of speech disorders. I transferred to the University of Southern Mississippi and majored in speech/language pathology. Immediately after attaining my master of science, I began what I thought would be a lifelong career.

After almost twenty years in that field, the Picayune school district superintendent, Dr. Penny Wallin, asked if I would take a job as the speech teacher at the high school. I said, "Let's do it." Why not end my career with what I

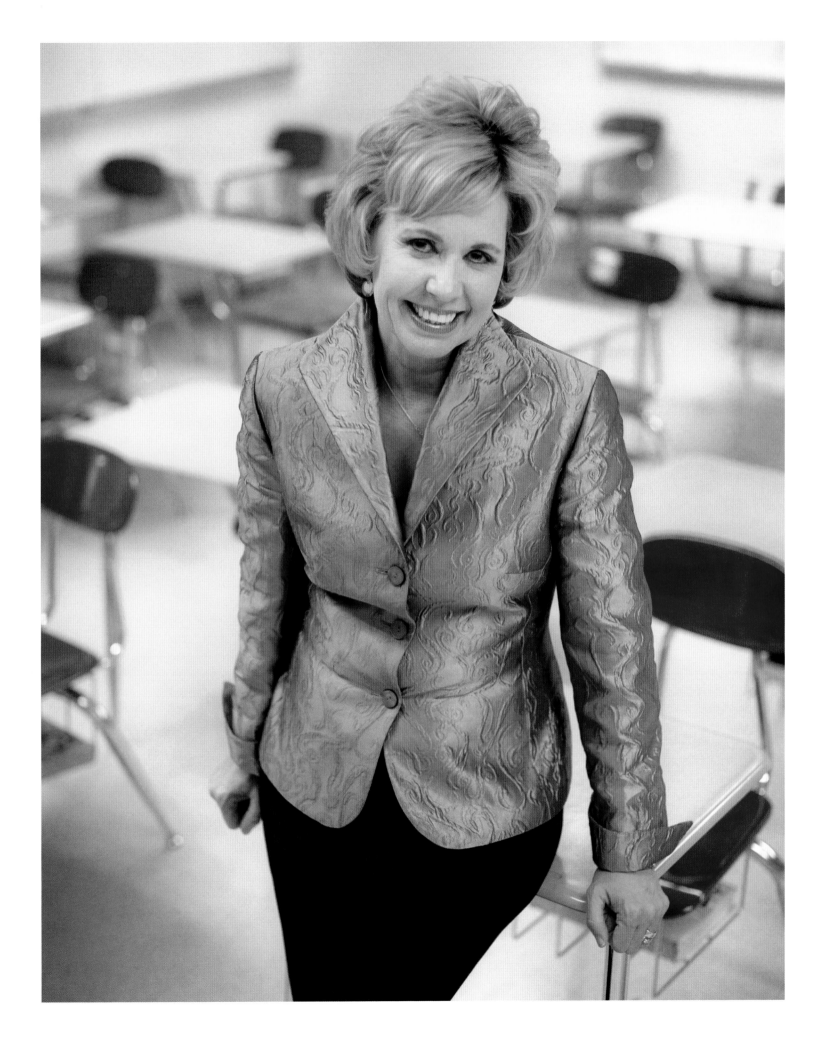

really wanted to start it with? As a teacher! However, I was forty-five years old and teenagers were complex. My friends and family doubted the wisdom of this new venture. An English teacher I knew warned me, "They will eat your lunch!" I truly believe that made me even more motivated to be successful. The classroom was where I belonged.

I knew my subject. I knew I was passionate about it. I also knew that public speaking is the number-one fear in America—ranked way above the fear of dying, which is number seven. People would rather die than give a public speech! So I needed to find a way to create an environment where a child would feel safe when they went to that podium. Fortunately, I had been trained in a classroom-management program developed by Dr. Becky Bailey called Conscious Discipline.® It is intended for elementary-school children, but I applied it to adolescents. They have the same needs. The approach is designed around building relationships: You are more likely to cooperate with people with whom you feel more connected.

Mrs. Porter changed my life; she opened my eyes to a whole new world, a world of love and reason, a world of right and wrong and most of all a world of hard work. She taught us on a higher level and didn't baby us. One thing that Mrs. Porter always said was, "Shoot for the moon, and even if you miss you'll land among the stars." That statement is what made me really want to try harder to make something of myself.

Written by a former student

It had to work...and it did! After only four years of teaching, I was selected as Teacher of the Year for my district. I advanced to become one of four finalists for State Teacher of the Year. Here was my affirmation. I could do it, and more important, I loved it!

Intrinsic motivation is the key to my approach. I tell students that they need to do the right thing because it is the right thing to do. There are no rewards in my classroom—only how good they feel when they make honorable choices. Success in their lives will not always be acknowledged by extrinsic incentives. I *notice* them instead. I try to acknowledge all the positive things they do. You'd be surprised by how much that means to a young person. In today's society, more than ever, many students have depressed self-worth. They often have no true belief in themselves and the value of their life. Maybe

I have changed that for some students. Maybe I have been the Ms. Derbonne in their lives.

On the very first day of school, I explain that our class is like a family. Our job is to create a community model, not a competitive model. I also give students a Multiple Intelligences questionnaire, as developed by Howard Gardner, to determine "*how* they are smart." This initially reveals to them that it's not a question of "if." Once I have identified their strengths, I use that to guide their roles in the classroom. Just like in kindergarten, my students have jobs. Because they feel needed, they value their jobs. This is the beginning of showing adolescents they have purpose and can contribute to the common good. Many students in today's society do not believe that they actually matter. In our room, everyone does! The valedictorian may watch in amazement as the student with autism shows his skills as the "Computer Manager." A student with known behavior/emotional deficits may be the "We Care Manager," who's responsible for choosing cards and presenting them to classmates experiencing difficulty in their lives. Those first few months are about establishing community, collaboration, empathy, concern for one another, and respect for me. They don't even give a speech until October. Teenagers are emotional—so I ask them to write about emotional things. It works because it's an egocentric time in their development. They aren't very empathetic. So they start by reading one another's essays before I ask them to walk up there and give their first informative speech. I want to create this synergy in the room, a familial atmosphere where my students start falling in love with one another, so they will be less fearful.

D.J. is one of my greatest successes. He was expelled from preschool. He started his own gang in the fifth grade. He was sent to alternative school twice. He served time in the juvenile justice jail. He was suspended countless times and fought constantly. He became a leader of a serious gang that committed many crimes. He had no plans to ever graduate from high school. D.J. remembers overhearing his teachers say, "I'll take three of your students if you will take D.J."

The first day he walked into my class with such disrespect, I realized that he must be fearless. Therefore, fear-based punishment would likely not be effective. I remember thinking of a famous quotation, "Recognition is what babies cry for and grown men will die for." So, I immediately gave him recognition in the form of a job. It worked. This gang member just wanted to be given posi-

tive affirmation in a classroom. I saw what he needed and gave it to him. So simple.

He'd always said the only reason he would be at graduation would be to cheer on his "homeboys." He never believed that he'd be alongside them. But our magical year ended with D.J. in his cap and gown. When "Pomp and Circumstance" began to play, he said, "Ms. Porter, there would be nothing I would want more than for you to walk me to my seat." So we walked into the stadium together. The applause was thunderous! I knew that was as good as it gets. That was my opus.

D.J. and I now travel all over the country inspiring others with our story. We motivate. We inspire. We laugh, we cry. We try to show America that teachers can be the only anchors in some children's storms of life. We rejuvenate teachers. We especially try to influence new teachers, because research shows that about half of them leave the profession within the first five years.

Because we live only forty-five miles from New Orleans and forty-five miles from the Mississippi Gulf Coast, after Hurricane Katrina we inherited a diverse group of academically poor students who came with nothing but pockets full of pain and suitcases full of hope. It showed me the resilience of kids. I had one student that lived in a tent for nine months. It was getting to the wintertime and I remember saying to the class that I would like to take up a collection for some of the students from Katrina. He was the first one to reach into his pocket and pull out a quarter. I thought to myself, "He is living in a tent and he is giving me a quarter. I do not understand." These children teach me so much.

It used to be that teachers could just be responsible for curriculum. Those days are over. With divorce rates skyrocketing and the economy and employment rate in decline, the classroom is more important than ever. It has to be more than just a place where instruction is delivered and tested. In every school there are students who need to be noticed and communicated with. You may be the only one in their lives who talks to them in a civil manner. All they may know at home is, "You are not worth anything," or, "You will never amount to anything."

For a decade, I have essentially been a lone ranger applying this elementary-classroom management approach to high-school students. I travel the nation giving motivational speeches to teachers about how a sense of family and community can be created. We do it with little kids with class parties and room mothers and valentines, so why can't it work for big kids? My goal is to inspire other secondary teachers to believe in this technique and try it. It would probably increase graduation rates—but even more so, create better citizens. I think no matter what the subject is, a teacher's job is ultimately to help shape citizens. I am told all the time at workshops: "If you taught physics, it wouldn't be the same." I say, "Yes, it would. I would teach physics with the same community model. I would teach communication skills in a physics class because that is the number-one skill most employers are looking for." These children do not know how to make eye contact. They do not know how to shake a hand and own a room when they walk into it. They have to feel that their words are valued and that they have power.

"I cannot save them all, but I made a difference to D.J. And I am making a difference to many others."

One time I was presenting to teachers about the way our class runs. A teacher raised her hand and said, "This sounds like magic, and I don't believe in magic!" Feeling defeated, I discussed this comment with my students, and one said, "Mrs. Porter, tell her to come watch...it *is* magic!" She was right. Magic *can* happen in a classroom if you provide a space where every student feels important and their opinion is valued, and teachers are given the tools they need to address classroom management. A school-family atmosphere must prevail so students will want to cooperate with one another and the teacher. With this type of environment, student motivation increases and apathy decreases. Students have often told me that they come to school for our class. The autocratic classroom can indeed yield good academic results. However, the democratic classroom can produce caring, empathetic citizens who also are high achievers.

In my classroom, there are starfish everywhere because of this legend I tell my students: an old man keeps throwing starfish back into the ocean even as they keep washing up on the shore. A little boy comes by and says, "Sir, you are wasting your time. As soon as you throw one back in the ocean, they are washing back up. You cannot be making a difference." The old man holds up one starfish and he says, "I am making a difference for this one." I cannot save them all, but I made a difference to D.J. And I am making a difference to many others.

> *"The beautiful thing about charters is that they have created all these different flavors. There are so many ways now to specialize your education. And it doesn't need to be restricted by the boundaries that you live in."*

Jennifer Rae Ramsey

6th Grade
English, Origami, and Gardening

Ms. Ramsey with her students on a library expedition.

Self-described as an "on my feet, sleeves rolled up, sitting on the carpet" type of teacher, Jennifer Ramsey has been doing her part to close the achievement gap in the public and public charter schools of Washington, DC, since 2006. Whether she's teaching students the tango or asking them to recount historical events in the form of a comic strip, Ramsey is always looking for outside-of-the-box techniques to unlock her young scholars' imaginations. In 2010 she was honored with the Rubenstein Award for Highly Effective Teaching. She now teaches at the highly regarded SEED School, which was featured in the 2010 documentary *Waiting for Superman,* and has become a national model for urban public boarding schools. In her student-run classroom at SEED, empowerment is always the word of the day, but fun is never far behind.

I consider myself a Washingtonian. However, true Washingtonians might try to fight me on that, because I actually grew up in a suburb of DC. My mom moved here from Seoul, South Korea, met my father, and went to nursing school. Having a Korean mother is much like living with a basketball coach—there is always a game plan to follow, and you are always expected to push yourself mentally and physically. I kept a busy social calendar—I was enrolled in every camp, lesson, and team you could imagine. My mother wanted the best for me and exposed me to so much. As a result, I consider myself a product of "all the systems." I attended both public and private schools in Maryland, a state school and a private college. Each of these educational experiences yielded invaluable character development and social skills.

As an undergraduate, I planned to be a physical therapist or nurse. I was also looking for a part-time job, and one of my best friends, who was teaching gymnastics and dance to children, urged me to give it a try. It was perfect—the connection to exercise was relevant to my schooling, and the opportunity to teach dance to kids barely seemed like work. I ended up teaching children in all socioeconomic brackets from throughout the DC area. It opened my eyes to the opportunities I could have to make an impact on educating urban youth.

After I graduated from the University of Maryland, I realized I wanted to apply my experiences to a real classroom. So I declined my acceptances to physical therapy and nursing schools and instead got involved with a small nonprofit, which handpicks and places teaching candidates into schools. They decided that because of my background and dance experience, I was a perfect fit for a performing-arts charter school in northeast DC. When I interviewed, it was an immediate love relationship. They hired me pretty much on the spot.

I taught kindergarten during the day and attended my master's classes at night. I received a lot of training my first year—as some charters offer to new teachers. And, within two or three years, I became a training mentor for teachers who were going through the same thing. I was very successful with my kindergarten class, so they had me loop to first grade. I watched as these kids completely learned to read and write. That was really beautiful.

Then I moved to a fifth-grade classroom that was in

complete chaos. Their teacher had left mid-year. I was terrified. That's when I got my feet wet with the older kids. It changed my life. Those kids taught me how to teach.

They could really express themselves. Most came from single-parent homes, or had social workers as their guardians. It was a really tough group. I could not beg or bribe those kids to pay attention. I won them over by showing them I was human. I let them see if I was having a bad day. I would tell them when I was going to get my hair done. Little things like that.

Man, I just love it when my Ms. Ramsey gives me advice

Because sometimes I don't know when to go

left or right

Sometimes when I hit the ground

Man, I just love it when my Ms. Ramsey comes

and I am now found.

Man, I just love it when Christmas comes

But when I don't have a gift for my Ms. Ramsey I

Feel bummed

When I go to bed with Christmas joy

Man, I just love that I am a boy.

Man, I just love it when Ms. Ramsey teaches

When she passes by me she smells like peaches (simile)

But when Ms. Ramsey teaches writing

Man, I just love it when no one's fighting

Khamar, age 12,
former student

I would not have been able to do it without the help of my fellow teachers. One of my friends, Mike Oaks, had the neighboring fifth-grade classroom. He had all these great ideas that I completely stole—and eventually made my own. Very simple things that made sense, like: We need to have some big ground rules. We need to be able to live and work together every single day. How are we going to do that?

There were some deep-seated issues among some of the students. They really did not like one another. I went from my biggest problem being that someone didn't want to share scissors to, "She is trying to steal my boyfriend." So I knew we weren't going to sit and sing "Kumbaya" every day, but they needed to learn how to grow together as a group. I did a lot of workshops on scenarios and trying to figure out ways to bond the class. We would play lots of games to help them team build. I just took it day by day.

At the time, I was an America's Choice Model Classroom. America's Choice was a very rigorous program that had been designed to close the achievement gap, to bring kids up to grade level. It provided this rigid structure to enable urban teachers to succeed. But because this was a performing-arts school as well, the arts were woven into every single lesson. So, for example, when the kids were preparing to do a performance of Dahl's *Willy Wonka*, I used that as our read-aloud book in class. So the America's Choice unit was regimented, but we were able to make different lesson plans out of that. It was never like, Day One, do this; Day Two, do that. And our director of curriculum was very innovative—she really encouraged us to be creative. Because of that setup in my first couple of years of teaching, it's been really hard for me to follow anybody else's curriculum without making it my own, making it hands-on, visual, and really fun.

After three years I felt like it was time to grow and have a new experience. I wanted to see what life was like in the DC public school system. I was getting antsy. After that fifth-grade class, I thought, I'm ready to do something else now.

I saw a Craigslist ad for a pre-K teacher. When I responded, the principal told me they had two teaching positions available—one for pre-K and one for upper elementary. I asked, "Can you please tell me a little bit about your school?" She replied, "We're John Eaton Elementary." My jaw dropped. That is one of the best public schools in the city, where all the kids start before they go on to the big-name private schools in DC, like Sidwell Friends. It's in Cleveland Park, right next to where the Vice President lives. I mean, it's just like a dream school, honestly. It's a beautiful, beautiful campus.

They hired me to teach third grade. It was culture shock. I was working with parents who had really high-profile jobs. It was intimidating. I was very lucky that the kids loved me. I created bonds with the parents from John Eaton that I still have today. To be very honest, my years at Eaton have probably been my best teaching years. I won the Rubenstein Award for Highly Effective Teaching during my years there. I got a lot of recognition.

I knew, however, that at some point I wanted to go back to a charter school. I wanted to serve a population that I felt needed me a bit more, perhaps, than the students at Eaton. I don't mean to make it sound like I thought I was some superhero, or that I was better than any of the other teachers. I just felt like the kids that were

falling farther and farther behind were more of my priority at the time.

I wanted to work at a successful charter—one where I could use my knowledge and really try to make some changes. I made my list. SEED was a late addition, only because it is a middle and high school. It's a really big deal because it's the only nationally recognized public charter boarding school (the kids live here on campus five days a week, and it's had all kinds of praise, from the President to *60 Minutes*). I thought, *I bet the staff there is amazing.* I knew I could learn so much. But I also thought, *I'm an elementary teacher, what am I going to do with a middle-school class? Or a high-school class?* I would be lost. I could do all the fun things on the carpet with my little kids. But how could I win over a group of urban middle schoolers? I had no idea.

SEED was actually my last interview. My principal here, Kara Stacks—we loved each other instantly, and she lured me in. Kara explained I would be teaching English to sixth graders who would need a teacher to help them transition to middle school. I would really be dealing with content that was more elementary because many of these students were coming in to sixth grade reading at second- and third-grade levels, which is a horrible and scary thing. I thought, *You know what? That's that. I'll take the job.* And she was absolutely right. Teaching sixth is the same as any other grade. They are all little kids at heart. The only difference is that now I have a revolving classroom door. I don't have the luxury of having them all day like I used to, when I could see them in every environment, in every subject, and more easily assess what their strengths and weaknesses were. So, it requires a different kind of organization and planning.

I'm working now with a population that's 99 percent African American. They are admitted by lottery, and there are usually two or three applicants for every spot. They feel lucky to be here. They know that their cousins and friends living in the same neighborhood do not have it so good. They know that they're part of something special. They are going to be the first ones in their family to attend college. So the idea is to remove outside distractions and surround them with an environment that is college preparatory. They are guaranteed to have three amazing meals a day. They can sleep well. This is a community operation. We have more educators on campus, because we have a student life staff that takes over once the teaching day is finished.

SEED has adopted the Lucy Calkins version of the Readers and Writers Workshops as its English program. It's similar to what I did with America's Choice, but because it's middle school the content is very different. I'm connecting the kids to the Common Core standards. For example, right now we're learning about social issues. I showed them clips of some old television shows, like *Saved by the Bell*, and we talked about them. Then, we further related that to how characters in our books deal with social issues. So, I'm using the content from Readers and Writers and from Common Core and I'm putting my spin on it as well. It's a challenge. So far, so good. But I know that some people are very nervous about what kinds of results the testing is going to produce.

> "*I went from my biggest problem being that someone didn't want to share scissors to, 'She is trying to steal my boyfriend.'*"

I asked my students one morning, "Why do we take the District of Columbia Comprehensive Assessment System exams?" They said, "So that we can go to seventh grade." And, "We take it because this is how you guys know if we learned anything." After I explained about Common Core, they now say things like, "We're going to figure out if we're smarter than California!" They want to compare scores. It's really tricky, because testing is so important. But the kids have no idea what it truly evaluates. I tell them to do their very best because, unfortunately, that number is going to follow them—that's the snapshot by which they'll be measured.

I have not been at SEED long enough to really get a lot of formal feedback, but I know the kids don't want to leave my classroom at the end of the day. And I work for them first. Many parents have commended me on how close their child feels to me and how much fun they think my class is. That is the entire point of doing what I do.

The reason I believe charter schools are part of the solution to our education problems is because they're providing an alternative—a choice. But beyond that, the beautiful thing about charters is that they have created all these different flavors. There are so many ways now to specialize your education. And it doesn't need to be restricted by the boundaries that you live in.

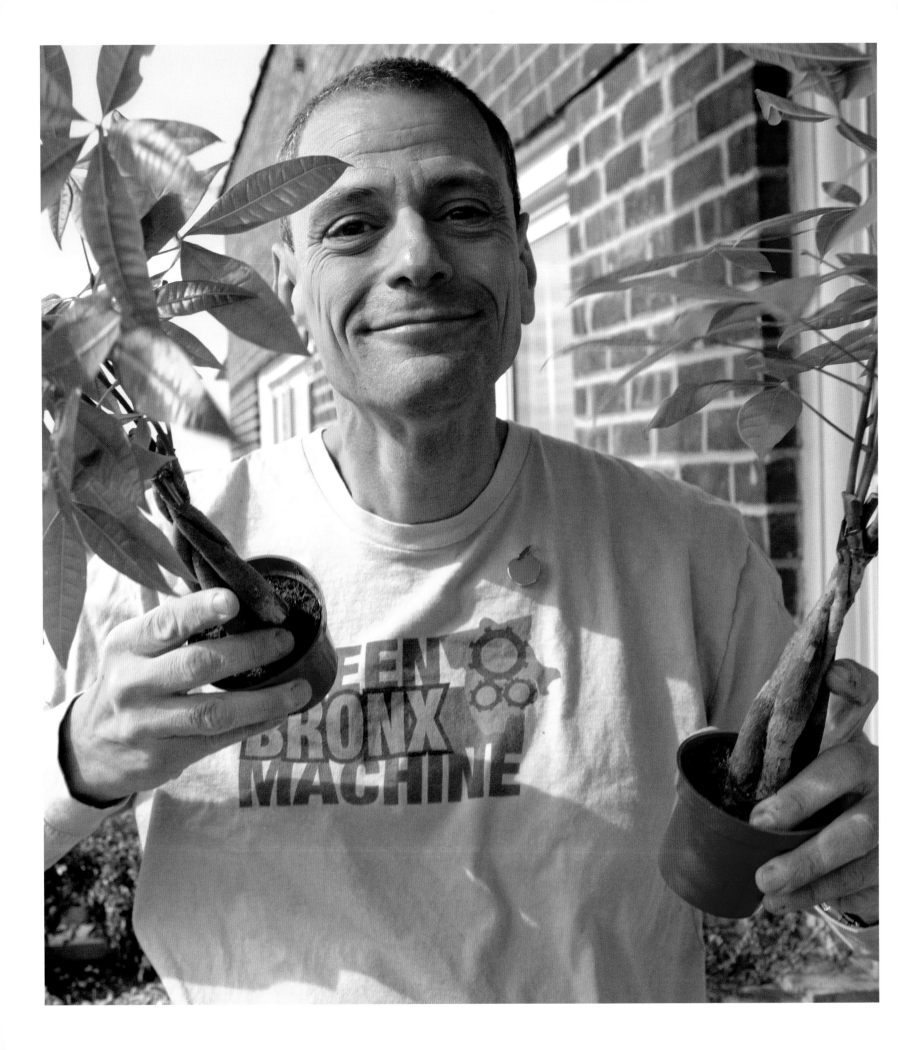

"My kids can get a handgun quicker than they can get an organic tomato. That said, when they get involved with nature and they learn to nurture, they feel good about themselves."

Stephen Ritz

Kindergarten–12th Grade
Special Education and Career Technical Education

Using the framework of sustainability and organic urban agriculture to cultivate a generation of curious learners and successful achievers, Stephen Ritz has single-handedly changed landscapes and mindsets throughout the South Bronx, one of New York City's poorest performing public school districts. Armed with the conviction that "kids should not have to leave their community to live, learn, and earn in a better one," Ritz is teaching his students how to literally grow their way to a greener, healthier, and wealthier life. In 2010, Ritz founded a nonprofit, Green Bronx Machine, to expand his groundbreaking program into the community. "Thirty thousand pounds of vegetables later," says Ritz, "and my favorite crop is organically grown citizens, graduates, voters, and members of the middle class."

Mr. Ritz holds plants his students have grown at the Green Bronx Machine headquarters.

The whole Green Teen Program started about eight years ago. I'd been a middle school crisis intervention teacher at a series of schools in the South Bronx for ten years. I taught the so-called "worst" kids at the frontline schools in the highest-of-the-high-need communities in one of the most challenged educational environments in terms of academic retention, staff competence, community engagement, the whole bit. In 2005, I wound up taking a job at Walton High School, which was among the most classically failed institutions in New York City at the time. I think it had an 11 percent graduation rate. Lo and behold, I walked in and I knew nearly every single kid in the school because it was the veritable dumping ground for the "worst of the worst" in the Bronx. But those kids trusted me already—they knew my daughter, knew my wife—and they respected me. They knew that the core of what I do is to treat every kid the way I want my own kid treated.

I was hired as a special-ed teacher but three weeks into the year they made me dean of students. Not long after that, out of the blue, someone sent me a bunch of bulbs in the mail—daffodil bulbs. I didn't know what they were. The kids didn't know what they were. So I shoved them behind a radiator in the school. Well, the radiator forced them. Before you knew it, we had these beautiful flowers blooming in our classroom. The boys wanted to give them to the girls for sex, the girls wanted to turn around and give them to each other, and everyone wanted to sell them and make money. Soon after that, I was introduced to "Bissel Gardens," which was a struggling community garden in the Bronx that was literally being used as a homeless encampment and was filled with substance abusers and abandoned cars—but it had tremendous potential. My kids and I cleaned it out. We planted fifteen-thousand daffodil bulbs that year, and I realized I was onto something.

That single box of bulbs gave birth to what I called the Green Teen Program. The program took seventeen overage, under-credited youth—many of whom had criminal backgrounds and came to me via the Probation Department—

and engaged them in learning for the first time in a very long time. These were the kids no one wanted. But I loved each and every one of them, and they loved and respected me. Together, we realized that we could make things grow. And that was an amazing revelation.

I always tell kids that if they bring their body, their brain will follow. And, if they show up, they grow up. This program was about moving kids who are apart from, to being a part of. I mean, sure, it was an academic problem we were facing, but really it was more of an engagement problem. I wholly felt that if kids were engaged, and wanted to be there, the rest would come.

Within two years, those seventeen "worst of the worst" kids all went on to become graduates, and the Green Teen Program became one of the most competitive programs to enter in the school. The big thing I learned is that the green thing works—because in the age of "No child left behind," no child should be left inside. Kids change when they get outside and interact with nature. Listen: My kids can get a handgun quicker than they can get an organic tomato. That said, when they get involved with nature and they learn to nurture, they feel good about themselves. And, the remarkable thing about plants is that they grow, and grow quickly. And the kids start to feel responsible for taking care of them.

> *"I always tell kids that if they bring their body, their brain will follow. And, if they show up, they grow up."*

For some kids, it takes them way back to the last time when they felt successful in school, generally kindergarten or first grade, when they did the lima-bean experiment. Somehow, subliminally I'm tying the Green Teen Program back to a very good message and memory, before school went off the rails for them. So they remember, "Oh, I did this when I was little. Why am I doing this now?" And I say, "I'm going to show you." Meanwhile, I'm equating it to a lab that they need to do for their Regents. I'm using this living environment as a tool to teach them the science, math, and English skills they need. It is a lot of smoke and mirrors but it's something that they respond to.

Of course, I also get the kids who say to me, "Mister, I have an uncle who grows 'something.' Let's just say it's... tomatoes." I gave a talk at Columbia University called From Crack to Cucumbers, where I brought kids who were

formerly selling crack and were now selling cucumbers and making more money than they were before. And, that, to me, is the greatest revolution of all, because I'd much rather see a cucumber-addicted baby than a crack-addicted baby. When my young men and women who are caught up in the drug trade for ridiculously poor sums of money realize that their lives will change for the better by doing something for the better, that is just transformational.

As the program grew, we started taking over abandoned lots throughout the Bronx, places where people were congregating for the wrong reasons. We moved prostitutes and stolen cars out and started connecting with people in the neighborhood who wanted to get involved. We live in a food desert in the Bronx. A whole lot of kids are on food stamps. But, when you see the production of food as the means to the production of income, and a way to empower yourself, that changes everything. Just do the math. We get one hundred seeds for $.99. We can sell them for $5.00 a pop. We like that margin. I just changed the content of what was in the Ziploc bag, so to speak.

My kids became phenomenally proficient at growing food in earth boxes. I don't think I could have named ten vegetables back then. Certainly, my kids couldn't have, so we grew what we knew, what we wanted to eat, which was limited to that which we got through a bulletproof window in a Chinese restaurant in the hood. We grew green peppers and we grew them as efficiently as anybody I've ever seen. We could write the book on green peppers. Then we went to Whole Foods, and we saw that there were also red peppers and yellow peppers, which was great because I could use that as a metaphor for how there are white kids, black kids, green kids, fat kids, and skinny kids. And just like that, they're learning about genetic variation.

But the funny part was, we also realized that yellow peppers and orange peppers and red peppers cost much more per pound than green peppers! And, the kids turned around and said to me, "Ritz, you screwed us! We should be growing these instead!" I replied, "Okay. So what's the critical learning?" Well, the critical learning was that we never grew a green pepper again and we started making tons more money. That was when the kids took ownership of it.

In 2009, I was introduced to green walls for the first time on the set of *Good Morning America*. My kids from

the South Bronx had gone to Harlem to build a garden. This was like putting the North Koreans in a room with the South Koreans. No one thought it could happen. But it did. And it was featured on *Good Morning America*. On that same day, a green wall was being donated to the morning show set and I fell in love with this technology the minute I saw it. By that time, I had six acres of community farms across the Bronx and it was totally unmanageable for me. When I saw a way to put one thousand plants into an eight by eight-foot vertical garden and keep it in a classroom with grow lights, I thought it was just about the coolest thing I'd ever seen.

I approached the manufacturer and invited him to come to my classroom and talk to my kids about how to build a green wall. He did a one-hour seminar. The kids fell in love with it. Two weeks later, we were on a bus to Boston to be trained and certified. And we put a twenty-foot wall up, twenty stories high, in the heart of the John Hancock building in Boston.

Just like that, I had the youngest nationally certified workforce in America.

We started installing green roofs all over the place. We went to the Hamptons. We went to places we couldn't imagine. The following year, we put one in on Rockefeller Center, and the rest was history. It got bigger and better and we started growing enough food in one classroom to feed 450 students at a time. Now, the White House is talking about our program. The Bronx Borough President is talking about our program. I'm asked to speak at colleges across the country. When you can grow enough food indoors to feed 450 people and put that fresh, healthy food right into the school cafeteria—zero miles to plate, with zero fossil fuels—that's a game changer. We run community gardens where every pound of food is donated to local soup kitchens. We are feeding our own community. And, we're feeding them healthy, nutritious food.

Along the way, we've also lost thousands of pounds. We've gone to school. We've eliminated truancy and all the reactive programs like home visits, Saturday school, and make-up classes. The kids come early and they stay late and they're engaged in between. And, they're passing classes. They're working hard for the privilege to farm, to climb up to the roof, to get out in the backyard. They're learning that food comes from the ground, not aisle nine in the supermarket. Not from the "food elves" in the basement of Costco.

I want to embed the lens of sustainability, conservation, health, nutrition, and wellness into every single content area: grades K to 12 and beyond. We're planting all kinds of seeds—academic seeds, cultural seeds, seeds of hope—I call it cultivating minds and harvesting hope. I don't expect them all to be farmers, but I expect them to read about it, write about it, blog about it, offer outstanding customer service, do twenty-first-century research, and be engaged.

"The important things in life need to be transformational. My relationship with my wife is transformational. My relationship with my students is transformational."

Realize this: My kids are the canaries in the coal mine. They are on the front lines of all that is wrong with America. There is this great myth that if we take a guy from jail, we take a kid from rehab, or we take a homeless person, and we somehow "get him" a high-school diploma, a nice résumé, and a good interview suit, everything's going to be fine. That's the biggest lie of all. Putting somebody in an environment where they're simply going to feel average, if not below average, is not a solution. The important things in life need to be transformational. My relationship with my wife is transformational. My relationship with my students is transformational. And, that's what this kind of work is, because you're feeding people, you're generating income, you're moving people who are apart *from* to being a part *of*, and you're changing lives. My students are experiencing what it feels like to be uniquely skilled and good at something that not everyone can do. It's not about some mindless job. This requires knowledge and experience, which they now have.

We can come together around this. This is an "us" moment. As a parent, local resident, educator, and citizen, the intention behind all I do is simple: It is easier to raise healthy children than to fix broken men. So what do we want? We want more schools and less jails. We want more books and less guns. We want more learning and less vice. We want more justice and less revenge. We want more leisure and less greed. We want more opportunities to cultivate our better nature.

It's totally doable. The answers are right in front of us. *The answers are right in front of us.*

"We put such a high value on writing and speaking, but when we give children the opportunity to express themselves in other ways, we see more sophisticated thinking and deeper engagement."

Kerry Salazar

1st–2nd Grade
General Studies

Ms. Salazar listens as her students read their stories.

Opal Charter School, where Kerry Salazar spends her days nurturing the imaginations and curiosities of young developing minds, is housed inside the Portland Children's Museum. Opal's philosophy is heavily influenced by the early-childhood centers in Italy's Reggio Emilia, which embrace a curriculum that is negotiated between children and teachers, and emphasizes the role of art in education. At Opal, which opened in 2000, students from kindergarten to fifth grade actively participate in the direction of their own learning, exploring many unconventional forms of expression and communication. After hearing the school's founders speak at an education seminar, Salazar was hooked. She relocated to Portland and joined Opal's team in 2008. The fit couldn't have been more perfect. Says Salazar, "I've fallen in love with my work." It's easy to understand why, considering a recent handwritten card she received from one of her students: "My sister said she thinks you're better than cinnamon bread! And so do I!"

W e are creating a city in my classroom. The first thing the children did was to create characters. They said, "You can't have a city without people." And, they love their characters. They carry them with them wherever they go. And, now we're getting to the part where they are starting to think more

OPAL CHARTER SCHOOL OF THE PORTLAND
CHILDREN'S MUSEUM, PORTLAND, OR

"Creating experiences that children can connect to, and keeping their sense of wonder alive, is what I strive for as a teacher."

collage) to bring the images of their stories to life. We are finding that when children are free to explore the arts as forms of communication, the sequences of their stories become stronger, the language they use becomes richer, and children naturally view themselves as authors. Strong writing is the result. Additionally, Story Workshop supports a sense of community as we get to know one another better through hearing about one another's lives.

We invite them to tell both true and imaginary stories. Sometimes, we dive into a genre study, if it is related to something we are doing in other parts of the curriculum. A student may raise her hand and say, "I'm going to go tell my story in blocks today." Or, "I need to build my building to see where the setting is." Or, "I'm going to paint my story today and see what new details I can find." Or, "I am going to explore the same story I explored in blocks yesterday, but in another material today." Or, "I'm ready to write my story down." We talk about finding stories that the students care enough about to want to publish, to sustain their interest for extended periods of time, and to share with others.

There is a multitude of research that supports the fact that children learn best through play. It's everyone's most natural learning strategy. This research tells us that children who learn a skill through play versus direct instruction learn the skill equally as quickly. But, the children who learn through play have increased motivation and will stick with it and remember it longer. School doesn't just have to be this place where you sit down at your desk and write with a pencil the answers you think someone else wants to hear. School can also be joyful and support creativity—full of wonder and awe. That's why it works so well to be teaching within the environment of a children's museum. This matches strongly with our goals for education.

deeply about what kind of city they want to build. They are asking questions like, "If we're going to create a city, what's going to be in it?" "Who gets to decide?" "How do we create a city where everyone feels included and where everyone feels like it's their community?" And we talk about how those things are different for every person.

Curriculum should be co-constructed with children. Curriculum that comes from a book or a set of predetermined lesson plans cannot take into account who the children are as individuals. If we do not begin from a place of what children already know, and what is meaningful to them, then it isn't possible to teach for understanding. Children remember more and build stronger connections to content when it has significance in their lives. Creating experiences that children can connect to, and keeping a sense of wonder alive, is what I strive for as a teacher.

One of my favorite ways to do this is through a structure we have created called Story Workshop. It has been developed in response to the question, "What is the connection between literacy and the arts?" The result is that we invite children every day to discover, remember, invent, and tell their stories using a variety of materials and techniques (such as blocks, paint, clay, loose parts,

When I was working on a double certification in both Early Childhood and Elementary Education at Western Washington University, I was introduced to the philos-

> *"The founder of the Reggio schools once said that teachers are 'professional marvelers.' I feel so lucky to be in a place with people who support that."*

ophy of the municipal preschools in Reggio Emilia, Italy. I was drawn in right away and was particularly interested in their principles of a strong image of the child, and using the arts not just to produce products but as a process for children to share their feelings and opinions. In the U.S., we put such a high value on writing and speaking, but when we give children the opportunity to express themselves in other ways, we see more sophisticated thinking and deeper engagement.

During my program, I developed a close relationship with one of my professors, who invited me to attend a three-day summer symposium hosted by a charter school in Portland, Oregon. It was there that I met Judy Graves and Susan MacKay, the leaders of Opal Charter School, which was inspired by the practices in Reggio Emilia. At the conference I was amazed and inspired by the work they presented. They placed a very high value on each child and the community as a whole. These were people I wanted to learn from. When, later that summer, Judy and Susan offered me an opportunity to come and student-teach there, my real journey into finding myself as a classroom teacher began.

The mission of Opal is to provoke fresh thinking in education. We open our classrooms for visits and workshops many times during the year. When people visit they are surprised and inspired by what we do. I have been here now for so long that our work seems typical. But I know it's not close to typical. In Reggio, the environment is considered the third teacher. Here our goal is to put a lot of value into organization and beauty. All these principles have to do with our environment, how it looks and feels and how it is supporting our children as learners.

I think the greatest challenge I've faced as a teacher has been working to stretch other people's limited expectations of children. Young children in our society are often viewed as empty vessels waiting to be filled. We do not value them or even realize that they have important, meaningful perspectives, different from those we carry as

adults. Their creativity, innovation, and leadership skills are often underdeveloped because of a lack of trust from adults who doubt their capacities.

Last year I taught kindergarten, and I noticed the children telling all kinds of stories about good guys and bad guys. I saw this as a learning opportunity, and we created experiences related to this idea. As a group, we invented language around knowing someone's outside story (what you know just by looking at them) and someone's inside story (what you couldn't know just by looking at them). We imagined what animals from the zoo's inside and outside stories were, what characters in a book's inside and outside stories were, and finally we used that shared understanding to learn more about each other and problem solve together in new ways in the classroom. By the end of the year my students had decided "there were no such thing as bad guys." I was awed and proud of the complex understanding that such young minds constructed and synthesized about people.

Too often we pay attention to what children cannot do or are not doing yet. I think we will get better results when we shift our attention to what they *can* do and what they already *are* doing. The founder of the Reggio schools once said that teachers are "professional marvelers." I feel so lucky to be in a place with people who support that.

"I was prepared to learn, to become a teacher, or an administrator—whatever the school needed me to be. I was very inspired and ready—ready to really dig into this project."

Jenni L. Schneiderman

Kindergarten–5th Grade
Expanded Learning Opportunity & Community Engagement Coordinator

Since being hired just a few short years ago to develop an after-school program and teach kindergarten wellness, Jenni Schneiderman's role at the Academy for Global Citizenship (AGC) has evolved to include overseeing family-engagement initiatives, the arts curriculum, the after-school program, and summer camp. AGC is a revolutionary public charter school on Chicago's South Side whose dual mission is to empower students to make a positive contribution to their communities and the world, and to become a replicable model for learning in the twenty-first century. At AGC, a rigorous academic program is taught through the lenses of sustainability (they are currently constructing a net-positive energy campus), international awareness, environmental stewardship, and community service. Schneiderman wears her many hats at AGC with such ease and dexterity, it's not hard to understand her rapidly expanding responsibilities. Her title may be quite a mouthful, but around the AGC campus she's known to all fondly and simply as "Miss Jenni."

Ms. Schneiderman with her bright-eyed global citizens.

I found the Academy for Global Citizenship (AGC) online while I was teaching in Argentina, and I became totally enamored by what I was reading, hearing, and seeing. I've got an adventurous spirit, and I just wanted to come check it out. I got back to the United States in April of 2010, found out AGC was having an Earth Day celebration on April 22, and jumped on a Greyhound from my parents' place in Ohio to be in Chicago for it. I could not believe what had already been accomplished in the year and nine months since the school's inception—there were vegetable beds in the asphalt playground, and such thoughtful language being used in the classroom. The lunch was unbelievable!

Operationally, I was totally fascinated by the teaching and learning, in the intentionality, the care that was going into everything. It was just amazing. And so I just sat down cross-legged in the middle of it all and wrote in my journal about what I was experiencing. The executive director and principal were probably thinking, "Who's this girl who just got off of a bus?" I demonstrated a lot of enthusiasm about what was going on, and let them know I wanted to be part of it. I was contacted not long afterward and told that a new multifaceted position was opening up. I didn't have a lot of formal education training, but I firmly believe I learn best through direct experience, and I was prepared to learn, to become a teacher, or an administrator—whatever the school needed me to be. I was very inspired and ready—ready to really dig into this project.

My approach to teaching is absolutely about the whole child. I didn't truly know what that meant until I came to AGC, but it's really what I was always looking for, philosophically. And in my three years here, I've learned that it means to understand the complicated stories of each child, and why their behaviors exist as they do. As a psychology major in college (I've always been fascinated by human behavior) I thought I was going to become a clinical psychologist. Now I'm much more interested in groups of people and adaptive human development on

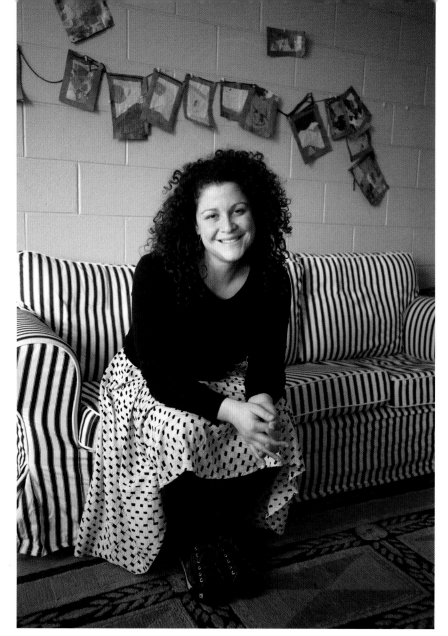

"My approach to teaching is absolutely about the whole child. I didn't truly know what that meant until I came to AGC, but it's really what I was always looking for, philosophically."

youth, family, and neighborhood developments so that we can support the growth of not just the students, but of the parents, because, with regard to the whole child, parents are inextricable from the equation.

And this is the reality of public education in an urban, low-income environment. We've got many other needs to tend to first. We can't get to the teaching and learning; we can't get to that fertile space of idea flow that I experience within myself when I'm a healthy being, until all of these other needs are being met.

Reflecting on my own education, I was raised in upper-middle-class white suburbia, and a foundation of safety and trust was always there, which I never really thought about until I stepped outside of my own experience when I traveled to Argentina and then moved to Chicago to work at AGC. These experiences have encouraged me to recognize the importance of variables such as financial and emotional stability of adult caregivers in the formative developmental years of young people. At AGC we value the voice and perspective of our parents as key partners in this work. So, when I'm not in the classroom with students, or working with a partner organization or with teachers, I'm collaborating with our parents and nurturing those relationships. We're now in the process of reorganizing our parent/teacher body and developing a new structure, called *Convivio*—which means "to coexist" or "to work and live together." We host a *Convivio* gathering every six weeks for our parents, teachers, and upper-level students to engage in community-building activities together, to form a foundation for trusting, caring relationships. We invite community resources to join us—for instance, we've had a Latina pediatrician talk to us about nutrition and a financial advisor discuss the financial health of families. It's designed to be very participatory and radically inclusive, and really get at the needs of our families.

more of a macro scale—understanding the context of each child, looking for demographic and cultural patterns, really getting to know the community we're working with, to build a foundation of fertility for these students to grow and self-actualize. That is my educational philosophy—the whole child, in a way that is deeply empathic, humble, and relevant to their needs. And that includes the whole family and the whole community. By building this network of support and potential, it really does create this oasis, this safety net.

I don't have the statistics, but we have a significant number of parents who are unemployed or underemployed, and much of that involves first- and second-generation immigrants struggling to navigate different aspects of U.S. systems, be it education, health care, employment, etc. At AGC, we believe the future of education is in letting the school be the community hub for positive

We're creating this community-education model, in which parents are becoming an essential part of the school team, and facilitating the positive development of their children. We have our families sign a contract at the beginning of each school year in which they commit to twenty volunteer hours, which can take on various forms—from helping in the classroom, to organizing an event, to working on a fund-raising initiative. We've noticed that the more involvement there is, the more parents are actively engaged in not only their children's learning but also in the culture and community of learning at school.

This also ties in to the curriculum I'm helping to cultivate with our after-school teachers, some of whom are teachers-in-training at local universities, and some of whom are parents. We're developing a hands-on, project-based, mission-aligned program. After-school really does take on its own culture, in that it's mostly made up of small groups. Clubs are generally eight to fifteen students, tops. And it's a much less structured environment and very much about the students guiding the experience. I communicate this to all of the teachers—that after-school is about relationship building and social/emotional growth more than it is about the particular club. We've got parents teaching art, cooking, woodshop, and sports in exchange for their own children participating in other classes for free. Dodgeball Dads is the most popular after-school club at the moment. To see how the kids look at their parents when they're acting as a leader—it's priceless. It's really impactful, for both the kids and the parents. This upcoming session, we're having a Mexican Cooking Club with one of our moms, and she's going to be teaching the kids how to make tortillas. She came to me and said, "Miss Jenni, I'm so frustrated that my child doesn't know the difference between a taco and a tortilla! He doesn't understand that a tortilla is a building block of a taco, and it's very important to me that he knows this."

The art program has been another initiative that has evolved over the past two and a half years. We bring in six art teachers, and I work with them to construct a curriculum that's integrated with and relevant to our school culture, and then help them implement their program across all grade levels for one day every two weeks. Out of three hundred students, about 75 percent participate. Those art days serve the dual purpose of enrichment for our students and professional development for our teachers. All of our educators are involved in training and collaboration during that time. It gives them the opportunity to connect and share what's going on in their classrooms, because teachers are so often working in isolation. Concurrently, the students have the chance to learn from experienced, trained artists from outside the school community. School can be such a closed system, so this influx of wonderful energy coming from the external world helps expand the culture.

"We're creating this community-education model, in which parents are becoming an essential part of the school team, and facilitating the positive development of their children."

Aside from overseeing parent- and family-engagement initiatives and expanded learning programs, another part of what I do is organize teachers to travel and look at different models of public education. Last year, I took a group of teachers to Guatemala to learn about Hug It Forward's model. Hug It Forward is an organization that has partnered with the Ministry of Education in Guatemala to build schools out of water bottles in rural communities, and to engage the communities. Through taking our teachers outside of our public education system and introducing them to the educational models in other cultures where communities are structured around their schools, they become enlightened. We really believe, here at AGC, that it's the future. We're becoming hyperconnected, and if we harness technology appropriately, we can continue to learn and grow from communities all over the world that are putting learning and the child at the center of development.

I grew up in a very loving, humanistic family. When I was in high school, my father got sick with brain cancer and passed away, which was a very formative experience in my life. But I had the foundation of stability, and a network of love and support to incubate me and help me get through that trauma and become who I am now, which is a well-adapted twenty-seven-year-old woman. But for so many children in urban Chicago, they're living with an overwhelming amount of trauma, and there aren't sufficient structures of support for them. It's been very humbling for me and my own process. I think about that all the time.

"The mark I make may be small globally, but it is large locally, very tangible, and extremely rewarding."

Greg Schwanbeck

11th–12th Grade
Physics and Astronomy

"Helping a student unravel a physics problem is like watching someone open a Christmas present," explains Greg Schwanbeck, whose technology-laced approach to teaching is far more hands-on than highbrow. Integrating QR codes, text messaging, and video labs into his lesson plans and classroom culture are just a few of the ways he leverages new media to engage and reward his students. Passionate about both education and technology, Schwanbeck, who hails from a family of proud math nerds, has been an Apple Distinguished Educator since 2011 and is a member of the TED-ED Brain Trust. Says Schwanbeck, "I try to model for my students that smart is cool every day, but as I get older, I admit it does get a little harder."

I come from a long line of engineers and math geeks. My grandfather was an aeronautical engineer, my dad has an engineering degree from MIT, my older brother is an electrical engineer, and my younger brother is an architect. So we live "nerd pride" every day.

I got my first inkling of my future career in third-grade math. After mastering the basic concepts, boredom set in, so my teacher, Mr. Lawton, put me to work assisting a pair of students who were struggling. I discovered that helping a friend was really satisfying. Thirteen years later, as a freshman in college, I was taking a course titled Integrated Math and Physics, which wrapped the first year and a half of college mathematics *and* physics into just thirty weeks, and I was struggling. It was the most difficult class I'd ever taken, at any level. Nevertheless, Professor Reich asked if I'd be interested in joining the student-run tutoring service provided by the physics department. I wondered, why did he select me? He said that while he knew I was having some trouble, I could explain a concept with surprising clarity.

I took him up on the offer and for the next three years I

felt the warmth of contentment when a student came into the tutoring center feeling like a slave to physics and left feeling like a physics master. Helping someone expand their understanding gave me a rush—I was hooked. I applied for teaching jobs right out of college, and started teaching physics and calculus at Nantucket High School at twenty-two years old.

I became really interested in the role technology could play in physics education while I was teaching in Nantucket because we didn't have very much in the way of physics lab supplies. I started doing virtual web-based labs, where you connect a virtual wire to a virtual lightbulb, or fire a canon and watch the parabolic motion of the projectile. I started to see how it was a powerful tool for the classroom.

In my first year at Westwood High in 2008, I was teaching physical science and spent a lot of time with the freshmen going over how to convert units and how to deal with scientific measurements. It was very frustrating and it took several weeks to teach them these basic lessons. I thought back to a course I'd taken on documentaries

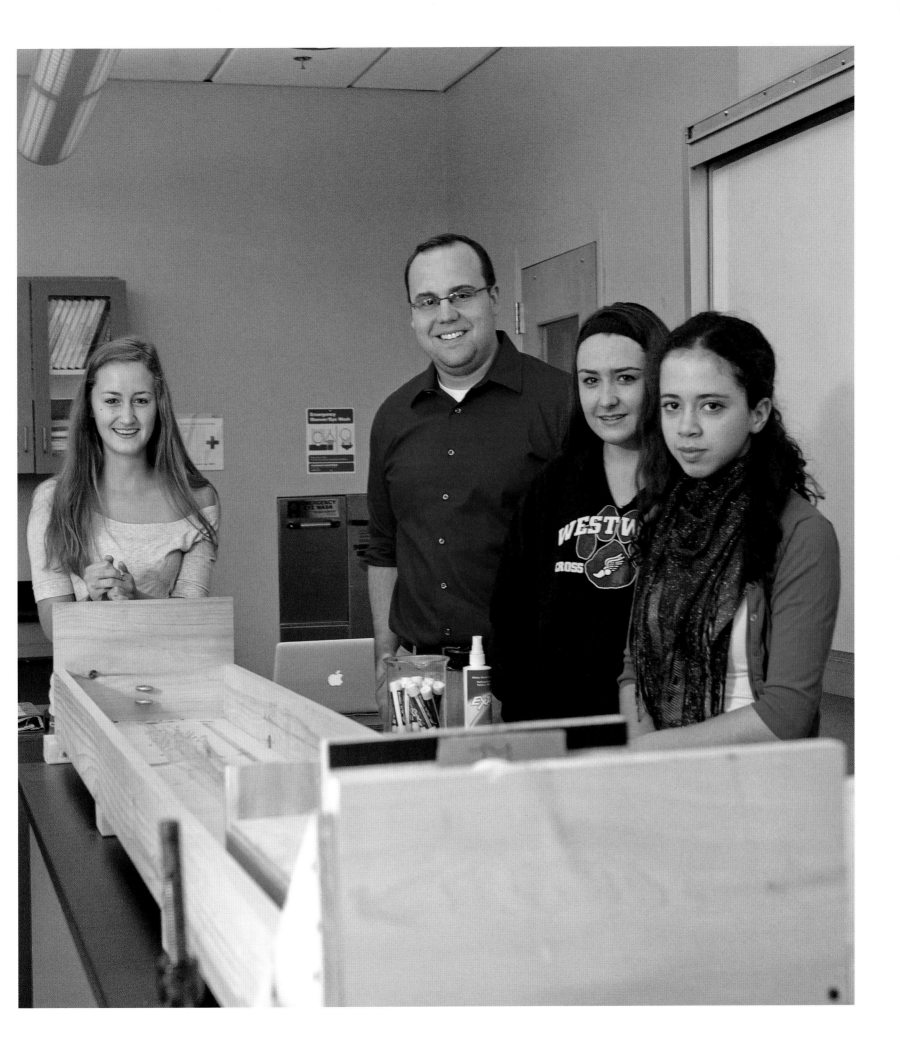

and I made a three-minute film called "How to Convert Units," which was really successful with the kids. It's had more than 100,000 views on YouTube. I bill it as the most entertaining video about unit conversions ever made. It's a low bar, of course, but if you Google "how to convert units," it shows up as either option number one or two. Anyway, I started using videos, collecting them as references for the students.

I walked into my first Physics class with extremely low expectations. But the teacher who—literally—jumped up to teach our class was nothing like I'd imagined. This man told jokes, provided engaging class demonstrations, and got so excited about physics that sometimes he'd *skip* to the white board. Mr. Schwanbeck's sense of humor is a Westwood High School legend, and his physics jokes are often recited over chocolate milk and pizza at lunchtime. Before meeting Mr. Schwanbeck in my junior year, I was going to be an author. "I'm a Humanities person" was always my excuse for less-than-honorable results on quantitative tests. Now, everywhere I go I see vectors.

Samantha, age 17, current student

Since then, I've branched out and am doing all sorts of things with text messaging and QR codes, which are those square static bar codes you see on magazines and advertisements that are imbedded with a link to a web page or with text or images.

I put QR codes on all the cool stuff I have in my classroom, like posters or models of spaceships. Students can scan them with their smart phones. If they, for instance, scan the poster of Einstein, they'll get a bunch of quotes from him. The QR code of our Saturn 5 rocket model takes them to a video clip of the actual launch. It's information on demand.

I even include "good job" QR codes when I mark the kids' tests. I create the QRs, print them out on mailing labels, and stick them to the graded papers. You don't know what it says until you scan it. If you got a high score, you're rewarded with an animation of a pop-culture person celebrating in a silly manner—Michael Phelps splashing around after winning one of his gold medals, Michelle Obama giving a thumbs-up, or Jon Stewart clapping his hands and dancing. I've got about thirty different ones; the kids get really excited and love to show them to one another. So everyone knows who got the great scores. It's one of the ways I am trying to make being really awesome at physics cool in my class.

Since I started sharing this idea at conferences, I've heard so many great stories about innovative ways of using QR codes—ways I'd never have imagined. One librarian added student reviews to the QR codes on her library books.

As for text messaging, I signed up for this free program called Remind 101, a service for teachers and students where I can send text messages to all the students in my class at once without having to give them my phone number or me knowing theirs. I can write things like, "Grades have been updated online," or, for my astronomy class: "Clouds have rolled in, so observation tonight is canceled."

One day in class, we were talking about field of vision and measuring objects at a distance. I said that the full moon in the night sky takes up a half degree of arc, about the width of your pinky held out at arm's length. The kids didn't believe me so that night I composed a text message that read: "Beautiful waxing gibbous out tonight. First three students to e-mail me a photo of themselves measuring the moon's angular size will win a homework pass." I sent it out and within seven minutes, had seventeen responses in my e-mail box with all these incredibly blurry photos of fingers being held up in front of the moon. I got feedback from the parents that the kids bolted out of their houses and said, "Mom, come take the picture of me measuring the moon." And of course, they all saw for themselves that, yes, they could easily block out the whole moon with their pinky. It was the type of really authentic and memorable learning experience that will stick with them.

I can only imagine how much technology is changing the way that these kids are learning compared to when I was in high school. Recently, I taught myself how to install a dishwasher by watching a five-minute YouTube video (it was great—it should have had a step in between steps six and seven that said, "Mop up the puddle of your own blood," but I did it the best I could). So anything I want to know, I can learn in fifteen minutes or less now. That instant access to information is making our students' learning more efficient, and it's making the impossible possible. It's allowing teachers to take a more student-centered approach. And that, to me, is what twenty-first-century skills are all about. The skills that we're trying to give to students, the ones that are really going to help

them, not just in the workplace but in life, are things like problem solving, creativity, critical thinking, collaboration, and communication. And technology is a really good tool for helping students practice those lessons. But as much as technology can change learning, whenever I'm doing a talk or seminar, I always emphasize that technology is just another tool in a teacher's toolbox. I have a very cool hammer at home—it's got a carbon-fiber handle and everything—but I am not going to use it for every project. Sometimes the right tool for the job is a power drill; sometimes it's a handsaw.

I know that everyone is afraid of change, but change is inevitable. Technology is advancing, as the world as a whole is advancing, and it is important that we make sure education advances along with it. Technology is already ubiquitous *except* in most classrooms. The moment kids walk out of the door, they've got their phone; at home they're watching TV while typing on their laptop and texting. It's everywhere, so it's in our best interest to at least teach kids how to use and interact with technology on our own turf. Our job is to provide the best possible education that we can, and if there are tools out there that will help, and methods that will improve the way we are delivering instruction, then we're obligated to seek those out and train ourselves in those.

I really enjoy what I do. I know I could have a more lucrative career, but teaching, to me, is a direct way of making a difference for the good. Every day I get to see how individual students have changed as a result of taking my class. The mark I make may be small globally, but it is large locally, very tangible, and extremely rewarding. I don't know if I'd be able to take the same amount of pride in my work if the output was merely monetary.

I know that most of my students won't become physicists or engineers, so I don't try to turn them into the next Stephen Hawking. Rather, I focus on helping them organize what they already know, become confident problem solvers, and foster an appreciation of physics. In my class, I want to connect physics to everyday life.

Tom, one of my students, did not fancy himself a scientist when he first walked into my honors physics class his junior year. Tom had always considered himself more of a humanities-focused student, but over the course of the year, he discovered that physics was intriguing and enjoyable, and—perhaps to his surprise—that he excelled at it. He began to find satisfaction in a lengthy battle with a challenging problem. At the end of his junior year, he

signed up to take my astronomy course as a senior, and did very well. He approached me for advice on applying to colleges when he decided to major in physics and I recommended several colleges, including my alma mater.

To be clear, Tom was the one who discovered his love of science, he put in the work, and got himself into college. He lifted the heavy weights; I just spotted him by facilitating his journey. But I believe that my skills and passion as an educator played a key role of opening the door for him, letting him see that science could be his future.

Earlier this spring, my alma mater's physics department invited me to come back to campus to speak. Sharing my ideas with those who inspired my passion—and with Tom, now majoring in physics and sitting in the audience—was the proudest moment of my professional career.

> *"The instant access we have to information is making our students' learning more efficient, and it's making the impossible possible."*

Most recently, I have been speaking to colleagues and at various conferences about the importance of thinking progressively when it comes to technology. Good teachers don't stereotype their students—we don't assume that the quarterback of the football team will struggle with science, just as we don't assume that the lead of the school play will excel at art—this is a given. Yet, teachers often stereotype technologies. I've heard teachers say that YouTube, text messaging, or video games have no place whatsoever in the classroom. This notion disturbs me, and I've been going public with my fight against it.

I've begun presenting a talk titled, "It's Not What You Think: Improving Education by Using Common Technologies Uncommonly." In it, I refute technological stereotyping by sharing some unconventional and powerful ways to use oft-maligned new media to improve teaching and learning. My goal is for educators to leave the talk with wide-open minds.

I'm passionate about education and I'm passionate about technology—and I've combined these two passions into my mission. I won't stop until I've enhanced education for as many students as possible. I am out to prove that smart is cool.

"At a performing-arts high school where celebrity is on the minds of our students, I am igniting a passion for science."

Neal Lutchme Singh

11th–12th Grade
AP Environmental Science

Mr. Singh holds a DNA model during his AP environmental science class.

In just three short years, Neal Singh has revamped the environmental science department at LaGuardia High School, tripling the number of AP sections offered and increasing enrollment exponentially. This would be no small feat in any educational atmosphere, but in the arts-centered public school that inspired the movie *Fame*, his achievements take on a heroic tint. Parents regularly solicit him to fit their child into one of his maxed-out AP classes, and devoted students often return after graduation just to visit and say thank you. In 2012, Singh was honored with The Fund for the City of New York and the Alfred P. Sloan Foundation Award For Excellence in Science Teaching. Through the lens of environmental consciousness and ethics, Singh is making science relevant and meaningful to his students. Says Singh, "I want them to realize their power to transform the planet."

I grew up in Trinidad, West Indies. My upbringing was simple and dynamic. Being the tenth of eleven children was an education in itself. My parents owned a farm and worked tirelessly to educate all of us. My father also worked as an accountant with Texaco. Growing up in an Indian household in a former British colony, I was filled with diverse thinking styles. My mother was a traditional Hindu thinker and my father was more of a Renaissance man. I looked up to him and idolized him.

When I was fourteen years old, my father died at the age of fifty-eight. It was devastating. He had spent a lifetime serving others and was never able to fulfill his dreams of becoming a doctor. My parents supported both their extended families and did not spend much on their own needs. My education became more important at that time, knowing that my father had such dreams for my future. I worked hard at school and was successful. My surroundings influenced my area of studies. I grew up with a tropical rain forest as my backyard and my love of and interest in nature took deep root. I witnessed the destruction caused by deforestation in the name of prog-

ress and the introduction of deadly chemicals to agriculture. These chemicals were responsible for the death and and suffering of many of our animals. I was a sensitive child who sometimes felt that my best learning came through observing the world firsthand and using deductive reasoning.

After finishing high school in Trinidad with eleven successful O-level subjects, I headed to New York's Brooklyn College (often referred to as the poor man's Harvard), another public institution. There I studied geology and was involved in environmental issues, serving as president of the New York Water Environment Association, Brooklyn College Chapter. I completed my master's in education at City College of New York while working full-time as a teacher. I have, at some point in my career, taught every grade, including college, except first and second.

I had planned to become an environmental scientist, but when I realized, through my first few years of teaching, that I was really reaching my students in a positive and affirming manner, I decided to take my love of science and

help train an army of environmental stewards in the New York City public schools.

At a performing-arts high school where celebrity is on the minds of our students, I am igniting a passion for science. When I started teaching AP Environmental Science at LaGuardia, there were three sections, and since then it has expanded to nine sections, of which I teach six. Students have fallen in love with the class. And I've fallen in love with teaching it. Right now I have a list of three hundred students waiting to get in for next year.

People ask me all the time how I can teach the same curriculum so many times. But each class, each group of students, has a different dynamic. I keep my energy high all day for every class because I love the subject. I have been like this since I first started teaching. I don't know how to do it any differently. When I'm on fire, I'm on fire. When I go home, I collapse. But while I'm in the classroom, I give my ninth period the same energy as I give my first.

You have to be innovative when you teach the sciences. I like to bring in a lot of outside resources and really utilize my community. In New York City, we're rich with amazing talent—experts who are willing to come in and share what they know with our public-school students. I just reach out—I beg sometimes if I have to! I invite all kinds of professionals into my classroom.

> "When I'm on fire, I'm on fire. When I go home, I collapse. But while I'm in the classroom, I give my ninth period the same energy as I give my first."

I remember my first year. I had a student whose father was making hydrogen batteries—converting water into hydrogen and doing the whole shebang. So he came to my class and did a demonstration. The students were fascinated. I also brought in translators from the United Nations who worked with indigenous peoples all over the world, translating for them. They spoke to the class about the voices of these groups not being heard; they were being shut out of the UN. That just sparked a fire among the kids.

When we talk about poverty and population in class, and the link to the environment, I'll bring in the president of Trickle Up, an organization that gives grants to the poorest women on the planet. Or I'll invite a naturalist from Maine to talk about forest preservation. Last year we had a guest speaker who had invented a new method of cleaning up oil spills. He brought his equipment in with him and demonstrated. The students took part and did it with him. I love to bring in environmental documentary filmmakers who answer students' questions about films we watch in class. I had a guest this year from Hawaii who is an environmental journalist writing about the state of the oceans, and about fishing and invasive species. I have an architect who is coming in a couple of weeks to speak about green architecture.

I'm learning as they're learning. And the learning has to be fun—for me as well as my students. I can't go into a classroom and just give worksheets. That's not my style.

When I do my labs, I bring in a soil scientist and a water scientist from the city. I actually bring the dirt and water from my backyard. The students love that because they feel they're learning about my home. And they bring in soil samples from Central Park and water from the Hudson. Then we compare samples. We look for lead in the soil, and whether there are nitrates and phosphates. We look for bacteria and chloroform in the water. We ask what the possible sources of these substances are? We link everything—I always connect the subject I'm teaching to a relevant story.

Last year, after taking the AP exam, one of my students, Martin, ran upstairs to my classroom, and said, "I got a five on the exam!" I'm like, "Martin, what do you mean you got a five? How could you tell you got a five? You just took it!" He replied, "I wrote about your garden. I wrote about integrated pest management. How you plant basil and marigolds. And you attract ladybugs by not using harmful pesticides, and instead you use neem oil. And you rotate the crops." And do you want to know something? Martin got a five on the exam.

At the end of the year, my students don't take a written final. I feel that's overkill after the AP exam. Instead I have them do a project integrating their arts specialty with environmental science. So, they come up with incredibly creative, innovative, amazing projects inspired by what they have learned throughout the year. They make documentaries. They write music. They choreograph dance pieces. They perform their work. It's just been beautiful, how much they've been able to accomplish.

It's important to put into practice what you're studying. Not every student will do that. But many of

> *"What's the sense in burying your head in a book to learn all the content, only to shut that book, do well on an exam, and then never revisit it?"*

them do. They get very impassioned. And this component of connecting knowledge and action is critical; otherwise, what's the purpose of learning? We shouldn't be doing it for the grade. We should be doing it to become invested, and to make a positive change. If we can do that, then the subject matter—the academic part of the course—becomes a practical part of our life. I encourage my students to ask themselves, "How can we do something that's going to make a difference in connection to what we just learned?"

For instance, after viewing the film *Flow*, which is about the international water crisis, my classes decided to collect money to fund the drilling of wells in Cambodia. Another group of my students recently went to the Global Climate Change rally in DC on their own initiative. I have a lot of kids who are out there, doing good things. I hear from many of them that what they learned in my classroom changed their lives.

Students have a new awareness of the importance of preserving the planet. In terms of their diet, they are eating differently. Parents come to me and say thank you for making an improvement in our family's life, because now we're buying more organic. Students have changed how they commute to school and use transportation. They recycle much more. They've become involved in political issues that support or don't support certain things. They say, "I never knew that these corporations that we buy from also support things that are detrimental to the environment." Like Mitsubishi buying up much of the bluefin tuna. That is not publicized. Or Nestle buying up water rights in Maine and other states for pretty much nothing. So, they're becoming aware of things that I think give them a bigger picture of the world.

It makes them global citizens. They have a heightened understanding of how vital it is to learn about other cultures and see how similar they are to us. They've learned about environmental racism that they didn't know existed, and about social injustice. These are all

topics that will give them the power to become educated citizens when it comes to voting and choosing the right people to represent us.

Knowledge is power. My father always said that to me when I was growing up. What's the sense in burying your head in a book to learn all the content, only to shut that book, do well on an exam, and then never revisit it? Whereas, how wonderful it is for you to learn this material, and to apply it. That's where the power comes from.

Every year I take my students (almost 300) on an overnight trip to the Catskill Mountains for two days of intensive outdoor science investigation based on our yearlong study. I write grants for students who cannot afford the trip. They run around outside; they lie on the grass. This year we had clear skies and they were able to go to the observatory at night. We gave them an amateur astronomy lesson. And then I had them go into the telescope. They looked at Jupiter, and they looked at the moon. They saw shooting stars. They saw all of these different things that they would never see in the city. They were amazed. For many of them, it was the first time they'd seen anything like that.

I had a student last year from Queens who came on the trip. And when we arrived, he said, "Mr. Singh, I feel like I'm in a painting. I have never left my apartment to go away anywhere before. And I feel like I'm walking through a painting."

> *"We sit in our classroom as ambassadors of our past, I tell my students. We will learn to read critically, write consciously, speak clearly, and tell our truth because that is the only way this world will ever listen to what we have to say."*

Clint Smith

10th Grade
English

English teacher by day, slam poet by night, Clint Smith is a living testament to his adolescent students that words—written, read, and spoken—can and do change lives. Through Teach For America, Smith was placed at Parkdale High School, a magnet school in Maryland's Prince George's County, where 96 percent of his students are minorities and about 70 percent receive free or reduced-cost lunches. At just twenty-four years old and with only two full years in the classroom, Smith has already made a dramatic impact on his students, raising their reading levels, test scores, and sense of self-worth by leaps and bounds. His dynamic style and fierce commitment to succeed as a teacher are fueled by an acute sense of urgency that young lives, and America's future, are literally at stake.

I grew up trapped between the dichotomy of my parents' expectations and those of society as a whole. Through my primary and secondary education, this struggle manifested itself throughout every realm of my life. How could I strive to gain both intelligence and affirmation from my peers in my identity as a black man, in a world where being smart and black were seen as paradoxical?

I have always loved literature. In my third-grade yearbook, one question asked was, "What do you want to be when you grow up?" In prototypical eight-year-old fashion, most of my peers stated, "ballerina," "basketball star," "astronaut," "fireman." My answer, reflective of the awkward, big-headed, dream-filled kid that I was, read, "I want to be a Newberry Award–winning author!"

And while selective memory could fool me into looking back on this with a playful sense of childhood nostalgia, it would be a mischaracterization to do so. Putting those feelings out into the world of my schoolyard was not a joyous experience, it was humiliating. My peers did not praise my answer to that question, but admonished it. My dreams were not admired, but chastised. As a black boy at a public school in New Orleans, Louisiana, becoming a writer did not fit into the box of options that this world had imposed on me, and that too many in my community had subsequently internalized. For so much of my life, I felt that being black with a book put me in danger.

I share this with my students—that so many of them are descendants of a history in which being able to read and write would have literally had them hung; or that others come from families in which the English language is a buried treasure their family's tongues have never been able to dig up. The opportunity to learn to read and write is not an option, I tell them. It is a responsibility. To not do so would be an injustice to everyone who came before you, so many of whom literally died so that you could sit in this classroom and open a book. There is Maria, whose mother slept for nights in the belly of trucks amid concrete and fertilizers so as not to be smelled by the dogs. I think of David, whose father comes from South Africa, where up until less than two decades ago, the Bantu Education Act ensured that in school he would have been taught

nothing other than how to be the servant of a white family. I think of my own grandfather, who fought for this country in a war it should have never been a part of, only to come home to a place that spit on his face as soon as he put down his gun; and my great-grandfather, who was prohibited from reading by law for fear that any enhancement to his intellect would make him more dangerous to his owners.

> *"I firmly believe that solving the public education crisis is the civil rights movement of our time, and I want my life to be lived on the frontlines."*

We sit in our classroom as ambassadors of our past, I tell my students. We will learn to read critically, write consciously, speak clearly, and tell our truth because that is the only way this world will ever listen to what we have to say. We are not here to celebrate the status quo of stereotypes. Whether it is what you look like, what you sound like, what your name is, or where your family is from, our role is to break out of these boxes the world has put us in. Every day in my class, we try to use literature to break out of these boxes. We question. We criticize. We agitate. We advocate. We read. We write. We recognize that we all have a story.

With less than two percent of the teachers in our school systems nationwide being black men, I know I have an added layer of responsibility. With that responsibility, however, also comes an added layer of opportunity. Through every word I speak and every interaction I have with my students, their community, and with those who may be unaware of the vast inequalities that exist in our education system, I am keenly aware of the fact that I represent something bigger than myself. I firmly believe that solving the public education crisis is the civil rights movement of our time, and I want my life to be lived on the front lines.

Become the sculptor and not sculpted./Become the statistician and not the statistic./Kevin, I am not perfect/I'm just a teacher/trying to get you to understand/all that you are already capable of doing. These words, from my poem "Aristotle," embody the culture I have sought to create in my classroom over the course of the last two years. My students have been born into a society that ingrains

them with an institutionalized sense of inferiority, and they are part of a system laden with low expectations and complacency. My responsibility in the classroom is to help my students understand that they are capable of achieving everything they have ever imagined. Their dreams are not something meant to be trapped amid the paralysis of penury. Their potential lies within them and it is completely within their own power to unlock it or not. I do not simply want students to be invested in me and my class, rather I want them to be invested in themselves with the belief that education is the only way for them to achieve the things they want from life.

From a strictly academic perspective, I have worked tirelessly to give my students the most rigorous and holistically beneficial learning experience possible. Through a quantitative lens, my students last year improved by an average of 2.3 years in reading growth. I have helped make collaboration an essential ingredient of my department's culture, by implementing independent reading and reflection time across every English class, adding a consistent resource-sharing session to our weekly departmental meetings, and making data analysis an integral part of how we reflect on our work. As a result, our entire department's English 10 High School Assessment scores increased by 14 percent, an unprecedented number relative to that of previous years.

Ultimately, however, my impact cannot be measured solely by my students' quarterly benchmark scores on standardized tests. Rather, it will be evaluated by their ability to leverage literature as a tool to become more empathetic human beings, and to enhance the perspectives through which they see the world, and their role within it. For instance, earlier in the year, we read the novel *Night*, by Elie Wiesel. A few months later, my students were tasked with writing letters to the author of the novel that has most profoundly affected them and the way they think about the world. It was an absolute joy to see how many students wrote to Wiesel, expressing reverence and deep gratitude to the author for exposing them to the horrors of the Auschwitz concentration camp during World War II—something they had previously known so little about. An excerpt from my student Jazmine's letter reads:

Mr. Wiesel, your book opened my eyes up to the society we live in. How could man destroy its own kind? This novel meant a lot to me because as an African-American teenager, I always hear stories about slavery that my elders are open to sharing. It was tough knowing that my own family suffered

through the same sorrow and pain that you went through. This story inspired me so much that I've decided to become a human rights lawyer in the future. I want to be a person who puts an end to genocide. I think that every human should be treated equally. No matter what race, ethnicity, gender, religion, height, weight, and the list goes on.

These are the moments that I seek to recreate every day in my classroom, whether it is by having my students analyze the modern-day significance of Sojourner Truth's *Ain't I a Woman?* speech or establishing text-to-self connections to Henry David Thoreau's *Walden*, they understand that literature gives you insight into the power of humanity.

Additionally, I want my students to leave my class with a stronger sense of self, knowing that education is something no one can take away from them. With knowledge comes power, and I want my kids to be the most powerful people in the world. My classes are very discussion-based. I hold Socratic seminars where I really push the value of students' voices and reaffirm that what they have to say is just as meaningful and important as what anyone else has to say. We do a lot of reading about current events, and particularly along the theme of social justice. For example, there have been several students at public schools in our county who have been killed as a result of gang violence over the past couple months. So we've been talking about gun violence, and their assignment is to write letters to their local congressman about what they believe needs to be done to ensure that their communities are safer. One of the major goals of my class is to teach my students how to learn to advocate for themselves. We study the prison-industrial complex. We delve into what it is, why it exists, what historical and systematic factors keep it going. We talk a lot about race and culture. I'm running a pilot program where I teach single-sex classes, so a lot of what I'll touch on is very gender-specific. We're constantly exploring the theme of identity: cultural, religious, racial, sexual, etc. When you're a teenager, there are so many insecurities that exist regarding who you are and what you look like. I want my students to leave my classroom with a stronger identity, more confidence and less insecurity about their differences. It's those differences that make us unique, and it's those diversities of experiences and ideas that make this world what it is.

So much of what I try to do is shift the mind-sets of my students in terms of how they approach their education. I constantly remind them of the social reality in which we live. Every day, people look at them and, based on nothing more than the color of their skin and where they are from, make judgments about who they are. To constantly wake up to a world that assumes them to be stupid, lazy, and dangerous inevitably takes a toll on their

My sophomore year Mr. Smith would always say the words "no days off" meaning "never stop being on top of your game" and "there's always room for improvement." In this Mr. Smith is the perfect example of "practice what you preach." There's never a day Mr. Smith isn't doing his best at something, whether it's poetry or teaching. Little does he know how much he inspires me to achieve great things, to become someone. If it wasn't for him saying "no days off" and making me read 30 minutes every day, my reading level would never have boosted from a 10th grade level to a 12th grade level in just a few months. I wouldn't have been so inspired to pursue my goals of becoming a writer. I thank and love Mr. Smith a great deal and encourage him to keep doing better (if that's even possible) so that he can inspire more children the way he inspired me.

Juanyeigh, age 16, former student

soul. As a black man in America, I share their frustration. I tell my kids, when I get on the Metro, nobody sees I have a bachelor's degree; nobody sees that I'm a cultural ambassador for the State Department; nobody sees that I'm an award-winning poet or Teacher of the Year. At the end of the day, when I sit on the Metro, the woman next to me is still going to hold her purse tighter to her because of what I look like. What I attempt to do is turn that disillusionment into motivation—to cultivate a "prove them wrong" mentality within my kids. Ultimately, it becomes less about proving to someone else what you're capable of, and instead my students are now just proving it to themselves. When that "Aha!" moment takes place, when students become deeply self-motivated by their work, I know that they will be successful long after they leave my classroom.

As a professional spoken-word poet, I try to embody how learning to read and write well serves a purpose beyond the academic. These are critical skills that have the power to open up new worlds of opportunities. My poetry provides an entry point for my students to engage

in literature, and empowers them to delve into text when they may have otherwise been hesitant to do so. They have so many preconceived notions as to what poetry is and who writes it—like it's all old white men sitting by the fire; it's all Yeats and Keats and Pound—people who are so archaic, in their minds, that they don't see the relevance to their own lives. I think that the coalescence of being a young black man, a poet, and an English teacher in a low-income community gives me an opportunity to provide my students with a perspective of and an experience with literature that they haven't had before.

One of my students, Camila, came to the United States two years ago from El Salvador. A diminutive girl whose wide eyes and generous smile pervade her face, Camila arrived in America without knowing any English. The first few weeks in my class, she was incredibly shy, in part because of her timid nature, but also because she was embarrassed that her command of the English language was so poor. She was always, however, a hard worker. Every assignment, no matter how grammatically incorrect, would be turned in on time, and I would often see her walking around with flash cards in the hallway. Yet, she still remained silent in class and operated without the confidence to speak her mind. That is, until we reached our poetry unit. At the beginning of each poetry class, to kick off the lesson, I perform an original poem of mine that touches on the theme of what we'll be addressing—love, race, identity, family—so that I can, essentially, model what we are going to be delving into and approaching. I remember performing a piece about my mother, and seeing Camila's eyes light up. She found so much beauty in the use of figurative language and reveled in the wonder of being able to compare love to a summer's day, or to learn that you could *see the world in someone's eyes*. She had never been exposed to language such as this.

Upon noticing Camila's infatuation with poetic devices and figurative language, I bought her a copy of *The Poetry of Pablo Neruda*. The esteemed Chilean Nobel Laureate wrote thousands of poems in Spanish, and has had almost all of them translated to English. The book presented the original version and the translated version side by side. I wanted Camila to be able to see that she could write beautiful poems in both English and Spanish. I wanted her to value her language and her culture, and find the beauty that already existed within it.

For the next several months, Camila would bring me a new poem she had written every week. It would be both

in English and Spanish. Her natural prowess as a word-smith was breathtaking. To return the favor, I would share new poems I had written as well. Her confidence grew exponentially, and it carried over to the rest of her classes. She reached two years of reading growth, is now on the honor roll, has dreams of attending a four-year university, and ultimately wants to become a writer.

> *"My students leave my class knowing that education is something no one can take away from them. With knowledge comes power, and I want my kids to be the most powerful people in the world."*

This process was also psychologically and emotionally important for Camila. Much of what she wrote about was her family life and growing up in a home with an alcoholic father and mother who could not speak English or find a job. Poetry provided an avenue for her to reflect and to make sense of her feelings in a way that is both safe and creative.

This past December, right before the holiday break, Camila came into my room and said, "I wanted to get you a present, but I don't have enough money right now, so I wrote you this poem instead." She handed me a folded sheet of paper, wished me a Merry Christmas, and slid out of the room to catch her bus home: *You are more than a teacher, a teacher who cares about you/Who has a voice like the wind, which is calm and peaceful/You are a friend, a friend I can trust/Who comes when you cry and not only when you are happy/Like a father who cares for his child/And when she/he does something wrong/You don't just yell at them, but you stay calm and talk to them/I enjoy each lesson you teach/As my role model you inspire me/To dream and to work and reach my goals./You are like spring/Who nurtures new green sprouts/Encourages and leads them/Whenever they have doubts/May God bless you/in every way/May God make you rich not with gold but with happiness.*

Two weeks ago, Camila came into my classroom with another note. This time it was not a poem, but a wedding invitation. Her father had become sober and proposed to Camila's mother, and Camila wanted me to be there to share that occasion with her family. It is in these moments, where I could not dream of doing anything else with my life.

"I want miraculous things to happen in my classroom every day."

Emily E. Smith

5th Grade
English Language Arts

Ms. Smith with her young scholars in the Hive Society.

The buzz of erudition fills every crack and crevice of Emily Smith's language arts classroom, which is aptly named the Hive Society, after the secret literary club that is the subject of the iconic coming-of-age film *Dead Poets Society*. In the Hive, students are called scholars (Why? "Their job is to learn," says Smith. "They are more scholars than I am."), *all* books are considered literature (yes, even the *The Hunger Games*), desks have been replaced by floor pillows, and Smith is the queen bee. This scholastic experiment is Smith's brainchild, but truly it's her heart that led her to it. Faced with a class full of struggling and often unruly fifth graders, Smith refused to pass the buck. Her steadfast belief that every child can succeed in the right environment inspired her to cast aside convention and create a new classroom culture that fosters independence, critical thinking, and a deep personal love for learning. Smith's aim is high: to give her scholars the best year of their elementary school life. By all measures, she is succeeding.

I suffer from an undiagnosed mutation; I was born with the heart of a teacher.

When I assess my approach to teaching, I would describe it as founded on complete and genuine love. If a child needs a snack, then I will dig into my drawer of granola bars and fruit chews and that child will have a snack. If a child needs a new pair of glasses, then I will contact enough of my friends to pay for the child's glasses. If a child needs a break from the chaos of home during the

CUNNINGHAM ELEMENTARY SCHOOL, AUSTIN, TX

summer, then I will make sure that I find opportunities for that child to run errands or take my dog to the park with me. I do all I can do. My approach to teaching is one that meets the needs of each individual child, and with the demographic that I work with, sometimes that means taking care of the child before I'm able to teach them.

Some teachers may feel uncomfortable breaking the boundaries of a "teacher and student relationship." But I view working with at-risk children as a different kind of teaching. On many occasions I play both educator and caretaker, which I admit can make one feel stretched thin at times, but I can't imagine shutting the door to my classroom and leaving all the troubles of my kiddos behind. How are my young scholars able to learn if they aren't first met on an emotional level? My thoughts on the rewards of teaching are simple: the joy of watching a child dream and imagine and think significantly outweighs the exhaustion. I would not have it any other way.

I love teaching the fifth grade. People daily say to me, "Oh my gosh, you need a raise," or, "Oh, I do not know how you do it." I know they are trying to be nice, but I want everyone to love my kids as much as I love them. It can be a tough age to love because they have a lot of opinions. Their brains and bodies are changing. They are becoming more vocal. But I absolutely love it. I love seeing them grow during this really crucial time. There is never a day that is boring.

"No letter or blog or epic novel could fully describe what happens within and without the walls of the Hive."

I taught fourth grade first, for three years, and then I really wanted to loop to fifth grade with my class. I begged my principal—it was a difficult group behavior-wise; there were some struggles. I needed more time with them. I wanted them to have the support. There was a problem that I saw and I wanted to fix it. They just did not feel like they fit in. I wanted to change that.

I've watched *Dead Poets Society* upwards of ten times, but when I watched it again a couple of years ago it struck me: those students were wealthy, privileged Ivy Leaguers, but still so much like my students—desperate to be inspired and to belong. So I began thinking about creating a truly literature-rich environment. Thunder-claps of a brainstorm began rolling in, one that involved recruiting other minds and resources and ended with reinventing the typical concept of a classroom. My vision began with the notion that everything revolves around the center of the classroom—like bees buzzing and moving and working together to create something pretty magnificent. I was like, yes, that is it. I want miraculous things to happen in my classroom every day. Thus was born the "Hive Society."

Our mission statement on the front page of our website states: *We, as Cunningham's Class of 2020, strive to learn and grow and experience and thrive and dream and explore in our classroom—our society. Throughout the year, the Hive Society will implement our creative ideas through technology, participate in insightful conversations and debates, interact with literature we love, and delve into the corners of our brains using an array of expository texts and thought-provoking literature. We are today. We are the future. We are the Hive Society.*

I tell my scholars, we will meet and discuss literature and write down our thoughts and work with other people and share our thinking and collaborate and be innovative. It is exciting, because they do not quite understand at the beginning. When I start integrating videos and iPads all the time, or when they realize, "Hey, I have not seen a single multiple-choice question yet," or notice that they are constantly talking about *literature* and *life*, then they begin to understand that it is a different kind of classroom.

The aesthetic was very important to me. I spent a lot of time on the design of the classroom. I took inspiration from all those new media start-ups in Brooklyn, San Francisco, and Portland. Those converted offices in abandoned warehouses that have been constructed right out of *Architectural Digest*. They are set up with lots of different workstations in one great big open space, with a central area where people come together to collaborate. Of course, I only have one room to play with, but I will take legs off of tables and drop them down on the ground; throw down some pillows and some rugs. I bring my custodian tacos and coffee at least once a month because I have six rugs in my classroom and I am only supposed to have one. But she vacuums all six of them and I love her for it.

Stacks of iPads are readily accessible and are carried from cluster to cluster of scholars. Every surface is fair game to spread out and work on. It is like a think tank. The environment allows children to move to different spaces and to talk and work together away from their desks.

Twice a week we come together to do literature circles. They are student-led and interest-driven. The kids write "thinking notes" throughout the week and use them to draw connections between fictional characters and their own lives. Like, "Oh my gosh, I cannot believe Ida B's mom has cancer. My aunt has cancer, that makes me feel really bad for her." Part of being a critical thinker is not just formulating answers, but developing questions as well. Sometimes, the kids just amaze me with the questions that they come up with. They dig deep because they are truly invested.

I have never copied anything from a workbook in my entire life. I create everything from scratch because I really want to push them. Every day, there is somebody who says, "This is hard, Ms. Smith." And somebody will always respond, because I say it all the time, "When is it ever easy in the Hive?" Because it is not. I want to challenge them every day. I bring in articles for us to read that I think will interest and stimulate my scholars. For example, during the Boston Marathon bombings, we dropped everything. I knew the kids were going to have questions so I found three appropriate articles. The news was not censored. They were scared. They wanted to know more. Someone came up with the idea of writing poems for the victims because it was poetry month. I said, "Great, awesome. Let's go in that direction." Sometimes I will give them things to read based on what is going on in the world and other times I will just find really cool texts or neat poems. They have grown to love the poetry of Billy Collins and the short stories of Sandra Cisneros. Those are not necessarily authors and poets that the average fifth grader is reading, but I love challenging them and they do a beautiful job with it.

My mind is constantly conjuring up new and creative ways to approach education. To me, education is an attitude. I'll watch a movie, listen to a TED Talk, visit a place, attend a lecture, hear a song, or experience a piece of art and think, "How is this relevant to my scholars?" Even though TED Talks are intended for adult minds, I use them in the Hive. Whether we're focusing on a theme, figurative language, or text structure, there is a multitude of TED Talks available to enhance their learning experience. Sometimes I'll pose questions beforehand or we'll spread out and take a look at the transcript first, and sometimes we'll just dive right in and then allow the content to soak in while we break into more intimate groups that are guided with purposeful open-ended questions.

The bustling and buzzing of academic conversations in the Hive Society isn't an accident; I believe they thrive because I understand the importance of taking the time to create an environment most conducive to an attitude of exploration and innovation. No letter or blog or epic novel could fully describe what happens within and without the walls of the Hive.

I try to help them feel what it's like to be a scholar and to be a thinker. I tell them: "One day, when you get to middle and high school you will have teachers that will allow you to do things like this and you will have teachers that will not. But you have to see the end goal and that is college. That is where you get to explore what you love. After that, you get to do whatever you want, whether it's becoming an animator, an entrepreneur, or an accountant. So, just remember, even though it is not always going to feel like this in every classroom, that does not change who you are. You are still a scholar."

*"Once the fire of learning has been ignited,
who knows which heart it will burn in next?"*

Brigitte Tennis

*7th–8th Grade
General Studies, Latin, and Violin*

Mrs. Tennis and her eighth graders explore the color spectrum while they blow bubbles outside.

Listening to Brigitte Tennis animatedly expound on her pedagogical philosophies, it is impossible not to envision her as a modern-day Mary Poppins. In Tennis' enchanted classroom, children are jewels to be polished and cherished, teachers are wizards who transform facts into fun, and lessons are recast as enthralling adventures. Tennis has spent thirty-two years molding young minds and activating imaginations with her interdisciplinary, participatory, and fairy-dusted approach to teaching. In 2000, she founded her very own public middle school, where she has been able to put all her unconventional methods into action, like building a 310-foot aqueduct out of PVC piping to highlight the techniques of ancient Roman engineers, and using "bubble-ology" to teach the basic principles of algebra.... A roomful of bubbles helps the math lesson go down.

Early in my career, when I moved from the gifted classroom into the regular classroom, I had a group of teachers call me into a meeting and flat-out tell me, "You need to stop doing these different activities because it makes the rest of us look bad." I was very young. I cried. I was scared and I didn't know what to do, but my inner conscience would not allow me to give up on our kids and give up on the system of public education that should be stellar for every kid every day. And so, I learned to close my door, and I did what I knew was right, and what was good for kids. That was a lonely time. Now that I've been around for a while and am much more established as a teacher, I don't have that fear anymore. My district is very supportive of what I'm doing with my students. They can see that it's really working.

Teaching is a vocation, a call that comes from the core of my being to ignite the fire of learning in others. Teaching beckons me to be part of the pulse of life and to participate in the formation of human beings that

work for the greater good. An outstanding teacher is a person who inspires others by uncovering the miracles of learning. How do I do that? I must be a master of content, brilliant at managing people, and above all, I must truly love what I do. Yes, I have accumulated various credentials and certificates, and those mean a lot, but without genuine passion and enthusiasm, those awards have little impact on the real job of a teacher. As Henry Ford said, "Enthusiasm is the yeast that makes your hopes shine to the stars. Enthusiasm is the sparkle in your eyes, the swing in your gait; the grip of your hand, the irresistible surge of will and energy to execute your ideas."

My personal teaching style begins with the foundation of best practices. It is kindled with discipline, but also with love. It is sparked with innovative and surprising hands-on activities, and fed with small doses of humor. The flames of enthusiasm start the fire of learning in my classroom, and then I sit back and give it air to breathe so it can burn on its own. And every now and then, I tend and nurture

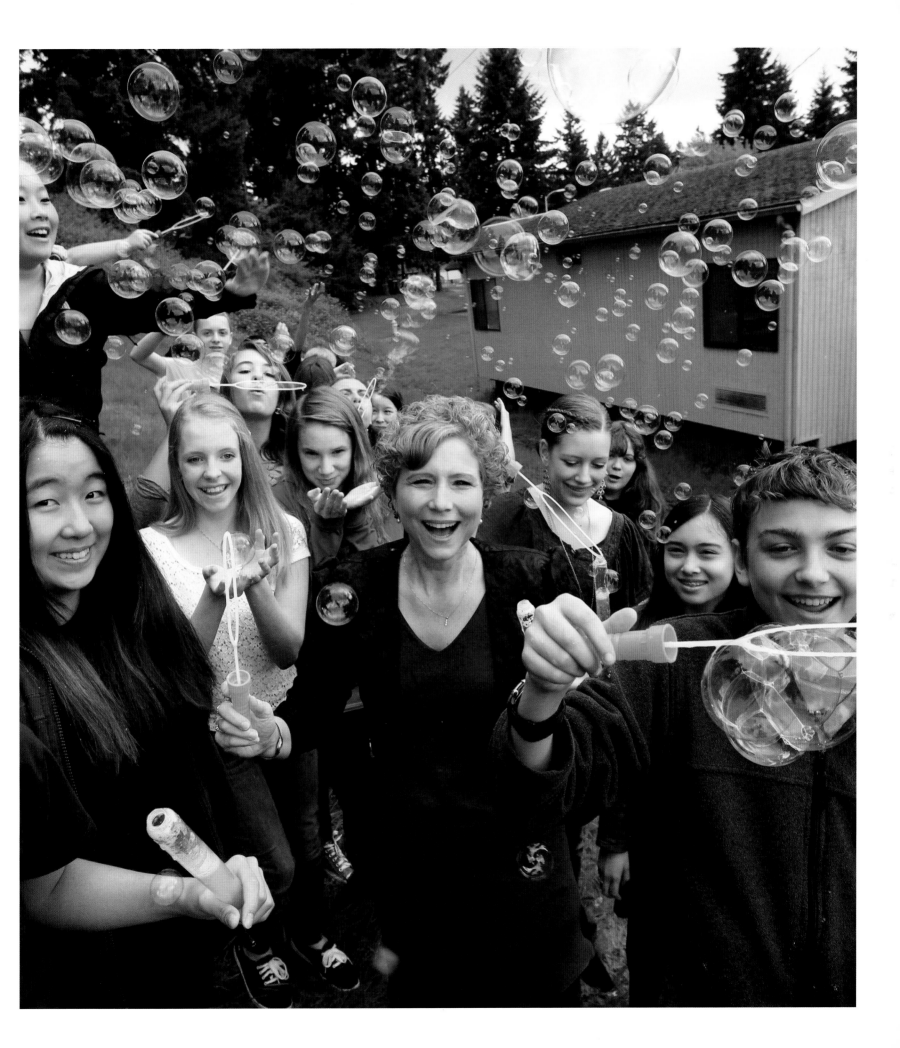

the fire to be sure it's still going strong. I believe that every student can learn. By setting the bar high and creating a positive and supportive learning environment, I find that students rise to my expectations. I "teach to the top" and then, after hours, I assist those who are struggling. The work my students are engaged in is challenging but meaningful. They know that I care about them, individually, and that I believe in them. It is then that they begin to believe in themselves. Once the fire of learning has been ignited, who knows which heart it will burn in next?

Mrs. Tennis has taught me most of all to be proud of who I am and what I believe. I've learned from her constant example that one driven person can change the world.

*Michelle, age 16,
former student*

Thirteen years ago, I founded a public school that developed out of my philosophy of how students best learn. At Stella Schola Middle School (it means "star school" in Latin), each grade stays with the same teacher all day, and this creates a solid and stable learning environment where kids feel supported and can grow and be accepted for who they are. We teach chronologically-based historical themes so that the teacher can integrate all subjects rather than spend only fifty minutes on one subject and then move on. This approach not only hooks students into learning, but also shows students that the world is woven together with many fibers. There are multiple opportunities to point out how science, art, math, history, English, and even Latin interconnect to make beauty in our lives. For example, when I teach Ancient Rome in history, I also teach Latin (which then continues on in the next year) and astronomy (because the planets and constellations have Latin names); students analyze Gustav Holst's orchestral suite *The Planets*; and we study Shakespeare's *Julius Caesar*, and learn the relationships of equations through algebra. I incorporate dance, music, art, and drama into subjects that students might not otherwise find that interesting. I build solid relationships with my students since I have them for the entire day and for all the subjects. I take them out into the world—on a three-day overnight in the Olympic Peninsula to track animals (when we study mammals), to study the stars with no light pollution, and to appreciate wildlife. We dissect a cow heart and a frog; we burn cheese puffs to figure out how to mathematically calculate a calorie; we sew a quilt in geometry as we study colonial life; we knit

like Madame Defarge when we read *A Tale of Two Cities*; and we dress up in togas when we celebrate Saturnalia in Latin. The list goes on, the enthusiasm abounds, and the kids—well, they are wonderfully happy.

An exemplary teacher brings out the best in students by teaching *in spite* of the obstacles and with positive energy. Students deserve our full attention and best practice even when the budget is small, even if they come from homes that do not support education, and even if their attitudes are poor when they walk through the door. For example, when we had no money for field trips, I obtained permission from parents to take students on a "Science Walk." I led our whole school, together with my colleagues, on a walk to the local park. Along the way, we talked about the venation of leaves, we laid down in an abandoned parking lot and observed the clouds, we broke into small groups and investigated bugs in rotting logs, and created "nature art" with leaves, sticks, and ferns. I found a bottle cap in the moss and asked the students to speculate how it had gotten there (a lesson in logical thinking). Okay, so I got lost once and slipped in the mud, but we all had a great laugh about it and students saw that I make mistakes, too! Back in the classroom, we wrote poetry, calculated the shadow that a tree cast on the pavement, and used the computer to look up what kinds of clouds we had seen. My eighth graders loved this! They realized that there's learning to be done everywhere—not just in a classroom or a laboratory. It turned out to be a fantastic teaching expedition (we do it every year now) and it costs us nothing.

Therein lies the joy of teaching. It's like a puzzle to be solved, a miracle to be unpacked. The reward? The "Aha!" at the end of a complex lesson, the lonely student who is invited by the popular one to eat lunch with him after a lesson on inclusion, the sound of humming—soft and almost inaudible—of a student working out a math problem, the exuberance of students bounding in the door and eagerly looking at the schedule to see what they will learn that day, and the smile of a parent who finally sees his child loving school because he is experiencing success. Those moments are priceless.

Of course, there are also challenges to stepping out and doing something different educationally. I have heard there's a perception out there among some of my peers that I feel I'm better than everybody else, which is not what Stella is about at all. There are those who believe that choice schools—not just mine, but all choice schools—

"steal" the "best" kids, and leave the rest for the regular schools. The fact is our enrollment is based on a lottery system. Anybody can apply. I have two autistic kids in my classroom right now, and I would say 60 percent of our kids are ADD or ADHD. It's true we also have kids out of the gifted program, but we have many academically average kids who need to be encouraged and shown that they have value, too. Because every child has a gift, and every child deserves love, acceptance, and encouragement, part of our job is to help all our students see that they are gifted. Maybe not always "book gifted," but all with something valuable to contribute.

Diamonds, rubies, sapphires, onyx, and emeralds—those are what make up a long career of teaching. Don't get me wrong—every day in the classroom is certainly not a "Diamond Day," because learning is not always—well, it's not always pretty. But within the everyday work of striving to instill the fire of learning in our young people, small gems show themselves in tiny but flashy sparkles all the time. The question is, are you, the teacher, observant enough to catch those glimmers?

Middle school, in particular, can be a challenge. Hormones bounce around the classroom like energetic atoms with feet, growing independence finds the confidence to say, "I know this—you don't need to teach me!" Heels dig in and mouths clam up, and attitude can flick its tail at a teacher quicker than you can turn a flapjack. Yes, that's middle school, and many people wonder where the sparkling gems are during these intense years of development, but I can assure you that they are still there—you just might have to look a little closer and dig a little deeper to bring them out. One year, on the first day of school not too long ago, a seventh grader stomped into my classroom complete with shiny black army boots, camo gear, and a fez jammed on the top of his head. This was Anthony. He plopped himself down at a desk and shouted, "I don't need this @#$%# stuff!" He threw his desk across the room, stomped out as loudly as he could, and slammed the door, while the rest of the class, stunned, watched in anticipation to see what I would do. Gathering all of my courage, I calmly walked out into the hall and gently closed the door behind me. There was Anthony, with challenge in his eyes. "Aren't ya goin' to leave the door open so they can hear ya yell at me?" I explained that I do not yell and that I was sure that we could work out whatever was bothering him so that I could teach him all the cool

things seventh grade had to offer. Anthony looked at me quizzically. I told him I would love to chat with him after school (he was surprised I was not calling his parents) and that he could rejoin class if he felt like it. I returned to the room, leaving the door ajar, and picked up with my first-day welcome. Anthony did not come back that day, but he did show up after school. All he would say was that things were "kinda rough" at home, and that he wanted to learn but he did not want to do a "bunch of mindless work" like he had done in the past. I could see that the sparkle was there—he even said he *wanted* to learn. I assured him that I would try very hard to make things interesting and exciting for him.

> *"Within the everyday work of striving to instill the fire of learning in our young people, small gems show themselves in tiny but flashy sparkles all the time."*

Over the next three weeks, the whole class seemed to pulsate with the desire to help Anthony succeed, and Anthony in turn helped the class, although he probably didn't realize it. Anthony's intensity was energizing and he often came up with innovative ideas that other students had never thought of. I did my part, too, and worked hard to plan lessons that were stimulating and meaningful. We did experiments with chemicals that made a little bang; we learned about the ancient Roman gladiators; we enjoyed the beauty of the inner parts of a flower; and we read the ancient tale *Beowulf* together. Within a month, a new Anthony was emerging. I knew we had turned the corner when one morning, as I was writing the schedule on the chalkboard, I heard a deep, commanding voice say, "Dude, we're doin' history and science today! Hurry up! Sit down!" Although I had my back to the class, I knew it was Anthony, and I smiled inside. Anthony had found the "fire of learning" and I had found a pearl. Last spring, I saw Anthony at the local theater. He was so excited to tell me that he was going to France to be a chef! So when people scoff at my chosen profession, which sometimes does happen, I just remind myself of the treasured gems that I have collected over the years. I have a whole chest of beautiful, sparkling jewels and if that is my legacy, that's more than enough for me.

> *"Teaching kids who are in Juvenile Hall, yet who are still trying to achieve in school, shows me that no child is hopeless."*

Melanie Tolan

11th–12th Grade
English, Social Studies, GED Preparation, and Physical Education

Ms. Tolan's students work at their desks in her classroom in Juvenile Hall.

For Melanie Tolan, an ideal day in the classroom would mean her door would remain closed for an entire two-hour block—no interruptions by probation officers or blaring loudspeakers, no students taken out to make their court appearances, no physical fights, no tension between rival gang members, no emotional outbursts. Tolan teaches in one of the most challenging educational environments imaginable: Juvenile Hall. Not only are her students under lock and key (awaiting a prison sentence or placement in a group home), they aren't even supposed to move from their desks (a rule Tolan openly eschews). Anyone else might feel entitled to a complaint every now and again. Not Tolan. She's right where she wants to be, doing exactly what she wants to be doing: helping the kids that need her help the most—the ones most everyone else has written off as lost causes. Whether a student sits in her classroom for a day or a month, Tolan offers them humanity, knowledge, respect, and that unforgettable feeling of what it's like to have a passionate adult in your corner, rooting for your success.

To be a student in my class at the Sarah Anthony School is to be in a class like no other. First, it means that you've been accused of a crime and have been taken to the Kearny Mesa Juvenile Hall in San Diego. You're probably shell-shocked by your situation and now, less than twenty-four hours after your arrival into intake and booking, you are sitting in my classroom. You are brought in by a probation officer who yells at you to shut up and tells you to cross your arms, stare straight ahead, and walk in a single-file line. That is your introduction to school at Juvenile Hall.

As soon as the door is locked and shut by the officer, I have to counteract all that has occurred up to that moment. My classroom is covered with inspirational quotes, posters, and student work to hide the concrete-block walls. I greet my students as they enter with a warm "Hello" or "How are you?" to show them that this classroom will be a safe haven from the chaos that takes place outside of it.

One of my main goals is to help students feel confident that they can achieve in school. Given what these kids have experienced and are dealing with, I have to keep in mind how that can affect them emotionally. I show empathy and compassion, but at the same time, I want them to learn that they have to start taking responsibility for making their life what they want it to be. I expect a lot out of my students and remind them of that daily. I cannot want their success more than they do; they have to be self-motivated. Recently I had a student who came into class and gave no effort at all on her first GED pretest. She said that she had not gone to school in a long time and did not plan on taking the GED. Because of her low scores on

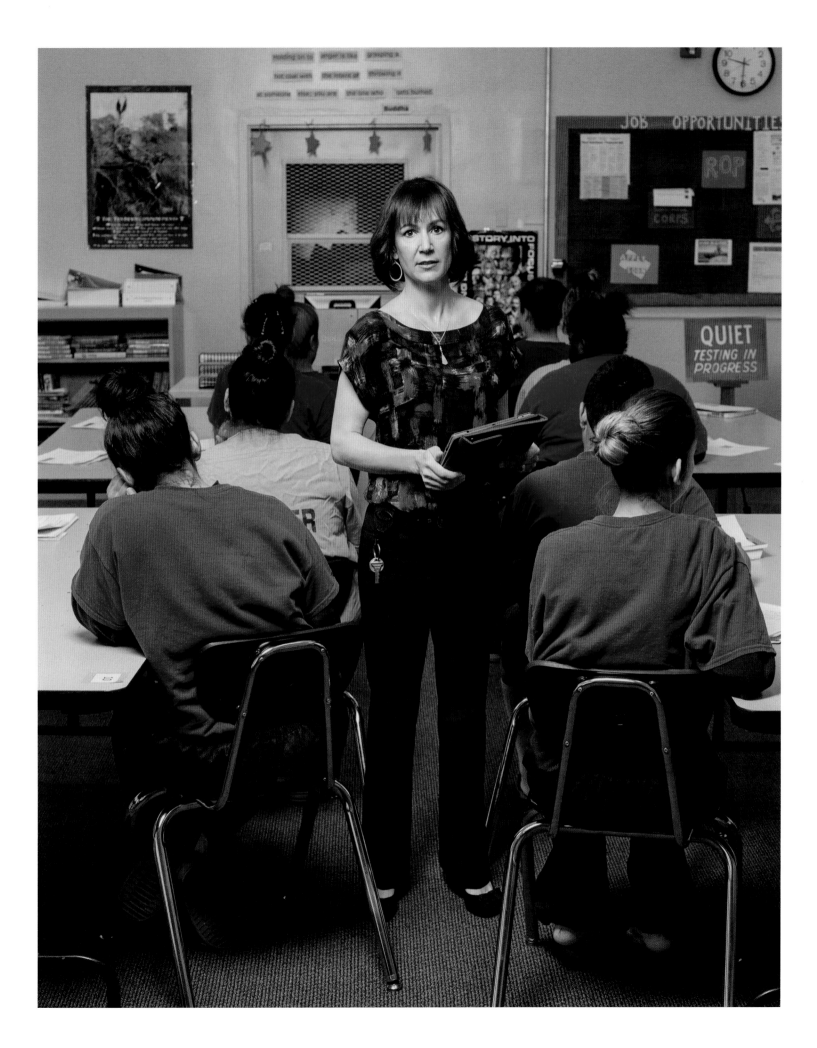

the first test, I assigned her work not really knowing what she was capable of. She started passing the assignment quizzes and her true potential began to emerge. I began building up her confidence at that point with lots of praise and excitement. She took the next pretest and passed with high scores. Her confidence soared as did her test scores, and she is now scheduled to take the GED exam and I have no doubt that she will pass. I teach students daily that they are capable of doing grade-level work, that there are positive ways to diffuse anger, and that they can make the best of a very challenging situation in their lives. During the last year, every student of mine who has taken the GED has passed.

"My students are not allowed to leave the facility unless they are in shackles and escorted by a probation officer; therefore, I have to get creative and bring the community to them."

Assessing student progress can be difficult due to the high turnover rate of students in my classroom. Despite that, I use several methods to measure student progress. I use formal assessments as a baseline, but have to remember that many of my students do not try their best on these tests, so they are not always accurate. I also use online curriculum that assesses what the students know, and assign lessons based on areas of need. Daily evaluations and immediate results are especially critical due to the changing student population each day. Much of my assessment is tied into technology such as SMART Response clickers. These are handheld push-button devices that enable the students to answer multiple-choice questions on a SMART Board. The percentage of students who answer correctly and incorrectly is tabulated into a pie chart instantly. This tool enables me to respond straightaway and reteach topics immediately rather than grade quizzes later and try and cover the missed concepts the next day, when many of the same students will not be present. If I have a student who is struggling, then I can work with him one-on-one, modify material and instructions, and/or use cooperative learning to help him. My maximum class size is just fifteen, so my struggling students often find themselves successful for the first time in their academic careers. Using technology,

and both formal and informal assessments, I am able to see that my students are achieving results each day.

When I first transferred to Sarah Anthony School, I was apprehensive about what kind of teaching I could do here. My husband gave me the best advice when he told me to just do what I have always done and not to change anything. Within the walls of my classroom, I have created an environment that tells students "this is a real school and I am a real teacher." Students are expected to work hard, have excellent behavior, and do homework. I have strived to go outside the traditional confines of teaching in Juvenile Hall. My students get up and move around the classroom for collaborative projects; they work on PowerPoint research assignments and learn to use technology; they do project-based and online learning. I am really proud of what they accomplish and I love it when I hear, "You give us too much work!" I always respond that if I demand less of them and "dumb down" the material, they should be offended, because what would that say about them? I do not accept their excuses and I let them know that even when work is hard, I expect them to do it. When a young person is incarcerated, it is hard for them to believe that anyone cares or believes they can achieve. My goal is for students to know that their future is important to me. Ultimately, there is no greater success than seeing the lightbulb go on when a student finally "gets" some concept. I also believe that promoting self-esteem is critical. Watching students' eyes light up when they qualify to take, or even better, pass the GED is the most beautiful thing. I've seen hardened gang members become giddy over a certificate of achievement.

Working at Juvenile Hall and serving youth from all over San Diego County can make it difficult to be involved with parents and the community, but I have made some progress. I talk to parents and tell them about their child's development. I have also worked with students to get them enrolled in a high school or community college before they leave here. My students are not allowed to leave the facility unless they are in shackles and escorted by a probation officer; therefore, I have to get creative and bring the community to them for what I call in-house "field trips." I regularly schedule speakers, which have included college counselors, community groups offering jobs and other services, and the humane society. Despite the obvious constraints, I feel it is imperative that my students still have the same opportunities that those in traditional schools have and that they learn that the

community does care about them.

I had a lot of great teachers throughout my education, but the ones who really influenced and inspired me were the ones who made learning fun. They were the teachers who tried crazy things and made me forget that I was actually working. They made me realize that it is not just about what you know, but how you teach it, and that there is a lot of creativity involved in great teaching. I am not an artist, musician, or poet, but teaching is my creative outlet. Yes, there are standards that have to be taught, but teachers have the autonomy to decide how to teach those standards.

As a teacher in the San Diego Juvenile Court and Community Schools, I am committed to our mission statement, in which we personally pledge to strive to eliminate the achievement gap. When statistics come out on national test scores and dropout rates, students of color are always behind white students. Why is that? The first thing we need to do as educators is change the terminology that we assign to this issue. We say that students of color are not achieving, but that places the blame on the students. Perhaps the real problem is that we as educators are not using strategies and curricula that work best for them. We are trained in all of the conventional teaching methods—visual, auditory, kinesthetic, artistic, etc.; but what about other cultural learning styles? The Center for Culturally Responsive Teaching and Learning (CCRTL) is dedicated to teaching strategies for educating students of color. While attending a five-day training put on by CCRTL, I had many "Aha!" moments. One centered on the topic of home language. This was defined as the language that a student learns in the home, and several forms of English were discussed, such as Black English and Chicano English. As teachers, we often chastise students to use proper grammar, but the message that we are sending is that their home language is bad. When students feel put down, even if inadvertently, by their teacher, they shut down. I ask my students to "code-switch," which means to translate their home language into academic language. We discuss examples of when to use home language and when to use standard English. Many students do not know that they should use standard English on tests, at job interviews, etc.

As a teacher of seventeen years, I feel that I can always continue to improve my teaching. My philosophy as an educator can be summed up with the phrase "experience discomfort." As teachers, we often get too comfort-able in what we are doing, especially if we teach the same subject year after year. Educators need to continue to read the research, and be willing to try new techniques that maybe are uncomfortable at first.

Teaching is not for the faint of heart. You can be the most knowledgeable person on a subject, but if you do not relate to children or have good classroom management skills, you will burn out quickly. For those who are passionate and well-suited to the classroom, it's a career that makes you a lifelong learner, challenges you mentally, and brings many intrinsic rewards. Hearing a student say that they learned something from me or that I helped him in some way is what keeps me motivated. I was at a Foot Locker recently, and the assistant manager came up to me and asked, "Hey, you still work at the Hall?" It took me a second before I recognized he'd been my student. I hadn't seen him in probably three years. He said, "Oh, I still remember your lesson on the three types of irony." And I just thought, "Wow." It's little things like that that make you want to continue.

> *"My philosophy as an educator can be summed up with the phrase 'experience discomfort.'"*

Teaching kids who are in Juvenile Hall, yet who are still trying to achieve in school, shows me that no child is hopeless. We cannot give up on our students who are the most difficult to teach. Teachers are going to have to get creative in these tough times, when there is little money and even fewer resources. We need to find connections with our students and learn what interests them. Teachers often motivate kids to come to school, and without enrichment, sports, and after-school programs, we may be all that our students have. The education field is a challenging one to be in. We have to stay current in teaching trends and technology, and know what our students' interests are. We have to be advocates for our students and their parents. We have federal, state, and local expectations of us that can be draining, but we should be proud of our profession. We can and do make a difference in our students' lives—sometimes tiny ones, sometimes monumental ones. We are crucial to student achievement, but it also takes the dedication of parents, communities, politicians, and businesses to support educators in doing our jobs.

"Eleven years ago, I quit my job in investment banking to teach high-school mathematics in Harlem and I've never looked back. Every day, my life has purpose. Every day, I make a difference."

Jane Klir Viau

11th–12th Grade
AP Statistics and Microeconomics

When Jane Klir Viau walked away from her high-stress, high-yield corporate job to educate at-risk inner-city kids, she did what so many of us dream of but never do: she gave up all the comforts of financial stability for the intangible karmic rewards of knowing she was making a positive difference in the world. Viau has attacked her second career, in the classroom, with the same ferocious ambition that made her a star in the boardroom. And the results are astonishing. Despite their economic, social, and educational disadvantages, her students' AP test scores simply blow away the national averages year after year. Proof positive, according to Viau, "that ALL children can learn, with the right mix of compassion, dedication, and commitment."

As the alarm rang on the morning after my thirty-sixth birthday, a dull dread began to sink in and I was startled into consciousness with racing thoughts of conducting another twelve- to sixteen-hour day of battle at my investment-banking job on Wall Street.

Since college, my life had been on autopilot for sixteen years. I got excellent grades and graduated as valedictorian; landed a prestigious management training position at a top investment firm; earned an MBA while continuing to work full-time; collected raises, promotions, and bonuses, and traveled the country on expense accounts. Oh, I was living the life. Why didn't it feel rewarding? Many days, I found myself in quite a quandary—will I be a good employee today, or will I be a good person? With the "gray" ethics demanded in investment banking, the options were often mutually exclusive. The invasions on my personal life were punitive. I missed weddings and other once-in-a-lifetime milestone events.

Any vacation that I had the audacity to take involved daily phone calls to the office, which I tried in vain to hide from my husband. The huge bonuses were earned through my blood, sweat, and oftentimes, my tears.

As I lay there that morning, I decided that enough was enough. I had to develop a better plan for the rest of my life. The work I did was cerebrally challenging and the pace was exhilarating, but what did it really add to society? What footprint would I be leaving on this planet?

I decided to take inventory of my skills to ascertain how I could apply them in some socially meaningful manner. My knowledge of finance initially steered me to successfully raising funds for much-needed charities, yet the job seemed too remote. Then 9/11 happened and that was the final wake-up call: Life is short; you just get one shot at it. What if I had been there? What would my eulogy say? It just slapped me in the face: I needed to be the one who's actually out there, getting her hands dirty, making a difference. And that's when it occurred to me

that I could become a math teacher. Instantly, everything fell into place. I could share my love of numbers and their practical applications in business and finance.

Eleven years ago, I began teaching high-school mathematics in Harlem and I've never looked back. Every day, my life has purpose. Every day, I make a difference. I teach content, even advanced placement statistics and advanced placement microeconomics at the college level, but I teach so much more. Simply by engaging in spontaneous reasoned dialogue with students, I offer them new ways of perceiving the world around them. I teach life skills; I teach morals; I teach wise choices; I teach compassion. I spend time with youngsters who need an adult who treats them with respect and kindness.

> *"My clients are my students now, and these stakeholders deserve the very best that I have to offer. I love my new career; it saved my soul."*

I remember in my first year of teaching I had the kids research careers that used math. I gave them a list of forty possible jobs and I instructed them to find a living, breathing person who did something that had to do with math. I'll never forget what their first reaction was, which made me so sad. They read the list and there was dead silence. I gave them different ways to research, like to find companies and organizations through the phone book or on the Web, but they just stared at me. And I swear to you they said, "These are white jobs." And it just made me want to cry. I said to them, "That is *not true*. Don't think that for one second. There is nowhere in the description of any of these jobs that says what color someone has to be. Any one of you could have these careers." "But we don't know anyone that does these jobs," they replied. And I said, "That's okay, because you will; you're going interview them, and then you can say that you know someone who does this job." And they did. It was really hard for them but they did it.

And that's what makes me realize, too, that they look at me and make certain assumptions about my background. For instance, because I used to be a banker I must have been born with some kind of silver spoon in my mouth. So I learned that it's okay to talk about myself and share things about my life, like that I grew up poor,

and that my parents were immigrants who went from dressing in clothes from the Salvation Army to being middle-income homeowners. I went to a state school instead of an expensive private school because I had to pay for it myself. And when I went back for my master's it was sponsored by the company that employed me—so I worked full-time and attended classes in the evening part-time. The MBA took me six years to complete in this manner, but I was able to avoid any loss of salary and stay financially independent. So my entire education was very cheap. This proves to my students that it can be done, that I'm not as dissimilar from them as they might think. I was different, too, because my parents had really thick accents and were foreigners and weren't anything like other parents. My story makes my students feel like it's okay to tell me about their struggles because I shared something with them that is very personal and not the most comfortable thing to talk about.

It is easy to find reasons why students don't learn; it is much harder, and much more rewarding, to find ways that they can. There is nothing more satisfying than seeing a life take off. In order to expect commitment from my students, I must first demonstrate my own commitment to each of them. I take the time to try to understand each of them personally; I make myself available during lunch hours, free periods, and after school to address any and all academic content questions completely. Through seeing that my motivations lie with *their* success and not my own track record, the students come to their own conclusions about my sincerity. It is after this realization that I begin to see my students, one by one, meeting me halfway. A wise person once told me, "They don't care how much you know until they know how much you care." That sums it up perfectly.

Sadly, many students report that I am the first adult who ever expected so much from them and who refused to give up on them. That motivates me even more to work doggedly for them. If I won't believe that they are worth it, who else will? Even when students do not initially meet my expectations, I do *not* lower them. I firmly believe that *all* children have the natural capacity to learn. Some may come to us better prepared than others. Some may have incentives reinforced in the home while others do not. It is my obligation as their teacher to tap into that reserve of potential and draw it out. No matter what it takes.

My advanced placement statistics and microeconomics students, although some of the best among our

school's population, are not "advanced" students by any stretch of the imagination. In most suburban high schools, they might be considered lower functioning. The specific mathematics skills that they bring to the table are significantly lacking and their studying and organizational skills are almost nonexistent. For various reasons, these children have been previously denied access to success; it is my obligation to bridge the gap. I set about leveling the playing field for them. I strive to set them up so that they are capable of applying themselves to develop and utilize their greatness to compete with their peers from more privileged backgrounds.

All of this takes time—a lot of extra time. My students need more instruction, more guidance, more encouragement—they need more of me. And I take it as my duty to provide that. My AP students are required to sign an academic contract in which they and their guardians agree to a certain commitment of time. In order to accomplish our aggressive goals, we hold mandatory after-school and Saturday supplemental classes. My students agree to meet during school breaks. We are making up for lost time. If my students are willing to make this journey with me, then I am willing to do it with them.

It's not an easy conversation to have with them, but I explain where we are and where we need to be. "And you know what?" I tell them, "We're not going to get upset about it. We're not going to say it's not fair. We're not going to whine about it. We're just going to put in the time and deal with it. The fact that you've been gypped in the past—oh well. Because you absolutely have the innate potential to do this and now there's no other option but success. It's just going to happen and it's as simple as that."

At various points throughout the year, several students will have "breakdowns" and threaten to quit the class, claiming that it is "too hard." I never accept such claims. I insist that the students *can* do the work; it is a matter of wanting to put in the necessary time and effort. It is these crucial moments that build character. My goal is for my students to be successful in life—not only in my course. I've found that if I tirelessly maintain my level of expectations, eventually the students also begin to expect more of themselves, and their higher achievements become a self-fulfilling prophecy. Last year, 92 percent of my students earned college credit on the AP Statistics exam, with 91 percent of those students scoring the equivalent of a college A or B. Our mean score was 4.08 compared to the national mean of 2.82. That was a huge accomplishment—for them and for me. It takes a lot of sacrifice—but it's all worth it, to see insecure youngsters with no goals transform into confident, skilled, ambitious scholars, and to know that I played a role in the metamorphosis.

I've been married for a long time. When I met my husband I was Little Miss Investment Banker. That's who he met and that's who he married. Well, look at what he ended up with, right? I'm not the same person. I've got to tell you, he's a saint. He didn't flinch when I said I wanted to give up my career to do something meaningful. The man did not flinch. And that's not even the most amazing part. All this time, he's been in computer programming. And then three years ago, guess what he decides to do? He quits his career too, to become a teacher. Now he teaches seventh-grade math in the South Bronx and he's never looked back. And you know what? Neither of us makes much money and we do not care. We both took this big leap off a cliff, and we have never thought, *God, why did I do this?*

> **Mrs. Viau,**
> **Some teachers teach about books and math, other teachers teach about life. Thanks for not only pushing us to become better students but better people along the way. You've pushed us to a limit we didn't know we could ever reach.**
>
> *Kimberly, age 18, former student*

We've never had children of our own, but I feel like I raise 150 children each school year. The relationships formed between teacher and student in an environment like ours are powerful. Many of my former students, most of whom are now attending college, keep in touch with me. Their kind words in my e-mail in-box or their joyful hugs delivered during pilgrimages to my classroom affirm that my impact on their lives is lasting. How many middle managers can say that former employees come back years later to thank them for their leadership?

Teaching the population of students that I've chosen to teach requires dedication, stamina, and consistency. I'm used to all that from my previous career. I'm no foreigner to long hours and hard work. The difference is that now I care about the end product. Teaching also requires creativity, spontaneity, and love. My clients are my students now, and these stakeholders deserve the very best that I have to offer. I love my new career; it saved my soul.

"My job is simply to be the lead learner, to be real for my students, to be authentic—to make mistakes, to be passionate, to geek out, and to get very serious when I need to be."

Sarah Brown Wessling

9th–12th Grade
Integrated Language Arts and
AP Literature & Composition

In 2010, when Sarah Brown Wessling embarked on her year-and-a-half sabbatical from the classroom to serve as National Teacher of the Year, she was prepared to miss many things: her family, her students, her routines. But she did not anticipate how much she would miss her favorite literary characters—those she had been passionately introducing to her high-school students for more than a decade. For Brown Wessling, these fictional heroes and heroines have become "old friends"—ones she unconsciously relishes revisiting each semester. "Every time we study a great novel, or read a play or work on a paper, I'm learning all over again with my students," she explains. This insatiable appetite for scholarship, coupled with her bold commitment to a democratic approach in the classroom, lies at the heart of Brown Wessling's extraordinary appeal as a teacher. Her passion in turn stirs the passions of her students, and so often, that is where great teaching begins. Since 2011, she has also gone beyond the four walls of her classroom by serving as the Teaching Laureate of the nonprofit Teaching Channel, where she regularly blogs about her profession, shares videos of her classroom lessons, and hosts their PBS television series, *Teaching Channel Presents.*

Ms. Wessling in her tenth-grade AP lit & composition classroom.

see the world in stories. I relish in the transformative power of language that can divide and unite us. When I look in a classroom, I see a story in every learner, unique and yearning to be read. Creating a community for learning means creating more than a classroom: it means constantly intertwining our stories in a way that reveals our potential.

Becoming a teacher was never a choice for me; rather it was a realization of something I must have always known. I come from a long line of educators. My maternal grandmother was the youngest of nine children. They were a farm family and all of them graduated from college, including the seven females, which is quite unusual for that time and place. My grandmother is eighty-six now. And in every generation of the family since then, there has been some kind of teacher. So I feel that a sense of curiosity and love of learning is simply part of my being.

Ms. Wessling was meant to teach, a fact evident to everyone who has participated in one of her classes.... No discussion was fruitless, no assignment was pointless, and not one day was boring. No matter how hard we worked, she was working harder.

Amra, age 18, former student

I was meant to be a teacher, but hadn't realized it when I went to college in search of my passion, following the course of many different majors: broadcast journalism, psychology, philosophy, and literature. In each, I found excitement and promise, but not myself. Finally, and quite suddenly, it dawned on me that I could pursue all of these disciplines each day in the classroom. With my compass clearly defined, the divides collapsed and my path was illuminated. I read and thought fervently about the psychology and philosophy of learning, and the lessons literature offers about the human experience. I've long known that my story of learning and teaching has never really been about me. My students would tell you, time and again, that it's my passion which permeates the classroom atmosphere each day and makes them want to join in. They would tell you that I work to see the potential in each one of them that they can't see in themselves. Though I could say my greatest contributions come from a published article, a successful in-service, an NBCT certification, a department I've led, or a state conference I've orchestrated, it wouldn't be true. My greatest contributions are my students.

When my seniors walk into class on the first day of the year, I don't give them a syllabus; rather I invite them to join a circle of their classmates on the floor. I hand out a copy of Plato's Parable of the Cave, light a candle, and tell them that by the end of class they need to be able to tell me the course expectations. This anecdote, like the candle in the center of our circle, serves as an acute symbol of my philosophy: learning must be learner-centered, it must be constructed, and its power already resides in each of us. Every single person who walks into my classroom is elevated to the status of learner and becomes part of our landscape for learning. Being a learner-centered teacher means respecting who students are right now. This means creating community by building a shared purpose and values. Cultivating this kind of environment begins when I relinquish the notion that I have a right answer or that I am a sieve of knowledge. At once, this liberates and challenges students. They recognize that their model is one of inquiry, of questioning, of thinking. While I am careful to construct the parameters of our pursuits, and am relentless about modeling processes for learning, we are unequivocally in it together. My job is simply to be the lead learner, to be real for my students, to be authentic—to make mistakes, to be passionate, to geek out, and to get very serious when I need to be. I often use the metaphor of my desk being in the far back corner of the classroom to illustrate this learner-centered philosophy. As much as anything, it's an outward sign of what is valued in our class: we are all students. Every time we study a novel, or read a play or work on a paper, I'm relearning it with my students. And that really fuels me. I've been doing this long enough now that certain literary characters are like old friends. At the beginning of each year, as I meet my new students and get to know them, I start to think about how I cannot wait to introduce Holden to Olivia, or for Tyler to meet Meursault.

I don't teach book by book. The days of reading a text, taking a test, and calling it done are long over. We cannot do that to our kids, because it suggests that each text functions in isolation, and we know that isn't true. So I organize the curriculum around essential questions or themes. For example, instead of teaching the theme of courage in *To Kill a Mockingbird*, I teach courage and *To Kill a Mockingbird* is just one of many texts in which we explore that theme. I tell the kids frequently that all of our texts have to be in conversation with one another. Today, for instance, we were talking about *The Glass*

Menagerie and the students were leading the discussion and one of them asked her classmates, "Does this remind you of that part in *The Catcher in the Rye*?" Well, we read *The Catcher in the Rye* months ago. It's so important for students to understand that we must not put our learning in little compartments, that it's all relative and evolutionary.

I get a little spooked by the idea in education that if you write the perfect lesson and you create the perfect rubric and you give students the perfect criteria, then everybody will have this perfect experience. That's simply not how learning works. You don't learn by painting by numbers. You learn by having messy hands. I'm not afraid to jump into a project and let the kids get a little frustrated so that they understand how to struggle and how to learn. For me that frame of mind is really important. My teaching is very constructivist. And that desire to have students construct their own learning manifests itself in a lot of different ways. Certainly one of those ways would be in project-based experiences.

Students construct knowledge when it is relevant to them, when they have a real and authentic purpose, when they have an audience that gives them context. Giving students a reason to construct knowledge gives students more of a desire to be challenged, to exceed their own expectations. I think students are more engaged when their purpose is clear and when they see their own passions, questions, and motivations reflected in their work. In each of my classes, you would see learners constructing knowledge through rigorous and relevant inquiry experiences. Students in my New Start English class might be creating their utopian school by generating surveys, composing a learner's Bill of Rights, rewriting the course descriptions, and composing a school song to match their school's mission. My sophomores read nonfiction books in literature circles, record their discussions, and create Public Service Announcements that educate their audience about an issue from their reading. Students in my elective writing class compose multi-genre papers and create podcasts to practice the research process before writing a more traditional piece. My Myths and Legends class creates a superhero for today using all the concepts we've studied throughout the course. Using a mock Facebook page and nominating the character for "Hero of the Year," each student gives a mock acceptance speech as that hero. My AP students go beyond the traditional curriculum of literary analysis and create storyboards for a film trailer, which must convince their audience of a particular "reading" of a film they've studied in seminar groups.

These same seniors also participate in the Grant Proposal Project: upon finishing a thematic literature unit on the American dream, student groups create nonprofit organizations that would benefit those in our community who are unable to achieve their American dream. Students engage in research and inquiry methods that enlighten them about our city. The project culminates with community members forming a panel in order to evaluate the grant requests students have written, ask them critical questions in a group interview, and ultimately determine whether or not to fund their project. The result of this seven-year experience has been inspiring for me to watch. I see students becoming more altruistic because of their research. I see community members spending hours in preparation to create an authentic audience. Most important, I see all of us learning because of our common goal.

> *"Students construct knowledge when it is relevant to them, when they have a real and authentic purpose, when they have an audience that gives them context."*

Creating these innovative learning experiences provides important context and motivation for students, but the real teaching resides in the nooks and crannies of each unique learner's process. And this is where you'd find me at my most intense and deliberate. To me, the learning process is sacred ground in whatever I'm calling my classroom. Because of my own willingness to put myself in the same positions I put my students in and reflect on the way learning occurs, I recognize that the path to autonomous learning is not through the accumulation of facts, but through the messy and edifying pursuit of ideas.

Knowing my students means I must know how they learn, the kind of feedback they need, when to nurture, and when to step aside. My most important teaching happens in the least obvious places. It's in the conferences I have with students about their writing; it's when I spend the class period questioning, probing, and supporting the ideas that might guide a particular project; it's in the think-aloud I do after I realize students didn't

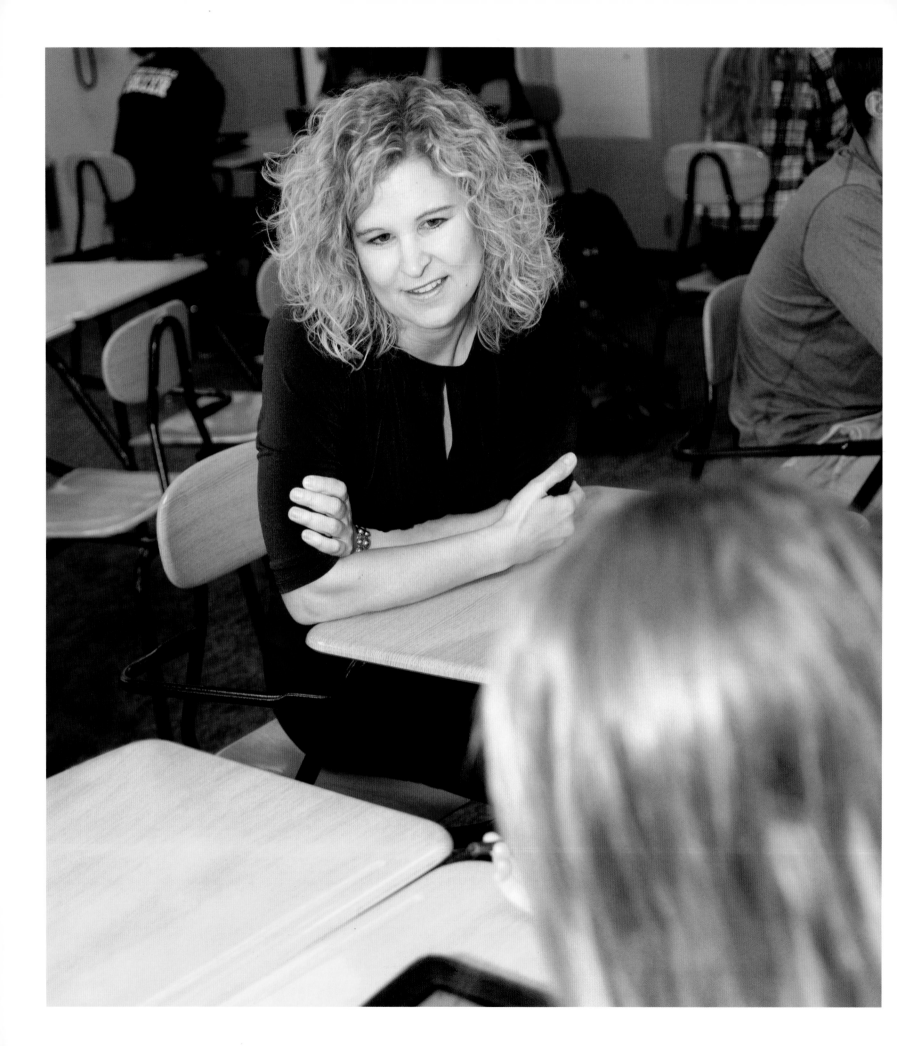

"get it" yesterday; it's in the copious feedback I give to the work students do, as I work toward creating the kinds of learners who don't need me anymore. I want students to take intellectual risks, so I give them plenty of chances to fail without penalty. I use assessment to scaffold progress, not to debilitate learners.

Perhaps one of my most successful strategies incorporates iPod technology. While in some classes I record our in-class conferences, for others I create individual podcasts for each student on each major paper outside of class. As I'm reading their papers, I note places for comments and then record my responses to their writing. In this way, I'm able to completely personalize their feedback. I can motivate, question, respond as a reader, or explain why you'd want to change the passive voice in one paragraph, but leave it in another. I distribute the sound files by e-mail or flash drive to students. Students tell me that they not only listen to these over and over, but parents tell me they listen too. One parent, a judge in our community, came to a parent/teacher conference and was so excited about the podcasts that he said, "My writing has gotten better by listening to what you tell my daughter."

There's no ranking for the rewards in teaching: it can vary from a student coming to class five days in a row to my grade-obsessed student who is willing to take the chance of getting a B to pursue an intellectual risk. The constant is that there's progress, no matter how minuscule. The reward is in recognizing and providing what a student needs today to become self-actualized tomorrow. Others would say that my teaching is outstanding because everything—from the first day to the last day—is deliberate and purposeful, because I see both a broad vision and the small details, because I believe everyone can learn, because I'm ceaselessly learning myself. I would say that I'm lucky. I'm lucky to have found my passion and a way to express it each day.

Being named National Teacher of the Year in 2010 was really an experience that I grew into. For me, it ultimately meant being a listener. It meant being a writer. It meant being a person who had been given this opportunity to connect dots that other people didn't have the opportunity to connect. And I tell you, it has made me feel so responsible to try to be a better teacher.

What I walked away with is how important the culture that we create is, whether it's in a classroom or a school or a district or a state or a country. We have so

many students who are learning in spite of our systems rather than because of them. I think the unintended consequences of initiatives like No Child Left Behind have created a culture of fear. And fear and learning are in direct opposition to each other. If I ever wanted to shut

"There is no silver bullet. I've learned that we have to stop trying to find one. We have to be willing to wrestle with the complexities that make our communities who they are, and have the tenacity to deal with them."

a student down, the first thing I would do is make that kid afraid, afraid to fail, because then they're afraid to take an intellectual risk. They're afraid to try, to make a mistake. And that's what we did to a country of educators. That's what we did to an entire system of teachers. And that's the atrocity. We know the brain does different things when it's in fear mode. We know that it closes up, but that's the way that we think it's going to create urgency. I've spent a lot of time talking to policy makers. I've spent a lot of time listening, too. They say they want more accountability, but what I actually hear them saying is that they want to see more urgency.

I really think that the best way to create urgency is to get teachers out of isolation. It's not to make them afraid that they're going to lose their job. I get most urgent when I see what amazing thing my colleague across the hall did, or when I go meet some teacher in Denver or Kentucky doing some cool thing. That makes me feel like, oh man, I've got to do more, and that makes me a better teacher, not the fear of doing something wrong.

I don't know if what I want to see changed is anything earth-shattering. Because I think it's probably what we all want: for every student to be able to flourish. We just disagree sometimes on how to make that happen. And I don't believe that there is just one way, because how it happens here at Johnston is not going to be the way that it happens in another state or even in another nearby community—there is no silver bullet. I've learned that we have to stop trying to find one. We have to be willing to wrestle with the complexities that make our communities who they are, and have the tenacity to deal with them.

"When I was hired to teach journalism at Palo Alto High School in 1984, the program had nineteen students, one typewriter, and a $20,000 debt. I decided I was just going to treat it as a challenge."

Esther Wojcicki

10th–12th Grade
Journalism

For three decades, Esther Wojcicki has been the driving force behind the country's most decorated and respected high school journalism program. From her "tech'd out" classroom at Palo Alto High School, "Woj," as her students fondly call her, has inspired and empowered generations of would-be writers, editors, and designers, and racked up a heap of prestigious awards along the way. Her student-run publications have won Gold and Silver Crowns from the Columbia Scholastic Press Association, the PaceMaker Award, and the Hall of Fame Award from National Scholastic Press, as well as best in nation from *Time* magazine (2003). For her excellence in teaching, Wojcicki has been personally honored as California Teacher of the Year (2002), and has received the Gold Key Award from Columbia University, among numerous other accolades.

Ms. Wojcicki and her advanced journalism class work on the student newspaper, the Campanile.

I'm a born teacher; I've always loved working with kids. When I was fourteen years old, a Christian private school hired me to teach sports. I loved it and the kids loved me. The program tripled in size after I got there, so I must have been doing something right. I was never trained. I just had the proper instincts. I've done a lot of teacher training and I'm sorry to say there are some people who are just never going to make it in a classroom, no matter how hard they try. I do think you can become a good teacher without the innate instincts, but you can't be a great one. And you have to be passionate

about teaching or you might as well forget it. It's simply one of the hardest things you can do.

Neither of my parents had an education. I'm the child of Russian Jewish immigrants who came to the United States in the 1930s with nothing. My dad was an artist and my mom worked as a clerk in a store. In the ninth grade I found out that if I wanted to go to college, I had to pay for it myself since my parents were too poor. I decided that I would earn money at the local newspaper by helping to write stories. I had no experience, but that didn't stop me from applying. I guess they liked the gutsy girl and so they hired me at three cents a word. I wrote for them for three years and they taught me everything I know today about journalism.

Honestly, I believe she's a kid at heart. She's one of the few teachers whose presence in the room doesn't change the tone or content of a conversation—not because we don't respect her as a teacher, but because she's more like one of us.

Abigail, age 17, former student

The most defining event in my elementary education was the failure of my brother Lee to do well in school. He was diagnosed as "retarded, a slow learner" (that was the terminology used back then) and was treated terribly by the system and the teachers. In fact, Lee just had dyslexia, but it was not a diagnosis at the time. Lee's school problems made a huge impression on me; I knew he wasn't dumb but somehow he could not learn to read. He eventually learned, went to college and, of course, now knows that he was improperly diagnosed. Lee's experience made me decide that I would never treat students poorly—ever—no matter what. Everyone can learn; there are just many different learning styles.

When I was hired to teach journalism at Palo Alto High School in 1984, the program had nineteen students, one typewriter, and a $20,000 debt that I was supposed to pay off. I decided I was just going to treat it as a challenge.

Within two years, the program doubled in size, but we were still using a typewriter. In 1987, I applied for a grant to the State of California for a Macintosh computer and received eight of them. When those computers arrived, I did not even know how to turn them on, much less how to use them. I admitted to my students that I had no clue what I was doing and asked them for help. They thought that was terrific. Together, we figured out how to set it all up. We became the first school probably in the nation to create a newspaper on computers. There was no software to do that at the time; so, we developed our own. I could never have done it by myself. And that was the beginning of my teaching style today, which is completely collaborative. I want each student to be engaged at his/her own pace, and differentiated instruction is easy with the use of computers.

I'm one of the first teachers to effectively use technology in a classroom. I bring in all the twenty-first-century electronic media—computers, cell phones, tablets, video recorders—and I teach kids how to use these tools. Not only am I a proponent of technology, I can't understand why other teachers don't see the value of it. It just makes so much sense. It's much easier than constantly standing up there, lecturing every day, having kids take notes and then testing them. But there are a lot of people who still need to be enlightened; so, that's what I do. I run around helping teachers understand how it would be in their best interest and in the best interest of their students to use technology as a tool.

I learn through my students. My philosophy is governed by peer-to-peer education. Students teach one another. I'm the resource; I'm the facilitator. I provide the tools and they work together in teams. I trust the kids and respect them as collaborators. Often you go through school and teachers don't trust you, they don't respect you. They give you bad grades without any explanation. They treat you like they're doing you a favor. In fact, the number-one problem in public schools today is that teachers and administrators don't want to give up any control to students. No one trusts anybody. The whole country doesn't trust. And, in about half the public schools, teachers' expectations are based on scripted education: the teachers are given the book and the tests, and told exactly what page they're supposed to be on every day. So, the whole thing is scripted; there's nothing left to chance. The idea is that the principal should be able to walk around the school, open any classroom door and see that every teacher is teaching the same page. It's supposed to be written on the board: "Turn to page—whatever it is." This isn't the case at my school, because we test at the very top. We're ranked ten out of ten, a distinguished school. So the pressure's off. But the lower the test scores—the lower the performance of the students—the more likely they are to have scripted education and worksheets.

The greatest challenge I had when I started teaching in the 1980s was that my style was not mainstream. I believed in collaborative teaching long before it was in fashion. Principals came into my room and criticized me for "lack of control" and for letting students talk to one another. The only reason I wasn't fired for how I taught in the beginning was that I had the support of the community. Everybody was stampeding into my classes; otherwise, I probably would have been eliminated for failing to do everything that they told me to do. It took years to convince administrators that this approach works. I do a lot of staff-development training now, and I find that most teachers are reluctant to relinquish control and allow students to have some choice in their education. It is a challenge for me to figure out the best way to show them that project-based learning and peer-to-peer instruction is much more effective *and* easier for the teacher than lecture-based learning.

The journalism program expanded slowly and consistently. By 1998, I had eighty-five kids signed up for my class and I said, "This is a bit crazy. I have to add another publication." So, I started a broadcast journalism course in the back of the classroom. I didn't know a thing about it. I just figured I'd learn with my students at the same time. And we did. In the years since, the program has expanded to include more than six hundred kids, a staff of four other teachers, eight publications, a website, and a daily newscast. Today, ours is the largest high-school journalism program in the nation.

All the publications operate with the same philosophy: student-run, student-produced, for students, by students. They write stories about things that matter to them and what's going on in their community, and that's what makes the difference. I set the structure and I tell them what the topic is, and then I put them in groups and they work in teams. If you came into our classroom on any given day you would see lots of kids working on a variety of projects and then coming together to report to one another what they found or what they learned. It doesn't look like your typical class, where everyone's lined up in a row raising their hands, quietly behaving until the teacher recognizes them. It's a much more engaged, active environment.

I allow the six editors to run the class session every day, with coaching from me before and after class. Yes, teenagers are in charge of teenagers—and it works. Putting them in charge is an act of trust and respect on my part. The typical class organization is a three-week cycle. The first week they generate story ideas and assign stories. The following week is spent writing stories, and the third week is for production. Each student has a role—there are editors, section editors, senior reporters, reporters, photographers, business managers, advertising managers, circulation managers. This process teaches students about teamwork, collaboration, problem solving and self-control—all skills that are in demand in the job market.

Our students have broken some important stories over the years. One of them, for instance, resulted in the resignation of the principal three years ago. During Spirit Week, the kids had this tradition of throwing eggs at night at one another in a deserted area. And the principal decided she didn't like that tradition. She wanted to stop

"Yes, teenagers are in charge of teenagers—and it works."

it. So, she had her people run around and block them at all these different spots. Somehow the kids managed to go over to the other high school in town and ended up having this egg-throwing contest there. The next day the administration suspended two hundred students. So, we wrote a story about what the principal did and the whole process. There were multiple community discussions about what happened. All we did was report the facts, and as a result of the story and the public discourse, she resigned.

The biggest story my students broke happened in 1996 when they discovered that the school board had violated the Brown Act and discussed financial matters behind closed doors, giving the administrators raises. They reported the story and within two days there was an emergency meeting of the board and the raises were rescinded. A couple of months later they wrote another article about unwarranted administrative use of district credit cards. Both stories were covered by the local television stations and the major press in the Bay Area.

I'm in my thirtieth year teaching journalism at Palo Alto. I could have retired a long time ago, but trust me when I tell you that I still look forward to every day (well, almost every day). I'm just not the yacht/beach type of person. I don't like going out to lunch every day. I actually prefer to be in a classroom helping kids rather than shopping or lying around a swimming pool.

"The arts and humanities are sexier than the sciences. Every kid wants to be a singer, a dancer, a rapper. Programming a computer? I think it's sexy, but I know a different side of it."

Pat Yongpradit

9th–12th Grade
Computer Science and Technology

Mr. Yongpradit with students in the Computer Lab of Learning, working on a video game project.

When Pat Yongpradit graduated from college, he had a plan: get his master's degree at Stanford, become a teacher, live in a small coastal community, and buy a convertible. He knew California would be expensive, but figured, "As long as I had a Miata and lived near the water so I could surf, I'd be happy." Ah, the best-laid plans. Finances and common sense intervened and Yongpradit ended up getting his teacher's certification in his home state of Maryland. He now lives and works not seven minutes from where he grew up. Yongpradit is passionate about the subject he teaches: computer science. His unique approach to teaching programming is embedded with the themes of public service and real-world relevance. Instead of creating games about blowing people up, Yongpradit's students make games and apps about saving people's lives. His unique integration of ethics and computer science won him the Microsoft Worldwide Innovator Award in 2010, and recently he became the Director of Education for Code.org, a national non-profit organization promoting computer science education. Last year, he finally got a Miata.

What I love about computer science is that you don't just read about it, you do it—it's a doing kind of subject: 10 percent of the time you might be learning from a book; 90 percent of the time you're learning from a hands-on project. And with

each project, you're creating something completely novel, because it comes straight from your imagination. No one else has ever done it the way you just did it. And, that's the beauty of it. It can be a very creative, innovative subject.

By my third year in the classroom, I started to feel comfortable. I had amassed dozens and dozens of labs and PowerPoint presentations, along with movies, assignments, tests, and quizzes; I had material prepared for every possible situation. At that point it was just a matter of cleaning it up and making it better. I chose contexts for my project assignments that kids would find fun and interesting—like wrestling or video games. That approach went well, except for one big thing: It mainly appealed to the crop of kids who would normally take computer science, like young boys. This illustrates a widespread problem in computer science: We over-appeal to a subset of the population, which leads to the stereotypes that we often see in our field.

I've learned a lot from you. Especially about ethics. I know that's weird but you told me once that people were going to come and go in my life, but I'd always have my integrity. That was one of the most influential things anyone has ever said to me and I still think about it every day. Thank you.

Meredith, age 21, former student

Then I had a professional-development opportunity through the Microsoft Worldwide Innovative Education Forum (now called the Partners in Learning Global Forum) in Cape Town, South Africa. I applied to the forum and was invited to present there. I basically put forth my best project and I placed first. They used a very detailed rubric to judge the submissions, which introduced me to a new way of understanding what an innovative project is. Through that experience in South Africa, I came to realize that I needed to think beyond my classroom—and get involved in more social causes.

I wanted to extend my approach beyond the contexts I'd been using for my lessons and my assignments, beyond the normal computer-science-y kinds of topics—even beyond the culture of computer science, which would very typically include topics like video games.

After I returned, my first assignment was to have kids model the life of a South-African street child. A *tsotsi* is like a street thug, a criminal, and unfortunately, some of these street children become tsotsis. I asked my students to program characters based on these kids. I had them really think about and research what it is like to be a South-African street child. What do they go through? What are their behaviors? What do you need to think about when you're portraying them in a computer program?

That marked a big change in how I approached my teaching. From then on, I started connecting my big student projects to the eight United Nations Millennium Development Goals. I thought, if kids are going to write video games—which I was still a fan of—they were not going to be about zombies and shooting people, but about issues surrounding poverty, maternal health, universal education, environmental sustainability, and so on.

Having to address a public need is integrated into every single project I assign. Honestly, the cleverest work I've gotten out of my students is when they have to think and develop an idea within the context of a social cause—much more so than when they were free to do whatever they wanted. For example, I had a student make a game about how to get a date with an environmentalist. It's almost like a "choose your own adventure" game, where you have to answer a female environmentalist's questions. She quizzes you, and you have to give the correct response, otherwise you'll lose the opportunity to get to know her better. Another group of my students created a game about maternal health called Just in Time, in which the main character is traveling around a rural village providing mothers in need with vitamins, food, and medical transportation. Another game they invented was called Electra Hope, which was dedicated to bringing attention to environmental sustainability and the energy crisis in the aftermath of the Tōhoku tsunami. My students have also built an app for the DC Office of Homeland Security, created games in which kids use their body to solve math problems, and just recently came up with an app to describe the anatomy of a cluster bomb in partnership with a nonprofit called Legacies of War.

I believe in making everything I teach applicable in the real world, and not just in terms of the content, but in terms of the process, the pedagogy. For instance, I have my students use industry practices while they're coding, like pair programming. Rather than just one person programming by him- or herself, you have two people working together at the same computer, taking turns with the mouse and keyboard. The person using the mouse and keyboard is called the driver and the other person is called the navigator. So imagine you have two people in a car. One person has the map and is directing the other person

where to go, so the driver can just concentrate on driving. Instead of working the way most people think a computer scientist works, which is alone, the kids are constantly interacting socially. And instead of asking me for help when they need it, they turn to their partner for help. So there's this constant collaboration. If you could ever see a video of my class when pair programming is happening, it's very buzzy, very dynamic. The kids are all engaged. They might be laughing. But they're also correcting each other, thinking of new and better ideas. I love that kind of environment.

The whole change in my approach to content and pedagogy coincided with this ambition to have my students enter as many contests as possible. Not because of the notoriety it brings us, though that does help to attract kids to the program, but more just giving kids a reason to expand their education outside of the boundaries of school. These are competitions for games about social causes. Like, the Kodu Cup. It's all about creating a game to represent the relationship that people have with water. So my students are making games about water pollution and water scarcity. If outside organizations are going to present competition opportunities like that and offer thousands of dollars in awards, then I'm going to shape my projects to match up to them. It's win-win.

I want my students to understand the value of competition. I think that's a really important component that's missing in American education. We all believe in the American dream, but the fact is you must compete to attain the American dream. Everyone can get an A in school, but there is always a better writer, better scientist, a better whatever. I'm not a competition monger but these contests allow me, as a teacher, to tell students, "If you do this, this, and this, then you'll get an A from me, but you're not going to win the contest." I can even ask them right off the bat, when they're designing their game or their project, "Do you think this is going to win? Is this a winning idea? Because if it's not your best idea, I don't want you pursuing it. I don't want you spending the hours and hours it's going to take to create it."

Students often don't understand the difference between fulfilling requirements and doing the best they can. They haven't made that mental switch. And that's why I do these contests: to teach them how to make that switch. And they've done very well. They've excelled at it. We participated in a national contest recently in which there were awards for the people's choice and the judge's choice in the game design and app design categories. Springbrook teams won both awards in both categories. They swept the entire competition.

"Computer-science education is my love. I really believe in it, and I want everyone to experience it."

Since I started teaching at Springbrook, we've doubled the size of the computer science program. It's taken a lot of hard work. We compete for new students. Some people don't like that, but I think it pushes programs to be better. I'll go out and talk to middle schools. Middle schools will come to us. We're trying to attract the best and the brightest, the kids who really care about technology. Kids hear about the program. They see the results. They see what our students are doing when they graduate—the internships, the jobs they have lined up, the college scholarships, the actual applications and games that they've already sold and are out in the marketplace. And they want a piece of that. The natural result has been that the program has grown. Everything has doubled—the number of girls in the program, the number of classes overall. Everything.

In terms of where computer science stands in the American education system, there are only thirteen states that consider the subject credit-worthy: where you can take a computer science class and it will actually count as a credit toward graduation. In most states, including mine, it's like a pure elective. It's not even on the level of yoga. With yoga, you get a PE credit. People don't understand its place—which is crazy when you think about all the innovations in technology during the last twenty or thirty years. When it comes to anything related to science, technology, engineering, or math, computer science is like half the pie: Half the job growth annually is in computing jobs. But the arts and humanities are sexier than the sciences, so kids gravitate toward those. Every kid wants to be a singer, a dancer, a rapper. It's what's on television. It's better publicized. It seems more fun, which I totally understand. Programming a computer? I think it's sexy; I think it's wonderful. But I know a different side of it.

Computer-science education is my love. I really believe in it, and I want everyone to experience it. Even if they don't think it's for them, which is completely fine. I just want them to have a shot.

Photographer Bios

RON BLAYLOCK is a regular contributor to several regional, national, and international publications, including the *Washington Post, Le Monde diplomatique* (France), *Block Magazine* (The Netherlands), *Living Blues, Real Simple,* and *Mississippi Magazine.* His commercial clients include Entergy, Viking Range, Cathead Vodka, AAU Junior Olympics, the New Orleans Zephyrs, Jackson Convention & Visitors Dept., and the Mississippi Health Commission. His fine art pieces have been exhibited in the New Orleans Museum of Art, are in the permanent collection of the Mississippi Museum of Art, and hang in private collections around the country. Ron has taught photography at the University of Mississippi and through private lessons and workshops. He currently teaches at Millsaps College. *(Page 33)*
www.blaylockphoto.com

NANCY BOROWICK, a graduate of the photojournalism and documentary Photography program at the International Center of Photography, is a native New Yorker based in New York City and Ghana, West Africa. She spent 2009-2010 using her lens to fund-raise for a well at a school in Ghana and is also the founder of the Ghana On Tap project. Nancy has exhibited her work in solo and group shows in New York and Russia, most recently in the shows "Significant Surfaces" at the Andrea Meislin Gallery in New York City and "Life In Motion" at the International Center of Photography. She is a regular contributor to *Newsday, amNY,* and *Demotix/Corbis,* and her work has appeared on ABC News and CNN and in the *Washington Post, Time, Lenscratch, Education Week,* and *JPG Magazine.* *(Pages 135, 183, 185, 205)*
www.nancyborowick.com

ROMAN CHO is a Los Angeles-based photographer. Clients include Universal Studios, Paramount Pictures, New Line Cinema, Disney Studios, KO Creative, and Real World Records, as well as *Time, Rolling Stone, GQ,* and *Los Angeles* magazine. Roman received his B.F.A. from California Institute of the Arts. Most recently, Roman and co-photographer Tatiana Wills shot the book *Heroes and Villains,* a collection of portraits that surveys some of the most intriguing personalities in today's art, street, and pop culture movements. *(Pages 2, 3, 13, 21, 23, 41, 43, 51, 58, 61, 73, 76, 97, 99, 107, 110, 113, 122, 127, 129, 143, 147, 151, 152, 163, 187, 190, 201, 214, 219)*
www.romancho.com

ASHLEY DETRICK graduated from the University of Missouri's journalism program and returned to her roots in the Rocky Mountains. She worked as a photographer and photo editor for six years at the *Daily Herald* in Provo, Utah. Currently she works as a freelance photographer in Salt Lake City. *(Page 68)*

PETER FELDSTEIN is an artist working at the intersection of photography, drawing, printmaking, and digital imaging. Feldstein's work has been exhibited at the Des Moines Art Center and the Center for Creative Photography, the Walker Art Center, and the Rhode Island School of Design. He has received an individual artist's grant from the National Endowment for the Arts and two Polaroid Collection grants. For more than three decades, Feldstein taught photography and digital imaging at the University of Iowa School of Art & Art History. His book *The Oxford Project,* published by Welcome Books (2008), won both an IPPY Gold Medal for Most Original Concept and the Alex Award. *(Pages 16, 89, 155, 156, 208, 212)*
www.peterfeldstein.com

STEVEN GIBBONS is an Oregon-based photographer working as an editorial, portrait, and food photographer. When not creating photos for clients he can be found hiking in the Columbia River Gorge or kayaking along the Oregon Coast. *(Pages 36, 171, 172, 173)*
www.stevengibbons.com

JENNI GIRTMAN received her B.A. in journalism from University of Florida with a concentration in photography. Since 1998, she has covered national and metro sports, entertainment, lifestyle, features, and environmental portraits for the *Atlanta Journal Constitution, Associated Press,* the *New York Times, USA Today,* the *Miami Herald,* the *St. Petersburg Times, Vibe Magazine,* and many other publications. In 2007, Girtman founded Atlanta Event Photography, covering corporate events, conventions, trade shows, award banquets, socials, and galas. Her clients include Cox Enterprises, Children's Healthcare of Atlanta, Turner Broadcasting, Hard Rock Cafe, Strayer University, Fox Sports South, and many more. *(Page 85)*
www.atlantaeventphotography.com

SAMANTHA ALYN GORESH recently completed her studies in photojournalism and multimedia production at Ohio University's School of Visual Communication. Before that she received her B.A. in visual arts from Eckerd College and an A.S. in digital photography from the International Academy of Design and Technology. Samantha has studied in Europe, Asia, and the UK and has worked on volunteer projects in India and Turkey. Currently she is working as a freelance photographer in Boston, Massachusetts. *(Pages 80, 92, 139, 179)*
www.samalynphotography.com

CHRIS GRANGER, based in New Orleans, has worked as an editorial, portrait, and food photographer for nearly 20 years in Louisiana. He has photographed five cookbooks, including his most recent one with Chef Emeril Lagasse. *(Page 159)*
www.chrisgranger.com

HEATHER HARRIS's specialty is portraiture of preeminent personalities, in the studio or on location. Her photographs of musicians have been published in *Rolling Stone, MOJO, Billboard, Los Angeles Times, Rock&Folk, Hits, Creem,* and *Music Connection,* and by Warner Brothers, A&M/Almo, Penguin Books, and St. Martins Press, among other publishers. Spanning Buffalo Springfield to the Red Hot Chili Peppers, her subjects include many of the most important figures in

rock that came through her native Los Angeles. She authored the books *Punk Rock 'n' Roll* and *Bob Marley—Rastaman Vibration* for A&M Records' publications division in the mid-1970s, and her popular blog Fastfilm currently attests to her skill annotating these photo shoots in lively terms. *(Page 62)*

www.fastfilm1.blogspot.com

www.heatherharris.net

BILL LUSTER began his career as a newspaper photojournalist in 1965, when he joined the staff of his hometown newspaper, the *Glasgow Daily Times*. Four years later, Luster moved to Louisville, where he started working for the *Courier-Journal* and the *Louisville Times*, eventually serving as Director of Photography, Photo Editor, and Chief Photographer. Spanning more than five decades, Luster's photographic pursuits have included exclusive access to United States Presidents Gerald Ford, Ronald Reagan, Bill Clinton, George H. W. Bush, and Barack Obama. His work has been published in *National Geographic*, *Time*, *Fortune*, *Sports Illustrated*, *Newsweek*, *Life*, and the *New York Times Magazine*. He has twice won the Pulitzer Prize alongside the staff of the *Courier-Journal*. *(Page 28)*

www.billluster.com

PAUL NATKIN is a Chicago-based photographer who combines his passion for photography with his love for music. His photos have appeared in *Creem* magazine, *Rolling Stone*, *Circus*, and *Hit Parader* as well as many mainstream magazines, including *Newsweek*, *Time*, *People*, *Playboy*, and *Entertainment Weekly*. He has also contributed to album art for artists such as Ozzy Osbourne, Alanis Morissette, Buddy Guy, and Johnny Winter. *(Pages 24, 131, 174, 176)*

www.natkin.net

JULIA RENDLEMAN grew up in Illinois. She graduated with a degree in political science from Loyola New Orleans in 2002 and lived in New Orleans until 2004. For four years she worked as a wedding photographer in Chicago before receiving a master's degree in photojournalism from Southern Illinois University. In 2010, she won a Getty Images Student Grant for Editorial Photography for a story about five incarcerated women at Dixon Springs IIP, a military-style prison boot camp. She worked as a staff photographer at the *Houma Courier* in southern Louisiana until May 2012. Currently she is working at the *Pittsburgh Post-Gazette*. *(Page 119)*

www.juliarendleman.com

ERICH SCHLEGEL lived throughout Latin America before moving to Texas in 1973. Erich has covered ten Olympic Games, four Super Bowls, two FIFA World Cups, and conflicts in Afghanistan, Bosnia, Albania, Zaire, and Sri Lanka. His favorite assignments are in Latin America, where he has documented stories in Cuba, Mexico, and Central America. Erich has won awards from World Press Photo, Pictures of the Year, Society of Newspaper Design, APME, and other national and regional competitions. Along with filmmaker Bud Force, Erich is the cofounder of Ultralite Films, LLC, a company that creates web spots and feature-length films. Current clients include *National Geographic Magazine*, the *New York Times*,

USA Today, the *Guardian*, the *Dallas Morning News*, *Texas Highways Magazine*, *Bristol Environmental Remediation Services*, and *Deep South Crane & Rigging*. *(Pages 193, 195)*

www.erichschlegel.com

JULIE SOEFER is a graduate of New York University's Tisch School of the Arts. She was the still photographer for the feature film *Supersize Me*. After years assisting environmental portraitist Arnold Newman, Soefer moved back to her hometown of Houston, Texas, where she currently lives and works as an editorial photographer. Her work has appeared in *Houston Magazine*, *Modern Luxury Dallas Magazine*, the *Financial Times*, *Texas Monthly*, and the *Wall Street Journal*. Soefer was named a 2011 finalist in Hearst Corporation's 8x10 Photography Biennial and has recently released two Texas-themed cookbooks—*Lone Star Chefs* and *Green Beans & Guacamole*. *(Pages 44, 49, 55)*

www.juliesoefer.com

LAURA STRAUS turned to photography after a career in photo editing. Her photographic monographs include *A Child's World*, published by Hearst Publications (2000), as well as *What Fathers Are* (2002), *What Love Is* (2001), *What Mothers Are* (2001), *What Girlfriends Do* (1999), *Girls, Girls, Girls* (2001), *The Bride's Book of Weddings* (1999), *Fathers & Daughters* (2001), *For Dad with Love* (2002), and *Classic Cocktails* (1999), all published by Andrews & McMeel. Her photographs have appeared in the *New York Times*, the *Boston Globe*, *Elle*, *Parenting*, *People*, and *Parent and Child Magazine*. In 2011, she opened Piermont Straus Gallery and Bookstore in Piermont, NY. *(Pages 102, 166)*

www.laurastraus.com

CHRIS JOSEPH TAYLOR is a Seattle-based award-winning photographer who loves to tell stories and capture iconic moments in his photographs. Having traveled to four different continents, Chris currently works in higher education for Seattle University as the University Photographer. Chris has strong ties to the Pacific Northwest photojournalism community and is a former photographer of The *Seattle Times*. *(Page 197)*

www.cjtaylorvisuals.com

BRIAN WIDDIS began his career in 1996 photographing commercial projects in Lansing and Grand Rapids, Michigan. In 2001, he relocated to his birthplace of Detroit, where he continues his work on editorial, corporate, and personal projects. He photographs life close to home, exploring the experience of being a dad, a husband, a son, a middle-aged person, and a Detroiter. From 2008 to 2011, Brian worked on Can't Forget the Motor City, a long-term project photographing the people and landscapes of Detroit. For 2012's In Time series he photographed the forsythia bushes that appear in early spring in Michigan. His editorial work has appeared in numerous national and international publications. Brian lives with his wife, Kathy, and two sons in Detroit. *(Page 114)*

www.brianwiddis.com

Acknowledgments

A huge thanks to:

All the teachers, who shared their stories and experiences with openness, honesty, and eloquence. I am humbled and nourished by the work that you do.

Alan Kahn, for his generous support and encouragement. You brought this book to life.

Lena Tabori, for being my greatest supporter, sounding board, cheerleader, and problem-solver. No matter what I needed, you were always there at the ready. I can't possibly articulate how much that means to me.

Emily Green, my partner in crime, whose title of Project Manager doesn't even begin to describe the many hats she wore and invaluable contributions she made. Em— this book is as much yours as it is mine. I adore you.

My editorial angels: Linda Sunshine, Veronica Kavass, and Natasha Fried—I literally could not have done this without you. I owe you one.

Vince Joy, whose profound gifts as a designer and collaborative spirit produced both a gorgeous book and a wonderful working experience.

Gregory Wakabayashi, the most brilliant art director I'll ever work with.

Alisa Koyrakh and everyone at Welcome, including our terrific interns Deanna, Hannah, Jackie, Mike and Morgan.

All the photographers, whose beautiful portraits bring our classroom heroes to life.

The individuals and photo editors from newspapers and journals around the country who recommended the talented photographers whose work is featured in these pages: Beverly Reese Church, Alexander Cohn, Rebecca Cooney, Bonnie Dickerson, Jay Godwin, Steve Gonzales, Angela Gottschalk, Jeremy Harmon, Bita Honarvar, Sarah Elizabeth Ippel, Erica Marcus, Greg Morago, John A. Mura, Rashan Rucker, Kurt Weber, and Mike Zacchino.

The organizations and individuals who generously recommended outstanding teachers, and were invaluable resources: American Federation of Teachers; Ashoka; Bill & Melinda Gates Foundation; The National Education Association; The National Teacher of the Year Program; DonorsChoose.org; Global Citizen Year; Golden Apple Foundation; Khan Academy; Playworks; Teach For America; TeachersCount; Youth Villages; David Kirp; Claire Wurtzel; Tony and Maria Shorris; Sylvia Shorris; and Susan Kahn.

Christian, Hopi, and Gianni, for your love, your patience, your hugs, and your encouragement. I love you more than anything.

—K.F.

American Teacher
Heroes in the Classroom

By Katrina Fried

Published in 2013 by Welcome Books®
An imprint of Welcome Enterprises, Inc.
6 West 18th Street, Suite 4B, New York, NY, 10011
(212) 989-3200; fax (212) 989-3205
www.welcomebooks.com

Publisher: Lena Tabori
President: H. Clark Wakabayashi
Associate Publisher and Editor: Katrina Fried
Designer: Vince Joy
Project Manager: Emily Nicole Green

Copyright © 2013 JAK Inc.
Design copyright © 2013 Welcome Enterprises, Inc.
Text copyright © 2013 Katrina Fried
Foreword copyright © 2013 Parker J. Palmer
Photographs copyright © 2013 Ron Blaylock, Nancy Borowick, Roman Cho, Ashley Detrick, Peter Feldstein, Steven Gibbons, Jenni Girtman, Samantha Alyn Goresh, Chris Granger, Heather Harris, Bill Luster, Paul Natkin, Julia Rendleman, Erich Schlegel, Julie Soefer, Laura Straus, Chris Joseph Taylor, Brian Widdis

If you notice an error, please check the website listed below where there will hopefully be a posted correction. If not, please alert us by emailing info@welcomebooks.com and we will post the corrections.

Library of Congress Cataloging-in-Publication Data on file

ISBN: 978-1-59962-127-2

First Edition
10 9 8 7 6 5 4 3 2 1

Printed in China through Asia Pacific Offset Inc.

For further information about this book please visit online:
www.welcomebooks.com/americanteacher